art in modern culture

The Open University

art in modern culture:
an anthology of critical texts

edited by francis frascina
and jonathan harris

COVER ILLUSTRATION:
Pablo Picasso, *Les Demoiselles d'Avignon*, 1907.
Collection, New York, The Museum
of Modern Art. Lillie P. Bliss Bequest.
Photo Giraudon, Paris.

The publishers would like to thank the following
for permission to reproduce texts: Design History
Society (Text 26, to be published in the *Journal of
Design History*); HarperCollins (Text 29); MIT
Press (Texts 20, 21, 22, 23, 31); Pantheon Books,
a division of Random House, Inc., copyright ©
1990 by Lucy R. Lippard (Text 16); Verso/NLB,
London and New York (Texts 7, 8).

Phaidon Press Limited
Regent's Wharf
All Saints Street
London N1 9PA

Published in association with the Open University

First published 1992
Reprinted 1994, 1995

A CIP catalogue record for this book
is available from the British Library
ISBN 0 7148 2840 8

Printed in Hong Kong

Contents

Part IV

Aesthetic Theory and
Social Critique
292

Introduction to Part IV
293

Preface

This Anthology is part of an Open University course, A316: *Modern Art: Practices and Debates*. As such, it is one component of an integrated teaching system. The selection of texts is, therefore, directly related to a variety of methods and approaches introduced in written material by David Batchelor, Tim Benton, Nigel Blake, Briony Fer, Francis Frascina, Tamar Garb, Jonathan Harris, Charles Harrison, Gill Perry and Paul Wood.

The essays, articles and extracts contained in this volume will also provide an important resource for undergraduates in other Universities, Polytechnics and Colleges. They should stimulate debate amongst those concerned with the study of modern art as a product of historical and socio-cultural relations. *Art in Modern Culture* should also appeal to general readers interested in the place of art in modern culture and history.

The majority of these articles and extracts have been edited as appropriate to the overall theme and purpose of this collection, particularly to enable them to have a wide student usage. All excisions are marked [...]. Texts are otherwise left unchanged (apart from standardization of spelling, punctuation and minor details of presentation) and authors' usages have been maintained. Original illustrations and footnotes have been retained only where necessary for reference, or at the express wish of individual authors. We would like to thank all authors who have agreed to the inclusion and editing of their material.

From our perspectives in the early 1990s it is clear that the twentieth century has brought about remarkable changes in the understanding and evaluation of the categories 'art' and 'culture'. In an important sense the bringing of the terms into self-conscious and critical alignment with each other has been a process bound up with central features of twentieth-century development in Western Europe and North America, for example: the struggle for 'universal suffrage'; the political revolutions in Eastern and Central Europe in the first quarter of the century; the persistence of economic and social crises in Western Europe and North America following the Depression of the 1930s; the effects of the Cold War settlement after 1945; the emergence of counter-cultural groups and resistance movements in the late 1960s. All of these phenomena have led, in various ways, to debate about how modern culture, transformed by nineteenth-century industrialization and urbanization, might be both a cause and an effect of these radical changes.

This is true in the writings of those who both opposed *and* supported the outbreak of revolution in Russia and other European countries after the First World War. Right- and left-wing political activists, critics and academics in the capitalist democracies have spent the last sixty years and more trying to understand the relationship between economic and social crisis and the forms of culture characteristic of those societies dominated by urban, industrial 'market-driven' life. The place and value of art within the cultures of Western and Eastern European societies, as well as within North America, during the century has been the particular interest of many who see culture – 'a whole way of life' – as the network of relationships and activities which necessarily inform the development of particular art forms. The first two introductory texts by Giddens and by Williams [Texts 1 and 2] open up this debate by providing incisive perspectives on 'modernity', the conditions of experience under modernization and industrialization, and on 'modernism', as a contested concept with political resonances in the various forms and theories of modern culture.

Perhaps it is fair to say that, historically, in the first half of the twentieth century two positions dominated. One began from the assumption that what mattered most was the inherently evaluative definition of both 'art' and

'culture'. Here the emphases are on autonomy, 'aesthetic experience' as a necessarily transcendent 'other' to everyday life, and formal analysis of art. A characteristic concern is: how might the best, the highest, 'art' survive and flourish within modern culture and the demands of an ever more rationalized life? The second position regarded such emphases and concerns as importantly ideological, as the manifestations of the interests of class-based élites whose power relied on asserting that differences (class, gender, race) in experience are irrelevant to judgements of 'quality'.

For critics of élitism, evaluative judgement was characterized by a broader agenda, by an effort to understand the complex relations between the elements that made up the whole of specific cultures, and they sought to relate this knowledge to the understanding of 'the arts' inherited from the nineteenth century and earlier. Many of the articles included in this anthology draw on the materials that have constituted these two traditions of cultural thought and at the same time are examples of the persistence of the two modes in writing produced over the last twenty years.

A narrower context for the discussion of these texts is that of the current status of the discipline known as 'art history'. For, despite the differences that characterize the varying premises, assumptions, methods and values within these accounts, most of the articles have been produced within, or have come to impinge upon, the writing of histories of art. Some texts reproduce the traditional forms of art-historical discourse: studies of individual artists or groups of artists, studies of style labels, the analysis of iconography within particular works. But, beyond these received forms of description and explanation, the discipline of art history has been expanded and at the same time challenged by concepts, methods and theories developed within other academic disciplines and by forms of thought closely tied to extra-academic objectives and programmes. The significance of Marxist and socialist ideas, along with feminist history and theory, are two key components of this contribution and challenge [see Text 3].

While forms of analysis influenced by these political movements have taken root in the Academy, Marxism and feminism have offered, and continue to offer, a critique of academic labour and its relation to political struggle outside the seminar room. Discipline speciality is a part of the division of intellectual labour, and despite the value and quality of highly developed methods and theories used by art historians influenced by Marxism and feminism, the challenge remains to link such work to an oppositional culture of struggle outside the Academy.

During the first half of the century there certainly were radical impulses within individuals and groups writing about art and culture directed towards making these issues central to the society as a whole, rather than simply the province of an intellectual élite within a set of minority institutions. Once again, such an impulse can be found within formations on both the left and right. Critics such as Roger Fry, Clive Bell and Clement Greenberg [Text 28, see, too, Texts 30 and 31] spoke up for a specific 'aesthetic experience' which, in theory at least, could be a common one, 'disinterested' and intu-

11

itive. All three figures were located, at decisive moments in their lives, as critics within apparently 'left' or 'liberal' groupings in England or the United States. An implicit or, in Greenberg's case, explicit critique of the effects of capitalism on culture was a part of their evaluative process: good, or great art, then, was a form of resistance to the pernicious effects of mass production, the division of labour and the encroachment of high technology.[1] Despite major differences, Theodor Adorno, particularly after the Second World War [Text 8, see, too, Texts 7, 9 and 27 for context], also argued for the autonomy of art as a resistance to what he characterized as both the modern 'culture industry' of capitalism and the doctrinaire manifestations of totalitarian and fascist societies.

There are two important points here. One is what Noam Chomsky describes as 'the role of the intelligentsia in a society like ours. This social class ... undertakes to analyse and present some picture of social reality ... [as mediators] they create the ideological justification for social practice' [Text 4]. Applying Chomsky's analysis, both generally to the modern period and specifically to post-1945 America, what is the social role of intellectual groups, with art world power (through galleries, museums, universities, art journals, dealers etc.) who share similar assumptions about art and culture? How and why do paradigms of explanation and interpretation, in the Kuhnian sense, become dominant?[2] Since at least the late 1960s, historians and theorists have demonstrated how such paradigms relate to the notion of social and psychological construction especially with respect to gender, ethnicity, and cultural difference [see Texts 12 to 16 in Part 11]. Raymond Williams provides a model of analysis of cultural groups in 'The Bloomsbury Fraction', focusing on the moment of power for Bell and Fry.[3] Here, Barbara Reise, especially, and also Serge Guilbaut and Anna Chave [Texts 23 to 25] consider comparable moments in the United States. These cases can be contrasted with the intellectual community, centred largely around the Institute of Social Research (The Frankfurt School), whose members produced debates on 'aesthetics and politics' [see Texts 7, 8, 9 and 27]. The second point relates directly to the latter: the role and importance of the debate around the 'autonomy of art'. Peter Bürger considers the historical origins and problems of this debate [Text 6] which is continued in a variety of contexts in many of the subsequent texts.

Out of a very different social and political background came a group of writers and academics committed to revolutionary anti-capitalist and anti-imperialist politics. Raymond Williams, Edward Said and Noam Chomsky [Texts 2, 4, 14 and 29], although politically heterogeneous – through diverse ethnic and social roots – came to share the belief that one necessary condition for the transformation of capitalist societies was the creation of wide-ranging cultural activities and relations based on co-operation and democratic control. Modernity, within their analyses, involved an ongoing dynamic of change and development propelled in the West by the priorities of a monopoly capitalist economy, a highly regulative and secretive State, and a 'foreign policy' of neo-colonialism centred around the protection of vital, so-called

'national interests'. In Europe and the United States since the turn of the century, 'avant-garde' or 'modernist' art has been a response to, and yet also, in its way, a constitutive part of this capitalist, neo-colonial culture; dependent on the forms of non-Western cultures appropriated by Imperialism for the ideal notions of 'primitive' and 'untainted' life which could be opposed to the realities of industrial capitalism.

The capitalist market in Europe and the United States at the same time provided the structures of exchange and consumption through which the avant-garde could reach a public. Art, within this account, was fully a part of the commodity culture, although differentiated within it and by no means politically, socially or ideologically uniform. An understanding of the complex relationships and character of particular practices and processes within the 'modern art world' as a component, in turn, of a growing international culture dominated by Western capitalist structures and interests has been the intention of Said and Williams, whose work, although originally centred around literature, has many important implications for the study of visual art.

Social Theory, as a specific branch of modern sociology and as a tradition of thought influenced by 'New Left' movements since the 1960s, has also made an important impact on the development of the study of art and culture in the post-war period. The nature and role of institutions within modern societies has been a particular concern of writers interested in such diverse subjects as penal systems, sexuality, mental health, educational systems and social work. Empirical research and theoretical studies have emphasized the operation of institutions as networks which regulate and give expression to people's senses of identity and belonging [see Texts 1, 10, 11, 15, 16, 17, 20, 25, 26 and 32]. It is clear that the concept of art and of its possible 'reforming' capacities is also a part of this network of institutions which constitute a major formal aspect of the modern Western culture. At the same time it is clear that this ideological use of art has taken place in ways that are class, gender and ethnically specific [see Texts 1, 2, 3, 5, 6, 9 to 17, 20, 23, 25, 29 and 32]. Feminist and non-American/European art historians have attempted to show the specific ways in which discourses on art, and the social institutions through which it is propagated, have reproduced white, middle-class and male values. Studies of modern art galleries and museums similarly indicate the range of roles such institutions have as sites for the promotion of normative values and judgements, roles that have historically been bound up with the interests of the capitalist State, both in terms of a projected notion of a national culture, and in terms of the formation of international opinion [see Texts 10, 15, 16, 17, 20, 25 and 26].

Over the past ten years or so, the notion of 'modern' art and culture has been subject to an important qualification which in some cases has been used to attempt to displace the concept of 'the modern' altogether. 'Postmodernism', understood not as a unitary concept, but rather as a 'discursive field' of clusters of concepts and differing descriptions and offered explanations, has grown up as a specifically 'cultural' problematic. Have new

forms of technology and representational systems, along with changes in pro-
duction processes and patterns of consumption, brought about a culture in
which the traditional senses of subjectivity and identity have disappeared,
replaced by more transitive, 'schizophrenic' forms of consciousness? Is there
no longer any consensus about the principles which underpin the society or
the sources of stability that allow it to continue? With the revolutions in
Eastern Europe beginning in the late 1980s and the legacies of Thatcherism
and Reaganism within British and United States societies, have 'non', or
'post' capitalist visions of alternative ways of living been written off the
agenda? [see Texts 1, 2, 11, 16 and 32].

From the point of view of art and culture, such a set of questions raises
important issues which relate back to the origins of debate about culture and
society in the twentieth century. Arguably, any position which sees cultural
practices and processes as simply reflections or effects of events and changes
elsewhere in the society, can be called 'conservative'. By this is meant that
such a view relegates culture to the status of a peripheral or supplementary
phenomenon. During the twentieth century groups and individuals of the
left and right have adopted such a stance and the results have been disastrous.
The failure of the 'Popular Front' in the 1930s against fascism in Europe
occurred partly, and importantly, because struggle and argument within cul-
tural activity was seen, until it was too late, as a very low priority by the
Communist left. This in turn sprang from a highly reductive reading of
Marxism which understood 'culture' as a secondary, 'superstructural' entity
only echoing the realities of economic production. Consciousness was
changed, it was believed, only when a revolution brought about (by whom?)
transformed economic relationships which then constituted 'socialism'. For
many the writings of Leon Trotsky and Antonio Gramsci offered an impor-
tant corrective to such reductionism, as did those of Bertolt Brecht and
Walter Benjamin [see Texts 7, 9 and 27]. Meanwhile, the Nazis and Italian
fascists utilized traditional and new forms of cultural production (especially
photography and film) in the building of group identities centred around the
myths of nationalism and racial superiority [on this see Benjamin's arguments
in Text 27].

What has been called a 'postmodernism of resistance'[4] argues that, what-
ever the truth about changes within the structure of capitalist economies and
international nation-state relations, it is up to people – as makers and critics –
to devise strategies that engage with and critique new forms of production
and exploitation, consumption and spectacle. Such a position recognizes that
'postmodern' society is still discernably capitalist, neo-colonial and patriar-
chal. Many, though *not all* of the articles within this collection are concerned
with the understanding of art, and the culture as a whole, in relation to the
dynamics of social and political development within the West in the period
since the end of the Second World War. The connections between visual
representation, language, power and social relations are the subject of several
of the analyses, both those that are recognizably 'art-historical' and those
which have their origins within different forms of inquiry.

The future of the discipline of art history in its critical forms – that is, those concerned with crisis and the resolution of crisis – will be closely related to the development of conceptual and methodological apparatuses attuned to the analysis of social, political and ideological features of life in the twenty-first century. The career of the term 'art' will be a part of that analysis, within a broad understanding of the growing complexities of the culture. These selected texts indicate some of the present directions of thought in this area, along with a sense of the development of these ideas during this century and their likely elaboration over the coming years.

Notes

1 Clement Greenberg, 'Avant-garde and Kitsch', *Partisan Review*, vol. 6, no. 5, Fall 1939, pp. 34-49, and 'The Plight of Our Culture', Part I ('Industrialism and Class Mobility'), *Commentary*, vol. 15, June 1953, pp. 558-66; Part II ('Work and Leisure Under Industrialism'), August 1953, pp. 54-62.

2 Thomas S. Kuhn, *The Structure of Scientific Revolutions*, Chicago, revised edition, 1972. For a discussion of the social, intellectual and institutional aspects of paradigms in the art world (with respect to Alfred H. Barr Jnr [see Plate 9] and Greenberg), see Francis Frascina, 'Introduction', *Pollock and After: The Critical Debate*, London and New York, 1985, pp. 3-20.

3 In *Problems in Materialism and Culture, Selected Essays*, London, 1980, pp. 148-69.

4 See Hal Foster, 'Postmodernism: A Preface', in *The Anti-Aesthetic: Essays on Postmodern Culture*, Port Townsend (Washington), 1983, pp. ix-xvi; reprinted in Britain as *Postmodern Culture*, London, 1985.

Introductory texts

1

Anthony Giddens
Modernity and Self-Identity:
Self and Society in the Late
Modern Age

Source: Anthony Giddens, 'Introduction',
*Modernity and Self-Identity: Self and Society in the
Late Modern Age*, Cambridge, Polity Press,
1991, pp. 1-9. This text has been edited.

The question of modernity, its past development and current institutional forms, has reappeared as a fundamental sociological problem at the turn of the twenty-first century. The connections between sociology and the emergence of modern institutions have long been recognized. Yet in the present day, we see not only that these connections are more complex and problematic than was previously realized, but that a rethinking of the nature of modernity must go hand in hand with a reworking of basic premises of sociological analysis.

Modern institutions differ from all preceding forms of social order in respect of their dynamism, the degree to which they undercut traditional habits and customs, and their global impact. However, these are not only extensional transformations: modernity radically alters the nature of day-to-day social life and affects the most personal aspects of our experience. Modernity must be understood on an institutional level; yet the transmutations introduced by modern institutions interlace in a direct way with individual life and therefore with the self. One of the distinctive features of modernity, in fact, is an increasing interconnection between the two 'extremes' of extensionality and intentionality: globalizing influences on the one hand and personal dispositions on the other.[...]

Although its main focus is on the self, this is not primarily a work of psychology. The overriding stress [here] is upon the emergence of new mechanisms of self-identity which are shaped by – yet also shape – the institutions of modernity. The self is not a passive entity, determined by external influences; in forging their self-identities, no matter how local their specific contexts of action, individuals contribute to and directly promote social influences that are global in their consequences and implications. [...]

Besides its institutional reflexivity, modern social life is characterized by profound processes of the reorganization of time and space, coupled to the expansion of disembedding mechanisms – mechanisms which prise social relations free from the hold of specific locales, recombining them across wide time–space distances. The reorganization of time and space, plus the disembedding mechanisms, radicalize and globalize pre-established institutional

traits of modernity; and they act to transform the content and nature of day-to-day social life.

Modernity is a post-traditional order, but not one in which the sureties of tradition and habit have been replaced by the certitude of rational knowledge. Doubt, a pervasive feature of modern critical reason, permeates into everyday life as well as philosophical consciousness, and forms a general existential dimension of the contemporary social world. Modernity institutionalizes the principle of radical doubt and insists that all knowledge takes the form of hypotheses: claims which may very well be true, but which are in principle always open to revision and may have at some point to be abandoned. Systems of accumulated expertise – which form important disembedding influences – represent multiple sources of authority, frequently internally contested and divergent in their implications. In the settings of what I call 'high' or 'late' modernity – our present-day world – the self, like the broader institutional contexts in which it exists, has to be reflexively made. Yet this task has to be accomplished amid a puzzling diversity of options and possibilities. [...]

Modernity is a risk culture. I do not mean by this that social life is inherently more risky than it used to be; for most people in the developed societies that is not the case. Rather, the concept of risk becomes fundamental to the way both lay actors and technical specialists organize the social world. Under conditions of modernity, the future is continually drawn into the present by means of the reflexive organization of knowledge environments. A territory, as it were, is carved out and colonized. Yet such colonization by its very nature cannot be complete: thinking in terms of risk is vital to assessing how far projects are likely to diverge from their anticipated outcomes. Risk assessment invites precision, and even quantification, but by its nature is imperfect. Given the mobile character of modern institutions, coupled to the mutable and frequently controversial nature of abstract systems, most forms of risk assessment, in fact, contain numerous imponderables.

Modernity reduces the overall riskiness of certain areas and modes of life, yet at the same time introduces new risk parameters largely or completely unknown to previous eras. These parameters include high-consequence risks: risks deriving from the globalized character of the social systems of modernity. The late modern world – the world of what I term high modernity – is apocalyptic, not because it is inevitably heading towards calamity, but because it introduces risks which previous generations have not had to face. However much there is progress towards international negotiation and control of armaments, so long as nuclear weapons remain, or even the knowledge necessary to build them, and so long as science and technology continue to be involved with the creation of novel weaponry, the risk of massively destructive warfare will persist. Now that nature, as a phenomenon external to social life, has in a certain sense come to an 'end' – as a result of its domination by human beings – the risks of ecological catastrophe form an inevitable part of our horizon of day-to-day life. Other high-consequence risks, such as the collapse of global economic mechanisms, or the rise of total-

itarian superstates, are an equally unavoidable part of our contemporary experience.

In high modernity, the influence of distant happenings on proximate events, and on intimacies of the self, becomes more and more commonplace. The media, printed and electronic, obviously play a central role in this respect. Mediated experience, since the first experience of writing, has long influenced both self-identity and the basic organization of social relations. With the development of mass communication, particularly electronic communication, the interpenetration of self-development and social systems, up to and including global systems, becomes ever more pronounced. The 'world' in which we now live is in some profound respects thus quite distinct from that inhabited by human beings in previous periods of history. It is in many ways a single world, having a unitary framework of experience (for instance, in respect of basic axes of time and space), yet at the same time one which creates new forms of fragmentation and dispersal. A universe of social activity in which electronic media have a central and constitutive role, nevertheless, is not one of 'hyperreality', in Baudrillard's sense. Such an idea confuses the pervasive impact of mediated experience with the internal referentiality of the social systems of modernity – the fact that these systems become largely autonomous and determined by their own constitutive influences.

In the post-traditional order of modernity, and against the backdrop of new forms of mediated experience, self-identity becomes a reflexively organized endeavour. The reflexive project of the self, which consists in the sustaining of coherent, yet continuously revised, biographical narratives, takes place in the context of multiple choice as filtered through abstract systems. In modern social life, the notion of lifestyle takes on a particular significance. The more tradition loses its hold, and the more daily life is reconstituted in terms of the dialectical interplay of the local and the global, the more individuals are forced to negotiate lifestyle choices among a diversity of options. Of course, there are standardizing influences too – most notably, in the form of commodification, since capitalistic production and distribution form core components of modernity's institutions. Yet because of the 'openness' of social life today, the pluralization of contexts of action and the diversity of 'authorities', lifestyle choice is increasingly important in the constitution of self-identity and daily activity. Reflexively organized life-planning, which normally presumes consideration of risks as filtered through contact with expert knowledge, becomes a central feature of the structuring of self-identity.

A possible misunderstanding about lifestyle as it interconnects with life-planning should be cleared up right at the beginning. Partly because the term has been taken up in advertising and other sources promoting commodified consumption, one might imagine that 'lifestyle' refers only to the pursuits of the more affluent groups or classes. The poor are more or less completely excluded from the possibility of making lifestyle choices. In some substantial part this is true. [...] Indeed, class divisions and other fundamental lines of

inequality, such as those connected with gender or ethnicity, can be partly *defined* in terms of differential access to forms of self-actualization and empowerment discussed in what follows. Modernity, one should not forget, produces *difference, exclusion* and *marginalization*. Holding out the possibility of emancipation, modern institutions at the same time create mechanisms of suppression, rather than actualization, of self. [...] 'Lifestyle' refers also to decisions taken and courses of action followed under conditions of severe material constraint; such lifestyle patterns may sometimes also involve the more or less deliberate rejection of more widely diffused forms of behaviour and consumption.

At one pole of the interaction between the local and the global stands what I call the 'transformation of intimacy'. Intimacy has its own reflexivity and its own forms of internally referential order. Of key importance here is the emergence of the 'pure relationship' as prototypical of the new spheres of personal life. A pure relationship is one in which external criteria have become dissolved: the relationship exists solely for whatever rewards that relationship as such can deliver. In the context of the pure relationship, trust can be mobilized only by a process of mutual disclosure. Trust, in other words, can by definition no longer be anchored in criteria outside the rela-tionship itself – such as criteria of kinship, social duty or traditional obliga-tion. Like self-identity, with which it is closely intertwined, the pure relationship has to be reflexively controlled over the long term, against the backdrop of external transitions and transformations.

Pure relationships presuppose 'commitment', which is a particular species of trust. Commitment in turn has to be understood as a phenomenon of the internally referential system: it is a commitment to the relationship as such, as well as to the other person or persons involved. The demand for intimacy is integral to the pure relationship, as a result of the mechanisms of trust which it presumes. It is hence a mistake to see the contemporary 'search for inti-macy', as many social commentators have done, only as a negative reaction to a wider, more impersonal social universe. Absorption within pure rela-tionships certainly may often be a mode of defence against an enveloping outside world: but such relationships are thoroughly permeated by mediated influences coming from large-scale social systems, and usually actively orga-nize those influences within the sphere of such relationships. In general, whether in personal life or in broader social milieux, processes of reappropri-ation and empowerment intertwine with expropriation and loss.

In such processes many different connections between individual experi-ence and abstract systems can be found. 'Reskilling' – the reacquisition of knowledge and skills – whether in respect of intimacies of personal life or wider social involvements, is a pervasive reaction to the expropriating effects of abstract systems. It is situationally variable, and also tends to respond to specific requirements of context. Individuals are likely to reskill themselves in greater depth where consequent transitions in their lives are concerned or fateful decisions are to be made. Reskilling, however, is always partial and liable to be affected by the 'revisable' nature of expert knowledge and by

internal dissensions between experts. Attitudes of trust, as well as more prag-matic acceptance, scepticism, rejection and withdrawal, uneasily coexist in the social space linking individual activities and expert systems. Lay attitudes towards science, technology and other esoteric forms of expertise, in the age of high modernity, tend to express the same mixed attitudes of reverence and reserve, approval and disquiet, enthusiasm and antipathy, which philosophers and social analysts (themselves experts of sorts) express in their writings.

The reflexivity of the self, in conjunction with the influence of abstract systems, pervasively affects the body as well as psychic processes. The body is less and less an extrinsic 'given', functioning outside the internally referential systems of modernity, but becomes itself reflexively mobilized. What might appear as a wholesale movement towards the narcissistic cultivation of bodily appearance is in fact an expression of a concern lying much deeper actively to 'construct' and control the body. Here there is an integral connection between bodily development and lifestyle – manifest, for example, in the pursuit of specific bodily regimes. Yet much more wide-ranging factors are important, too, as a reflection of the socializing of biological mechanisms and processes. In the spheres of biological reproduction, genetic engineering and medical interventions of many sorts, the body is becoming a phenomenon of choices and options. These do not affect the individual alone: there are close connections between personal aspects of bodily development and global factors. Reproductive technologies and genetic engineering, for example, are parts of more general processes of the transmutation of nature into a field of human action.

Science, technology and expertise more generally play a fundamental role in what I call the sequestration of experience. The notion that modernity is associated with an instrumental relation to nature, and the idea that a scientific outlook excludes questions of ethics or morality, are familiar enough. However, I seek to reframe these issues in terms of an institutional account of the late modern order, developed in terms of internal referential-ity. The overall thrust of modern institutions is to create settings of action ordered in terms of modernity's own dynamics and severed from 'external criteria' – factors external to the social systems of modernity. Although there are numerous exceptions and countertrends, day-to-day social life tends to become separated from 'original' nature and from a variety of experiences bearing on existential questions and dilemmas. The mad, the criminal and the seriously ill are physically sequestered from the normal population, while 'eroticism' is replaced by 'sexuality' – which then moves behind the scenes to become hidden away. The sequestration of experience means that, for many people, direct contact with events and situations which link the individual lifespan to broad issues of morality and finitude are rare and fleeting.

This situation has not come about, as Freud thought, because of the increasing psychological repression of guilt demanded by the complexities of modern social life. Rather, what occurs is an institutional repression, in which [...] mechanisms of shame rather than guilt come to the fore. Shame has close affiliations with narcissism, but it is a mistake, as noted earlier, to

21

suppose that self-identity becomes increasingly narcissistic. Narcissism is one among other types of psychological mechanism – and, in some instances, pathology – which the connections between identity, shame and the reflexive project of the self bring into being.

Personal meaninglessness – the feeling that life has nothing worthwhile to offer – becomes a fundamental psychic problem in circumstances of late modernity. We should understand this phenomenon in terms of a repression of moral questions which day-to-day life poses, but which are denied answers. 'Existential isolation' is not so much a separation of individuals from others as a separation from the moral resources necessary to live a full and satisfying existence. The reflexive project of the self generates programmes of actualization and mastery. But as long as these possibilities are understood largely as a matter of the extension of the control systems of modernity to the self, they lack moral meaning. 'Authenticity' becomes both a pre-eminent value and a framework for self-actualization, but represents a morally stunted process.

Yet the repression of existential questions is by no means complete, and in high modernity, where systems of instrumental control have become more nakedly exposed than ever before and their negative consequences more apparent, many forms of counter-reaction appear. It becomes more and more apparent that lifestyle choices, within the settings of local–global interrelations, raise moral issues which cannot simply be pushed to one side. Such issues call for forms of political engagement which the new social movements both presage and serve to help initiate. 'Life politics' – concerned with human self-actualization, both on the level of the individual and collectively – emerges from the shadow which 'emancipatory politics' has cast.

Emancipation, the general imperative of progressivist Enlightenment, is in its various guises the condition for the emergence of a life-political programme. In a world still riven by divisions and marked by forms of oppression both old and new, emancipatory politics does not decline in importance. Yet these pre-existing political endeavours become joined by novel forms of life-political concern [in] an agenda which demands an encounter with specific moral dilemmas, and forces us to raise existential issues which modernity has institutionally excluded.

2

Raymond Williams
When Was Modernism?

Source: Raymond Williams, 'When was
Modernism?', *New Left Review,*
no. 175, May/June 1989, pp. 48-52.

[This lecture was given on 17 March 1987 at the University of Bristol, as one of an annual series
founded by a former student at the University and subsequent benefactor. The version printed
here is reconstructed from my brief notes and Raymond's even briefer ones. Although he spoke
on that occasion in unhesitating, delicate and sinewy prose – the unmistakable and, where nec-
essary, rousing Williams style – his notes are merely composed of jottings and very broad head-
ings ('Metropolis', 'Exiles', '1840s', '1900-1930' etc.). [...] I cannot hope to have caught
Raymond's voice accurately, but the trenchancy and relevance of one of his last public lectures
are not in doubt. Postmodernism for him was a strictly ideological compound from an enemy
formation, and long in need of this authoritative rebuttal. This was a lecture by the 'Welsh
European' given against a currently dominant international ideology. Fred Inglis]

My title is borrowed from a book by my friend Professor Gwyn Williams:
When Was Wales? That was a historical questioning of a problematic history.
My own inquiry is a historical questioning of what is, in very different ways,
a problem, but also a dominant and misleading ideology. 'Modern' began to
appear as a term more or less synonymous with 'now' in the late sixteenth
century, and in any case used to mark the period off from medieval *and*
ancient times. By the time Jane Austen was using it with a characteristically
qualified inflection, she could define it (in *Persuasion*) as 'a state of alteration,
perhaps of improvement', but her eighteenth-century contemporaries used
'modernize', 'modernism' and 'modernist', without her irony, to indicate
updating and improvement. In the nineteenth century it began to take on a
more favourable and progressive ring: Ruskin's *Modern Painters* was published
in 1846, and Turner became the type of a modern painter for his demonstra-
tion of the distinctively up-to-date quality of truth-to-nature. Very quickly,
however, 'modern' shifted its reference from 'now' to 'just now' or even
'then', and for some time has been a designation always going into
the past with which 'contemporary' may be contrasted for its presentness.
'Modernism', as a title for a whole cultural movement and moment, has been
retrospective as a general term since the 1950s, thereby stranding the domi-
nant version of 'modern' or even 'absolute modern' between, say, 1890 and
1940. We still habitually use 'modern' of a world between a century and half-
a-century old. When we note that in English at least (French usage still
retaining some of the meaning for which the term was coined) 'avant-garde'
may be indifferently used to refer to Dadaism seventy years after the event or

to recent fringe theatre, the confusion both willed and involuntary which leaves our own deadly separate era in anonymity becomes less an intellectual problem and more an ideological perspective. By its point of view, all that is left to us is to become post-moderns.

Determining the process which fixed the moment of modernism is a matter, as so often, of identifying the machinery of selective tradition. If we follow the Romantics' victorious definition of the arts as out-riders, heralds, and witnesses of social change, then we may ask why the extraordinary innovations in social realism, the metaphoric control and economy of seeing discovered and refined by Gogol, Flaubert or Dickens from the 1840s on, should not take precedence over the conventionally modernist names of Proust, Kafka or Joyce. The earlier novelists, it is widely acknowledged, make the later work possible; without Dickens, no Joyce. But in excluding the great realists, this version of modernism refuses to see how they devised and organized a whole vocabulary and its structure of figures of speech with which to grasp the unprecedented social forms of the industrial city. By the same token, the Impressionists in the 1860s also defined a new vision and a technique to match in their painting of modern Parisian life, but it is of course only the Post-Impressionists and the Cubists who are situated in the tradition.

The same questions can be put to the rest of the literary canon and the answers will seem as arbitrary: the Symbolist poets of the 1880s are superannuated by the Imagists, Surrealists, Futurists, Formalists and others from 1910 onwards. In drama, Ibsen and Strindberg are left behind, and Brecht dominates the period from 1920 to 1950. In each of these oppositions the late-born ideology of modernism selects the later group. In doing so, it aligns the later writers and painters with Freud's discoveries and imputes to them a view of the primacy of the subconscious or unconscious as well as, in both writing and painting, a radical questioning of the processes of representation. The writers are applauded for their denaturalizing of language, their break with the allegedly prior view that language is either a clear, transparent glass or a mirror, and for their making abruptly apparent in the texture of narrative the problematic status of the author and his authority. As the author appears in the text, so does the painter in the painting. The self-reflexive text assumes the centre of the public and aesthetic stage, and in doing so declaratively repudiates the fixed forms, the settled cultural authority of the academies and their bourgeois taste, and the very necessity of market popularity (such as Dickens's or Manet's).

A Selective Appropriation

These are indeed the theoretic contours and specific authors of 'modernism', a highly selected version of the modern which then offers to appropriate the whole of modernity. We have only to review the names in the real history to

see the open ideologizing which permits the selection. At the same time, there is unquestionably a series of breaks in all arts in the late nineteenth century, breaks with forms (the three-decker novel disappears) and with power, especially as manifested in bourgeois censorship – the artist becomes a dandy or an anti-commercial radical, sometimes both.

Any explanation of these changes and their ideological consequences must start from the fact that the late nineteenth century was the occasion for the greatest changes ever seen in the media of cultural production. Photography, cinema, radio, television reproduction and recording all make their decisive advances during the period identified as modernist, and it is in response to these that there arise what in the first instance were formed as defensive cultural groupings, rapidly if partially becoming competitively self-promoting. The 1890s were the earliest moment of the movements, the moment at which the manifesto (in the new magazine) became the badge of self-conscious and self-advertising schools. Futurists, Imagists, Surrealists, Cubists, Vorticists, Formalists and Constructivists all variously announced their arrival with a passionate and scornful vision of the new, and as quickly became fissiparous, friendships breaking across the heresies required in order to prevent innovations becoming fixed as orthodoxies.

The movements are the products, at the first historical level, of changes in public media. These media, the technological investment which mobilized them and the cultural forms which both directed the investment and expressed its preoccupations, arose in the new metropolitan cities, the centres of the also new imperialism, which offered themselves as transnational capitals of an art without frontiers. Paris, Vienna, Berlin, London, New York took on a new silhouette as the eponymous City of Strangers, the most appropriate locale for art made by the restlessly mobile emigré or exile, the internationally anti-bourgeois artist. From Apollinaire and Joyce to Beckett and Ionesco, writers were continuously moving to Paris, Vienna and Berlin, meeting there exiles from the Revolution coming the other way, bringing with them the manifestos of post-revolutionary formation.

Such endless border-crossing at a time when frontiers were starting to become much more strictly policed and when, with the First World War, the passport was instituted, worked to naturalize the thesis of the *non*-natural status of language. The experience of visual and linguistic strangeness, the broken narrative of the journey and its inevitable accompaniment of transient encounters with characters whose self-presentation was bafflingly unfamiliar raised to the level of universal myth this intense, singular narrative of unsettlement, homelessness, solitude and impoverished independence: the lonely writer gazing down on the unknowable city from his shabby apartment. The whole commotion is finally and crucially interpreted and ratified by the City of Emigrés and Exiles itself, New York.

But this version of modernism cannot be seen and grasped in a unified way, whatever the likenesses of its imagery. Modernism thus defined *divides* politically and simply – and not just between specific movements but even *within* them. In remaining anti-bourgeois, its representatives either choose

the formerly aristocratic valuation of art as a sacred realm above money and commerce, or the revolutionary doctrines, promulgated since 1848, of art as the liberating vanguard of popular consciousness. Mayakovsky, Picasso, Silone, Brecht are only some examples of those who moved into direct support of communism, and D'Annunzio, Marinetti, Wyndham Lewis, Ezra Pound of those who moved towards fascism, leaving Eliot and Yeats in Britain and Ireland to make their muffled, nuanced treaty with Anglo-Catholicism and the Celtic twilight.

After modernism is canonized, however, by the post-war settlement and its complicit academic endorsements, the presumption arises that since modernism is here, in this specific phase or period, there is nothing beyond it. The marginal or rejected artists become classics of organized teaching and of travelling exhibitions in the great galleries of the metropolitan cities. 'Modernism' is confined to this highly selective field and denied to everything else in an act of pure ideology, whose first, unconscious irony is that, absurdly, it stops history dead. Modernism being the terminus, everything afterwards is counted out of development. It is *after*, stuck in the past.

The Artistic Relations of Production

The ideological victory of this selection is no doubt to be explained by the relations of production of the artists themselves in the centres of metropolitan dominance, living the experience of rapidly mobile emigrés in the migrant quarters of their cities. They were exiles one of another, at a time when this was still not the more general experience of other artists, located as we would expect them to be, at home, but without the organization and promotion of group and city – simultaneously located and divided. The life of the emigré was dominant among the key groups, and they could and did deal with each other. Their self-referentiality, their propinquity and mutual isolation all served to represent the artist as necessarily estranged, and to ratify as canonical the works of radical estrangement. So, to *want* to leave your settlement and settle nowhere like Lawrence or Hemingway, became presented, in another ideological move, as a normal condition.

What quite rapidly happened is that modernism lost its anti-bourgeois stance, and achieved comfortable integration into the new international capitalism. Its attempt at a universal market, trans-frontier and trans-class, turned out to be spurious. Its forms lent themselves to cultural competition and the commercial interplay of obsolescence, with its shifts of schools, styles and fashion so essential to the market. The painfully acquired techniques of significant *dis*connection are relocated, with the help of the special insensitivity of the trained and assured technicists, as the merely technical modes of advertising and the commercial cinema. The isolated, estranged images of alienation and loss, the narrative discontinuities, have become the easy iconography of the commercials, and the lonely, bitter, sardonic and sceptical hero takes his ready-made place as star of the thriller.

These heartless formulae sharply remind us that the innovations of what is called modernism have become the new but fixed forms of our present moment. If we are to break out of the non-historical fixity of *post*-modernism, then we must search out and counterpose an alternative tradition taken from the neglected works left in the wide margin of the century, a tradition which may address itself not to this by now exploitable because quite inhuman rewriting of the past, but for all our sakes, to a modern future in which community may be imagined again.

3

Griselda Pollock
Vision, Voice and Power:
Feminist Art History and Marxism

Source: Griselda Pollock, 'Vision, Voice and
Power: Feminist Art History and Marxism',
Block, 6, 1982, pp. 2-21. Extract from pp. 3-5
and p. 21. First published in *Kvinnovetenskaplig
Tidskrift*, no. 4, 1981, Lund, Sweden.
This text has been edited and footnotes
renumbered accordingly.

It ought to be clear by now that I'm not interested in the social history of art as part
of a cheerful diversification of the subject, taking its place alongside other varieties –
formalist, 'modernist', sub-Freudian, filmic, feminist, 'radical', all of them hot-foot in
pursuit of the New. For diversification, read disintegration. And what we need is
the opposite: concentration, the possibility of argument instead of this deadly co-
existence, a means of access to the old debates. This is what the social history of art has
to offer: it is the place where the questions have to be asked, but where they cannot
be asked in the old way.
T. J. Clark 'On the Conditions of Artistic Creation', *The Times Literary Supplement*,
24 May 1974, p.562.

[...] I agree with Clark that one – and a very substantive one too – paradigm
for the social history of art lies within Marxist cultural theory and historical
practice. Yet in as much as society is structured by relations of inequality at
the point of material production, so too is it structured by relations of
inequality between the sexes. The nature of the societies in which art has
been produced has not only been, for example, feudal or capitalist, but patri-
archal and sexist. Neither of these forms of exploitation is reducible to the
other. As Jean Gardiner has pointed out, a Marxist perspective which remains
innocent of feminist work on sexual divisions cannot adequately analyse
social processes: 'It is impossible to understand women's class position
without understanding the way in which sexual divisions shape women's
consciousness of class ... No socialist can afford to ignore this question.'[1]

But it would be a mistake to see a solution in a simple extension of
Marxism to acknowledge sexual politics as an additional element.
Domination and exploitation by sex are not just a supplement to a more
basic level of conflict between classes. Feminism has exposed new areas and
new forms of social conflict and thus demands its own forms of analysis of
kinship, construction of gender, sexuality, reproduction, labour and, of
course, culture. Culture can be defined as those social practices whose
prime aim is signification, i.e. the production of sense or making orders of
'sense' for the world we live in.[2] Culture is the social level in which those
images of the world and definitions of reality are produced which can be
ideologically mobilized to legitimate the existing order of relations of dom-

ination and subordination between both classes and sexes. Art history takes an aspect of this cultural production, art, as its object of study; but the discipline itself is also a crucial component of the cultural hegemony by the dominant class and gender. Therefore it is important to contest the definitions of our society's ideal reality which are produced in art-historical interpretations of culture.

The project before us is therefore the development of kinds of art history which analyse cultural production in the visual arts and related media by attending to the imperatives of both Marxism and feminism. This requires the mutual transformation of existing Marxist and recent feminist art history. Marxist art historians' prime concern with class relations is brought into question by feminist argument about the social relations of the sexes around sexuality, kinship, the family and the acquisition of gender identity. At the same time existing feminist art history is challenged by the rigour, historical incentive and theoretical developments of Marxists in the field. Feminist art history in this new form will not be a mere addition, a matter of producing a few more books about women artists. These can easily be incorporated and forgotten as were the many volumes on women artists published in the nineteenth century.[3] Alliance with the social history of art is necessary but should always be critical of its unquestioned patriarchal bias.

Why does it matter politically for feminists to intervene in so marginal an area as art history, 'an outpost of reactionary thought' as it has been called? Admittedly art history is not an influential discipline, locked up in universities, art colleges and musty basements of museums, peddling its 'civilizing' knowledge to the select and cultured. We should not, however, underestimate the effective significance of its definitions of art and artist to bourgeois ideology. The central figure of art-historical discourse is the artist, who is presented as an ineffable ideal which complements the bourgeois myths of a universal, classless Man (sic).

Our general culture is furthermore permeated with ideas about the individual nature of creativity, how genius will always overcome social obstacles, that art is an inexplicable, almost magical sphere to be venerated but not analysed. These myths are produced in ideologies of art history and are then dispersed through the channels of TV documentaries, popular art books, biographic romances about artists' lives like *Lust for Life* about Van Gogh or *The Agony and the Ecstasy* about Michelangelo. 'To deprive the bourgeoisie not of its art but of its concept of art, this is the precondition of a revolutionary argument.'[4]

Feminist interrogations of art history have extended that programme to expose and challenge the prevailing assumptions that this 'creativity' is an exclusively masculine prerogative and that, as a consequence, the term artist automatically refers to a man. A useful reminder of this occurred in Gabhart and Broun's introductory essay to the exhibition they organized in 1972, *Old Mistresses: Women Artists of the Past*: 'The title of this exhibition alludes to the unspoken assumption in our language that art is created by men. The reverential term "Old Master" has no meaningful equivalent; when cast in its fem-

29

inine form, "Old Mistresses", the connotation is altogether different, to say the least.'[5]

Gabhart and Broun expose the relationship between language and ideology. But they do not ask *why* there is no place for women in the language of art history, despite the fact that there have been so many women artists. In the light of my joint research with Rozsika Parker, I would reply that it is because the evolving concepts of the artist and the social definitions of woman have historically followed different and almost contradictory paths. Creativity has been appropriated as an ideological component of masculinity while femininity has been constructed as man's, and therefore the artist's negative. As the late-nineteenth-century writer clearly put it: 'As long as a woman refrains from unsexing herself let her dabble in anything. The woman of genius does not exist; when she does she is a man.'[6]

This is part of a larger question. What is the relationship between this pejorative view of women as incapable of being artists – creative individuals – and their subordinated position as workers, the low pay, the unskilled and disregarded domestic labour to which they are so often restricted because such jobs are described as the 'natural' occupations of women? It is of course no mirror image here between ideology and the economy. But there is a relationship. Art is represented to us as the ideal of self-fulfilling individual creative activity. Its lived antithesis is proletarian alienated labour. But I suggest its full opposite is the repetitive and self-effacing drudgery of what is called 'women's work'. Another related level of correspondence of this kind is the call to biology that is made to support the claim for men's inevitable greatness in art and women's eternal second-rateness. Men create art; women merely have babies. This false opposition has been frequently used to justify women's exclusion from cultural recognition. It is no coincidence that such appeals to 'biology' are utilized in many other spheres of women's endeavour to prejudice their equal employment, to lower wages, and to refuse social provision for child care. The sexual divisions embedded in concepts of art and the artist are part of the cultural myths and ideologies peculiar to art history. But they contribute to the wider context of social definitions of masculinity and femininity and thus participate at the ideological level in reproducing the hierarchy between the sexes. It is this aspect of art history that Marxist studies of it have never addressed.

The radical critiques proposed by Marxist and feminist art history therefore stand in double and not necessarily coinciding opposition to bourgeois art history. Yet to date feminist art history has refused the necessary confrontation with mainstream art-historical ideologies and practices. Instead feminists have been content to incorporate women's names in the chronologies and to include work by women in the inventories of styles and movements. Liberal policies within the art-history establishment have allowed this unthreatening, 'additive' feminism a marginal place at its conferences as a diverting sideline or given it the space for a few odd articles in its academic journals. However, the critical implications of feminism for art history as a whole have been stifled and have not been allowed to change what is studied

30

in art history, nor how it is studied and taught. [...]

Notes

1 J. Gardiner, 'Women in the Labour Process and Class Structure', in *Class and Class Structure*, edited A. Hunt, London, 1977, p.163. See also L. Comer, 'Women and Class: The Question of Women and Class', *Women's Studies International Quarterly*, vol.1,1978, pp.165-73.

2 [...] I use culture in this article to [...] include ideology, science and art which share linguistic and visual forms of communication, interact within one another and are organized through institutions such as schools, universities, publishing, broadcasting and the institutions of high and popular culture and entertainment. In this, culture is a site therefore of a particular kind of struggle, cultural struggle,which entails challenges to particular regimes of sense, orders of representation – ways in which the world is imaged for us, represented to us and interpreted, for us and by us. For further definition of this approach see F. Mulhern, 'On Culture and Cultural Struggle', *Screen Education*, no. 34, Spring 1980.

3 e.g. E. Guhl, *Die Frauen in der Kunstgeschichte,* 1858, Ellen Clayton, *English Female Artists,* 1876, M. Vachon, *La Femme dans l'Art,* 1893.

4 Cited in G. Wall, 'Translator's Preface' to P. Macherey, *A Theory of Literary Production,* London, 1978, p.vii. For full discussion of this point see G. Pollock, 'Artist, Media and Mythologies', *Screen,* vol. 21, no. 3, 1980, pp.57-96.

5 A. Gabhart and E. Broun, in *Walters Art Gallery Bulletin*, vol. 24, no.7. 1972.

6 Cited in Octave Uzanne, *The Modern Parisienne*, 1912.

4 **Noam Chomsky**
Politics and the Intelligentsia

Source: Noam Chomsky, 'Politics', in *Language and Responsibility,* based on conversations with Mitsou Ronat, translated from the French by John Viertel, Hassocks, The Harvester Press, 1979, pp. 3-42. Extract from pp. 4-14. First published in French as Noam Chomsky, *Dialogues avec Mitsou Ronat,* Paris, Flammarion, 1977. This text has been edited.

32

[...] Take the question of the role of the intelligentsia in a society like ours. This social class, which includes historians and other scholars, journalists, political commentators, and so on, undertakes to analyse and present some picture of social reality. By virtue of their analyses and interpretations, they serve as mediators between the social facts and the mass of the population: they create the ideological justification for social practice. Look at the work of the specialists in contemporary affairs and compare their interpretation with the events, compare what they say with the world of fact. You will often find great and fairly systematic divergence. Then you can take a further step and try to explain these divergences, taking into account the class position of the intelligentsia.

Such analysis is, I think, of some importance, but the task is not very difficult, and the problems that arise do not seem to me to pose much of an intellectual challenge. With a little industry and application, anyone who is willing to extricate himself from the system of shared ideology and propaganda will readily see through the modes of distortion developed by substantial segments of the intelligentsia. Everybody is capable of doing that. If such analysis is often carried out poorly, that is because, quite commonly, social and political analysis is produced to defend special interests rather than to account for the actual events.

Precisely because of this tendency one must be careful not to give the impression, which in any event is false, that only intellectuals equipped with special training are capable of such analytic work. In fact that is just what the intelligentsia would often like us to think: they pretend to be engaged in an esoteric enterprise, inaccessible to simple people. But that's nonsense. The social sciences generally, and above all the analysis of contemporary affairs, are quite accessible to anyone who wants to take an interest in these matters. The alleged complexity, depth, and obscurity of these questions is part of the illusion propagated by the system of ideological control, which aims to make the issues seem remote from the general population and to persuade them of their incapacity to organize their own affairs or to understand the social world in which they live without the tutelage of intermediaries. For that reason alone one should be careful not to link the analysis of social issues with

scientific topics which, for their part, do require special training and tech-niques, and thus a special intellectual frame of reference, before they can be seriously investigated.

In the analysis of social and political issues it is sufficient to face the facts and to be willing to follow a rational line of argument. Only Cartesian common sense, which is quite evenly distributed, is needed ... if by that you understand the willingness to look at the facts with an open mind, to put simple assumptions to the test, and to pursue an argument to its conclusion. But beyond that no special esoteric knowledge is required to explore these 'depths', which are non-existent.

[...] I do not say that it is impossible to create an intellectually interesting theory dealing with ideology and its social bases. That's possible, but it isn't necessary in order to understand, for example, what induces intellectuals often to disguise reality in the service of external power, or to see how it is done in particular cases of immediate importance. To be sure, one can treat all of this as an interesting topic of research. But we must separate two things:

1. Is it possible to present a significant theoretical analysis of this? Answer: Yes, in principle. And this type of work might attain a level at which it would require special training, and form, in principle, part of science.

2. Is such a science necessary to remove the distorting prism imposed by the intelligentsia on social reality? Answer: No. Ordinary scepticism and application are sufficient.

Let us take a concrete example: When an event occurs in the world, the mass media – television, the newspapers – look for someone to explain it. In the United States, at least, they turn to the professionals in social science, basing themselves on the notion, which seems superficially reasonable and in some instances is reasonable within limits, that these experts have a special competence to explain what is happening. Correspondingly, it is very impor-tant for the professionals to make everyone believe in the existence of an intellectual frame of reference which they alone possess, so that they alone have the right to comment on these affairs or are in a position to do so. This is one of the ways in which the professional intelligentsia serve a useful and effective function within the apparatus of social control. [...]

The United States is unusual among the industrial democracies in the rigidity of the system of ideological control – 'indoctrination', we might say – exercised through the mass media. One of the devices used to achieve this narrowness of perspective is the reliance on professional credentials. The uni-versities and academic disciplines have, in the past, been successful in safe-guarding conformist attitudes and interpretations, so that by and large a reliance on 'professional expertise' will ensure that views and analyses that depart from orthodoxy will rarely be expressed. [...]

To my knowledge, in the American mass media you cannot find a single socialist journalist, not a single syndicated political commentator who is a socialist. From the ideological point of view the mass media are almost 100 per cent 'state capitalist'. In a sense, we have over here the 'mirror image' of the Soviet Union, where all the people who write in *Pravda* represent the

33

position which they call 'socialism' – in fact, a certain variety of highly authoritarian state socialism. Here in the United States there is an astonishing degree of ideological uniformity for such a complex country. Not a single socialist voice in the mass media, not even a timid one; perhaps there are some marginal exceptions, but I cannot think of any, offhand. Basically, there are two reasons for this. First, there is the remarkable ideological homogeneity of the American intelligentsia in general, who rarely depart from one of the variants of state capitalistic ideology (liberal or conservative), a fact which itself calls for explanation. The second reason is that the mass media are capitalist institutions. It is no doubt the same on the board of directors of General Motors. If no socialist is to be found on it – what would he be doing there! – it's not because they haven't been able to find anyone who is qualified. In a capitalist society the mass media are capitalist institutions. The fact that these institutions reflect the ideology of dominant economic interests is hardly surprising. [...]

It is notable that despite the extensive and well-known record of government lies during the period of the Vietnam war, the press, with fair consistency, remained remarkably obedient, and quite willing to accept the government's assumptions, framework of thinking, and interpretation of what was happening. Of course, on narrow technical questions – is the war succeeding? for example – the press was willing to criticize, and there were always honest correspondents in the field who described what they saw. But I am referring to the general pattern of interpretation and analysis, and to more general assumptions about what is right and proper. Furthermore, at times the press simply concealed easily documented facts – the bombing of Laos is a striking case. [...]

As compared with the other capitalist democracies, the United States is considerably more rigid and doctrinaire in its political thinking and analysis. Not only among the intelligentsia, though in this sector the fact is perhaps most striking. The United States is exceptional also in that there is no significant pressure for worker participation in management, let alone real workers' control. These issues are not alive in the United States, as they are throughout Western Europe. And the absence of any significant socialist voice or discussion is again quite a striking feature of the United States, as compared to other societies of comparable social structure and level of economic development.

Here one saw some small changes at the end of the 1960s; but in 1965 you would have had great difficulty in finding a Marxist professor, or a socialist, in an economics department at a major university, for example. State capitalist ideology dominated the social sciences and every ideological discipline almost entirely. This conformism was called 'the end of ideology', It dominated the professional fields – and still largely does – as well as the mass media and the journals of opinion. Such a degree of ideological conformity in a country which does not have a secret police, at least not much of one, and does not have concentration camps, is quite remarkable. Here the range of ideological diversity (the kind that implies lively debate on social issues) for

many years has been very narrow, skewed much more to the right than in other industrial democracies. This is important. [...]

Some changes did take place at the end of the sixties in the universities, largely due to the student movement, which demanded and achieved some broadening of the tolerated range of thinking. The reactions have been interesting. Now that the pressure of the student movement has been reduced, there is a substantial effort to reconstruct the orthodoxy that had been slightly disturbed. And constantly, in the discussions and the literature dealing with that period – often called 'the time of troubles' or something of that sort – the student left is depicted as a menace threatening freedom of research and teaching; the student movement is said to have placed the freedom of the universities in jeopardy by seeking to impose totalitarian ideological controls. That is how the state capitalist intellectuals describe the fact that their near-total control of ideology was very briefly brought into question, as they seek to close again these slight breaches in the system of thought control, and to reverse the process through which just a little diversity arose within the ideological institutions: the totalitarian menace of fascism of the left! And they really believe this, to such an extent have they been brainwashed and controlled by their own ideological commitments. One expects that from the police, but when it comes from the intellectuals, then that's very striking. [...]

The major effect of the student movement, however, was quite different, I believe. It raised a challenge to the subservience of the universities to the state and other external powers – although that challenge has not proved very effective, and this subordination has remained largely intact – and it managed to provoke, at times with some limited success, an opening in the ideological fields, thus bringing a slightly greater diversity of thought and study and research. In my opinion, it was this challenge to ideological control, mounted by the students (most of them liberals), chiefly in the social sciences, which induced such terror, verging at times on hysteria, in the reactions of the 'intellectual élite', The analytic and retrospective studies which appear today often seem to me highly exaggerated and inexact in their account of the events that took place and their significance. Many intellectuals are seeking to reconstruct the orthodoxy and the control over thought and inquiry which they had institutionalized with such success, and which was in fact threatened – freedom is always a threat to the commissars. [...]

Part I
Capitalism and Culture

Introduction to Part I

The texts in this section all begin with the assumption that capitalism and culture cannot escape each other. Some of the texts offer broad analyses of the character and dynamics of capitalism as a mode of economic production decisively shaping the social and political relationships of groups and individuals within the urban, industrial nation-states during the nineteenth and twentieth centuries. Others are highly specific accounts of the place of art practices and debates within particular social and historical 'moments': Paris from the 1860s onwards; Central Europe during the inter-war period; New York during the Cold War. These descriptions, narratives and evaluations all share the belief that the materials that have gone into the making of 'art' are themselves fundamentally shaped within, and are a part of, capitalist structures of production and consumption.

'Materials' in this sense is a term which denotes the entire range of physical and ideological components which have constituted both the art objects and the debates about the status and value of these objects within the culture of particular societies during the modern period. The status of art objects as commodities within this period – produced within specific economic and social relations of production, and available to be bought within a market – indicates the basic interlocking of a system of economic production and consumption (capitalism) and the highly valued objects deemed 'art' (part of culture). The political and ideological ramifications of this interlocking are the substance of the arguments and energies contained within these texts.

All of the authors owe a debt to Marxist traditions of analysis, though the range of influences brought to bear is extremely wide and in some cases involves substantial disagreement. Such disagreements over method and value have also been part of the Marxist tradition. In the discussion of culture in particular, there has never been a single, dominant interpretation or judgement: Marxists such as Theodor Adorno, Walter Benjamin, Bertolt Brecht and Georg Lukács – important voices within a number of these texts – have themselves *constituted* 'Marxist cultural criticism', rather than simply explained or argued with views expressed by Marx, Engels, Lenin or Trotsky. The development of capitalism as a system embracing all production within urban, industrial societies – including art, film, the press, television,

etc. (the so-called 'culture industries' of the twentieth century) – was a development which proceeded the work of the latter group. Because of this, Marxist theory and history has itself developed and changed, in relation to a range of highly significant factors.

For Adorno, Benjamin [see Text 27], Brecht and Lukács (and commentators on their work such as Peter Bürger and Fredric Jameson[Texts 6 and 7]) two key issues have dominated: (1) how art (and culture in the widest sense) embodies and represents the type of society within which it is made, and against which certain artists may try to pit themselves; and (2) whether a sphere of practices and values can be created or defended which stands *outside* the structures and effects of capitalism as a system which threatens to engulf all of human life and interests. These questions were politically, as well as theoretically, vital, because these authors were writing in the context of the aftermath of the First World War, the Bolshevik Revolution of 1917 and the growth of fascism during the 1930s. Culture, including art, as a weapon of propaganda, had been embraced by Lenin and Hitler as a vehicle for transforming people's identities and values. The bourgeois democracies – France, Britain and the United States – had also utilized cultural forms as vehicles for ideological inculcation during the First World War; the rapidly developing capitalist 'culture industry' after 1918 appeared to present a similar threat to human interests and values as that posed by fascism and, by the 1930s, Stalinism in the Soviet Union.

Many Marxists and others believed that capitalist economic and social relations had spread from controlling 'primary' production to all facets of human life; in Max Weber's words normalized and rationalized. What kind of 'art', based on what principles and made within what actual circumstances, could offer an opposition or at least a resistance to these dire consequences? To some, the answer was an 'abstract' or 'autonomous' art, because it was believed that such a form, practice and intellectual endeavour managed to separate itself from the rest of a 'corrupting' society. This art, it was claimed, was concerned centrally with 'itself' as a practice, and therefore was unhinged from any relationship to social or ideological factors imbricated with capitalism. A classic celebratory example of such a claim is Clement Greenberg's 'Modernist Painting' [Text 28] whilst Bürger [Text 6] considers some of the problems inherent in the autonomy thesis. Alternatively, it is clear from the three Adorno extracts [Text 8] that he was strongly ambivalent on the issue. In 1936, he could write to Benjamin (in response to his 'Work of Art' [Text 27]) that both 'autonomous' high art and mass culture 'bear the stigmata of capitalism ... Both are torn halves of an integral freedom, to which, however, they do not add up' [Text 8a]. However, after the horrors of the Second World War, symbolized by the Nazi extermination camps, Adorno became a pessimistic advocate of 'autonomous works', epitomized by the works of Kafka, Schoenberg and Beckett [Text 8c]. He saw such difficult and intractable works as signs of human potential creating a shudder of revulsion, as 'resistance', amongst the audiences for both 'avant-garde' art and 'committed' art. He distanced himself from all directly political art advocated, with

different emphases on the concept of 'realism', by Benjamin, Brecht and Lukács [Text 8b].

Texts by Tim Clark, Peter Bürger and Eva Cockcroft interrogate the history of the notion of the 'avant-garde' and discuss particular instances of its formation and activities within specific social, political and ideological contexts. Their primary strengths lie in being historical analyses concerned not with *a priori* categories which assume the separateness or autonomy of a group, practice or object (for this is how the term is often used). Rather they consider how particular works were produced in relation to a set of ideas and values, within a social and historical framework which exerted pressures and limits on what was possible and what a practice, or object, or idea might mean. For instance, taking up the arguments in Meyer Schapiro's 'Nature of Abstract Art', 1937, Clark argues that the apparent autonomy, or separateness, of painting by Manet and the Impressionists is itself socially determined by the place of figures and of groups, within a highly complex relationship of classes within French, and specifically Parisian, society during the 1860s and 1870s. Here concepts of 'class', 'ideology', 'spectacle' and 'modernism' are mobilized to account for paintings *as representations* produced in the social relationships of a highly fractured, stratified and transforming capitalist society.

Terry Eagleton's text summarizes some of the history of Marxist thinking about culture during the twentieth century. His account emphasizes both the different traditions within that history – differences that still characterize debate and disagreement between those who consider themselves to be using basically 'Marxist' ideas and methods when considering art and culture – and the need for rigorous monitoring of how capitalism, as a dynamic process, may have changed and developed during the twentieth century. For if capitalism and culture are decisively integrated within contemporary western societies, then any dynamic within the former must have significant impact on the status of the latter.

Timothy J. Clark
The Painting of Modern Life

Source: T. J. Clark, 'Introduction', *The Painting of Modern Life: Paris in the Art of Manet and his Followers*, London, Thames and Hudson, 1985, pp. 3–22 and pp. 271–2. This text has been edited and footnotes renumbered accordingly. Six plates have been omitted.

[...] Early Impressionism, wrote Schapiro, depended for its force on something more than painterly hedonism or a simple appetite for sunshine and colour. The art of Manet and his followers had a distinct 'moral aspect', visible above all in the way it dovetailed an account of visual truth with one of social freedom.

Early Impressionism ... had a moral aspect. In its unconventionalized, unregulated vision, in its discovery of a constantly changing phenomenal outdoor world of which the shapes depended on the momentary position of the causal or mobile spectator, there was an implicit criticism of symbolic social and domestic formalities, or at least a norm opposed to these. It is remarkable how many pictures we have in early Impressionism of informal and spontaneous sociability, of breakfasts, picnics, promenades, boating trips, holidays and vacation travel. These urban idylls not only present the objective forms of bourgeois recreation in the 1860s and 1870s; they also reflect in the very choice of subjects and in the new aesthetic devices the conception of art as solely a field of individual enjoyment, without reference to ideas and motives, and they presuppose the cultivation of these pleasures as the highest field of freedom for an enlightened bourgeois detached from the official beliefs of his class. In enjoying realistic pictures of his surroundings as a spectacle of traffic and changing atmospheres, the cultivated rentier was experiencing in its phenomenal aspect that mobility of the environment, the market and of industry to which he owes his income and his freedom. And in the new Impressionist techniques which broke things up into finely discriminated points of colour, as well as in the 'accidental' momentary vision, he found, in a degree hitherto unknown in art, conditions of sensibility closely related to those of the urban promenader and the refined consumer of luxury goods.

As the contexts of bourgeois sociability shifted from community, family and church to commercialized or privately improvised forms – the streets, the cafés and resorts – the resulting consciousness of individual freedom involved more and more an estrangement from older ties; and those imaginative members of the middle class who accepted the norms of freedom, but lacked the economic means to attain them, were spiritually torn by a sense of helpless isolation in an anonymous indifferent mass. By 1880 the enjoying individual becomes rare in Impressionist art; only the private spectacle of nature is left. And in neo-Impressionism, which restores and even monumentalizes the figures, the social group breaks up into isolated spectators, who do not communicate with each other, or consists of mechanically repeated dances submitted to a preordained movement with little spontaneity.[1]

The argument in these paragraphs has some strange shifts, and I have done my share of quibbling with them. For instance, the actual bourgeois's being brought on to enjoy Impressionist painting, and to revel in its consonance with his day-to-day experience, is no doubt marvellous; but it does not seem to me much more than a metaphor, and is surely not warranted by what we know of this painting's first purchasers and enthusiasts. Equally, it is not clear if Schapiro believes that once upon a time the bourgeoisie, or at least its enlightened members, really did delight in an 'informal and spontaneous sociability', and that only later did estrangement and isolation come to characterize the pleasures on offer in these 'commercialized or privately improvised forms', If that is the argument, we might ask how informal and spontaneous is the sociability depicted already in Manet's *Déjeuner sur l'herbe*, or for that matter in Monet's, with its anxious regard for the latest fashions and its discreet servant (in livery?) crouched on the other side of the tree.

But these objections are small beer. Schapiro's 'Nature of Abstract Art' was an essay, after all; and the few lines it devoted to Impressionist painting still seem to me the best thing on the subject, simply because they suggest so tellingly that the form of the new art is inseparable from its content – those 'objective forms of bourgeois recreation in the 1860s and 1870s'. [...]

It sounds right – it corresponds to normal usage – to say that any social order consists primarily of classifications. What else do we usually mean by the word 'society' but a set of means for solidarity, distance, belonging, and exclusion? These things are needed pre-eminently to enable the production of material life – to fix an order in which men and women can make their living and have some confidence that they will continue to do so. Orders of this sort appear to be established most potently by representations or systems of signs, and it does not seem to me to trivialize the concept of 'social formation' – or necessarily to give it an idealist as opposed to a materialist gloss – to describe it as a hierarchy of representations. That way one avoids the worst pitfalls of vulgar Marxism, in particular the difficulties involved in claiming that the base of any social formation is some brute facticity made of sterner and solider stuff than signs – for instance, the stuff of economic life. It is one thing (and still necessary) to insist on the determinate weight in society of those arrangements we call economic; it is another to believe that in doing so we have poked through the texture of signs and conventions to the bedrock of matter and action upon it. Economic life – the 'economy,' the economic realm, sphere, level, instance, or what-have-you – is in itself a realm of representations. How else are we to characterize money, for instance, or the commodity form, or the wage contract?

I believe it is possible to put this kind of stress on representation and remain, as I want to, within the orbit of historical materialism. Everything depends on how we picture the links between any one set of representations and the totality which Marx called 'social practice.' In other words, the notion of social activity outlined so far can be sustained only if we simultaneously recognize that the world of representations does not fall out neatly into watertight sets of systems or 'signifying practices'. Society is a battlefield of

representations, on which the limits and coherence of any given set are constantly being fought for and regularly spoilt. Thus it makes sense to say that representations are continually subject to the test of a reality more basic than themselves – the test of social practice. Social practice *is* that complexity which always outruns the constraints of a given discourse; it is the overlap and interference of representations; it is their rearrangement in use; it is the test which consolidates or disintegrates our categories, which makes or unmakes a concept, which blurs the edge of a particular language game and makes it difficult (though possible) to distinguish between a mistake and a metaphor.
[...]

In capitalist society, economic representations are the matrix around which all others are organized. In particular, the class of an individual – his or her effective possession of or separation from the means of production – is the determinant fact of social life. This is not to say that from it can be read off immediately the individual's religious beliefs, voting habits, choice of clothes, sense of self, aesthetic preferences, and sexual morality. All of these are articulated within particular, separate worlds of representation; but these worlds are constricted and invaded by the determining nexus of class; and often in the nineteenth century the presence of class as the organizing structure of each separate sphere is gross and palpable: only think of the history of bourgeois costume, or the various ways in which the logical structure of market economics came to dominate the accounts on offer of the self and others. This makes it possible to expand the concept of class to include facts other than the economic: for instance, to talk of certain forms of entertainment or sexuality as 'bourgeois'. There seems to me no harm in doing so: it registers a connection which was perceived by the actors themselves, and it would be pedantry to avoid the usage altogether; but we should be clear about the liberties being taken and beware, for example, of calling things 'inherently bourgeois' when what we are pointing to is relation, not inherence. This caution has more of a point, perhaps, when we turn from the bourgeoisie to its great opposite in the nineteenth century, since here we are so clearly dealing with a class and a set of 'class characteristics' still in the making – as evinced by the simple instability of vocabulary in the case, from *peuple* to *prolétariat*, from *classes laborieuses* to *classe ouvrière*.

Class will in any case necessarily be a complex matter: to make the simplest point, there is never only one 'means of production' in society for individuals to possess or be denied: any social formation is always a palimpsest of old and new modes of production, hence old and new classes, and hybrids born of their mating. Notably, [...] it is clear that the reality designated at the time – in the 1870s, say – as *petit bourgeois* included men and women whose trades had previously allowed them a modicum of security in the city's economic life, but who had been robbed of that small safety by the growth of large-scale industry and commerce; but it also included new groups of workers – clerks, shop assistants, and the like – who were the products, offensively brand-new and ambitious, of the same economic changes, and whose instability had nothing to do with the loss of bygone status but, rather, with the inability of

the social system to decide what their situation, high or low, might be in the new order of things. To call these different people *petits bourgeois* was not wrong: it may strike us now as profound of contemporaries to have seen from the start how the various fractions would be made, by monopoly capitalism, into one thing. But the one thing, in the case of class, is regularly made out of the many and various.

It is somewhat the same with ideology, since I use the word to indicate the existence in society of distinct and singular bodies of knowledge: *orders* of knowing, most often imposed on quite disparate bits and pieces of representation. The sign of an ideology is a kind of inertness in discourse: a fixed pattern of imagery and belief, a syntax which seems obligatory, a set of permitted modes of seeing and saying; each with its own structure of closure and disclosure, its own horizons, its way of providing certain perceptions and rendering others unthinkable, aberrant, or extreme. And these things are done – I suppose this is the other suggestion carried in the word – as it were *surreptitiously*. Which is to say that ideologies, like any forms of knowledge, are constructs; they are meanings produced in a special and partial social practice; they are most often tied to the attitudes and experiences of a particular class, and therefore at odds, at least to some extent, with the attitudes and experience of those who do not belong to it. [...] But in any case, the function of ideology is as far as possible to dispose of the very ground for such conflicts. Ideologies tend to deny in their very structure and procedures that they have any such thing: knowledge, in ideology, is not a procedure but a simple array; and insofar as pictures or statements possess a structure at all, it is one provided for them by the Real. Ideologies naturalize representation, one might say: they present constructed and disputable meanings as if they were hardly meanings at all, but, rather, forms inherent in the world-out-there which the observer is privileged to intuit directly.

Therefore one ought to beware of a notion of ideology which conceives it merely as a set of images, ideas, and 'mistakes', for its action on and in the process of representation is different from this: it is more internal, more interminable. Rather, an ideology is a set of limits to discourse; a set of resistances, repetitions, kinds of circularity. It is that which closes speech against consciousness of itself as production, as process, as practice, as subsistence and contingency. And of necessity this work of deletion is never done: it would hardly make sense to think of it finished.

About the concepts of 'spectacle' and 'spectacular society' it is not so easy to be cut and dried. They were developed first in the mid-1960s as part of the theoretical work of a group called the Situationist International, and they represent an effort to theorize the implications for capitalist society of the progressive shift within production towards the provision of consumer goods and services, and the accompanying 'colonization of everyday life'.[2] The word 'colonization' conjures up associations with the Marxist theory of imperialism, and is meant to. It points to a massive *internal* extension of the capitalist market – the invasion and restructuring of whole areas of free time, private life, leisure, and personal expression which had been left, in the first

push to constitute an urban proletariat, relatively uncontrolled. It indicates a new phase of commodity production – the marketing, the making-into-commodities, of whole areas of social practice which had once been referred to casually as everyday life.

The concept of spectacle is thus an attempt – a partial and unfinished one – to bring into theoretical order a diverse set of symptoms which are normally treated, by bourgeois sociology or conventional Leftism, as anecdotal trappings affixed somewhat lightly to the old economic order: 'consumerism', for instance, or 'the society of leisure'; the rise of mass media, the expansion of advertising, the hypertrophy of official diversions (Olympic Games, party conventions, *biennales*). The Situationists were primarily interested, in ways which have since become fashionable, in the possible or actual crisis of this attempt to regulate or supplant the sphere of the personal, private, and everyday. They described the erosion of family controls in later capitalist society, and derided their febrile replacements – the apparatus of welfare, social work, and psychiatry. They put great stress on, and a degree of faith in, the signs of strain in just this area: the question of Youth, the multiplication of delinquent subcultures, the strange career of 'clinical depression', the inner-city landscape of racism and decay. The concept of spectacle, in other words, was an attempt to revise the theory of capitalism from a largely Marxist point of view. The most celebrated of Situationist metaphors – it comes from a book by Guy Debord – is meant more soberly than it may seem at first sight: 'The spectacle is *capital* accumulated until it becomes an image.'[3]

There are various problems here: for instance, deciding when exactly the spectacular society can be said to begin. One is obviously not describing some neat temporality but, rather, a shift – to some extent an oscillation – from one kind of capitalist production to another. But certainly the Paris that Meyer Schapiro was celebrating, in which commercialized forms of life and leisure were so insistently replacing those 'privately improvised', does seem to fit the preceding description quite well. [...]

'Modernism', finally, is used here in the customary, somewhat muddled way. Something decisive happened in the history of art around Manet which set painting and the other arts upon a new course. Perhaps the change can be described as a kind of scepticism, or at least unsureness, as to the nature of representation in art. There had been degrees of doubt on this subject before, but they had mostly appeared as asides to the central task of constructing a likeness, and in a sense they had guaranteed that task, making it seem all the more necessary and grand. Certain painters in the seventeenth century, for example, had failed to hide the gaps and perplexities inherent in their own procedures, but these traces of paradox in perception – these markers in the picture of where the illusion almost ended – only served to make the likeness, where it was achieved, the more compelling, because it was seen to exist in the face of its opposite, chaos. There is no doubt that Manet and his friends looked back for instruction to painters of just this kind – to Velásquez and Hals, for example – but what seemed to impress them most was the evidence of palpable and frank inconsistency, and not the fact that the image was

somehow preserved in the end from extinction. This shift of attention led, on the one hand, to their putting a stress on the material means by which illusions and likenesses were made (in this sense, my previous accounts of society and ideology are modernist in some of their emphases); on the other, to a new set of proposals as to the form representation should take, insofar as it was still possible at all without bad faith. 'The scope and aim of Manet and his followers,' we shall find Mallarmé saying in an article in 1876, '(not proclaimed by authority of dogmas, yet none the less clear) is that painting shall be steeped again in its cause ...'[4] [...]

Mallarmé's statement of the modernist case is primitive, and therefore optimistic and clear-cut – perhaps misguidedly so – in its picture of the future. The stress on exactness, simplicity, and steadfast attention is something which was to recur in the next hundred years, but it can hardly be said to be characteristic of the art to which Manet gave birth. The steadfast gaze quickly gave way to uncertainty (in this the case of Cézanne is exemplary). Doubts about vision became doubts about almost everything involved in the act of painting; and in time the uncertainty became a value in its own right; we could almost say it became an aesthetic. A special and effective rhetoric was devised – it is in full possession of the field by the time one encounters it in the art criticism of the Symboliste magazines of the late 1880s – in which the preference of painting for the not-known, the not-arranged, and the not-interpreted was taken largely as an article of faith. Painting has a subject, these critics say, and it is rightly that area of experience we dismiss in practical life as vestigial and next to nothing. Art seeks out the edges of things, of understanding; therefore its favourite modes are irony, negation, deadpan, the pretence of ignorance or innocence. It prefers the unfinished: the syntactically unstable, the semantically malformed. It produces and savours discrepancy in what it shows and how it shows it, since the highest wisdom is knowing that things and pictures do not add up. [...]

In general, the terms of modernism are not to be conceived as separate from the particular projects – the specific attempts at meaning – in which they are restated. An example of that truism would be the notorious history of modernism's concern for 'flatness'. Certainly it is true that the two dimensions of the picture surface were time and again recovered as a striking fact by painters after Courbet. But I think that the question we should be asking in this case is *why* that literal presence of surface went on being interesting for art. How could a matter of effect or procedure seemingly stand in for value in this way? What was it that made it vivid?

The details of an answer will of course be open to argument as to emphasis, evidence, and so forth; but surely the answer must take approximately this *form*. If the fact of flatness was compelling and tractable for art – in the way it was for Manet and Cézanne, for example – that must have been because it was made to stand for something: some particular and substantial set of qualities which took their place in a picture of the world. So that the richness of the avant-garde, conceived as a set of contexts for art in the years between, say, 1860 and 1918, might best be redescribed in terms of its ability to give

45

flatness such complex and compatible values – values which necessarily derived from elsewhere than art. On various occasions, for instance, flatness was imagined to be some kind of analogue of the 'Popular' [...]. It was therefore made as plain, workmanlike, and emphatic as the painter could manage; loaded brushes and artisans' combs were held to be appropriate tools; painting was henceforth honest manual labour. (A belief of this kind underlies even Mallarmé's argument: earlier in the 1876 text he can be found describing the Impressionist as 'the energetic modern worker' about to supplant 'the old imaginative artist',[5] and greeting the development on the whole with glee.) Or flatness could signify modernity, with the surface meant to conjure up the mere two dimensions of posters, labels, fashion prints, and photographs. There were painters who took those same two dimensions, in what might seem a more straightforwardly modernist way, to represent the simple fact of Art, from which other meanings were excluded. But during this period that too was most often an argument about the world and art's relation to it – a quite complex argument, and stated as such. Painting would replace or displace the Real, accordingly, for reasons having to do with the nature of subjectivity, or city life, or the truths revealed by higher mathematics. And finally, unbrokenness of surface could be seen – by Cézanne par excellence – as standing for the evenness of seeing itself, the actual form of our knowledge of things. That very claim, in turn, was repeatedly felt to be some kind of aggression on the audience, on the ordinary bourgeois. Flatness was construed as a barrier put up against the viewer's normal wish to enter a picture and dream, to have it be a space apart from life in which the mind would be free to make its own connections.

My point is simply that flatness in its heyday *was* these various meanings and valuations; they were its substance, they were what it was seen *as*; their particularity was what made flatness a matter to be painted. Flatness was therefore in play – as an irreducible, technical fact of painting – with all of these totalizations, all of these attempts to make it a metaphor. Of course, in a way it resisted the metaphors, and the painters we most admire insisted also on its being an awkward, empirical quiddity; but 'also' is the key word here: there was no fact without the metaphor, no medium without its being made the vehicle of some sense or other. [...]

I wish to show that the circumstances of modernism were not modern, and only became so by being given the forms called 'spectacle'. On the face of things it seems that Impressionist painting was one of those forms, but the question is: How completely? Are we to take Impressionism's repertoire of subjects and devices as merely complicit in the spectacle – lending it consistency or even charm – or as somehow disclosing it as farce or tragedy? Is the truth of the new painting to be found in Renoir's *Parapluies* or in Caillebotte's *Rue de Paris, temps de pluie* [Plate 1] – in the sheer *appeal* of modernity, or its unexpected desolation? Are they grand and poetic still, these people in their cravats and patent-leather shoes, 'these millions ... who do not need to know one another' and who lead their modern lives accordingly?[6] Or has something occurred to make the very idea of heroism in

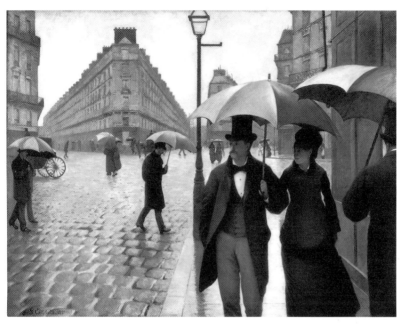

1 Gustave Caillebotte, *Paris Street, Rainy Day*, 1877. Oil on canvas, 212.2 × 276.2 cm.
The Art Institute, Chicago, Charles H. and Mary F.S. Worcester, 1964.336.

modern life – even one as hedged in with ironies as Baudelaire's had been –
already seem the relic of a simpler age?

There are surely readers who right from the start of this [...] found
Schapiro's account overheated, and have been wondering since where the
traditional notion of Impressionism has gone. Are we supposed these days to
give up believing in the 'painting of light' and the simple determination of
these artists to look and depict without letting the mind interfere too much?
The answer to that question is obviously no. The problem, on the contrary,
is to rediscover the force of these terms – light, looking, strict adherence to
the facts of vision – since they have nowadays become anodyne. [...]

This will be partly a matter of looking at Impressionist pictures again and
being struck by their strangeness. Let us take, for example, a landscape
Pissarro showed at the same exhibition in which Renoir's *Balançoire*
appeared, his *Coin de village, effet d'hiver* [Plate 2]. Pissarro's whole contribu-
tion to the show that year came in for rough handling from the critics. 'M.
Pissarro,' wrote one Ernest Fillonneau, 'is becoming completely unintelligi-
ble. He puts together in his pictures all the colours of the rainbow; he is
violent, hard, brutal. From an *effect* which might well have been acceptable,
he makes something unbelievable, against seeing and even against reason.'[7] It
was not enough, some writers thought, for the artist's friends to tell the
viewer to stand back and see the pictures from the other side of the room:

We have had enough of them repeating that, to judge the Impressionists, one has to
take one's distance. At fifty paces, they assure us, arms bulge, naked legs protrude from

2 Camille Pissarro, *Corner of the Village, Effect of Winter*, 1877. Oil on canvas, 54.5 × 65.6 cm. Musée d'Orsay, Paris. Photo: Réunion des Musées Nationaux Documentation Photographique.

skirts, eyes light up, the painting takes on body, ease, movement, each colour asserts itself and each tone leaps to its proper place. Thus it gives the impression of something seen and translated by the feelings rather than with every form defined. One or two of the coterie just about to realize this programme; and all of them take pains, the sweat standing out on their brow, to spread their colour all over the canvas, in pursuit of transparency all the while, and, putting green in their shadows, they stay muddy, without freshness or relief. [8]

Cézanne one knew about: he was clearly mad. But on reflection, Pissarro was almost as wayward:

There is no way to figure out M. Cesanne's [sic] *impressions d'après nature*; I took them for palettes that had not been cleaned. But M. Pissarro's landscapes are no more legible and no less prodigious. Seen close up, they are incomprehensible and awful; seen from afar, they are awful and incomprehensible. They are like rebuses with no solution. [9]

These criticisms are ungenerous, but they point to things in the paintings which truly are odd and ought to be recognized as such. The pattern of brushstrokes which Pissarro uses on the right-hand side of the *Coin de village* – where the branches half obscure the sides of a house, some shuttered windows, and a door – is very near to not being pattern at all. If we look at the picture at arm's length (the painter's distance), the various marks which may stand for branches, shadow, scrub, plaster, tiling, the lines of eaves or tree

trunks, all do their job of representing in a way which barely makes sense. The individual marks are scratched and spread into one another as if they had been worked over too long or too emphatically; sometimes the surface of the paint is visibly swollen with separate dabs of raw colour, and sometimes it is overlaid, almost cancelled out, with one or two declarative smears of red or green. The purpose of all this is not clear at arm's length: it is hard to see what produced the build-ups and erasures, or the sudden shifts of colour along the line of a branch or the edge of a roof. And presumably these things would have been obscure even to the painter as he put the particular touches down.

Not irretrievably so, of course: if he moved back from his work the marks would eventually congeal and release something seen – the way light falls on a house front or the space between one tree trunk and another. The technique was none the less strange, for as Pissarro was painting – I mean the word 'painting' in a crude materialist way, as modernist writers might use it – he would have had no very well-formed notion of what the paint could stand for and how effectively. While it was being made the likeness was barely one at all, and at best the justice of it was provisional; no doubt the thing did resolve at a distance, and the painter went back and back to the proper point to look and compare. But the walk back was itself an odd distancing; it was as if a space had to be kept between painting and representing: the two procedures must never quite mesh, they were not to be seen as part and parcel of each other. That was because (the logic here was central to the modernist case) the normal habits of representation must not be given a chance to function; they must somehow or other be outlawed. The established equivalents in paint – between that colour and that shadow or that kind of line and that kind of undergrowth – are always *false*. They are short-cuts for hand and eye and brain which tell us nothing we do not already know; and what we know already is not worth rehearsing in paint. [...]

There is certainly a set of Realist intentions still at work here, and even the stress on painterly substance could be and occasionally was justified in empirical terms. [...] Painting was now supposed to be about seeing, and the painter determined to stick to the look of a scene at all costs. But doing so proved exquisitely difficult: it involved a set of fragile and unprecedented equations between the painted and the visible, and above all it meant keeping the two terms of the equation apart, insisting on them as separate quantities.

No wonder a writer in *Le Télégraphe* in 1877 could toy with the idea of figuration's disappearing altogether from painting of this kind. He offered the following synopsis for an 'Impressionist novel' which would surely soon replace, he thought, the 'excessively minute descriptions' of Zola: 'A white – or black – form, which could be a man unless it be a woman, moves forward (is it forward?). The old sailor shudders – or is it sneezes? – we can't be sure; he cries, "Let's go!" and throws himself into a whitish – or blackish – sea (we can't be sure) which could well be the Ocean.'[10]

And did not all this ambiguity have to do at bottom with the character of modern life? 'The Impressionists proceed from Baudelaire,' wrote Jules Claretie.[11] Their exhibition 'shows this much, that painting is not uniquely

49

an archaeological art and that it accommodates itself without effort to "modernity" '. [12] Well, perhaps 'effort' *is* the wrong word for Pissarro's procedures, or even Cézanne's, but surely this writer's confidence somewhat misses the point of the pictures he is describing; and the careful scare quotes he puts round that final 'modernity' rather give the game away. If it was so delicate a matter to insert the concept into a sentence in 1877, then getting it into a picture promised to be no easy task. 'Yes or no, must we allow art to effect its own naturalization of the costume whose black and deforming uniformity we all suffer? In other words, must we paint the stovepipe hat, the umbrella, the shirt with wing collar, the waistcoat, and the trousers?'[13] It remained to be seen what the attractive new category meant when it was reduced to such particulars, and what kind of accommodation art could make with it.

50

Notes

1 Meyer Schapiro, 'Nature of Abstract Art', *Marxist Quarterly*, January-March 1937, p. 83. [...]
2 See *Internationale Situationniste 1958-69*, nos. 1-12, Paris, 1975, also reprinted in one volume; Guy Debord, *La Société du spectacle*, Paris, 1967; Raoul Vaneigem, *Traité de savoir-vivre à l'usage des jeunes générations,* Paris, 1967; and the unsigned *La Véritable Scission dans l'Internationale*. In translation: Christopher Gray, ed., *Leaving the 20th Century: The Incomplete Work of the Situationist International*; Guy Debord, *Society of the Spectacle,* London, 1974; Ken Knabb, ed., *Situationist International Anthology,* Berkeley, 1981; Raoul Vaneigem, *The Revolution of Everyday Life* (trans. of *Traité de savoir-vivre*), London, 1983.
3 Debord, *La Société du spectacle*, p. 24.
4 Stéphane Mallarmé, 'The Impressionists and Edouard Manet', *Art Monthly Review*, 30 September 1876, p. 222. The Mallarmé text is known to us only in this translated form.
5 Mallarmé, 'The Impressionists and Edouard Manet', p. 221.
6 'That one will be the *painter*, the true painter, who will know how to wrest from the life of the present its epic aspect, and make us see and understand, through colour and drawing, how great and poetic we are in our cravats and patent-leather boots' (Charles Baudelaire, 'Salon de 1845', in *Oeuvres complètes*, Paris, 1961, p. 866). For the phrase from Rimbaud in quotation marks, see 'Ville' in *Les Illuminations*, 1872, O. Bernard, ed., *Rimbaud: Selected Verse*, Harmondsworth, 1962, pp. 256-7.
7 Ernest Fillonneau, 'Les Impressionnistes', *Le Moniteur des Arts*, 10 April 1877 [...].
8 Marc de Montifaud, *L'Artiste*, 48th year, vol. 1, p. 337 [...].
9 Léon de Lora, *Le Gaulois*, 10 April 1877 [...].
10 Zed, 'Menus propos', *Le Télégraphe*, 6 April 1877 [...].
11 Jules Claretie, 'Salon de 1875', in *L'Art et les artistes français contemporains*, Paris, 1876, p. 337.
12 Jacques, 'Exposition impressioniste', *L'Homme Libre*, 12 April 1877 [...].
13 Emile Bergerat, *Le Journal officiel de la République Française*, 17 April 1877 [...].

6

Peter Bürger
On the Problem of the Autonomy
of Art in Bourgeois Society

Source: Peter Bürger, 'On the Problem of the
Autonomy of Art in Bourgeois Society', in
Theory of the Avant-Garde, translated from the
German by Michael Shaw, Manchester and
Minneapolis, Manchester University Press and
University of Minnesota Press, 1984, pp. 35-54
and pp. 112-14. First published in German as
Theorie der Avantgarde, Frankfurt, Suhrkamp
Verlag, 1974. This text has been edited and
footnotes renumbered accordingly.

Its autonomy (that of art) surely remains irrevocable.[1]

It is impossible to conceive of the autonomy of art without covering up work.[2]

I Research Problems

The two sentences of Adorno circumscribe the contradictoriness of the cat-
egory 'autonomy': necessary to define what art is in bourgeois society, it also
carries the taint of ideological distortion where it does not reveal that it is
socially conditioned. This suggests the definition of autonomy that will
underlie the following comments and also serves to distinguish it from two
other, competing concepts: the autonomy concept of *l'art pour l'art* and the
autonomy concept of a positivist sociology that sees autonomy as the merely
subjective idea of the producer of art.

If the autonomy of art is defined as art's independence from society, there
are several ways of understanding that definition. Conceiving of art's apart-
ness from society as its 'nature' means involuntarily adopting the *l'art pour l'art*
concept of art and simultaneously making it impossible to explain this apart-
ness as the product of a historical and social development. If, on the other
hand, one puts forward the view that art's independence from society exists
only in the artist's imagination and that it tells us nothing about the status of
works, the correct insight that autonomy is a historically conditioned phe-
nomenon turns into its denial; what remains is mere illusion. Both
approaches miss the complexity of autonomy, a category whose characteris-
tic it is that it describes something real (the detachment of art as a special
sphere of human activity from the nexus of the praxis of life) but simultane-
ously expresses this real phenomenon in concepts that block recognition of
the social determinacy of the process. Like the public realm (*Öffentlichkeit*),
the autonomy of art is a category of bourgeois society that both reveals and
obscures an actual historical development. All discussion of this category
must be judged by the extent to which it succeeds in showing and explaining
logically and historically the contradictoriness inherent in the thing itself.

[...] B. Hinz explains the genesis of the idea of the autonomy of art[3] as follows: 'During this phase of the historical separation of the producer from his means of production, the artist remained as the only one whom the division of labour had passed by, though most assuredly not without leaving a trace. ... The reason that his product could acquire importance as something special, "autonomous", seems to lie in the continuation of the handicraft mode of production after the historical division of labour had set in' (*Autonomie der Kunst*, pp. 175f.).[4] Being arrested at the handicraft stage of production within a society where the division of labour and the separation of the worker from his means of production becomes increasingly the norm would thus be the actual precondition for seeing art as something special. Because the Renaissance artist worked principally at a court, he reacted 'feudally' to the division of labour. He denied his status as craftsman and conceived of his achievement as purely intellectual. M. Müller comes to a similar conclusion: 'At least in theory, it is the court that promotes the division of artistic work into material and intellectual production, the field in which this happens being the art that is created there. This division is a feudal reflex to changed conditions of production' (*Autonomie der Kunst*, p. 26). [...]

[...] Although artists' studios were still places of handicraft in the fifteenth century, Hauser writes,[5] and subject to guild rules (p. 56ff.), the social status of the artist changed around the beginning of the sixteenth century because the new seigneuries and principalities on the one hand, and wealthy cities on the other, became sources of an ever-increasing demand for qualified artists who were capable of taking on and executing important orders. In this context also, Hauser speaks of a demand on the art market, but what is meant is not the 'market' on which individual works are bought and sold, but the growing number of important commissions. This increase resulted in a loosening of the guild ties of the artists (the guilds were an instrument of the producers by which they protected themselves against surplus production and the fall in prices this entailed). Whereas Winckler derives 'artistic abstraction', the interest in techniques of composition and colour, from the market mechanism (artists produce for the anonymous market on which the collector buys the works; they no longer produce for the individual who commissions something), an explanation that contradicts Winckler's could be deduced from the Hauser comments just given. The interest in techniques of composition and colour would then be a consequence of the new social position of the artist, which results not from the decreasing importance of commissioned art but from its growth.

This is not the place to determine what the 'correct' explanation may be. What is important is to recognize the research problem that the divergence of the various explanatory attempts makes apparent. The development of the art market (both of the old 'commission' market and the new market where individual works are bought and sold) furnishes a kind of 'fact' from which it is difficult to infer anything about the developing autonomy of the aesthetic. The process of the growth of the social sphere that we call art, which extended over centuries and was fitful because it was inhibited time and again

by countermovements, can hardly be derived from any single cause, even though that cause be of such central importance for society as the market mechanism.

The study of Bredekamp differs from the approaches discussed so far because the author attempts to show 'that the concept and idea of "free" (autonomous) art is tied from the very beginning to a specific class, that the courts and the great bourgeoisie promoted art as a witness to their rule' (*Autonomie der Kunst*, p. 92). [...]

2 The Autonomy of Art in the Aesthetics of Kant and Schiller

[...] Not until the eighteenth century, with the rise of bourgeois society and the seizure of political power by a bourgeoisie that had gained economic strength, do a systematic aesthetics as a philosophical discipline and a new concept of autonomous art come into being. In philosophical aesthetics, the result of a centuries-long process is conceptualized. By the 'modern concept of art as a comprehensive designation for poetry, music, the stage, sculpture, painting and architecture which did not become current until the end of the 18th century,'[6] artistic activity is understood as an activity that differs from all others. 'The various arts were removed from the context of everyday life and conceived of as something that could be treated as a whole. ... As the realm of non-purposive creation and disinterested pleasure, this whole was contrasted with the life of society which it seemed the task of the future to order rationally, in strict adaptation to definable ends.'[7] With the constitution of aesthetics as an autonomous sphere of philosophical knowledge, this concept of art comes into being. Its result is that artistic production is divorced from the totality of social activities and comes to confront them abstractly. [...]

In Kant's *Critique of Judgement* (1790), the subjective aspect of the detachment of art from the practical concerns of life is reflected.[8] It is not the work of art but the aesthetic judgement (judgement of taste) that Kant investigates. It is situated between the realm of the senses and that of reason, between the 'interest of inclination in the case of the agreeable' (*Critique of Judgement*, § 5) and the interest of practical reason in the realization of the moral law, and is defined as *disinterested*. 'The delight which determines the judgement of taste is independent of all interest' (§ 2) where interest is defined by 'reference to the faculty of desire' (ibid.). If the faculty of desire is that human capability which makes possible on the side of the subject a society based on the principle of the maximization of profit, then Kant's axiom also defines the freedom of art from the constraints of the developing bourgeois–capitalist society. The aesthetic is conceived as a sphere that does not fall under the principle of the maximization of profit prevailing in all spheres of life. In Kant, this element does not yet come to the fore. On the contrary, he makes clear what is meant (the detachment of the aesthetic from all practical life contexts) by emphasizing the universality of aesthetic judgement as compared with the particularity of the judgement to which the bourgeois social

53

critic subjects the feudal life style: 'If anyone asks me whether I consider that the palace I see before me is beautiful, I may, perhaps, reply that I do not care for things of that sort that are merely made to be gaped at. Or I may reply in the same strain as that Iroquois sachem who said that nothing in Paris pleased him better than the eating-houses. I may even go a step further and inveigh with the vigour of a Rousseau against the vanity of the great who spend the sweat of the people on such superfluous things. ... All this may be admitted and approved; only it is not the point now at issue. All one wants to know is whether the mere representation of the object is to my liking' (*Critique of Judgement*, § 2).

The quotation makes clear what Kant means by disinterest. Both the interest of the 'Iroquois sachem', which is directed toward the immediate satisfaction of needs, and the practical interest of reason of Rousseau's social critic lie outside the sphere Kant stakes out for aesthetic judgement. With his demand that the aesthetic judgment be universal, Kant also closes his eyes to the particular interests of his class. Toward the products of the class enemy also, the bourgeois theoretician claims impartiality. What is bourgeois in Kant's argument is precisely the demand that the aesthetic judgement have universal validity. The pathos of universality is characteristic of the bourgeoisie, which fights the feudal nobility as an estate that represents particular interests.

Kant not only declares the aesthetic as independent of the sphere of the sensuous and the moral (the beautiful is neither the agreeable nor the morally good) but also of the sphere of the theoretical. The logical peculiarity of the judgement of taste is that whereas it claims universal validity, it is not 'a logical universality according to concepts' (§ 31) because in that case, the 'necessary and universal approval would be capable of being enforced by proofs' (§ 35). For Kant, the universality of the aesthetic judgement is thus grounded in the agreement of an idea with the subjective conditions of the use of judgement that apply to all, concretely, in the agreement of imagination (*Einbildungskraft*) and understanding (*Verstand*).

In Kant's philosophical system, judgement occupies a central place, for it is assigned the task of mediating between theoretical knowledge (nature) and practical knowledge (freedom). It furnishes the 'concept of a purposiveness of nature' that not only permits moving upward from the particular to the general but also the practical modification of reality. For only a nature conceived as purposive in its manifoldness can be cognized as unity and become the object of practical action.

Kant assigned the aesthetic a special position between sensuousness and reason, and defined the judgement of taste as free and disinterested. For Schiller, these Kantian reflections become a point of departure from which he can proceed toward something like a definition of the social function of the aesthetic. The attempt strikes one as paradoxical, for it was precisely the disinterestedness of the aesthetic judgement and, it would seem at first, the *functionlessness* of art as an implicit consequence that Kant had emphasized. Schiller attempts to show that it is on the very basis of its autonomy, its not being tied to immediate ends, that art can fulfil a task that cannot be fulfilled

any other way: the furtherance of humanity. The point of departure of his reflections is an analysis of what, under the influence of the Reign of Terror of the French Revolution, he calls the 'drama of our period':

Among the lower and more numerous classes we find crude, lawless impulses which have been unleashed by the loosening of the bonds of civil order, and are hastening with ungovernable fury to their brutal satisfaction. ... The extinction of the state contains its vindication. Society uncontrolled, instead of hastening upward into organic life, is relapsing into its original elements. On the other hand, the civilized classes present to us the still more repugnant spectacle of indolence and a depravity of character which is all the more shocking since culture itself is the source of it. ... The intellectual enlightenment on which the refined ranks of society, not without justification, pride themselves, reveal, on the whole, an influence on the disposition so little ennobling that it rather furnishes maxims to confirm depravity.[9]

At the level of analysis quoted here, the problem seems to have no solution. In their actions, the 'lower and more numerous classes' are slaves to the immediate satisfaction of their drives. Not only that, the 'enlightenment of reason' has done nothing to teach the 'civilized classes' to act morally. According to Schiller's analysis, in other words, one may put one's trust neither in man's good nature nor in the educability of his reason.

What is decisive in Schiller's procedure is that he does not interpret the result of his analysis anthropologically, in the sense of a definitively fixed human nature, but historically, as the result of a historical process. He argues that the development of civilization has destroyed the unity of the senses and of reason, which still existed among the Greeks: 'We see not merely individual persons but whole classes of human beings developing only part of their capacities, while the rest of them, like a stunted plant, show only a feeble vestige of their nature' (p. 38). 'Eternally chained to only one single little fragment of the whole, Man himself grew to be only a fragment; with the monotonous noise of the wheel he drives everlastingly in his ears, he never develops the harmony of his being, and instead of imprinting humanity upon his nature he becomes merely the imprint of his occupation, of his science' (p. 40). As activities become distinct from each other, 'a more rigorous dissociation of ranks and occupations' becomes necessary (p. 39). Formulated in concepts of the social sciences, this means that the division of labour has class society as its unavoidable consequence. But Schiller argues that class society cannot be abolished by a political revolution because the revolution can be carried out only by those men who, having been stamped by a society where the division of labour prevails, have for that reason been unable to develop their humanity. The *aporia* that appeared at the first level of Schiller's analysis as the irresolvable contradiction of sensuousness and reason reappears at the second. Although the contradiction here is no longer an eternal but a historical one, it seems no less hopeless, for every change that would make society both rational and humane presupposes human beings who would need such a society to develop in.

It is at precisely this point of his argument that Schiller introduces art, to which he assigns no less a task than to put back together the 'halves' of man

that have been torn asunder – which means that it is within a society already characterized by the division of labour that art is to make possible the development of the totality of human potentialities that the individual cannot develop in his sphere of activity. 'But can Man really be destined to neglect himself for any end whatever? Should Nature be able, by her designs, to rob us of a completeness which Reason prescribes to us by hers? It must be false that the cultivation of individual powers necessitates the sacrifice of their totality; or however much the law of Nature did have that tendency, we must be at liberty to restore by means of a higher Art this wholeness in our nature which Art has destroyed' (p. 45). This is a difficult passage, because the concepts here are not rigid but, seized by the dialectics of thought, pass into their opposite. 'End' refers first to the limited task of the individual, then to the teleology (unfolding into distinct human powers) that occurs in and through historical development ('nature'); and finally, to an all-around development of man that reason calls for. Similar considerations apply to the concept of nature that is both a law of development but also refers to man as a psychophysical totality. Art also means two different things. First, it refers to technique and science, and then it has the modern meaning of a sphere that has been set apart from the praxis of life ('higher art'). It is Schiller's idea that precisely because it renounces all direct intervention in reality, art is suited to restore man's wholeness. Schiller, who sees no chance in his time for the building of a society that permits the development of the totality of everyone's powers, does not surrender this goal, however. It is true, though, that the creation of a rational society is made dependent on a humanity that has first been realized through art.

It cannot be our purpose here to trace Schiller's thought in its detail, to observe how he defines the play impulse, which he identifies with artistic activity as the synthesis of sense impulse and form impulse, or how, in a speculative history, he seeks to find liberation from the spell of sensuousness through the experience of the beautiful. What is to be emphasized in our context is the central social function that Schiller assigns to art precisely because it has been removed from all the contexts of practical life.

To summarize: the *autonomy of art* is a category of bourgeois society. It permits the description of art's detachment from the context of practical life as a historical development – that among the members of those classes which, at least at times, are free from the pressures of the need for survival, a sensuousness could evolve that was not part of any means–ends relationships. Here we find the moment of truth in the talk about the autonomous work of art. What this category cannot lay hold of is that this detachment of art from practical contexts is a *historical process*, i.e., that it is socially conditioned. And here lies the untruth of the category, the element of distortion that characterizes every ideology, provided one uses this term in the sense the early Marx does when he speaks of the critique of ideology. The category 'autonomy' does not permit the understanding of its referent as one that developed historically. The relative dissociation of the work of art from the praxis of life in bourgeois society thus becomes transformed into the (erroneous) idea that the work of

art is totally independent of society. In the strict meaning of the term, 'auton-omy' is thus an ideological category that joins an element of truth (the apart-ness of art from the praxis of life) and an element of untruth (the hypostatization of this fact, which is a result of historical development as the 'essence' of art).

3 The Negation of the Autonomy of Art by the Avant-Garde

In scholarly discussion up to now, the category 'autonomy' has suffered from the imprecision of the various subcategories thought of as constituting a unity in the concept of the autonomous work of art. Since the development of the individual subcategories is not synchronous, it may happen that sometimes courtly art seems already autonomous, while at other times only bourgeois art appears to have that characteristic. To make clear that the contradictions between the various interpretations result from the nature of the case, we will sketch a historical typology that is deliberately reduced to three elements (purpose or function, production, reception), because the point here is to have the non-synchronism in the development of individual categories emerge with clarity.

A. Sacral Art (example: the art of the High Middle Ages) serves as cult object. It is wholly integrated into the social institution 'religion'. It is pro-duced collectively, as a craft. The mode of reception also is institutionalized as collective.[10]

B. Courtly Art (example: the art at the court of Louis XIV) also has a pre-cisely defined function. It is representational and serves the glory of the prince and the self-portrayal of courtly society. Courtly art is part of the life praxis of courtly society, just as sacral art is part of the life praxis of the faith-ful. Yet the detachment from the sacral tie is a first step in the emancipation of art. ('Emancipation' is being used here as a descriptive term, as referring to the process by which art constitutes itself as a distinct social subsystem.) The difference from sacral art becomes particularly apparent in the realm of pro-duction: the artist produces as an individual and develops a consciousness of the uniqueness of his activity. Reception, on the other hand, remains collec-tive. But the content of the collective performance is no longer sacral, it is sociability.

C. Only to the extent that the bourgeoisie adopts concepts of value held by the aristocracy does bourgeois art have a representational function. When it is genuinely bourgeois, this art is the objectification of the self-understand-ing of the bourgeois class. Production and reception of the self-understand-ing as articulated in art are no longer tied to the praxis of life. Habermas calls this the satisfaction of residual needs, that is, of needs that have become sub-merged in the life praxis of bourgeois society. Not only production but reception also are now individual acts. The solitary absorption in the work is the adequate mode of appropriation of creations removed from the life praxis of the bourgeois, even though they still claim to interpret that praxis. In

Aestheticism, finally, where bourgeois art reaches the stage of self-reflection, this claim is no longer made. Apartness from the praxis of life, which had always been the condition that characterized the way art functioned in bourgeois society, now becomes its content. The typology we have sketched here can be represented in the accompanying tabulation (the vertical lines in bold-face refer to a decisive change in the development, the broken ones to a less decisive one).

	Sacral Art	Courtly Art	Bourgeois Art
Purpose or function	cult object	representational object	portrayal of bourgeois self-understanding
Production	collective craft	individual	individual
Reception	collective (sacral)	collective (sociable)	individual

The tabulation allows one to notice that the development of the categories was not synchronous. Production by the individual that characterizes art in bourgeois society has its origins as far back as courtly patronage. But courtly art still remains integral to the praxis of life, although as compared with the cult function, the representational function constitutes a step toward a mitigation of claims that art plays a direct social role. The reception of courtly art also remains collective, although the content of the collective performance has changed. As regards reception, it is only with bourgeois art that a decisive change sets in: its reception is one by isolated individuals. The novel is that literary genre in which the new mode of reception finds the form appropriate to it. The advent of bourgeois art is also the decisive turning point as regards use or function. Although in different ways, both sacral and courtly art are integral to the life praxis of the recipient. As cult and representational objects, works of art are put to a specific use. This requirement no longer applies to the same extent to bourgeois art. In bourgeois art, the portrayal of bourgeois self-understanding occurs in a sphere that lies outside the praxis of life. The citizen who in everyday life has been reduced to a partial function (means-ends activity) can be discovered in art as 'human being'. Here, one can unfold the abundance of one's talents, though with the proviso that this sphere remain strictly separate from the praxis of life. Seen in this fashion, the separation of art from the praxis of life becomes the decisive characteristic of the autonomy of bourgeois art (a fact that the tabulation does not bring out adequately). To avoid misunderstandings, it must be emphasized once again that autonomy in this sense defines the status of art in bourgeois society but that no assertions concerning the contents of works are involved. Although art as an institution may be considered fully formed toward the end of the eighteenth century, the development of the contents of works is subject to a historical dynamic, whose terminal point is reached in Aestheticism, where art becomes the content of art.

The European avant-garde movements can be defined as an attack on the status of art in bourgeois society. What is negated is not an earlier form of art

(a style) but art as an institution that is unassociated with the life praxis of men. When the avant-gardistes demand that art become practical once again, they do not mean that the contents of works of art should be socially significant. The demand is not raised at the level of the contents of individual works. Rather, it directs itself to the way art functions in society, a process that does as much to determine the effect that works have as does the particular content.

The avant-gardistes view its dissociation from the praxis of life as the dominant characteristic of art in bourgeois society. One of the reasons this dissociation was possible is that Aestheticism had made the element that defines art as an institution the essential content of works. Institution and work contents had to coincide to make it logically possible for the avant-garde to call art into question. The avant-gardistes proposed the sublation of art – sublation in the Hegelian sense of the term: art was not to be simply destroyed, but transferred to the praxis of life where it would be preserved, albeit in a changed form. The avant-gardistes thus adopted an essential element of Aestheticism. Aestheticism had made the distance from the praxis of life the content of works. The praxis of life to which Aestheticism refers and which it negates is the means-ends rationality of the bourgeois everyday. Now, it is not the aim of the avant-gardistes to integrate art into *this* praxis. On the contrary, they assent to the Aestheticists' rejection of the world and its means-ends rationality. What distinguishes them from the latter is the attempt to organize a new life praxis from a basis in art. In this respect also, Aestheticism turns out to have been the necessary precondition of the avant-gardiste intent. Only an art the contents of whose individual works is wholly distinct from the (bad) praxis of the existing society can be the centre that can be the starting point for the organization of a new life praxis.

With the help of Herbert Marcuse's theoretical formulation concerning the twofold character of art in bourgeois society [...] the avant-gardiste intent can be understood with particular clarity. All those needs that cannot be satisfied in everyday life, because the principle of competition pervades all spheres, can find a home in art, because art is removed from the praxis of life. Values such as humanity, joy, truth, solidarity are extruded from life as it were, and preserved in art. In bourgeois society, art has a contradictory role: it projects the image of a better order and to that extent protests against the bad order that prevails. But by realizing the image of a better order in fiction, which is semblance (*Schein*) only, it relieves the existing society of the pressure of those forces that make for change. They are assigned to confinement in an ideal sphere. Where art accomplishes this, it is 'affirmative' in Marcuse's sense of the term. If the twofold character of art in bourgeois society consists in the fact that the distance from the social production and reproduction process contains an element of freedom and an element of the non-committal and an absence of any consequences, it can be seen that the avant-gardistes' attempt to reintegrate art into the life process is itself a profoundly contradictory endeavour. For the (relative) freedom of art vis-à-vis the praxis of life is at the same time the condition that must be fulfilled if there is to be

a critical cognition of reality. An art no longer distinct from the praxis of life but wholly absorbed in it will lose the capacity to criticize it, along with its distance. During the time of the historical avant-garde movements, the attempt to do away with the distance between art and life still had all the pathos of historical progressiveness on its side. But in the meantime, the culture industry has brought about the false elimination of the distance between art and life, and this also allows one to recognize the contradictoriness of the avant-gardiste undertaking.[11]

In what follows, we will outline how the intent to eliminate art as an institution found expression in the three areas that we used above to characterize autonomous art: purpose or function, production, reception. Instead of speaking of the avant-gardiste work, we will speak of avant-gardiste manifestation. A Dadaist manifestation does not have work character but is nonetheless an authentic manifestation of the artistic avant-garde. This is not to imply that the avant-gardistes produced no works whatever and replaced them by ephemeral events. We will see that whereas they did not destroy it, the avant-gardistes profoundly modified the category of the work of art.

Of the three areas, the *intended purpose or function* of the avant-gardiste manifestation is most difficult to define. In the aestheticist work of art, the disjointure of the work and the praxis of life characteristic of the status of art in bourgeois society has become the work's essential content. It is only as a consequence of this fact that the work of art becomes its own end in the full meaning of the term. In Aestheticism, the social functionlessness of art becomes manifest. The avant-gardiste artists counter such functionlessness not by an art that would have consequences within the existing society, but rather by the principle of the sublation of art in the praxis of life. But such a conception makes it impossible to define the intended purpose of art. For an art that has been reintegrated into the praxis of life, not even the absence of a social purpose can be indicated, as was still possible in Aestheticism. When art and the praxis of life are one, when the praxis is aesthetic and art is practical, art's purpose can no longer be discovered, because the existence of two distinct spheres (art and the praxis of life) that is constitutive of the concept of purpose or intended use has come to an end.

We have seen that the *production* of the autonomous work of art is the act of an individual. The artist produces as individual, individuality not being understood as the expression of something but as radically different. The concept of genius testifies to this. The quasi-technical consciousness of the makeability of works of art that Aestheticism attains seems only to contradict this. Valéry, for example, demystifies artistic genius by reducing it to psychological motivations on the one hand, and the availability to it of artistic means on the other. While pseudo-romantic doctrines of inspiration thus come to be seen as the self-deception of producers, the view of art for which the individual is the creative subject is let stand. Indeed, Valéry's theorem concerning the force of pride (*orgueil*) that sets off and propels the creative process renews once again the notion of the individual character of artistic production central to art in bourgeois society.[12] In its most extreme manifestations,

3 Marcel Duchamp, *The Fountain by R. Mutt*, 1917 (Urinal). Photograph by Alfred Steiglitz, reproduced in the second issue of *The Blind Man*, May 1917, p. 4. Philadelphia Museum of Art: Louise and Walter Arensberg Collection. © ADAGP, Paris and DACS, London 1993.

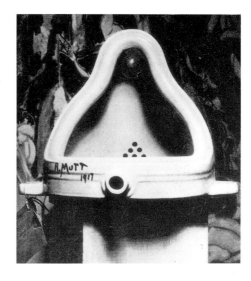

61

the avant-garde's reply to this is not the collective as the subject of production but the radical negation of the category of individual creation. When Duchamp signs mass-produced objects (a urinal, a bottle-drier) and sends them to art exhibitions, he negates the category of individual production [Plate 3]. The signature, whose very purpose it is to mark what is individual in the work, that it owes its existence to this particular artist, is inscribed on an arbitrarily chosen mass product, because all claims to individual creativity are to be mocked. Duchamp's provocation not only unmasks the art market where the signature means more than the quality of the work; it radically questions the very principle of art in bourgeois society according to which the individual is considered the creator of the work of art. Duchamp's Ready-Mades are not works of art but manifestations. Not from the form-content totality of the individual object Duchamp signs can one infer the meaning, but only from the contrast between mass-produced object on the one hand, and signature and art exhibit on the other. It is obvious that this kind of provocation cannot be repeated indefinitely. The provocation depends on what it turns against: here, it is the idea that the individual is the subject of artistic creation. Once the signed bottle-drier has been accepted as an object that deserves a place in a museum, the provocation no longer provokes; it turns into its opposite. If an artist today signs a stove pipe and exhibits it, that artist certainly does not denounce the art market but adapts to it. Such adaptation does not eradicate the idea of individual creativity, it affirms it, and the reason is the failure of the avant-gardiste intent to sublate art. Since now the protest of the historical avant-garde against art as institution is accepted as *art*, the gesture of protest of the neo-avant-garde becomes inauthentic. Having been shown to be irredeemable, the claim to be protest can no longer be maintained. This fact accounts for the arts-and-crafts impression that works of the avant-garde not infrequently convey.[13]

The avant-garde not only negates the category of individual production

but also that of individual *reception*. The reactions of the public during a Dada manifestation where it has been mobilized by provocation, and which can range from shouting to fisticuffs, are certainly collective in nature. True, these remain reactions, responses to a preceding provocation. Producer and recipient remain clearly distinct, however active the public may become. Given the avant-gardiste intention to do away with art as a sphere that is separate from the praxis of life, it is logical to eliminate the antithesis between producer and recipient. It is no accident that both Tzara's instructions for the making of a Dadaist poem and Breton's for the writing of automatic texts have the character of recipes.[14] This represents not only a polemical attack on the individual creativity of the artist; the recipe is to be taken quite literally as suggesting a possible activity on the part of the recipient. The automatic texts also should be read as guides to individual production. But such production is not to be understood as artistic production, but as part of a liberating life praxis. This is what is meant by Breton's demand that poetry be practised (*pratiquer la poésie*). Beyond the coincidence of producer and recipient that this demand implies, there is the fact that these concepts lose their meaning: producers and recipients no longer exist. All that remains is the individual who uses poetry as an instrument for living one's life as best one can. There is also a danger here to which Surrealism at least partly succumbed, and that is solipsism, the retreat to the problems of the isolated subject. Breton himself saw this danger and envisaged different ways of dealing with it. One of them was the glorification of the spontaneity of the erotic relationship. Perhaps the strict group discipline was also an attempt to exorcize the danger of solipsism that Surrealism harbours.[15]

In summary, we note that the historical avant-garde movements negate those determinations that are essential in autonomous art: the disjunction of art and the praxis of life, individual production, and individual reception as distinct from the former. The avant-garde intends the abolition of autonomous art by which it means that art is to be integrated into the praxis of life. This has not occurred, and presumably cannot occur, in bourgeois society unless it be as a false sublation of autonomous art.[16] Pulp fiction and commodity aesthetics prove that such a false sublation exists. A literature whose primary aim is to impose a particular kind of consumer behaviour on the reader is in fact practical, though not in the sense the avant-gardists intended. Here, literature ceases to be an instrument of emancipation and becomes one of subjection. Similar comments could be made about commodity aesthetics that treat form as mere enticement, designed to prompt purchasers to buy what they do not need. Here also, art becomes practical but it is an art that enthrals. This brief allusion will show that the theory of the avant-garde can also serve to make us understand popular literature and commodity aesthetics as forms of a false sublation of art as institution. In late capitalist society, intentions of the historical avant-garde are being realized but the result has been a disvalue. Given the experience of the false sublation of autonomy, one will need to ask whether a sublation of the autonomy status can be desirable at all, whether the distance between art and the praxis of life

is not requisite for that free space within which alternatives to what exists become conceivable.

Notes

1 Th. W. Adorno, *Ästhetische Theorie*, ed. Gretel Adorno, R. Tiedemann, Frankfurt, 1970, p. 9.

2 Th. W. Adorno, *Versuch über Wagner,* Munich/Zürich, 1964, pp. 88f.

3 I am referring to the following studies: M. Müller, 'Künstlerische und materielle Produktion. Zur Autonomie der Kunst in der italienischen Renaissance'; H. Bredekamp, 'Autonomie und Askese'; B. Hinz, 'Zur Dialektik des bürgerlichen Autonomie-Begriffs,' all of which appeared in the volume *Autonomie der Kunst. Zur Genese und Kritik einer bürgerlichen Kategorie,* Frankfurt, 1972, which is quoted as '*Autonomie der Kunst*' in what follows. I refer further to L. Winckler, 'Entstehung und Funktion des literarischen Marktes', in Winckler, *Kulturwarenproduktion. Aufsätze zur Literatur und Sprachsoziologie,* Frankfurt, 1973, pp. 12–75; and B. J. Warneken, 'Autonomie und Indienstnahme. Zu ihrer Beziehung in der Literatur der bürgerlichen Gesellschaft', in *Rhetorik, Ästhetik, Ideologie. Aspekte einer kritischen Kulturwissenschaft,* Stuttgart, 1973, pp. 79–115.

4 In the1920s, the Russian avant-gardiste B. Arvatov had already given a similar interpretation of bourgeois art: 'While the entire technique of capitalist society is based on the highest and most recent achievements and represents a technique of mass production (industry, radio, transport, newspapers, scientific laboratory etc.) – bourgeois art has remained handicraft in principle and has for that reason been pushed out of the general social praxis of mankind and into isolation, into the sphere of pure aesthetics ... The solitary master is the only type of artist in capitalist society, the type of the specialist of "pure" art who works outside a directly utilitarian praxis because that praxis is based on the technique of machines. This is the cause of the illusion that art is an end in itself, and it is here that all of its bourgeois fetishism originates', H. Günther and Karla Hielscher, ed., trans., *Kunst und Produktion* [Munich, 1972], pp.11f.).

5 A. Hauser, *The Social History of Art*, vol. II, New York, n.d. Quoted as 'Hauser' in what follows.

6 H. Kuhn, 'Ästhetik', in *Das Fischer Lexikon. Literatur 2/1,* ed. W. H. Friedrich, W. Killy, Frankfurt, 1965, pp.52, 53.

7 Ibid.

8 I. Kant, *Critique of Judgement*, trans. James Creed Meredith (Oxford, 1952).

9 Schiller, *On the Aesthetic Education of Man,* trans. Reginald Snell New York, 1965, pp. 35-6.

10 On this, see the recent essay by R. Warning, 'Ritus, Mythos und geistliches Spiel', in *Terror und Spiel. Probleme der Mythenrezeption,* ed. Fuhrmann Munich, 1971, pp.211-39.

11 On the problem of the false sublation of art in the praxis of life, see J. Habermas, *Strukturwandel der Öffentlichkeit. Untersuchungen zu einer Kategorie der bürgerlichen Gesellschaft,* Neuwied/Berlin, 1968, § 18, pp. 176ff.

12 See P. Bürger, 'Funktion und Bedeutung des *orgueil* bei Paul Valéry', in *Romanisches Jahrbuch,* 16 1965, pp. 149-68.

13 Examples of neo-avant-gardiste painting and sculptures to be found in the catalogue of the exhibition *Sammlung Cremer. Europäische Avantgarde 1950-1970,* ed. G. Adriani Tübingen, 1973.

14 T. Tzara, 'Pour faire un Poème dadaiste', in Tzara, *Lampisteries précédées des sept manifestes dada* (place of publication not given, 1963), p. 64. A. Breton, 'Manifeste du surréalisme' (1924), in Breton, *Manifestes du surréalisme,* Paris, 1963, pp.42f.

15 On the Surrealists' conception of groups and the collective experiences they sought and partially realized, see Elisabeth Lenk, *Der springende Narziss. André Bretons poetischer Materialismus,* Munich, 1971, pp. 57ff., 73 f.

16 One would have to investigate to what extent, after the October Revolution, the Russian avant-gardistes succeeded to a degree, because social conditions had changed, in realizing their intent to reintegrate art in the praxis of life. [...] With the theory of the avant-garde as a point of departure, and with concrete investigations as guide, one should also discuss the problem of the extent (and of the kinds of consequences for the artistic subjects) to which art as an institution occupies a place in the society of the socialist countries that differs from its place in bourgeois society.

Fredric Jameson
Aesthetics and Politics

Source: Fredric Jameson, 'Reflections in
Conclusion', in *Aesthetics and Politics*, London,
New Left Books, 1977, pp. 196-213. This text
has been edited and footnotes renumbered
accordingly.

It is not only political history which those who ignore history are condemned
to repeat. A host of recent 'post-Marxisms' document the truth of the asser-
tion that attempts to 'go beyond' Marxism typically end by reinventing older
pre-Marxist positions [...]. Even within Marxism itself, the terms of the prob-
lems, if not their solutions, are numbered in advance, and the older contro-
versies – Marx versus Bakunin, Lenin versus Luxemburg, the national
question, the agrarian question, the dictatorship of the proletariat – rise up to
haunt those who thought we could now go on to something else and leave
the past behind us.

Nowhere has this 'return of the repressed' been more dramatic than in the
aesthetic conflict between 'Realism' and 'Modernism', whose navigation and
renegotiation is still unavoidable for us today, even though we may feel that
each position is in some sense right and yet that neither is any longer wholly
acceptable. The dispute is itself older than Marxism, and in a longer perspec-
tive may be said to be a contemporary political replay of the seventeenth-
century *Querelle des anciens et des modernes*, in which, for the first time, aes-
thetics came face to face with the dilemmas of historicity.

Within the Marxism of this century, the precipitant of the controversy
over Realism and Modernism was the living fact and persisting influence of
Expressionism among the writers of the German Left in the 1920s and 1930s.
An implacable ideological denunciation by Lukács in 1934 set the stage for
the series of interconnected debates and exchanges between Bloch, Lukács,
Brecht, Benjamin and Adorno [...]. Much of the fascination of these jousts,
indeed, comes from the internal dynamism by which all the logical possibili-
ties are rapidly generated in turn, so that it quickly extends beyond the local
phenomenon of Expressionism, and even beyond the ideal type of realism
itself, to draw within its scope the problems of popular art, naturalism, social-
ist realism, avant-gardism, media, and finally modernism – political and non-
political – in general. Today, many of its fundamental themes and concerns
have been transmitted by the Frankfurt School, and in particular by Marcuse,
to the student and anti-war movements of the 1960s, while the revival of
Brecht has ensured their propagation among political modernisms. [...]

It is at any rate clear that the Realism/Modernism controversy loses its

interest if one side is programmed to win in advance. The Brecht-Lukács debate alone is one of those rare confrontations in which both adversaries are of equal stature, both of incomparable significance for the development of contemporary Marxism, the one a major artist and probably the greatest literary figure to have been produced by the Communist movement, the other a central philosopher of the age and heir to the whole German philosophical tradition, with its unique emphasis on aesthetics as a discipline. It is true that in recent accounts of their opposition,[1] Brecht has tended to get the better of Lukács, the former's 'plebeian' style and Schweikian identifications proving currently more attractive than the 'mandarin' culture to which the latter appealed.[2] In these versions, Lukács is typically treated as a professor, a revisionist, a Stalinist – or a general 'in the same way as the brave Moses Mendelssohn in Lessing's time treated Spinoza as a "dead dog",' as Marx described the standard view of Hegel current among his radical contemporaries.

To the degree to which Lukács single-handedly turned the Expressionism debate around into a discussion of Realism, and forced the defenders of the former to fight on his own ground and in his own terms, their annoyance with him was understandable. [...] On the other hand, such meddling interference was at one with everything that made Lukács a major figure in twentieth-century Marxism – in particular his lifelong insistence on the crucial significance of literature and culture in any revolutionary politics. His fundamental contribution here was the development of a theory of mediations that could reveal the political and ideological content of what had hitherto seemed purely formal aesthetic phenomena. One of the most famous instances was his 'decoding' of the static descriptions of naturalism in terms of reification.[3] Yet at the same time, it was precisely this line of research – itself an implicit critique and repudiation of traditional content analysis – which was responsible for Brecht's characterization of Lukács's method as *formalistic*: by which he meant the latter's unwarranted confidence in the possibility of deducing political and ideological positions from a protocol of purely formal properties of a work of art. The reproach sprang from Brecht's experience as a man of the theatre, in which he constructed an aesthetic of performance and a view of the work of art in situation that was in diametric contrast to the solitary reading and individualized bourgeois public of Lukács's privileged object of study, the novel. Can Brecht then be enlisted in current campaigns against the very notion of mediation? It is probably best to take Brecht's attack on Lukács's formalism (along with the Brechtian watchword of *plumpes Denken*) at a somewhat less philosophical and more practical level, as a therapeutic warning against the permanent temptation of idealism present in any ideological analysis as such, the professional proclivity of intellectuals for methods that need no external verification. There would then be *two* idealisms: one the common-or-garden variety to be found in religion, metaphysics or literalism, the other a repressed and unconscious danger of idealism within Marxism itself, inherent in the very ideal of science itself in a world so deeply marked by the division of mental and manual labour. To that

danger the intellectual and the scientist can never sufficiently be alerted. At the same time, Lukács's work on mediation, rudimentary as at times it may have been, can on another reading be enlisted as a precursor of the most interesting work in the field of ideological analysis today – that which, assimilating the findings of psychoanalysis and of semiotics, seeks to construct a model of the text as a complex and symbolic ideological act. The reproach of 'formalism', whose relevance to Lukács's own practice is only too evident, may consequently have a wider extension to present-day research and speculation.

The charge of 'formalism' was only one item of Brecht's attack on Lukács's position; its corollary and obverse was indignation at the ideological judgements the latter used his method to substantiate. The primary exhibit at the time was Lukács's denunciation of alleged links between Expressionism and trends within social-democracy (in particular the USPD), not to speak of fascism, which launched the Realism debate in the German emigration and which Ernst Bloch's essay ['Discussing Expressionism', *Das Wort*, 1938, in *Aesthetics and Politics*, pp. 16-17] was designed to refute in some detail. Nothing has, of course, more effectively discredited Marxism than the practice of affixing instant class labels (generally 'petty bourgeois') to textual or intellectual objects; nor will the most hardened apologist for Lukács want to deny that of the many Lukácses conceivable, this particular one – epitomized in the shrill and outrageous postscript to *Die Zerstörung der Vernunft* – is the least worthy of rehabilitation. But abuse of class ascription should not lead to over-reaction and mere abandonment of it. In fact, ideological analysis is inconceivable without a conception of the 'ultimately determining instance' of social class. What is really wrong with Lukács's analyses is not too frequent and facile a reference to social class, but rather too incomplete and intermittent a sense of the relationship of class to ideology. A case in point is one of the more notorious of Lukács's basic concepts, that of 'decadence' – which he often associates with fascism, but even more persistently with modern art and literature in general. The concept of decadence is the equivalent in the aesthetic realm of that of 'false consciousness' in the domain of traditional ideological analysis. Both suffer from the same defect – the common presupposition that in the world of culture and society such a thing as pure error is possible. They imply, in other words, that works of art or systems of philosophy are conceivable which have no content, and are therefore to be denounced for failing to grapple with the 'serious' issues of the day, indeed distracting from them. In the iconography of the political art of the 1920s and 1930s, the 'index' of such culpable and vacuous decadence was the champagne glass and top hat of the idle rich, making the rounds of an eternal night-club circuit. Yet even Scott Fitzgerald and Drieu la Rochelle are more complicated than that, and from our present-day vantage point, disposing of the more complex instruments of psychoanalysis (in particular the concepts of repression and denial or *Verneinung*), even those who might wish to sustain Lukács's hostile verdict on modernism would necessarily insist on the existence of a repressed social content even in those modern works that seem

most innocent of it. Modernism would then not so much be a way of avoiding social content – in any case an impossibility for beings like ourselves who are 'condemned' to history and to the implacable sociability of even the most apparently private of our experiences – as rather of managing and containing it, secluding it out of sight in the very form itself, by means of specific techniques of framing and displacement which can be identified with some precision. If so, Lukács's summary dismissal of 'decadent' works of art should yield to an interrogation of their buried social and political content.

The fundamental weakness in Lukács's view of the relationship of art and ideology surely finds its ultimate explanation in his politics. What is usually called his 'Stalinism' can, on closer examination, be separated into two quite distinct problems. The charge that he was complicit with a bureaucratic apparatus and exercised a kind of literary terrorism (particularly against political modernists, for example, of the Proletkult variety), is belied by his resistance in the Moscow of the 1930s and 1940s to what was later to be known as Zhdanovism – that form of socialist realism which he disliked as much as Western modernism, but was obviously less free to attack openly. 'Naturalism' was his pejorative code-word for it at the time. Indeed, the structural and historical identification for which he argued between the symbolic techniques of modernism and the 'bad immediacy' of a photographic naturalism was one of his most profound dialectical insights. As for his continuing party membership, what he called his 'entry ticket to history', the tragic fate and wasted talents of so many oppositional Marxists of his generation, like Korsch or Reich, are powerful arguments for the relative rationality of Lukács's choice – one, of course, that he shared with Brecht. A more serious problem is posed by the 'popular frontism' of his aesthetic theory. That betokened a formal mean between a modernistic subjectivism and an overly objectivistic naturalism which, like most Aristotelian strategies of moderation, has never aroused much intellectual excitement. Even Lukács's most devoted supporters failed to evince much enthusiasm for it. So far as the political alliance between revolutionary forces and the progressive sections of the bourgeoisie went, it was rather Stalin who belatedly authorized a version of the policy that Lukács had advocated in the 'Blum Theses' of 1928-9, which foresaw a first-stage democratic revolution against the fascist dictatorship in Hungary, prior to any socialist revolution. Yet it is precisely that distinction, between an anti-fascist and an anti-capitalist strategy, that seems less easy to maintain today and less immediately attractive a political programme, over wide areas of a 'free world' in which military dictatorships and 'emergency regimes' are the order of the day – indeed multiplying precisely to the degree that genuine social revolution becomes a real possibility. From our present perspective, Nazism itself, with its charismatic leader and unique exploitation of a nascent communications technology in the widest sense of the term (including transportation and autobahns as well as radio and television), now seems to represent a transitional and special combination of historical circumstances not likely to recur as such; while routine torture and the institutionalization of counter-insurgency techniques have proved perfectly

consistent with the kind of parliamentary democracy that used to be distinguished from fascism. Under the hegemony of the multinational corporations and their 'world system', the very possibility of a progressive bourgeois culture is problematic – a doubt that obviously strikes at the very foundation of Lukács's aesthetic.

Finally, the preoccupations of our own period have seemed to reveal in Lukács's work the shadow of a literary dictatorship somewhat different in kind from the attempts to prescribe a certain type of production which were denounced by Brecht. It is Lukács as a partisan, less of a specific artistic style than of a particular critical method, who is the focus of new polemics today – an atmosphere in which his work has found itself regarded by admirers and opponents alike as a monument to old-fashioned content-analysis. There is some irony in this transformation of the name of the author of *History and Class Consciousness* into a signal not unlike that emitted by the names of Belinsky and Chernyshevsky in an earlier period of Marxist aesthetics. Lukács's own critical practice is in fact very much genre-oriented, and committed to the mediation of the various forms of literary discourse, so that it is a mistake to enlist him in the cause of a naïve mimetic position that encourages us to discuss the events or characters of a novel, in the same way we would look at 'real' ones. On the other hand, in so far as his critical practice implies the ultimate possibility of some full and non-problematical 'representation of reality', Lukácsian realism can be said to give aid and comfort to a documentary and sociological approach to literature which is correctly enough felt to be antagonistic to more recent methods of construing the narrative text as a freeplay of signifiers. Yet these apparently irreconcilable positions may prove to be two distinct and equally indispensable moments of the hermeneutic process itself – a first naïve 'belief' in the density or presence of novelistic representation, and a later 'bracketing' of that experience in which the necessary distance of all language from what it claims to represent – its substitutions and displacements – are explored. At any rate, it is clear that as long as Lukács is used as a rallying cry (or bogeyman) in this particular methodological conflict, there is not much likelihood of any measured assessment of his work as a whole.

Brecht, meanwhile, is certainly much more easily rewritten in terms of the concerns of the present, in which he seems to address us directly in an unmediated voice. His attack on Lukács's formalism is only one aspect of a much more complex and interesting stand on realism in general, to which it is surely no disservice to observe a few of the features which must seem dated to us today. In particular, Brecht's aesthetic, and his way of framing the problems of realism, are intimately bound up with a conception of science which it would be wrong to identify with the more scientistic currents in contemporary Marxism (for example the work of Althusser or Colletti). For the latter, science is an epistemological concept and a form of abstract knowledge, and the pursuit of a Marxian 'science' is closely linked to recent developments in the historiography of science – the findings of scholars like Koyré, Bachelard and Kuhn. For Brecht, however, 'science' is far less a

matter of knowledge and epistemology than it is of sheer experiment and of practical, well-nigh manual activity. His is more an ideal of popular mechanics, technology, the home chemical set and the tinkering of a Galileo, than one of 'epistemes' or 'paradigms' in scientific discourse. Brecht's particular vision of science was for him the means of annulling the separation between physical and mental activity and the fundamental division of labour (not least that between worker and intellectual) that resulted from it: it puts knowing the world back together with changing the world, and at the same time unites an ideal of praxis with a conception of production. The reunion of 'science' and practical, change-oriented activity – not without its influence on the Brecht–Benjamin analysis of the media, as we shall see in a moment – thus transforms the process of 'knowing' the world into a source of delight or pleasure in its own right; and this is the fundamental step in the construction of a properly Brechtian aesthetics. For it restores to 'realistic' art that principle of play and genuine aesthetic gratification which the relatively more passive and cognitive aesthetic of Lukács had seemed to replace with the grim duty of a proper reflection of the world. The age-old dilemmas of a didactic theory of art (to teach *or* to please?) are thereby also overcome, and in a world where science is experiment and play, knowing and doing alike are forms of production, stimulating in their own right, a didactic art may now be imagined in which learning and pleasure are no longer separate from each other. In the Brechtian aesthetic, indeed, the idea of realism is not a purely artistic and formal category, but rather governs the relationship of the work of art to reality itself, characterizing a particular stance towards it. The spirit of realism designates an active, curious, experimental, subversive – in a word, *scientific* – attitude towards social institutions and the material world; and the 'realistic' work of art is therefore one which encourages and disseminates this attitude, yet not merely in a flat or mimetic way or along the lines of imitation alone. Indeed, the 'realistic' work of art is one in which 'realistic' and experimental attitudes are tried out, not only between its characters and their fictive realities, but also between the audience and the work itself, and – not least significant – between the writer and his own materials and techniques. The threefold dimensions of such a practice of 'realism' clearly explode the purely representational categories of the traditional mimetic work.

What Brecht called science is thus in a larger sense a figure for non-alienated production in general. It is what Bloch would call a Utopian emblem of the reunified and satisfying praxis of a world that has left alienation and the division of labour behind it. The originality of the Brechtian vision may be judged by juxtaposing his figure of science with the more conventional image of art and the artist which, particularly in bourgeois literature, has traditionally had this Utopian function. At the same time, it must also be asked whether Brecht's vision of science is still available to us as a figure today, or whether it does not itself reflect a relatively primitive stage in what has now come to be known as the second industrial revolution. Seen in this perspective, the Brechtian delight in 'science' is rather of a piece with Lenin's definition of communism as 'the soviets plus electrification', or Diego

69

Rivera's grandiose Rockefeller Centre mural (repainted for Bellas Artes) in which, at the intersection of microcosm and macrocosm, the massive hands of Soviet New Man grasp and move the very levers of creation.

Together with his condemnation of Lukács's formalism and his conception of a union of science and aesthetics in the didactic work of art, there is yet a third strain in Brecht's thinking – in many ways the most influential – which deserves attention. This is, of course, his fundamental notion of *Verfremdung*. It is the so-called 'estrangement effect' which is most often invoked to sanction theories of political modernism today, such as that of the Tel Quel Group.[4] The practice of estrangement – staging phenomena in such a way that what had seemed natural and immutable in them is now tangibly revealed to be historical, and thus the object of revolutionary change – has long seemed to provide an outlet from the dead end of agitational didacticism in which so much of the political art of the past remains confined. At the same time it allows a triumphant reappropriation and a materialist re-grounding of the dominant ideology of modernism (the Russian Formalist 'making strange', Pound's 'make it new', the emphasis of all of the historical varieties of modernism on the vocation of art to alter and renew perception as such) from the ends of a revolutionary politics. Today, traditional realism – the canon defended by Lukács, but also old-fashioned political art of the socialist realist type – is often assimilated to classical ideologies of representation and to the practice of 'closed form'; while even bourgeois modernism (Kristeva's models are Lautréamont and Mallarmé) is said to be revolutionary precisely to the degree to which it calls the older formal values and practices into question and produces itself as an open 'text'. Whatever objections may be made to this aesthetic of political modernism – and we will reserve a fundamental one for our discussion of similar views of Adorno – it would seem most difficult to associate Brecht with it. Not only was the author of 'On Abstract Painting'[5] [see Text 9 where this is presented in an alternative translation] as hostile to purely formal experimentation as was Lukács himself: that might be held to be a historical or generational accident, and simply to spell out the limits of Brecht's personal tastes. What is more serious is that his attack on the formalism of Lukács's literary analyses remains binding on the quite different attempts of the political modernists to make ideological judgements (revolutionary/bourgeois) on the basis of the purely formal characteristics of closed or open forms, 'naturality', effacement of the traces of production in the work, and so forth. For example, it is certainly the case that a belief in the natural is ideological and that much of bourgeois art has worked to perpetuate such a belief, not only in its content but through the experience of its forms as well. Yet in different historical circumstances the idea of nature was once a subversive concept with a genuinely revolutionary function, and only the analysis of the concrete historical and cultural conjuncture can tell us whether, in the post-natural world of late capitalism, the categories of nature may not have acquired such a critical charge again.

It is time, indeed, to make an assessment of those fundamental changes which have taken place in capitalism and its culture since the period in which

Brecht and Lukács spelled out their options for a Marxist aesthetics and a Marxian conception of realism. What has already been said about the transitional character of Nazism – a development which has done much to date many of Lukács's basic positions – is not without its effect on those of Brecht as well. Here it is necessary to emphasize the inextricable relationship between Brecht's aesthetic and the analysis of the media and its revolutionary possibilities worked out jointly by him and Walter Benjamin, and most widely accessible in the latter's well-known essay on 'The Work of Art in the Age of Mechanical Reproduction'[6] [see Text 27]. For Brecht and Benjamin had not yet begun to feel the full force and constriction of that stark alternative between a mass audience or media culture, and a minority 'élite' modernism, in which our thinking about aesthetics today is inevitably locked. Rather, they foresaw a revolutionary utilization of communications technology such that the most striking advances in artistic technique – effects such as those of 'montage', for instance, which today we tend to associate almost exclusively with modernism as such – could at once be harnessed to politicizing and didactic purposes. Brecht's conception of 'realism' is thus not complete without this perspective in which the artist is able to use the most complex, modern technology in addressing the widest popular public. Yet if Nazism itself corresponds to an early and still relatively primitive stage in the emergence of the media, then so does Benjamin's cultural strategy for attacking it, and in particular his conception of an art that would be revolutionary precisely to the degree to which it was technically (and technologically) 'advanced'. In the increasingly 'total system' of the media societies today, we can unfortunately no longer share this optimism. Without it, however, the project of a specifically political modernism becomes indistinguishable from all the other kinds – modernism, among other things, being characterized by its consciousness of an absent public.

In other words the fundamental difference between our own situation and that of the thirties is the emergence in full-blown and definitive form of that ultimate transformation of late monopoly capitalism variously known as the *société de consommation* or as post-industrial society. This is the historical stage reflected by Adorno's two post-war essays [see Texts 8b and 8c], so different in emphasis from the pre-war [debates]. It may appear easy enough in retrospect to identify his repudiation of *both* Lukács *and* Brecht, on the grounds of their political praxis, as a characteristic example of an anti-communism now outmoded with the Cold War itself. More relevant in the present context, however, is the Frankfurt School's premise of a 'total system', which expressed Adorno's and Horkheimer's sense of the increasingly closed organization of the world into a seamless web of media technology, multinational corporations, and international bureaucratic control.[7] Whatever the theoretical merits of the idea of the 'total system' – and it would seem to me that where it does not lead out of politics altogether, it encourages the revival of an anarchist opposition to Marxism itself, and can also be used as a justification for terrorism – we may at least agree with Adorno that in the cultural realm, the all-pervasiveness of the system, with its 'culture-' or

(Enzensberger's variant) its 'consciousness-industry', makes for an unpropitious climate for any of the older, simpler forms of oppositional art, whether it be that proposed by Lukács, that produced by Brecht, or indeed those celebrated in their different ways by Benjamin and by Bloch. The system has a power to co-opt and to defuse even the most potentially dangerous forms of political art by transforming them into cultural commodities (witness, if further proof be needed, the grisly example of the burgeoning Brecht-Industrie itself!). On the other hand, it cannot be said that Adorno's rather astonishing 'resolution' of the problem – his proposal to see the classical stage of high modernism itself as the very prototype of the most 'genuinely' political art ('this is not a time for political art, but politics has migrated into autonomous art, and nowhere more so than where it seems to be politically dead' [see Text 8c]) and his suggestion that it is Beckett who is the most truly revolutionary artist of our time – is any more satisfactory. To be sure, some of Adorno's most remarkable analyses – for instance, his discussion of Schoenberg and the twelve-tone system in the *Philosophy of Modern Music* – document his assertion that the greatest modern art, even the most apparently un- or anti-political, in reality holds up a mirror to the 'total system' of late capitalism. Yet in retrospect, this now seems a most unexpected revival of a Lukács-type 'reflection theory' of aesthetics, under the spell of a political and historical despair that plagues both houses and finds praxis henceforth unimaginable. What is ultimately fatal to this new and finally itself once more anti-political revival of the ideology of modernism is less the equivocal rhetoric of Adorno's attack on Lukács or the partiality of his reading of Brecht,[8] than very precisely the fate of modernism in consumer society itself. For what was once an oppositional and anti-social phenomenon in the early years of the century, has today become the dominant style of commodity production and an indispensable component in the machinery of the latter's ever more rapid and demanding reproduction of itself. That Schoenberg's Hollywood pupils used their advanced techniques to write movie music, that the masterpieces of the most recent schools of American painting are now sought to embellish the splendid new structures of the great insurance companies and multinational banks [see Texts 10 and 25](themselves the work of the most talented and 'advanced' modern architects), are but the external symptoms of a situation in which a once scandalous 'perceptual art' has found a social and economic function in supplying the styling changes necessary to the *société de consommation* of the present. [...]

Notes

1 See Werner Mittenzwei, 'Die Brecht-Lukács Debatte', *Das Argument*, 46, March 1968; Eugene Lunn, 'Marxism and Art in the Era of Stalin and Hitler: A Comparison of Brecht and Lukács', *New German Critique*, 3 Fall, 1974, pp. 12-44; and, for the somewhat earlier period of the review *Die Linskskurve* (1928-1932), Helga Gallas, *Marxistische Literaturtheorie-Kontroversen im Bund proletarisch-revolutionärer Schriftsteller*, Neuwied, 1971.
2 See Lunn, op. cit., pp. 16-18.
3 See in particular 'Narrate or Describe?' in Georg Lukács, *Writer and Critic*, London, 1970.
4 For a persuasive yet self-critical statement of such a Brechtian modernism, see Colin

McCabe, 'Realism and the Cinema: notes on some Brechtian theses', *Screen*, vol. 15, no. 2, Summer 1974, pp. 7-27.

5 'You say that you are communists, people intent on changing a world no longer fit for habitation ... Yet were you in reality the cultural servants of the ruling classes, it would be cunning strategy on your part to make material things unrecognizable, since the struggle concerns things and it is in the world of things that your masters have the most to answer for.' Über gegenstandslose Malerei', in *Schriften zur Literatur und Kunst*, II, Frankfurt, 1967, pp. 68-9 [see Text 9, alternative translation].

6 See *Illuminations*, London, 1970 [see Text 27]; also 'The Author as Producer', in *Understanding Brecht*, London, 1973; and for further developments in a radical theory of the media, Jürgen Habermas, *Strukturwandel der Öffentlichkeit*, Neuwied, 1962; Hans-Magnus Enzensberger, *The Consciousness Industry*, New York, 1974; and Oskar Negt and Alexander Kluge, *Öffentlichkeit und Erfahrung*, Frankfurt, 1973.

7 The more recent French variant on this position – as for example in Jean Baudrillard – enlarges the model to include the 'socialist bloc' within this new dystopian entente.

8 For a path-breaking Marxian corrective to Adorno's reading of the *Caucasian Chalk Circle*, see Darko Suvin, 'Brecht's *Caucasian Chalk Circle* and Marxist Figuration: Open Dramaturgy as Open History', in Norman Rudick, ed., *The Weapons of Criticism*, Palo Alto, California, 1976.

8 **Theodor Adorno**
Art, Autonomy and Mass Culture

Source: Theodor Adorno, three extracts as follows: (a) 'Letter to Walter Benjamin' on the latter's 'The Work of Art in the Age of Mechanical Reproduction' [See Text 27], 18 March 1936, translated by Harry Zohn, in *Aesthetics and Politics*, London, New Left Books, 1977, pp. 120-6 (this extract from pp. 122-3). First published in Adorno, *Über Walter Benjamin*, Frankfurt, Suhrkamp Verlag, 1970; (b) 'Reconciliation under Duress', translated by Rodney Livingstone, in *Aesthetics and Politics*, pp. 151-76 (this extract from pp. 162-4). First published in *Der Monat*, 1958/9 (a journal created by the US army in West Germany and financed by the CIA), as a review of Georg Lukacs's *The Meaning of Contemporary Realism*, published in West Germany, Classen Verlag, 1958 (English translation, London, Merlin Press, 1962); (c) 'Commitment', translated by Francis McDonagh, in *Aesthetics and Politics*, pp. 177-95 (this extract from pp. 193-5). First published in *Die Neue Rundschau*, 1962, as a critique of Sartre (his *What is Literature?* appeared in German translation in 1962) and especially of Brecht. These texts have been edited and footnotes renumbered accordingly.

a Letter to Walter Benjamin

[...] If you defend the *kitsch* film against the 'quality' film, no one can be more in agreement with you than I am; but *l'art pour l'art* is just as much in need of a defence, and the united front which exists against it and which to my knowledge extends from Brecht to the Youth Movement, would be encouragement enough to undertake a rescue. [...]

Understand me correctly. I would not want to claim the autonomy of the work of art as a prerogative, and I agree with you that the aural element of the work of art is declining – not only because of its technical reproducibility, incidentally, but above all because of the fulfilment of its own 'autonomous' formal laws (this is the subject of the theory of musical reproduction which Kolisch and I have been planning for years). But the autonomy of the work of art, and therefore its material form, is not identical with the magical element in it. The reification of a great work of art is not just loss, any more than the reification of the cinema is all loss. It would be bourgeois reaction to negate the reification of the cinema in the name of the ego, and it would border on anarchism to revoke the reification of a great work of art in the spirit of immediate use-values. '*Les extrèmes me touchent*' [Gide], just as they touch you – but only if the dialectic of the lowest has the same value as the dialectic of the highest, rather than the latter simply decaying. Both bear

the stigmata of capitalism, both contain elements of change (but never, of course, the middle term between Schoenberg and the American film). Both are torn halves of an integral freedom, to which, however, they do not add up. It would be romantic to sacrifice one to the other, either as the bourgeois romanticism of the conservation of personality and all that stuff, or as the anarchistic romanticism of blind confidence in the spontaneous power of the proletariat in the historical process – a proletariat which is itself a product of bourgeois society.

To a certain extent I must accuse your essay of this second romanticism. You have swept art out of the corners of its taboos – but it is as though you feared a consequent inrush of barbarism (who could share your fear more than I?) and protected yourself by raising what you fear to a kind of inverse taboo. The laughter of the audience at a cinema [...] is anything but good and revolutionary; instead, it is full of the worst bourgeois sadism. I very much doubt the expertise of the newspaper boys who discuss sports; and despite its shock-like seduction I do not find your theory of distraction convincing – if only for the simple reason that in a communist society work will be organized in such a way that people will no longer be so tired and so stultified that they need distraction. On the other hand, certain concepts of capitalist practice, like that of the test, seem to me almost ontologically congealed and taboo-like in function – whereas if anything does have an aural character, it is surely the film which possesses it to an extreme and highly suspect degree. To select only one more small item: the idea that a reactionary is turned into a member of the avant-garde by expert knowledge of Chaplin's films strikes me as out-and-out romanticization. [...]

b Reconciliation under Duress

[...] Even in Beckett – and perhaps in him above all – where seemingly all concrete historical components have been eliminated, and only primitive situations and forms of behaviour are tolerated, the unhistorical façade is the provocative opposite of the absolute Being idolized by reactionary philosophies. The primitivism with which his works begin so abruptly represents the final phase of a regression, especially obvious in *Fin de Partie* [End Game], in which, as from the far-distant realm of the self-evident, a terrestrial catastrophe is presupposed. His primitive men are the last men. One theme we discover in his works is something which Horkheimer and I have already discussed in *Dialectic of Enlightenment*: the fact that a society wholly in the grip of the Culture Industry displays all the reactions of an amphibian. The substantive content of a work of art can survive in the precise, wordless polemic which depicts the dawn of a nonsensical world; and it can vanish again as soon as it is positively asserted, as soon as existence is claimed for it, a fate similar to the one that befalls the didactic antithesis between a right and a wrong mode of life to be found in Tolstoy after *Anna Karenina*.

Lukács's favourite old idea of an 'immanent meaning' points towards that

same dubious faith in the face value of things which his own theory sets out to destroy. Conceptions like Beckett's, however, have an objective, polemical thrust. Lukács twists them into 'the straightforward portrayal of the pathological, of the perverse, of idiocy, all of which are seen as types of the 'condition humaine'' ([*The Meaning of Contemporary Realism*, 1958, English edition, London, 1962], p. 32) – and in this he follows the example of the film censor who regards the content as a defect of the treatment. Above all, Lukács's confusion of Beckett with the cult of Being [...] exposes his inability to see what is in front of him. This blindness arises from his stubborn refusal to acknowledge the central claims of literary technique. He sticks imperturbably to what is narrated. But in literature the point of the subject-matter can only be made effective by the use of techniques – something which Lukács himself hopes for from the more than suspect concept of 'perspective'. One would like to ask what would be left of Greek drama, which Lukács, like Hegel, has duly canonized, if the criterion of its value were the story which could be picked up in the street. The same holds good for the traditional novel and even for writers such as Flaubert who come into Lukács's category of the 'realist' novel: here too composition and style are fundamental.

Today, when empirical veracity has sunk to the level of superficial reportage, the relevance of technique has increased enormously. By structuring his work, the writer can hope to master the arbitrary and the individual against which Lukács so passionately inveighs. He fails to follow the insight contained in his last chapter to its logical conclusion: the purely arbitrary cannot be overcome simply by a determination to look at things in what purports to be a more objective manner. Lukács ought surely to be familiar with the key importance of the technical forces of production in history. No doubt this was more concerned with material than with cultural production. But can he really close his eyes to the fact that the techniques of art also develop in accordance with their own logic? Can he rest content with the abstract assertion that when society changes, completely different aesthetic criteria automatically come into force? Can he really persuade himself that this justifies him in nullifying the technical advance of the forces of production and providing for the canonical restoration of older, outdated forms? Does he not simply don the dictatorial mantle of socialist realism in order to expound an immutable doctrine which differs from the one he rightly repudiates only by its greater insensitivity?

Lukács places himself in the great philosophical tradition that conceives of art as knowledge which has assumed concrete shape, rather than as something irrational to be contrasted with science. This is perfectly legitimate, but he still finds himself ensnared in the same cult of immediacy of which he myopically accuses modernist literature: the fallacy of mere assertion. Art does not provide knowledge of reality by reflecting it photographically or 'from a particular perspective' but by revealing whatever is veiled by the empirical form assumed by reality, and this is possible only by virtue of art's own autonomous status. Even the suggestion that the world is unknowable, which

Lukács so indefatigably castigates in writers like Eliot or Joyce, can become a moment of knowledge. This can happen where a gulf opens up between the overwhelming and unassimilable world of things, on the one hand, and a human experience impotently striving to gain a firm hold on it, on the other.

Lukács over-simplifies the dialectical unity of art and science, reducing it to bare identity, just as if works of art did nothing but apply their perspective in such a way as to anticipate some of the insights that the social sciences subsequently confirm. The essential distinction between artistic and scientific knowledge, however, is that in art nothing empirical survives unchanged; the empirical facts only acquire objective meaning when they are completely fused with the subjective intention. Even though Lukács draws a line between Realism and Naturalism, he nevertheless fails to make it clear that, if the distinction is to hold good, realist writing must necessarily achieve that synthesis with the subjective intentions which he would like to see expelled from Realism. In fact there is no way of preserving the antithesis between realist and 'formalist' approaches which, like an inquisitor, he erects into an absolute standard. On the one hand, it turns out that the principles of form which Lukács anathematizes as unrealistic and idealistic, have an objective aesthetic function; on the other, it becomes no less obvious that the novels of the early nineteenth century, e.g. those of Dickens and Balzac, which he holds in such high esteem, and which he does not scruple to hold up as paradigms of the novelist's art, are by no means as realistic as all that. It is true that Marx and Engels might have considered them so in their polemic against the marketable romantic literature so fashionable in their day. Today, however, we not only see romantic and archaic, pre-bourgeois elements in both novelists, but even worse, Balzac's entire *Comédie Humaine* stands revealed as an imaginative reconstruction of the alienated world, i.e. of a reality no longer experienced by the individual subject. Seen in this light, the difference between it and the modernist victims of Lukács's class-justice is not very great; it is just that Balzac, in tune with his whole conception of form, thought of his monologues in terms of the plenitude of real life, while the great novelists of the twentieth century encapsulate their worldly plenitude within the monologue.

This shatters Lukács's approach to its foundations. His concept of 'perspective' sinks inexorably to the level of what he strives in vain to distinguish it from in the last chapter of his book, namely an element of tendentiousness or, to use his own word, 'agitation', imposed from without. His whole position is paradoxical. He cannot escape the awareness that, aesthetically, social truth thrives only in works of art autonomously created. But in the concrete works of modern times this autonomy is accompanied by all those things which have been proscribed by the prevailing communist doctrine and which he neither could, nor can, tolerate. His hope was that obsolete and unsatisfactory aesthetic techniques might be legitimated if they could achieve a different standing in a different social system, i.e. that they might be justified from outside, from a point beyond their own internal logic. But this hope is pure superstition. It is not good enough for Lukács simply to dismiss the fact

that the very products of socialist realism that have claimed to represent an advanced state of consciousness, in fact do no more than serve up the crumbling and insipid residues of bourgeois artforms. This is a fact which stands in need of an objective explanation. Socialist realism did not simply have its origins, as communist theologians would like to believe, in a socially healthy and sound world; it was equally the product of the backwardness of consciousness and of the social forces of production. The only use they make of the thesis of the qualitative rupture between socialism and the bourgeoisie is to falsify that backwardness, which it has long been forbidden to mention, and twist it into something more progressive. [...]

c Commitment

[...] Today the curmudgeons whom no bombs could shake out of their complacency have allied themselves with the philistines who rage against the alleged incomprehensibility of the new art. The underlying impulse of these attacks is petty-bourgeois hatred of sex, the common ground of Western moralists and ideologists of socialist realism. No moral terror can prevent the side the work of art shows its beholder from giving him pleasure, even if only in the formal fact of temporary freedom from the compulsion of practical goals. Thomas Mann called this quality of art 'high spirits', a notion intolerable to people with morals. Brecht himself, who was not without ascetic traits – which reappear transmuted in the resistance of any great autonomous art to consumption – rightly ridiculed culinary art; but he was much too intelligent not to know that pleasure can never be completely ignored in the total aesthetic effect, no matter how relentless the work. The primacy of the aesthetic object as pure refiguration does not smuggle consumption, and thus false harmony, in again through the back door. Although the moment of pleasure, even when it is extirpated from the effect of a work, constantly returns to it, the principle that governs autonomous works of art is not the totality of their effects but their own inherent structure. They are knowledge as non-conceptual objects. This is the source of their nobility. It is not something of which they have to persuade men, because it has been given into their hands. This is why today autonomous rather than committed art should be encouraged in Germany. Committed works all too readily credit themselves with every noble value, and then manipulate them at their ease. Under fascism too, no atrocity was perpetrated without a moral veneer. Those who trumpet their ethics and humanity in Germany today are merely waiting for a chance to persecute those whom their rules condemn, and to exercise the same inhumanity in practice of which they accuse modern art in theory. In Germany, commitment often means bleating what everyone is already saying or at least secretly wants to hear. The notion of a 'message' in art, even when politically radical, already contains an accommodation to the world: the stance of the lecturer conceals a clandestine entente with the listeners, who could only be rescued from deception by refusing it.

The type of literature that, in accordance with the tenets of commitment but also with the demands of philistine moralism, exists for man, betrays him by traducing that which could help him, if only it did not strike a pose of helping him. But any literature which therefore concludes that it can be a law unto itself, and exist only for itself, degenerates into ideology no less. Art, which even in its opposition to society remains a part of it, must close its eyes and ears against it: it cannot escape the shadow of irrationality. But when it appeals to this unreason, making it a *raison d'être*, it converts its own malediction into a theodicy. Even in the most sublimated work of art there is a hidden 'it should be otherwise'. When a work is merely itself and no other thing, as in a pure pseudo-scientific construction, it becomes bad art – literally pre-artistic. The moment of true volition, however, is mediated through nothing other than the form of the work itself, whose crystallization becomes an analogy of that other condition which should be. As eminently constructed and produced objects, works of art, including literary ones, point to a practice from which they abstain: the creation of a just life. This mediation is not a compromise between commitment and autonomy, nor a sort of mixture of advanced formal elements with an intellectual content inspired by genuinely or supposedly progressive politics. The content of works of art is never the amount of intellect pumped into them: if anything, it is the opposite.

Nevertheless, an emphasis on autonomous works is itself sociopolitical in nature. The feigning of a true politics here and now, the freezing of historical relations which nowhere seem ready to melt, oblige the mind to go where it need not degrade itself. Today every phenomenon of culture, even if a model of integrity, is liable to be suffocated in the cultivation of kitsch. Yet paradoxically in the same epoch it is to works of art that has fallen the burden of wordlessly asserting what is barred to politics. Sartre himself has expressed this truth in a passage which does credit to his honesty.[1] This is not a time for political art, but politics has migrated into autonomous art, and nowhere more so than where it seems to be politically dead. An example is Kafka's allegory of toy guns, in which an idea of non-violence is fused with a dawning awareness of the approaching paralysis of politics. Paul Klee too has a place in any debate about committed and autonomous art; for his work, *écriture par excellence*, had its roots in literature and would not have been what it was without them – or if it had not consumed them. During the First World War or shortly after, Klee drew cartoons of Kaiser Wilhelm as an inhuman iron-eater. Later, in 1920, these became – the development can be shown quite clearly – the *Angelus Novus*, the angel of the machine, who, though he no longer bears any emblem of caricature or commitment, flies far beyond both. The machine angel's enigmatic eyes force the onlooker to try to decide whether he is announcing the culmination of disaster or salvation hidden within it. But, as Walter Benjamin, who owned the drawing, said, he is the angel who does not give, but takes.

Notes

1 See Jean-Paul Sartre, *L'Existentialisme est un Humanisme*, Paris, 1946, p. 105.

Bertolt Brecht
On Non-Objective Painting

Source: Bertolt Brecht, 'On Non-Objective Painting', translated by Berel Lang, in Berel Lang and Forrest Williams (eds.), *Marxism and Art: Writings in Aesthetics and Criticism*, New York and London, Longman, 1972, pp. 423-5. Taken from Brecht's Notebooks, 1935-39, published in Volume II of *Schriften zur Literatur und Kunst*, Frankfurt, Suhrkamp Verlag, 1967.

I see that you have removed the motifs from your paintings. No recognizable objects appear there any more. You reproduce the sweeping curve of a chair – not the chair; the red of the sky, not the burning house. You reproduce the combination of lines and colours, not the combination of things. I must say that I wonder about it, and especially because you say that you are communists, going out to reconstruct a world which is not habitable. If you were not communists but subject spirits of the ruling classes, I would not wonder about your painting. It would seem to me then not inappropriate, even logical. Because things as they now are (people are among them, too) arouse for the most part feelings of repugnance – mixed with thoughts that criticism applies to them which would have them other than they are. Painting, reproducing them as recognizable, would fall into this conflict of feelings and thoughts; and if you were subject spirits of the Establishment, it would be cunning of you to make things unrecognizable, since it is things after all which are vexing, and since your patrons would be blamed for it. If you were subject spirits of the Establishment, you would do well to fulfil the wish of your patrons by representations rather opaque, general, uncommitted. It is the ruling classes who enjoy hearing such expressions as: 'One must enjoy one's work, irrespective of what it accomplishes, of how it is to be done, or why' or: 'One can enjoy a forest, even if one doesn't own it.' It is only those who are ruled who cannot enjoy themselves even in the most beautiful landscapes, if, as road workers, they have to pound stones into it – and among whom such strong emotions as love are lost if their living conditions are too bad. As painters and subject spirits of the Establishment, you could proclaim that the most beautiful and important perceptions are composed of lines and colours (so that anyone can enjoy them, even the most costly things, since lines and colours can be obtained *gratis*). And as court painters, you could drag all objects out of the world of perception, everything that is of value, all needs, anything substantial. You would require as painters for the ruling classes no specific perceptions, like anger in the face of injustice, or desire for certain things which are wanting, no perceptions bound to knowledge which call up other perceptions of a changing world – but just quite general, vague, unidentifiable perceptions, available to everyone, to the thieves and to their

victims, to the oppressors and to the oppressed. You paint, for example, an indeterminate red; and some cry at the sight of this indeterminate red because they think of a rose, and others, because they think of a child lacerated by bombs and streaming with blood. Your task is then completed: you have composed a perceptual object of lines and colours. It is clear that motifs, recognizable objects in painting, must, in our world of class conflict, redeem the most diverse perceptions. If the profiteer laughs, the man from whom he made the profit cries. The poor man who lacks a kitchen chair does not lack colour and form. The wealthy man who has a beautiful old chair does not regard it as something to sit on, but as form and colour. We Communists see things differently than do the profiteers and their lackeys. The difference in our seeing validates things; it is concerned with things not with eyes. If we wish to teach that things should be seen differently, we must teach it to the things. And we want not only that things should simply be seen 'differently', but that they should be seen in a certain way; not just differently from every other way, but correctly – that is, as fits the thing. We want to master things in politics and in art; we do not wish simply to 'master'. Assume that someone comes up and says, 'I am mastering'. Would not everyone ask, 'What?' I hear you say: 'With our tubes of oils and our pencils, we can only reproduce the colours and lines of the things, nothing more.' This sounds as if you were modest men, honest men, without pretences. But it sounds better than it is. A thousand examples prove that one can say more about things with tubes of oils and pencils, that one can communicate and expound more than simple solids with lines and colours. Brueghel, too, had only tubes of oil and pencils; he, too, reproduced the colours and lines of things – but not only that. The perceptual objects which he composes emerge from his relations to the objects which he reproduces; it is specific objects of perception which may alter the relation of the viewer of his paintings to the objects represented in them. Nor should you say: 'There is much good in art which is not understood in its own time.' It doesn't follow from this that something must be good *if* it is not understood in its own time. You would be better to show in your paintings how man in our times has been a wolf to other men, and to say then: 'This will not be bought in our time.' Because only the wolves have money to buy paintings in our times. But it will not always be this way; and our paintings will contribute to seeing that it will not be.

81

Eva Cockcroft
Abstract Expressionism,
Weapon of the Cold War

Source: Eva Cockcroft, 'Abstract Expressionism, Weapon of the Cold War', *Artforum*, vol. 15, no. 10, June 1974, pp. 39-41. One plate has been omitted.

To understand why a particular art movement becomes successful under a given set of historical circumstances requires an examination of the specifics of patronage and the ideological needs of the powerful. During the Renaissance and earlier, patronage of the arts went hand in hand with official power. Art and artists occupied a clearly defined place in the social structure and served specific functions in society. After the Industrial Revolution, with the decline of the academies, development of the gallery system, and rise of the museums, the role of artists became less clearly defined, and the objects artists fashioned increasingly became part of a general flow of commodities in a market economy. Artists, no longer having direct contact with the patrons of the arts, retained little or no control over the disposition of their works.

In rejecting the materialistic values of bourgeois society and indulging in the myth that they could exist entirely outside the dominant culture in bohemian enclaves, avant-garde artists generally refused to recognize or accept their role as producers of a cultural commodity. As a result, especially in the United States, many artists abdicated responsibility both to their own economic interests and to the uses to which their artwork was put after it entered the marketplace.

Museums, for their part, enlarged their role to become more than mere repositories of past art, and began to exhibit and collect contemporary art. Particularly in the United States, museums became a dominant force on the art scene. In many ways, American museums came to fulfil the role of official patronage – but without accountability to anyone but themselves. The United States museum, unlike its European counterpart, developed primarily as a private institution. Founded and supported by the giants of industry and finance, American museums were set up on the model of their corporate parents. To this day they are governed largely by self-perpetuating boards of trustees composed primarily of rich donors. It is these boards of trustees – often the same 'prominent citizens' who control banks and corporations and help shape the formulation of foreign policy – which ultimately determine museum policy, hire and fire directors, and to which the professional staff is held accountable. Examination of the rising success of Abstract Expressionism in America after the Second World War, therefore, entails

consideration of the role of the leading museum of contemporary art – The Museum of Modern Art (MOMA) – and the ideological needs of its officers during a period of virulent anti-communism and an intensifying 'cold war'.

In an article entitled 'American Painting During the Cold War', published in the May 1973 issue of *Artforum*, Max Kozloff pointed out the similarity between 'American cold war rhetoric' and the way many Abstract Expressionist artists phrased their existentialist-individualist credos. However, Kozloff failed to examine the full import of this seminal insight, claiming instead that 'this was a coincidence that must surely have gone unnoticed by rulers and ruled alike'. Not so.

Links between cultural cold war politics and the success of Abstract Expressionism are by no means coincidental, or unnoticeable. They were consciously forged at the time by some of the most influential figures controlling museum policies and advocating enlightened cold war tactics designed to woo European intellectuals.

The political relationships between Abstract Expressionism and the cold war can be clearly perceived through the international programmes of MOMA. As a tastemaker in the sphere of contemporary American art, the impact of MOMA – a major supporter of the Abstract Expressionist movement – can hardly be overestimated. In this context, the fact that MOMA has always been a Rockefeller-dominated institution becomes particularly relevant (other families financing the museum, although to a lesser extent than the Rockefellers, include the Whitneys, Paleys, Blisses, Warburgs and Lewisohns).

MOMA was founded in 1929, mainly through the efforts of Mrs John D. Rockefeller, Jr. In 1939, Nelson Rockefeller became president of MOMA. Although Nelson vacated the MOMA presidency in 1940 to become President Roosevelt's co-ordinator of the Office of Inter-American Affairs and later Assistant Secretary of State for Latin American Affairs, he dominated the museum throughout the 1940s and 1950s, returning to MOMA's presidency in 1946. In the 1960s and 1970s, David Rockefeller and Mrs John D. Rockefeller, 3rd, assumed the responsibility of the museum for the family. At the same time, almost every secretary of state after the end of the Second World War, right up to the present, has been an individual trained and groomed by the various foundations and agencies controlled or managed by the Rockefellers. The development of American cold war politics was directly shaped by the Rockefellers in particular and by expanding corporations and banks in general (David Rockefeller is also chairman of the board of Chase Manhattan Bank, the financial centre of the Rockefeller dynasty).

The involvement of The Museum of Modern Art in American foreign policy became unmistakably clear during the Second World War. In June, 1941, a Central Press wire story claimed MOMA as the 'latest and strangest recruit in Uncle Sam's defense line-up'. The story quoted the Chairman of the Museum's Board of Trustees, John Hay Whitney, on how the Museum could serve as a weapon for national defence to 'educate, inspire and strengthen the hearts and wills of free men in defense of their own freedom'.[1]

Whitney spent the war years working for the Office of Strategic Services (OSS, predecessor of CIA), as did many another notable cold warrior (e.g. Walt Whitman Rostow). In 1967, Whitney's charity trust was exposed as a CIA conduit (*New York Times*, 25 February 1967). Throughout the early 1940s MOMA engaged in a number of war-related programmes which set the pattern for its later activities as a key institution in the cold war.

Primarily, MOMA became a minor war contractor, fulfilling 38 contracts for cultural materials totalling $1,590,234 for the Library of Congress, the Office of War Information, and especially Nelson Rockefeller's Office of the Co-ordinator of Inter-American Affairs. For Nelson's Inter-American Affairs Office, 'mother's museum' put together 19 exhibitions of contemporary American painting which were shipped around Latin America, an area in which Nelson Rockefeller had developed his most lucrative investments – e.g. Creole Petroleum, a subsidiary of Standard Oil of New Jersey, and the single most important economic interest in oil-rich Venezuela.

After the war, staff from the Inter-American Affairs Office were transferred to MOMA's foreign activities. René d'Harnoncourt, who had proven himself an expert in the organization and installation of art exhibits when he helped American Ambassador Dwight Morrow cultivate the Mexican muralists at the time Mexico's oil nationalism threatened Rockefeller oil interests, was appointed head of the art section of Nelson's Office of Inter-American Affairs in 1943. A year later, he was brought to MOMA as vice-president in charge of foreign activities. In 1949, d'Harnoncourt became MOMA's director. The man who was to direct MOMA's international programmes in the 1950s, Porter A. McCray, also worked in the Office of Inter-American Affairs during the war.

McCray is a particularly powerful and effective man in the history of cultural imperialism. He was trained as an architect at Yale University and introduced to the Rockefeller orbit through Rockefeller's architect Wallace Harrison. After the war Nelson Rockefeller brought McCray into MOMA as director of circulating exhibits. From 1946 to 1949, while the Museum was without a director, McCray served as a member of MOMA's co-ordinating committee. In 1951, McCray took a year's leave of absence from the Museum to work for the exhibitions section of the Marshall Plan in Paris. In 1952, when MOMA's international programme was launched with a five-year grant of $625,000 from the Rockefeller Brothers Fund, McCray became its director. He continued in that job, going on to head the programme's expanded version, the International Council of MOMA (1956), during some of the most crucial years of the cold war. According to Russell Lynes, in his comprehensive new book *Good Old Modern: An Intimate Portrait of the Museum of Modern Art*, the purpose of MOMA's international programme was overtly political: 'to let it be known especially in Europe that America was not the cultural backwater that the Russians, during that tense period called "the cold war", were trying to demonstrate that it was.'

MOMA's international programme, under McCray's directorship, provided exhibitions of contemporary American art – primarily the Abstract

Expressionists – for international exhibitions in London, Paris, São Paulo, and Tokyo (it also brought foreign shows to the United States). It assumed a quasi-official character, providing the 'United States representation' in shows where most nations were represented by government-sponsored exhibits. The United States Government's difficulties in handling the delicate issues of free speech and free artistic expression, generated by the McCarthyist hysteria of the early 1950s, made it necessary and convenient for MOMA to assume this role of international representation for the United States. For example, the State Department refused to take responsibility for the United States representation at the Venice Biennale, perhaps the most important of international-cultural-political art events, where all the European countries including the Soviet Union competed for cultural honours. MOMA bought the United States pavilion in Venice and took sole responsibility for the exhibitions from 1954 to 1962. This was the only case of a privately owned (instead of government-owned) pavilion at the Venice Biennale.

The CIA, primarily through the activities of Thomas W. Braden, also was active in the cold-war cultural offensive. Braden, in fact, represents once again the important role of MOMA in the cold war. Before joining the CIA in 1950 to supervise its cultural activities from 1951 to 1954, Braden had been MOMA's executive secretary from April 1948 to November 1949. In defence of his political cultural activities, Braden published an article – 'I'm Glad the CIA is "Immoral"', in the 20 May, 1967 issue of *Saturday Evening Post*. According to Braden, enlightened members of the governmental bureaucracy recognized in the 1950s that 'dissenting opinions within the framework of agreement on cold-war fundamentals' could be an effective propaganda weapon abroad. However, rabid anti-communists in Congress and the nation as a whole made official sponsorship of many cultural projects impracticable. In Braden's words, '... the idea that Congress would have approved of many of our projects was about as likely as the John Birch Society's approving medicare.' As the 1967 exposés revealed, the CIA funded a host of cultural programmes and intellectual endeavours, from the National Student Association (NSA) to *Encounter* magazine and innumerable lesser-known 'liberal and socialist' fronts.

In the cultural field, for example, CIA went so far as to fund a Paris tour of the Boston Symphony Orchestra in 1952. This was done, according to Braden, to avoid the severe security restrictions imposed by the United States Congress, which would have required security clearance for every last musician in order to procure official funds for the tour. 'Does anyone think that congressmen would foster a foreign tour by an artist who has or had left-wing connections?' Braden asked in his article to explain the need for CIA funding. The money was well spent, Braden asserted, because 'the Boston Symphony Orchestra won more acclaim for the United States in Paris than John Foster Dulles or Dwight D. Eisenhower could have brought with a hundred speeches.' As this example suggests, CIA's purposes in supporting international intellectual and cultural activities were not limited to espionage or establishing contact with leading foreign intellectuals. More crucially, CIA

sought to influence the foreign intellectual community and to present a strong propaganda image of the United States as a 'free' society as opposed to the 'regimented' communist bloc.

The functions of both the CIA's undercover aid operations and MOMA's international programmes were similar. Freed from the kinds of pressure of unsubtle red-baiting and super-jingoism applied to official governmental agencies like the United States Information Agency (USIA), CIA and MOMA cultural projects could provide the well-funded and more persuasive arguments and exhibitions needed to sell the rest of the world on the benefits of life and art under capitalism.

In the world of art, Abstract Expressionism constituted the ideal style for these propaganda activities. It was the perfect contrast to 'the regimented, traditional, and narrow' nature of 'socialist realism'. It was new, fresh, and creative. Artistically avant-garde and original, Abstract Expressionism could show the United States as culturally up-to-date in competition with Paris. This was possible because Pollock, as well as most of the other avant-garde American artists, had left behind his earlier interest in political activism.[2] This change was manifested in the organization of the Federation of Modern Painters and Sculptors in 1943, a group which included several of the Abstract Expressionists. Founded in opposition to the politically motivated Artists Congress, the new Federation was led by artists who, in Kozloff's words, were 'interested more in aethestic values than in political action'. On the one hand, the earlier political activism of some of the Abstract Expressionists was a liability in terms of gaining congressional approval for government-sponsored cultural projects. On the other hand, from a cold warrior's point of view, such linkages to controversial political activities might actually heighten the value of these artists as a propaganda weapon in demonstrating the virtues of 'freedom of expression' in an 'open and free society'.

Heralded as the artistic 'coming of age' of America, Abstract Expressionist painting was exported abroad almost from the beginning. Willem de Kooning's work was included in the United States representation at the Venice Biennale as early as 1948. By 1950, he was joined by Arshile Gorky and Pollock. The United States's representation at the Biennales in São Paulo beginning in 1951 averaged three Abstract Expressionists per show. They were also represented at international shows in Venezuela, India, Japan, etc. By 1956, a MOMA show called 'Modern Art in the U.S.', including works by 12 Abstract Expressionists (Baziotes, Gorky, Guston, Hartigan, de Kooning, Kline, Motherwell, Pollock, Rothko, Stamos, Still, and Tomlin), toured eight European cities, including Vienna and Belgrade.

In terms of cultural propaganda, the functions of both the CIA cultural apparatus and MOMA's international programmes were similar and, in fact, mutually supportive. As director of MOMA's international activities throughout the 1950s, Porter A. McCray in effect carried out governmental functions, even as Braden and the CIA served the interests of the Rockefellers and other corporate luminaries in the American ruling class.

McCray served as one of the Rockefellers' main agents in furthering programmes for the export of American culture to areas considered vital to Rockefeller interests: Latin America during the war, Europe immediately afterwards, most of the world during the 1950s, and – in the 1960s – Asia. In 1962-3, McCray undertook a year's travel in Asia and Africa under the joint auspices of the State Department and MOMA. In October 1963, when Asia had become a particularly crucial area for the United States, McCray left MOMA to become director of the John D. Rockefeller 3rd Fund, a newly created cultural exchange programme directed specifically towards Asia.

The United States government simply could not handle the needs of cultural imperialism alone during the cold war, at least overtly. Illustrative of the government's problems were the 1956 art-show scandals of the USIA – and the solution provided by MOMA. In May 1956, a show of paintings by American artists called *Sport in Art*, organized by *Sports Illustrated* for USIA, was scheduled to be shown in conjunction with the Olympic Games in Australia. This show had to be cancelled after strong protests in Dallas, Texas, where the show toured before being sent abroad. A right-wing group in Dallas, the Patriotic Council, had objected to the exhibition on the grounds that four of the artists included had once belonged to communist-front groups.

In June 1956, an even more serious case of thought censorship hit the press. The USIA abruptly cancelled a major show of American art, '*100 American Artists*'. According to the 21 June issue of the *New York Times*, this show had been planned as 'one of the most important exhibits of American painting ever sent abroad'. The show was organized for USIA by the American Federation of Arts, a non-profit organization based in New York, which refused to co-operate with USIA's attempt to force it to exclude about ten artists considered by the information agency to be 'social hazards' and 'unacceptable' for political reasons. The Federation's trustees voted unanimously not to participate in the show if any paintings were barred by the government, citing a 1954 resolution that art 'should be judged by its merits as a work of art and not by the political or social views of the artist'.

Objections against censorship were also raised by the American Committee for Cultural Freedom (which was revealed as receiving CIA funds in the 1967 exposés). Theodore Streibert, Director of USIA, testifying before Senator Fulbright's Foreign Relations Committee, acknowledged that USIA had a policy against the use of politically suspect works in foreign exhibitions. The USIA, as a government agency, was handcuffed by the noisy and virulent speeches of right-wing congressmen like Representative George A. Dondero (Michigan) who regularly denounced from the House floor abstract art and 'brainwashed artists in the uniform of the Red art brigade'. As reported on 28 June, 1956 by the *New York Times*, Fulbright replied: 'unless the agency changes its policy it should not try to send any more exhibitions overseas.'[3]

The Rockefellers promptly arranged a solution to this dilemma. In 1956, the international programme of MOMA was greatly expanded in both its

financial base and in its aims. It was reconstituted as the International Council of MOMA and officially launched six months after the censorship scandal of USIA's *100 American Artists* show. MOMA's newly expanded role in representing the United States abroad was explained by a *New York Times* article of 30 December, 1956. According to the *Times*,

The government is leery of anything so controversial as art and hampered by the discreditable interference on the part of some politicians who are completely apathetic to art except when they encounter something really significant ... Some of the immediate projects which the Council is taking over financially are United States participation in three major international art exhibitions and a show of modern painting to travel in Europe.

This major show of American painting was produced two years later by MOMA's International Council as *The New American Painting*, an elaborate travelling exhibition of the Abstract Expressionists. The exhibition, which included a comprehensive catalogue by the prestigious Alfred H. Barr, Jr, toured eight European countries in 1958-9. Barr's introduction to the catalogue exemplified the cold-war propaganda role of Abstract Expressionist art.

Indeed one often hears Existentialist echoes in their words, but their 'anxiety', their commitment, their 'dreadful freedom' concern their work primarily. They defiantly reject the conventional values of the society which surrounds them, but they are not politically engagés even though their paintings have been praised and condemned as symbolic demonstrations of freedom in a world in which freedom connotes a political attitude.

As the director of MOMA from its inception until 1944, Barr was the single most important man in shaping the Museum's artistic character and determining the success or failure of individual American artists and art movements. Even after leaving MOMA's directorship, Barr continued to serve as the Museum's reigning tastemaker. His support of Abstract Expressionist artists played an influential role in their success. In addition to his role at MOMA, Barr was an artistic adviser to Peggy Guggenheim, whose Surrealist-oriented Art of This Century Gallery gave some of these artist their first important shows in the mid-1940s. For example, Peggy Guggenheim's gallery offered one-man shows to Jackson Pollock in 1943, 1945, 1947, Hans Hofmann in 1944, Robert Motherwell in 1944 and Mark Rothko in 1945. Barr was so enthusiastic about the work of the Abstract Expressionists that he often attended their informal meetings and even chaired some of their panel discussions at their meeting place, The Club, in New York City.

Barr's 'credentials' as a cultural cold warrior, and the political rationale behind the promotion and export of Abstract Expressionist art during the cold-war years, are set forth in a *New York Times Magazine* article Barr wrote in 1952, 'Is Modern Art Communist?', a condemnation of 'social realism' in Nazi Germany and the Soviet Union. Barr argued in his article that totalitarianism and Realism go together. Abstract art, on the other hand, is feared and prohibited by the Hitlers and Stalins (as well as the Donderos of the world, who would equate abstraction with communism). In his battle against

the ignorant right-wing McCarthyists at home, Barr reflected the attitudes of enlightened cold warriors like CIA's Braden and MOMA's McCray. However, in the case of MOMA's international policies, unlike those of CIA, it was not necessary to use subterfuge. Similar aims as those of CIA's cultural operations could be pursued openly with the support of Nelson Rockefeller's millions.

Especially important was the attempt to influence intellectuals and artists behind the 'iron curtain'. During the post-Stalin era in 1956, when the Polish government under Gomulka became more liberal, Tadeusz Kantor, an artist from Cracow, impressed by the works of Pollock and other abstractionists which he had seen during an earlier trip to Paris, began to lead the movement away from socialist realism in Poland. Irrespective of the role of this art movement within the internal artistic evolution of Polish art, this kind of development was seen as a triumph for 'our side'. In 1961, Kantor and four-teen other non-objective Polish painters were given an exhibition at MOMA. Examples like this one reflect the success of the political aims of the international programmes of MOMA.

Having succeeded so handsomely through MOMA in supporting the cold war, Nelson Rockefeller moved on, in the 1960s, to launch the Council of the Americas and its cultural component, the Center for Inter-American Relations. Funded almost entirely by Rockefeller money and that of other American investors in Latin America, the Council advises the United States Government on foreign policy, even as does the older and more influential Council on Foreign Relations (headed by David Rockefeller, the CFR is where Henry Kissinger began his rise to power). The Center for Inter-American Relations represents a thinly veiled cultural attempt to woo back respect from Latin America in the aftermath of the Cuban Revolution and the disgraceful Bay of Pigs and Missile Crisis incidents. In its Park Avenue offices of a former mansion donated by the Rockefeller family, the Center offers exhibitions of Latin America art and guest lectures by leading Latin American painters and intellectuals. Like the John D. Rockefeller 3rd Fund for Asia, the Center is yet another link in a continuing and expanding chain of Rockefeller-dominated imperialism.

The alleged separation of art from politics proclaimed throughout the 'free world' with the resurgence of abstraction after the Second World War was part of a general tendency in intellectual circles toward 'objectivity'. So foreign to the newly developing apolitical milieu of the 1950s was the idea of political commitment – not only to artists but also to many other intellectu-als – that one social historian, Daniel Bell, eventually was to proclaim the post-war period as 'the end of ideology'. Abstract Expressionism neatly fitted the needs of this supposedly new historical epoch. By giving their painting an individualist emphasis and eliminating recognizable subject-matter, the Abstract Expressionists succeeded in creating an important new art move-ment. They also contributed, whether they knew it or not, to a purely polit-ical phenomenon – the supposed divorce between art and politics which so perfectly served America's needs in the cold war.

89

Attempts to claim that styles of art are politically neutral when there is no overt political subject-matter are as simplistic as Dondero-ish attacks on all abstract art as 'subversive'. Intelligent and sophisticated cold warriors like Braden and his fellows in the CIA recognized that dissenting intellectuals who believe themselves to be acting freely could be useful tools in the international propaganda war. Rich and powerful patrons of the arts, men like Rockefeller and Whitney, who control the museums and help oversee foreign policy, also recognize the value of culture in the political arena. The artist creates freely. But his work is promoted and used by others for their own purposes. Rockefeller, through Barr and others at the Museum his mother founded and the family controlled, consciously used Abstract Expressionism, 'the symbol of political freedom', for political ends.

90

Notes

1 Cited in Russell Lynes, *Good Old Modern*, New York, 1973, p. 233.

2 For Pollock's connections with the Communist Party see Francis V. O' Connor, *Jackson Pollock*, New York, 1967, pp. 14, 21, 25, and Harold Rosenberg, 'The Search for Jackson Pollock', *Art News,* February 1961, p. 58. The question here is not whether or not Jackson Pollock was, in fact, affiliated with the Communist Party in the 1930s, but, simply, if there were enough 'left-wing' connections to make him 'politically suspect' in the eyes of right-wing congressmen.

3 For a more complete history of the right-wing offensive against art in the 1950s and the role of Dondero, see William Hauptman, 'The Suppression of Art in the McCarthy Decade', *Artforum,* October 1973, pp. 48-52.

11

Terry Eagleton
Capitalism, Modernism
and Postmodernism

Source: Terry Eagleton, 'Capitalism,
Modernism and Postmodernism', *New Left
Review,* no. 152, July–August 1985, pp. 60–73.
This text has been edited and footnotes
renumbered accordingly.

In his article 'Postmodernism, or the Cultural Logic of Late Capitalism' (*New
Left Review,* 146), Fredric Jameson argues that pastiche, rather than parody, is
the appropriate mode of postmodernist culture. 'Pastiche', he writes, 'is, like
parody, the imitation of a peculiar mask, speech in a dead language; but it is
a neutral practice of such mimicry, without any of parody's ulterior motives,
amputated of the satiric impulse, devoid of laughter and of any conviction
that alongside the abnormal tongue you have momentarily borrowed, some
healthy linguistic normality still exists.' This is an excellent point; but I want
to suggest here that parody of a sort is not wholly alien to the culture of post-
modernism, though it is not one of which it could be said to be particularly
conscious. What is parodied by postmodernist culture, with its dissolution of
art into the prevailing forms of commodity production, is nothing less than
the revolutionary art of the twentieth-century avant-garde. It is as though
postmodernism is among other things a sick joke at the expense of such rev-
olutionary avant-gardism, one of whose major impulses, as Peter Bürger has
convincingly argued in his *Theory of the Avant-Garde* [see Text 6], was to dis-
mantle the institutional autonomy of art, erase the frontiers between culture
and political society and return aesthetic production to its humble, unprivi-
leged place within social practices as a whole.[1] In the commodified artifacts
of postmodernism, the avant-gardist dream of an integration of art and
society returns in monstrously caricatured form; the tragedy of a Mayakovsky
is played through once more, but this time as farce. It is as though postmod-
ernism represents the cynical belated revenge wreaked by bourgeois culture
upon its revolutionary antagonists, whose utopian desire for a fusion of art
and social praxis is seized, distorted and jeeringly turned back upon them as
dystopian reality. Postmodernism, from this perspective, mimes the formal
resolution of art and social life attempted by the avant-garde, while remorse-
lessly emptying it of its political content; Mayakovsky's poetry readings in the
factory yard became Warhol's shoes and soup-cans.

I say it is *as though* postmodernism effects such a parody, because Jameson
is surely right to claim that in reality it is blankly innocent of any such devious
satirical impulse, and is entirely devoid of the kind of historical memory
which might make such a disfiguring self-conscious. To place a pile of bricks

in the Tate Gallery once might be considered ironic; to repeat the gesture endlessly is sheer carelessness of any such ironic intention, as its shock value is inexorably drained away to leave nothing beyond brute fact. The depthless, styleless, dehistoricized, decathected surfaces of postmodernist culture are not meant to signify an alienation, for the very concept of alienation must secretly posit a dream of authenticity which postmodernism finds quite unintelligible. Those flattened surfaces and hollowed interiors are not 'alienated' because there is no longer any subject to be alienated and nothing to be alienated from, 'authenticity' having been less rejected than merely forgotten. It is impossible to discern in such forms, as it is in the artifacts of modernism proper, a wry, anguished or derisive awareness of the normative traditional humanism they deface. If depth is metaphysical illusion, then there can be nothing 'superficial' about such art-forms, for the very term has ceased to have force. Postmodernism is thus a grisly parody of socialist utopia, having abolished all alienation at a stroke. By raising alienation to the second power, alienating us even from our own alienation, it persuades us to recognize that utopia not as some remote *telos* but, amazingly, as nothing less than the present itself, replete as it is in its own brute positivity and scarred through with not the slightest trace of lack. Reification, once it has extended its empire across the whole of social reality, effaces the very criteria by which it can be recognized for what it is and so triumphantly abolishes itself, returning everything to normality. The traditional metaphysical mystery was a question of depths, absences, foundations, abysmal explorations; the mystery of some modernist art is just the mind-bending truth that things are what they are, intriguingly self-identical, utterly shorn of cause, motive or ratification; postmodernism preserves this self-identity, but erases its modernist scandalousness. The dilemma of David Hume is surpassed by a simple conflation: fact *is* value. Utopia cannot belong to the future because the future, in the shape of technology, is already here, exactly synchronous with the present. William Morris, in dreaming that art might dissolve into social life, turns out, it would seem, to have been a true prophet of late capitalism: by anticipating such a desire, bringing it about with a premature haste, late capitalism deftly inverts its own logic and proclaims that if the artifact is a commodity, the commodity can always be an artifact. 'Art' and 'life' indeed interbreed – which is to say that art models itself upon a commodity form which is already invested with aesthetic allure, in a sealed circle. The *eschaton*, it would appear, is already here under our very noses, but so pervasive and immediate as to be invisible to those whose eyes are still turned stubbornly away to the past or the future.

The Aesthetics of Postmodernism

The productivist aesthetics of the early twentieth-century avant-garde spurned the notion of artistic 'representation' for an art which would be less 'reflection' than material intervention and organizing force. The aesthetic of

postmodernism is a dark parody of such anti-representationalism: if art no longer reflects it is not because it seeks to change the world rather than mimic it, but because there is in truth nothing there to be reflected, no reality which is not itself already image, spectacle, simulacrum, gratuitous fiction. To say that social reality is pervasively commodified is to say that it is always 'aesthetic' – textured, packaged, fetishized, libidinalized; and for art to reflect reality is then for it to do no more than mirror itself, in a cryptic self-referentiality which is indeed one of the most inmost structures of the commodity fetish. The commodity is less an image in the sense of a 'reflection' than an image of itself, its entire material being devoted to its own self-presentation; and in such a condition the most authentically representational art becomes, paradoxically, the anti-representational artifact whose contingency and facticity figures the fate of all late-capitalist objects. If the unreality of the artistic image mirrors the unreality of its society as a whole, then this is to say that it mirrors nothing real and so does not really mirror at all. Beneath this paradox lies the historical truth that the very autonomy and brute self-identity of the postmodernist artifact is the effect of its thorough *integration* into an economic system where such autonomy, in the form of the commodity fetish, is the order of the day.

93

To see art in the manner of the revolutionary avant-garde, not as institutionalized object but as practice, strategy, performance, production: all of this, once again, is grotesquely caricatured by late capitalism, for which, as Jean-François Lyotard has pointed out, the 'performativity principle' is really all that counts. In his *The Postmodern Condition*, Lyotard calls attention to capitalism's 'massive subordination of cognitive statements to the finality of the best possible performance'. 'The games of scientific language', he writes, 'become the games of the rich, in which whoever is wealthiest has the best chance of being right.'[2] It is not difficult, then, to see a relation between the philosophy of J.L. Austin and IBM, or between the various neo-Nietzscheanisms of a post-structuralist epoch and Standard Oil. It is not surprising that classical models of truth and cognition are increasingly out of favour in a society where what matters is whether you deliver the commercial or rhetorical goods. Whether among discourse theorists or the Institute of Directors, the goal is no longer truth but performativity, not reason but power. The CBI are in this sense spontaneous post-structuralists to a man, utterly disenchanted (did they but know it) with epistemological realism and the correspondence theory of truth. That this is so is no reason for pretending that we can relievedly return to John Locke or Georg Luckács; it is simply to recognize that it is not always easy to distinguish politically radical assaults on classical epistemology (among which the early Lukács must himself be numbered, alongside the Soviet avant-garde) from flagrantly reactionary ones. Indeed it is a sign of this difficulty that Lyotard himself, having grimly outlined the most oppressive aspects of the capitalist performativity principle, has really nothing to offer in its place but what amounts in effect to an anarchist version of that very same epistemology, namely the guerrilla skirmishes of a 'paralogism' which might from time to time induce ruptures, instabili-

ties, paradoxes and micro-catastrophic discontinuities into this terroristic techno-scientific system. A 'good' pragmatics, in short, is turned against a 'bad' one; but it will always be a loser from the outset, since it has long since abandoned the Enlightenment's grand narrative of human emancipation, which we all now know to be disreputably metaphysical. Lyotard is in no doubt that '(socialist) struggles and their instruments have been transformed into regulators of the system' in all the advanced societies, an Olympian certitude which, as I write, Mrs Thatcher might at once envy and query. (Lyotard is wisely silent on the class-struggle outside the advanced capitalist nations.) It is not easy to see how, if the capitalist system has been effective enough to negate all class-struggle entirely, the odd unorthodox scientific experiment is going to give it much trouble. 'Postmodernist science', as Fredric Jameson suggests in his introduction to Lyotard's book, is here playing the role once assumed by high modernist art, which was similarly an experimental disruption of the given system; and Lyotard's desire to see modernism and postmodernism as continuous with one another is in part a refusal to confront the disturbing fact that modernism proved prey to institutionalization. Both cultural phases are for Lyotard manifestations of that which escapes and confounds history with the explosive force of the Now, the 'paralogic' as some barely possible, mind-boggling leap into free air which gives the slip to the nightmare of temporality and global narrative from which some of us are trying to awaken. Paralogism, like the poor, is always with us, but just because the system is always with us too. The 'modern' is less a particular cultural practice or historical period, which may then suffer defeat or incorporation, than a kind of permanent ontological possibility of disrupting all such historical periodization, an essentially timeless gesture which cannot be recited or reckoned up within historical narrative because it is no more than an atemporal force which gives the lie to all such linear categorization.

History and Modernity

As with all such anarchistic or Camusian revolt, modernism can thus never really die – it has resurfaced in our own time as paralogical science. But the reason why it can never be worsted – the fact that it does not occupy the same temporal terrain or logical space as its antagonists – is exactly the reason why it can never defeat the system either. The characteristic post-structuralist blend of pessimism and euphoria springs precisely from this paradox. History and modernity play a ceaseless cat-and-mouse game in and out of time, neither able to slay the other because they occupy different ontological sites. 'Game' in the positive sense – the ludic disportings of disruption and desire – plays itself out in the crevices of 'game' in the negative sense – game theory, the techno-scientific system – in an endless conflict and collusion. Modernity here really means a Nietzschean 'active forgetting' of history: the healthy spontaneous amnesia of the animal who has wilfully repressed its own sordid

determinations and so is free. It is thus the exact opposite of Walter Benjamin's 'revolutionary nostalgia': the power of active remembrance as a ritual summoning and invocation of the traditions of the oppressed in violent constellation with the political present. It is no wonder that Lyotard is deeply opposed to any such historical consciousness, with his reactionary celebrations of narrative as an eternal present rather than a revolutionary recollection of the unjustly quelled. If he could remember in this Benjaminesque mode, he might be less confident that the class struggle could be merely extirpated. Nor, if he had adequately engaged Benjamin's work, could he polarize in such a simplistic binary opposition — one typical of much post-structuralist thought — the grand totalizing narratives of the Enlightenment on the one hand and the micropolitical or paralogistic on the other (postmodernism as the death of metanarrative). For Benjamin's unfathomably subtle meditations on history throw any such binary post-structuralist scheme into instant disarray. Benjamin's 'tradition' is certainly a totality of a kind, but at the same time a ceaseless detotalization of a triumphalist ruling-class history; it is in some sense a given, yet is always constructed from the vantage-point of the present; it operates as a deconstructive force within hegemonic ideologies of history, yet can be seen too as a totalizing movement within which sudden affinities, correspondences and constellations may be fashioned between disparate struggles. [...]

Defining the Concept

[...] 'Modernism' as a term at once expresses and mystifies a sense of one's particular historical conjuncture as being somehow peculiarly pregnant with crisis and change. It signifies a portentous, confused yet curiously heightened self-consciousness of one's own historical moment, at once self-doubting and self-congratulatory, anxious and triumphalistic together. It suggests at one and the same time an arresting and denial of history in the violent shock of the immediate present, from which vantage-point all previous developments may be complacently consigned to the ashcan of 'tradition', and a disorienting sense of history moving with peculiar force and urgency within one's immediate experience, pressingly actual yet tantalizingly opaque. All historical epochs are modern to themselves, but not all live their experience in this ideological mode. If modernism lives its history as peculiarly, insistently *present*, it also experiences a sense that this present moment is somehow of the *future*, to which the present is nothing more than an orientation; so that the idea of Now, of the present as full presence eclipsing the past, is itself intermittently eclipsed by an awareness of the present as deferment, as an empty excited openness to a future which is in one sense already here, in another sense yet to come. The 'modern', for most of us, is that which we have always to catch up with: the popular use of the term 'futuristic', to donate modernist experiment, is symptomatic of this fact. Modernism — and here

Lyotard's case may be given some qualified credence – is not so much a punctual moment in time as revaluation of time itself, the sense of an epochal shift in the very meaning and modality of temporality, a qualitative break in our ideological styles of living history. What seems to be moving in such moments is less 'history' than that which is unleashed by its rupture and suspension; and the typically modernist images of the vortex and the abyss, 'vertical' inruptions into temporality within which forces swirl restlessly in an eclipse of linear time, represent this ambivalent consciousness. So, indeed, does the Benjaminesque spatializing or 'constellating' of history, which at once brings it to a shocking standstill and shimmers with all the unquietness of crisis or catastrophe.

High modernism, as Fredric Jameson has argued elsewhere, was born at a stroke with mass commodity culture.[3] This is a fact about its internal form, not simply about its external history. Modernism is among other things a strategy whereby the work of art resists commodification, holds out by the skin of its teeth against those social forces which would degrade it to an exchangeable object. To this extent, modernist works are in contradiction with their own material status, self-divided phenomena which deny in their discursive forms their own shabby economic reality. To fend off such reduction to commodity status, the modernist work brackets off the referent or real historical world, thickens its textures and deranges its forms to forestall instant consumability, and draws its own language protectively around it to become a mysteriously autotelic object, free of all contaminating truck with the real. Brooding self-reflexively on its own being, it distances itself through irony from the shame of being no more than a brute, self-identical thing. But the most devastating irony of all is that in doing this the modernist work escapes from one form of commodification only to fall prey to another. If it avoids the humiliation of becoming an abstract, serialized, instantly exchangeable thing, it does so only by virtue of reproducing that other side of the commodity which is its fetishism. The autonomous, self-regarding, impenetrable modernist artifact, in all its isolated splendour, is the commodity as fetish resisting the commodity as exchange, its solution to reification part of that very problem.

The Social World Bracketed

It is on the rock of such contradictions that the whole modernist project will finally founder. In bracketing off the real social world, establishing a critical, negating distance between itself and the ruling social order, modernism must simultaneously bracket off the political forces which seek to transform that order. There is indeed a political modernism – what else is Bertolt Brecht? – but it is hardly characteristic of the movement as a whole. Moreover, by removing itself from society into its own impermeable space, the modernist work paradoxically reproduces – indeed intensifies – the very illusion of aes-

thetic autonomy which marks the bourgeois humanist order it also protests against. Modernist works are after all 'works', discrete and bounded entities for all the free play within them, which is just what the bourgeois art institution understands. The revolutionary avant-garde, alive to this dilemma, were defeated at the hands of political history. Postmodernism, confronted with this situation, will then take the other way out. If the work of art really is a commodity then it might as well admit it, with all the *sang-froid* it can muster. Rather than languish in some intolerable conflict between its material reality and its aesthetic structure, it can always collapse that conflict on one side, becoming aesthetically what it is economically. The modernist reification – the art work as isolated fetish – is therefore exchanged for the reification of everyday life in the capitalist marketplace. The commodity as mechanically reproducible exchange ousts the commodity as magical aura. In a sardonic commentary on the avant-garde work, postmodernist culture will dissolve its own boundaries and become coextensive with ordinary commodified life itself, whose ceaseless exchanges and mutations in any case recognize no formal frontiers which are not constantly transgressed. If all artifacts can be appropriated by the ruling order, then better impudently to pre-empt this fate than suffer it unwillingly; only that which is already a commodity can resist commodification. If the high modernist work has been institutionalized within the superstructure, postmodernist culture will react demotically to such élitism by installing itself within the base. Better, as Brecht remarked, to start from the 'bad new things', rather than from the 'good old ones'.

That, however, is also where postmodernism stops. Brecht's comment alludes to the Marxist habit of extracting the progressive moment from an otherwise unpalatable or ambivalent reality, a habit well exemplified by the early avant-garde's espousal of a technology able both to emancipate and to enslave. At a later, less euphoric stage of technological capitalism, the post-modernism which celebrates kitsch and camp caricatures the Brechtian slogan by proclaiming not that the bad contains the good, but that the bad *is* good – or rather that both of these 'metaphysical' terms have now been decisively outmoded by a social order which is to be neither affirmed nor denounced but simply accepted. From where, in a fully reified world, would we derive the criteria by which acts of affirmation or denunciation would be possible? Certainly not from history, which postmodernism must at all costs efface, or spatialize to a range of possible styles, if it is to persuade us to forget that we have ever known or could know any alternative to itself. Such forgetting, as with the healthy amnesiac animal of Nietzsche and his contemporary acolytes, *is* value: value lies not in this or that discrimination within contemporary experience but in the very capacity to stop our ears to the siren calls of history and confront the contemporary for what it is, in all its blank immediacy. Ethical or political discrimination would extinguish the contemporary simply by mediating it, sever its self-identity, put us prior or posterior to it; value is just that which *is*, the erasure and overcoming of history, and *discourses* of value, which cannot fail to be historical, are therefore by definition valueless. [...]

'A Desiring Machine'

In some postmodernist theory, the injunction to glimpse the good in the bad has been pursued with a vengeance. Capitalist technology can be viewed as an immense desiring machine, an enormous circuit of messages and exchanges in which pluralistic idioms proliferate and random objects, bodies, surfaces come to glow with libidinal intensity. 'The interesting thing', writes Lyotard in his *Economie libidinale*, 'would be to stay where we are – but to grab without noise all opportunities to function as bodies and good conductors of intensities. No need of declarations, manifestos, organizations; not even for exemplary actions. To let dissimulation play in favour of intensities.'[4] It is all rather closer to Walter Pater than to Walter Benjamin. Of course capitalism is not uncritically endorsed by such theory, for its libidinal flows are subject to a tyrannical ethical, semiotic and juridical order; what is wrong with late capitalism is not this or that desire but the fact that desire does not circulate freely enough. But if only we could kick our metaphysical nostalgia for truth, meaning and history, of which Marxism is perhaps the prototype, we might come to recognize that desire is here and now, fragments and surfaces all we ever have, kitsch quite as good as the real thing because there is in fact no real thing. What is amiss with old-fashioned modernism, from this perspective, is just the fact that it obstinately refuses to abandon the struggle for meaning. It is still agonizingly caught up in metaphysical depth and wretchedness, still able to experience psychic fragmentation and social alienation as spiritually wounding, and so embarrassingly enmortgaged to the very bourgeois humanism it otherwise seeks to subvert. [...]

But the fact that modernism continues to struggle for meaning is exactly what makes it so interesting. For this struggle continually drives it towards classical styles of sense-making which are at once unacceptable and inescapable, traditional matrices of meaning which have become progressively empty but which nevertheless continue to exert their implacable force. It is in just this way that Walter Benjamin reads Franz Kafka, whose fiction inherits the form of a traditional storytelling without its truth contents. A whole traditional ideology of representation is in crisis, yet this does not mean that the search for truth is abandoned. Postmodernism, by contrast, commits the apocalyptic error of believing that the discrediting of this particular representational epistemology is the death of truth itself, just as it sometimes mistakes the disintegration of certain traditional ideologies of the subject for the subject's final disappearance. In both cases, the obituary notices are greatly exaggerated. Postmodernism persuades us to relinquish our epistemological paranoia and embrace the brute objectivity of random subjectivity; modernism, more productively, is torn by the contradictions between a still ineluctable bourgeois humanism and the pressures of a quite different rationality, which, still newly emergent, is not even able to name itself. If modernism's underminings of a traditional humanism are at once anguished and exhilarated, it is in part because there are few more intractable

problems in the modern epoch than of distinguishing between those critiques of classical rationality which are potentially progressive, and those which are irrationalist in the worst sense. It is the choice, so to speak, between feminism and fascism; and in any particular conjuncture the question of what counts as a revolutionary rather than barbarous break with the dominant Western ideologies of reason and humanity is sometimes undecidable. There is a difference, for example, between the 'meaninglessness' fostered by some postmodernism, and the 'meaninglessness' deliberately injected by some trends of avant-garde culture into bourgeois normality.

The Bourgeois-Humanist Subject

[...] The subject of late capitalism [...] is neither simply the self-regulating synthetic agent posited by classical humanist ideology, nor merely a decentred network of desire, but a contradictory amalgam of the two. The constitution of such a subject at the ethical, juridical and political levels is not wholly continuous with its constitution as a consuming or 'mass cultural' unit. 'Eclecticism', writes Lyotard, 'is the degree zero of contemporary general culture: one listens to reggae, watches a western, eats McDonald's food for lunch and local cuisine for dinner, wears Paris perfume in Tokyo and "retro" clothes in Hong Kong; knowledge is a matter of TV games.'[5] It is not just that there are millions of other human subjects, less exotic than Lyotard's jet-setters, who educate their children, vote as responsible citizens, withdraw their labour and clock in for work; it is also that many subjects live more and more at the points of contradictory intersection between these two definitions.

[...] The new post-metaphysical subject proposed by Bertolt Brecht and Walter Benjamin, the *Unmensch* emptied of all bourgeois interiority to become a faceless mobile functionary of revolutionary struggle, is at once a valuable metaphor for thinking ourselves beyond Proust, and too uncomfortably close to the faceless functionaries of advanced capitalism to be uncritically endorsed. In a similar way, the aesthetics of the revolutionary avant-garde break with the contemplative monad of bourgeois culture with their clarion call of 'production', only to rejoin in some respects the labouring or manufacturing subject of bourgeois utilitarianism. We are still, perhaps, poised as precariously as Benjamin's Baudelairian *flâneur* between the rapidly fading aura of the old humanist subject, and the ambivalently energizing and repellent shapes of a city landscape.

Postmodernism takes something from modernism and the avant-garde, and in a sense plays one off against the other. From modernism proper, postmodernism inherits the fragmentary or schizoid self, but eradicates all critical distance from it, countering this with a poker-faced presentation of 'bizarre' experiences which resembles certain avant-garde gestures. From the avant-garde postmodernism takes the dissolution of art into social life, the rejection of tradition, an opposition to 'high' culture as such, but crosses this with the

unpolitical impulses of modernism. It thus unwittingly exposes the residual formalism of any radical art-form which identifies the de-institutionalization of art, and its reintegration with other social practices, as an intrinsically revolutionary move. For the question, rather, is under what conditions and with what likely effects such reintegration may be attempted. An authentically political art in our own time might similarly draw upon both modernism and the avant-garde, but in a different combination from postmodernism. The contradictions of the modernist work are, as I have tried to show, implicitly political in character, but since the 'political' seemed to such modernism to belong precisely to the traditional rationality it was trying to escape, this fact remained for the most part submerged beneath the mythological and metaphysical. Moreover, the typical self-reflexiveness of modernist culture was at once a form in which it could explore some of the key ideological issues I have outlined, and by the same stroke rendered its products opaque and unavailable to a wide public. An art today which, having learnt from the openly committed character of avant-garde culture, might cast the contradictions of modernism in a more explicitly political light, could do so effectively only if it had also learnt its lesson from modernism too – learnt, that is to say, that the 'political' itself is a question of the emergence of a transformed rationality, and if it is not presented as such will still seem part of the very tradition from which the adventurously modern is striving to free itself.

Notes
1 Peter Bürger, *Theory of the Avant-Garde*, Minneapolis, 1984 [see Text 6].
2 Jean-François Lyotard, *The Postmodern Condition: A Report on Knowledge*, Manchester, 1984, p. 45.
3 See Fredric Jameson, 'Reification and Utopia in Mass Culture', *Social Text,* Winter 1979.
4 Jean-François Lyotard, *Economie libidinale,* Paris, 1974, p. 311.
5 *The Postmodern Condition,* p. 76.

Part II
'Gender', 'Race' and the Politics
of Representation

At the centre of Part II is an extract from a book by Edward Said [Text 14] in which he argues that Orientalism is 'a discourse' which is 'produced and exists in an uneven exchange with power political ... power intellectual ... power cultural ... power moral ...'. 'Orientalism' is a *distribution* of geopolitical awareness into aesthetic, scholarly, economic, sociological, historical, and philological texts'. As Said suggests, for many, 'Western culture' is based on a series of exclusions, blindnesses and marginalizations: especially those of ethnic and gender difference. The notion of 'culture' itself is often assumed to consist of the supposed 'civilizing' traditions of the imperialist powers, particularly active in the nineteenth and twentieth centuries. During this period, especially, private and public collections systematically categorized the objects of different, exploited and plundered cultures, by means of signifying systems alien to those of the cultures and societies in which the objects and their meanings were produced [see Text 20].

On the one hand, the 'arts' (itself a loaded term) of societies and cultures 'discovered' by Europeans in colonizing the world acquired the special prestige of the 'timeless' and the 'instinctive'; a fantasized 'other' to the determining world of Western modernization and its subjection of the individual to alienating processes, ranging from rationalized factory labour to modern means of surveillance and control. On the other hand, official designations classified these as 'backward' or 'uncivilized' products of 'savage', 'primitive' people 'benefiting' from modern Western social organization. The values of exploitation and commodification struggle with those of projected feelings as fantasy or dream. For some (especially art historians; again see Text 20) this has a focus in the late nineteenth and early twentieth centuries. However, many commentators argue that the Western interventions during, for instance, the Vietnam War of the 1960s and early 1970s and the Gulf War of 1990-1 demonstrate the continuing role of the 'other' in Western culture and politics.

While Said's is a more theoretical discussion, the two texts by Laura Mulvey and Peter Wollen and by Lucy Lippard [Texts 15 and 16] provide more specific case studies in raising fundamental questions about 'marginality'. For Mulvey and Wollen, these relate to 'the status, in terms of main-

stream art history as presented in books and museum displays, assigned to
Mexican art and to women's art and (in Modotti's case) to photography'.
Headings from political, psychoanalytic and cultural studies structure their
discussion of the work of Kahlo and Modotti: 'On the Margins', 'Women,
Art and Politics', 'The Interior and the Exterior', 'The Discourse of the
Body'. Until at least the late 1960s, conventional art history and certainly
institutional and critical Modernism systematically excluded not only such
methodological perspectives but also the work of women artists as at best
'irrelevant' and at worst 'bad art' (what ever these terms might mean). For
Lippard, questions of marginality are central to the need to provide a
mapping of a terrain full of contradictions and dilemmas. As she makes clear,
to discuss 'multiculturalism' is to raise numerous loaded terms and codes
about 'race', 'class', and 'gender' across a wealth of different experiences and
signifying systems. Western preconceptions and the structure of power rela-
tions, in thought and fantasy as well as in the realities of everyday life, inflect
and distort the expressions and experiences of groups and individuals sub-
jected to patriarchal, white and Western class interests. Lippard's work on
'multicultural art in America' parallels her writings and activities in the
women's movement since the late 1960s. In the wake of the Civil Rights and
Anti-Vietnam War Movements in the United States and '1968' as a symbolic
moment in Europe, a counterpublic sphere was created. In its space previ-
ously repressed needs (or those denied a voice), interests and desires found
symbolic form. Many of these were mediated by changed idioms, practices
and cultural modes. One of these was the 'collective practice' where 'voices'
could be expressed, heard and debated. One such site was the journal *Heresies*
which first appeared in New York in 1977. Structured as a 'collective of fem-
inists, some of which were socialists', including Lippard, it was 'devoted to
the examination of art and politics from a feminist perspective' (first issue,
inside of front cover).

The first two texts in this section focus on a more traditional area of art-
historical investigation: painting in Paris in the second half of the nineteenth
century. However, the accounts on offer differ radically from those previ-
ously produced. Tim Clark's discussion of Manet's *Olympia* was a major
landmark in the social history of art as it was developed in the light of a range
of studies; from those such as Alain Corbin's study of the discourse on, and
realities of, prostitution in the nineteenth and twentieth centuries (1978, see
Text 12, fn.3) to those on subjectivity, desire and gender published in jour-
nals such as *Screen* from the 1970s onwards. The article raises issues about rep-
resentation and historical method. Drawing upon a comprehensive reading
of *Salon* criticism of *Olympia* in 1865, Clark examines the 'set of discourses
Olympia encountered in 1865 ... two main discourses were in question: a dis-
course in which the relations and disjunctions of the terms Woman / Nude /
Prostitute were obsessively rehearsed ... and the complex but deeply repeti-
tive discourse of aesthetic judgement in the Second Empire'. Griselda
Pollock's examination of 'modernity and the spaces of femininity' builds on
Clark's work but criticizes it for 'its peculiar closures on the issue of sexual-

ity'. Her aim is to examine not only the social position of women artists, such as Morisot and Cassatt, but also the ways in which sexuality and gender were encoded in representations (by women and by men) and relate to the 'viewing positions' (gender, class, ethnicity etc.) of spectators.

Timothy J. Clark
Preliminaries to a Possible
Treatment of 'Olympia' in 1865

Source: T. J. Clark, 'Preliminaries to a Possible
Treatment of "Olympia" in 1865', *Screen*, vol.
21, no. 1, Spring 1980, pp. 18-41. This text has
been edited and footnotes renumbered accord-
ingly. Two plates have been omitted. It is
important to note that Tim Clark's article was
responded to by Peter Wollen, 'Manet:
Modernism and Avant-Garde, Timothy
Clark's Article on Manet's "Olympia",
"Screen", Spring 1980', *Screen*, vol. 21, no.2,
Summer 1980, pp. 15-25; in turn this produced
a reply by Clark, 'A Note in Reply to Peter
Wollen', *Screen*, vol. 21, no. 3, Autumn 1980,
pp. 97-100. Lack of space prevents us from
including these two texts here.

I

Manet was not in the habit of hesitating before trying to put his large-scale
works on public exhibition; he most often sent them to the *Salon* the same
year they were painted. But for reasons we can only guess at, he kept the
picture entitled *Olympia* in his studio for almost two years, perhaps repainted
it, and submitted it to the Jury in 1865 [Plate 4]. It was accepted for showing,
initially hung in a good position, and was the subject of excited public
scrutiny and a great deal of writing in the daily newspapers and periodicals of
the time. The 1860s were they heyday of the Parisian press, and a review of
the *Salon* was established as a necessary feature of almost any journal. [...]

If Manet's hesitation had to do with anxieties over what the papers would
say, then what happened when the *Salon* opened was to prove his worst fears
well-founded. The critical reaction to *Olympia* was decidedly negative. Only
four critics out of sixty were favourably disposed to the picture, and that
figure disguises the extremity of the situation: if we apply the test not merely
of approval, but of some sustained description of the object in hand – some
effort at controlled attention to particulars, some ordinary mobilization of the
resources of criticism in 1865 – then a response to *Olympia* simply does not
exist, except in a solitary text written by Jean Ravenel. [...]

I believe this mass of disappointing art criticism can provide an opportu-
nity to say more about the relation of a text to its spectators. I shall regularly
use the words 'text' and 'spectator' in this article, for all their awkwardness as
applied to pictures. In the case of *Olympia* the vocabulary is not especially
forced, since an important part of what spectators reacted to in 1865 was
textual in the ordinary sense of the word: the perplexing title, the outlandish
five lines of verse provided in the *Salon livret*: [...]

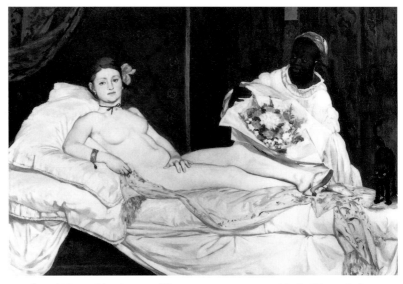

4 Edouard Manet, *Olympia*, 1863. Oil on canvas, 130 × 190 cm. Musée d'Orsay, Paris. Photo: Réunion des Musées Nationaux Documentation Photographique.

Quand, lasse de rêver, Olympia s'éveille,
Le Printemps entre au bras du doux messager noir,
C'est l'esclave à la nuit amoureuse pareille,
Qui vient fleurir le jour délicieux à voir:
L'auguste jeune fille en qui la flamme veille.

 (When, weary of dreaming, Olympia awakes,/Spring enters in the arms of a gentle black messenger,/It is the slave who, like the amorous night,/Comes in and makes the day delicious to see with flowers:/The august young woman in whom the flame [of passion] burns constantly.)

These verses greatly exercised the critics: they figured as one of the grounds for their contemptuous dislike.

 A complete study of *Olympia* and its spectators would be cumbersome, and I am not going to present it here.[1] What I intend instead is to sketch the necessary components of such a study, to raise some theoretical questions which relate to *Screen*'s recent concerns, and to give, in conclusion, a rather fuller account of the ways in which this exercise might provide 'a material-ist reading [specifying] articulations with the [picture] on determinate grounds'.[2] [...]

III

I would like to know which set of discourses *Olympia* encountered in 1865, and why the encounter was so unhappy. I think it is clear that two main dis-courses were in question: a discourse in which the relations and disjunctions of the terms Woman/Nude/Prostitute were obsessively rehearsed (which I

shall call, clumsily, the discourse on Woman in the 1860s), and the complex but deeply repetitive discourse of aesthetic judgement in the Second Empire. These are immediately historical categories, of an elusive and developing kind; they cannot be deducted from the critical texts alone, and it is precisely their absence from the writings on *Olympia* – their appearance there in spasmodic and unlikely form – which concerns us most. So we have to establish, in the familiar manner of the historian, some picture of normal functioning: the regular ways in which these two discourses worked, and their function in the historical circumstances of the 1860s.

Olympia is a picture of a prostitute: various signs declare that unequivocally. The fact was occasionally acknowledged in 1865: several critics called the woman *courtisane*, one described her as 'some redhead from the *quartier Bréda*' (the notorious headquarters of the profession), another referred to her as 'une manolo du bas étage'. Ravenel tried to specify more precisely, calling her a 'girl of the night from Paul Niquet's' – in other words, a prostitute operating right at the bottom end of the trade, in the all-night bar run by Niquet in Les Halles, doing business with a clientele of market porters, butchers and *chiffonniers*. But by and large this kind of recognition was avoided, and the sense that Olympia's was a sexuality laid out for inspection and sale appeared in the critics' writings in a vocabulary of uncleanness, dirt, death, physical corruption and actual bodily harm. Now this is odd, because both the discourse on Woman in the 1860s, and the established realm of art, had normally no great difficulty in including and accepting the prostitute as one of their possible categories. There is even a sense, as Alain Corbin establishes in his study of *le discours prostitutionnel* in the nineteenth century, in which the prostitute was necessary to the articulation of discourse on Woman in general.[3] She was maintained – anxiously and insistently – as a *unity*, which existed as the end-stop to a series of differences which constituted the feminine. The great and absolute difference was that between *fille publique* and *femme honnête*: the two terms were defined by their relation to each other, and therefore it was necessary that the *fille publique* – or at least her *haute bourgeoise* variant, the *courtisane* – should have her representations. The *courtisane* was a category in use in a well-established and ordinary ideology: she articulated various (false) relations between sexual identity, sexual power and social class. Of course at the same time she was declared to be almost unmentionable – at the furthest margin of the categorizable – but that only seemed to reaffirm her importance as a founding signification of Woman.

So it was clearly not the mere fact – the palpable signs – of Olympia being a prostitute that produced the critics' verbal violence. It was some transgression of *le discours prostitutionnel* that was at stake; or rather, since the characterization of the *courtisane* could not be disentangled from the specification of Woman in general in the 1860s, it was some disturbance in the normal relations between prostitution and femininity.

When I introduced the notion of a discourse on Woman in the 1860s, I included the nude as one of its terms. Certainly it deserves to take its place there, but the very word indicates the artificiality of the limits we have to

inscribe – for description's sake – around our various 'discourses'. The nude is indelibly a term of art and art criticism: the fact is that art criticism and sexual discourse intersect at this point, and the one provides the other with crucial representations, forms of knowledge, and standards of decorum. One could almost say that the nude is the mid-term of the series which goes from *femme honnête* to *fille publique:* it is the important form (the complex of established forms) in which sexuality is revealed and not-revealed, displayed and masked, made out to be unproblematic. It is the frankness of the bourgeoisie: here, after all, is what Woman looks like; and she can be known in her nakedness, without too much danger of pollution. This too *Olympia* called into question, or at least failed to confirm.

One could put the matter schematically in this way. The critics asked certain questions of *Olympia* in 1865, and did not get an answer. One of them was: what sex is she, or has she? Has she a sex at all? In other words, can we discover in the image a pre-ordained constellation of signifiers which keeps her sexuality in place? Further question: can *Olympia* be included within the discourse on Woman/the nude/the prostitute? Can this particular body, acknowledged as one for sale, be articulated as a term in an artistic tradition? Can it be made a modern example of the nude? Is there not a way in which the terms *nude* and *fille publique* could be mapped on to each other, and shown to belong together? There is no *a priori* reason why not. (Though I think there may be historical reasons why the mapping could not be done effectively in 1865: reasons to do with the special instability of the term 'prostitute' in the 1860s, which was already producing, in the discourse on Woman, a peculiar mythology of invasion, whereby the prostitute was made out to have vacated her place at the edge of society, and be engaged in building a new city, in which everything was edges and no single demarcation was safe.)

It is a matter of tracking down, in the writings on *Olympia*, the appearance of the normal forms of discourse and the points/topics/tropes at which (or around which) they are simply absent, or present in a grossly disturbed state. For instance, the various figures of uncleanness, and the way these figures cannot be maintained as descriptions of sexual or moral status, but always teeter over into figures of death and decay. Or the figures which indicate the ways in which the hand of Olympia – the one spread over her pubic hair – disobeys, crucially, the conventions of the nude. The hand is *shamelessly flexed*, it is *improper*, it is *in the form of a toad*, it is *dirty*, it is in a state of *contraction*. It comes to stand for the way Olympia's whole body is disobedient: the hand is the sign of the unyielding, the unrelaxed, the too-definite where indefiniteness is the rule, the non-supine, the concealment which declares itself as such: the 'unfeminine', in short. Or again: the figures of physical violence done to the body, or of hideous constraint: 'a woman on a bed, or rather some form or other, blown up like a grotesque in india rubber, a skeleton dressed in a tight jacket made of plaster, outlined in black, like the armature of a stained glass window without the glass'.[4] Or the figures which intimate – no more than that – the critics' unease over Olympia's handling of

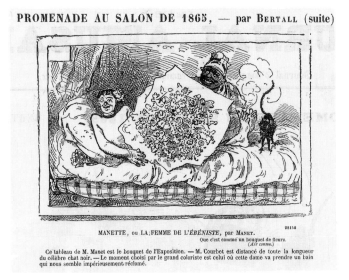

PROMENADE AU SALON DE 1865, — par BERTALL (suite)

MANETTE, ou LA FEMME DE L'ÉBÉNISTE, par MANET. 25155
Que c'est comme un bouquet de fleurs.
(Air connu.)

Ce tableau de M. Manet est le bouquet de l'Exposition. — M. Courbet est distancé de toute la longueur du célèbre chat noir. — Le moment choisi par le grand coloriste est celui où cette dame va prendre un bain qui nous semble impérieusement réclamé.

5 Bertall, *Manette, ou La femme de l'ébéniste ...*, caricature of Manet's *Olympia*, *Le Journal Amusant*, 27 May 1865, Bibliothèque Nationale, Paris.

hair and hairlessness: precious *pudeurs*, with which the nude makes clear its moral credentials. One of the easy triumphs of Bertall's caricature is to put the cat and flowers in place of the hand, and let us have the great explosion of foliage, and the black absence at its centre [Plate 5].

IV

[...] I think it is possible to say that at its first showing *Olympia* was not given a meaning that was stabilized long enough to provide the framework for any further investigation – for some kind of knowledge, for criticism. It seems reasonable to call that a failure on *Olympia*'s part; since the picture, it is clear to us now, certainly attempts – blatantly, even ponderously – to instate within itself a relationship to established, previous forms of representation. The evidence suggests that this relationship was *not* instated, for the specta-tors in 1865; or that even when it was – the very few cases when the picture's points of reference were perceived – this did not lead to an articulated and consistent reading (whether one of approval or dissent).

I shall give two examples: one concerning *Olympia*'s relation to Titian's so-called *Venus of Urbino* [Plate 6], and the other Ravenel's treatment of the picture's relation to the poetry of Baudelaire. That *Olympia* is arranged in such a way as to invite comparison with the Titian has become a common-place of criticism in the twentieth century, and a simple charting of the stages of Manet's invention, in preparatory sketches for the work, is sufficient to show how deliberate was the reference back to the prototype.[5] The reference was not obscure in the nineteenth century: the Titian painting was a hal-

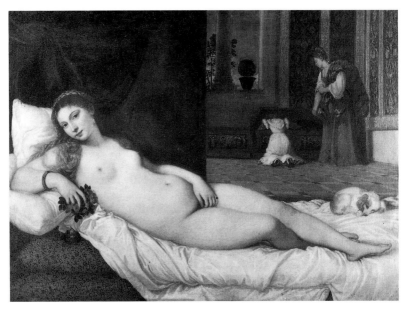

6 Titian, *Venus of Urbino*, 1538. Oil on canvas, 120 × 165 cm. Uffizi, Florence.
Photo: Giraudon.

lowed and hackneyed example of the nude: when Manet had done an oil
copy of it as a student, he would have known he was learning the very alpha-
bet of Art. Yet in the mass of commentary on *Olympia* in 1865, only two
critics talked at all of this relation to Titian's *Venus*; only twice, in other
words, was it allowed that *Olympia* existed 'with reference to' the greater tra-
dition of European painting. And the terms in which it was allowed are
enough to indicate why the other critics were silent.

'This Olympia,' wrote Amédée Cantaloube in *Le Grand Journal*, the same
paper that holds the bouquet in Bertall's caricature, 'sort of female gorilla,
grotesque in indiarubber surrounded by black, apes on a bed, in a complete
nudity, the horizontal attitude of the Venus of Titian, the right arm rests on
the body in the same way, except for the hand which is flexed in a sort of
shameless contraction.'[6] The other, a writer who called himself Pierrot, in a
fly-by-night organ called *Les Tablettes de Pierrot*, had this entry: 'A woman on
a bed, or rather some form or other blown up like a grotesque in india-
rubber; sort of monkey making fun of the pose and the movement of the arm
of Titian's Venus, with a hand shamelessly flexed'. [...]

The point is this. For the most part, for almost everyone, the reference
back to tradition in *Olympia* was invisible. Or if it could be seen, it could cer-
tainly not be said. And if, once, it could be spoken of, it was in these terms:
Titian's arrangement of the nude was there, vestigially, but in the form of
absolute travesty, a kind of vicious aping which robbed the body of its femi-
ninity, its humanity, it very fleshiness, and put in its place *une forme quelconque*,
a rubber-covered gorilla flexing her dirty hand above her crotch.

I take Pierrot's entry, and the great silence of the other texts, as licence to say, quite crudely in the end, that the meaning contrived in terms of Titian – *on* and *against* that privileged schema of sex – was *no* meaning, had no meaning, in 1865. [...]

The example of Ravenel is more complex, I have already said that Ravenel's text is the only one in 1865 that could possibly be described as articulate, and somehow appropriate to the matter in hand. But it is an odd kind of articulacy. Ravenel's entry on *Olympia* comes at the end of the eleventh long article in the immense series he published in *L'Époque*, a paper of the far left opposition.[7] It comes in the middle of an alphabetical listing of pictures which he has so far left out of account, and not allotted their proper place in the extended critical narrative of the first ten instalments of the *Salon*. The entry itself is a peculiar, brilliant, *inadvertent* performance; a text which blurts out the obvious, blurts it out and passes on; ironic staccato, as if aware of its own uncertainty.

MONSIEUR MANET – *Olympia* – The scapegoat of the Salon, the victim of Parisian lynch law. Each passer-by takes a stone and throws it in her face. *Olympia* is a very crazy piece of Spanish madness, which is a thousand times better than the platitude and inertia of so many canvases on show in the Exhibition.

Armed insurrection in the camp of the bourgeois: it is a glass of iced water which each visitor gets full in the face when he sees the BEAUTIFUL *courtesan* in full bloom.

Painting of the school of Baudelaire, freely executed by a pupil of Goya; the vicious strangeness of the little *faubourienne*, a woman of the night from Paul Niquet's, from the mysteries of Paris and the nightmares of Edgar Poe. Her look has the sourness of someone prematurely aged, her face the disturbing perfume of a *fleur de mal*; the body fatigued, corrupted ['corrumpu' also carries the meaning 'tainted', 'putrid'], but painted under a single transparent light, with the shadows light and fine, the bed and the pillows are put down in a velvet modulated grey. Negress and flowers insufficient in execution, but with real harmony to them, the shoulder and arm solidly established in a clean and pure light. – The cat arching its back makes the visitor laugh and relax, it is what saves M. Manet from a popular execution.

De sa fourrure noir [sic] *et brune*
Sort un parfum si doux, qu'un soir
J'en fus embaumé pour l'avoir
Caressé [sic] *une fois ... rein qu'une.*
(From its black and brown fur/Comes a perfume so sweet, that one evening/
I was embalmed in it, from having/Caressed it once ... only once.)
C'est l'esprit familier du lieu;
Il juge, il préside, il inspire
Toutes choses dans son empire;
Peut-être est-il fée, est-il dieu?
(It is the familiar spirit of the place;/It judges, presides, inspires/All things
within its empire;/Is it perhaps a fairy, or a god?)

Monsieur Manet, instead of Monsieur Astruc's verses would perhaps have done well to take as epigraph the quatrain devoted to Goya by the most *advanced* painter of our epoch:

GOYA - Cuachemar plein de choses inconnues
De foetus qu'on fait cuire au milieu des sabbats,

De vieilles au miroir et d'enfants toutes nues
Pour tenter les démons ajustant bien leurs bas.
(GOYA – Nightmare full of unknown things/Of foetuses cooked in the middle
of witches' sabbaths,/Of old women at the mirror and children quite naked/
To tempt demons who are making sure their stockings fit.)
Perhaps this *olla podrida de toutes les Castilles* is not flattering for Monsieur Manet,
but all the same it is something. You do not make an *Olympia* simply by wanting to.
– The *Christ* would call for a certain technical analysis which we do not have time to
give. – To summarize, it is hideous, but all the same it is something. A painter is in
evidence and the strange group is bathed in light.

This is effective criticism, there is no doubt. But let me restrict myself to
saying one thing about it. Ravenel – it is the achievement which first
impresses us, I suppose – breaks the codes of *Olympia*. He gets the picture
right, and ties the picture down to Baudelaire and Goya; he is capable of dis-
cussing the image, half playfully and half in earnest, as deliberate provocation,
designed to be anti-bourgeois; he can even give Olympia, for a moment, a
class identity, and call her a *petite faubourienne* – a girl from the working-class
suburbs – or a *fille des nuits de Paul Niquet*. But getting things right does not
seem to enable Ravenel to accede to meaning: it is almost as if breaking the
codes makes matters worse from that point of view; the more particular
signifiers and signified are detected, the more perplexing and unstable the
totality of signs becomes. What, for instance, does the reference to Baudelaire
connote, for Ravenel? There are, as it were, four signs of that connotation in
the text: the 'school of Baudelaire' leads on (1) to the disturbing perfume of
a *fleur du mal*, then (2) to two verses from a short poem from the first book of
Baudelaire's collection, entitled *Le Chat*, a poem precise in diction, spare and
lucid in rhythm, deliberately decorous in its intimations of sexuality; and
then, in passing, (3) to the description of Baudelaire as 'le peintre le plus
avancé de notre époque', where the ironic underlining of *avancé* does not
make the meaning any easier to pin down; and finally (4) to the nightmare
ride of the Goya quatrain from *Les Phares*, the fetid stew of cooked foetuses
and devil women, the self-consciously Satanic Baudelaire, the translator of
Tales of Mystery and Imagination.

My point is this: the discovery of Baudelaire does not stabilize meaning.
On the contrary, for a reader like Ravenel it destabilizes meaning still further,
since Baudelaire's meanings are so multiple and refractory, so unfixed, so
unmanageable, in 1865. We are face to face with the only text equipped and
able to take on the picture's central terms of reference; and this is how it takes
them, as guarantee of its own perplexity, its opinion that the picture is a stew
of half-digested significations. Perhaps guarantee is too weak a word in this
connection: the code, once discovered, compounds the elusiveness; it speeds
up the runaway shifts of connotation; it fails, completely, to give them an
anchorage in any one pre-eminent, privileged system of signs.

The same is true for the recognition or attribution of class. Once again, we
are entitled to draw breath at Ravenel's *petite faubourienne*: It may seem to us
close to the mark, that phrase. But what does it signify in the text itself, what

system of meanings does it open on to? It means nothing precise, nothing maintainable: it opens on to three phrases, 'fille des nuits de Paul Niquet, des mystères de Paris et des cauchemars d'Edgar Poe'. A working girl from the *faubourgs*/a woman from the farthest edges of *la prostitution populaire clandestine*, soliciting the favours of *chiffonniers* (one might reasonably ask: With a black maid bringing in a tribute of flowers? Looking like this, with these accessories, this décor, this imperious presentation of self?)/a character out of Eugène Sue's melodramatic novel of the city's lower depths/a creature from Edgar Allen Poe. The shifts are motivated clearly, but it is thoroughly unclear what the motivation *is*: the moves are too rapid and abrupt, they fail to confirm each other's sense — or even to intimate some one thing, too elusive to be caught directly, but to which the various metaphors of the text all tend.

The identification of class is not a *brake* on meaning: it is the trigger, once again, of a sequence of connotations which do not add up, which fail to circle back on themselves, declaring their meaning evident and uniform. It may be that we are too eager, now, to point to the illusory quality of that circling back, that closure against the 'free play of the signifier'. Illusion or not, it seems to me the necessary ground on which meanings can be established and maintained: kept in being long enough, and endowed with enough coherence, for the ensuing work of dispersal and contradiction to be seen to matter — to have matter, in the text, to work against.

V

[...] I suppose it will be obvious that *my* reading of *Olympia* will be produced as a function of the analysis of its first readings: I do not claim that this gives it some kind of objectivity, or even some privileged status 'within historical materialism'. But it provides the reading with certain tests of appropriateness, or, to put it another way, it presents the reading with a set of particular questions to answer, which have been produced as part of historical enquiry. [...]

My reading of *Olympia* would address the question: what is it in the image which produces, or helps produce, the critical silence and uncertainty I have just described? What is it that induces this interminable displacement and conversion of meanings? I would like, ideally, to give the answer to those questions an interleaved, almost a scholiastic form, tying my description back and back to the terms of the critics' perplexity, and its blocked, unwilling insight into its own causes. Clearly, the reading would hinge on *Olympia's* handling of sexuality, and its relation to the tradition of the nude. [...]

VI

[...] The picture turns, inevitably, on the signs of sexual identity. I want to argue that, for the critics of 1865, sexual identity was precisely what Olympia did not possess. She failed to occupy a place in the discourse on Woman, and

specifically she was neither a nude, nor a prostitute: by that I mean she was not a modification of the nude in ways which made it clear that what was being shown was sexuality on the point of escaping from the constraints of decorum — sexuality proffered and scandalous. There is no scandal in *Olympia*, in spite of the critics' effort to construct one. It was the odd coexistence of decorum and disgrace — the way in which neither set of qualities established its dominance over the other — which was the difficulty of the picture in 1865.

[...] I shall deal with three aspects of the matter here: (a) The question of access and address; (b) The 'incorrectness' in the drawing of the body; (c) The handling of hair and hairlessness.

(a) One of the primary operations of the nude is, to borrow MacCabe's phrase again, 'a placing of the spectator in a position of imaginary knowledge'. The spectator's access to the presented body has to be arranged rather precisely; and this is done first through a certain arrangement of distance, which must be neither too great nor too small; and then through a placing of the naked body at a determinate height, which in turn produces a specific relation to the viewer. The body, again, must not be too high — put up on some fictive pedestal — nor too low, otherwise it may turn into an object of mere scrutiny, or humiliation — laid out on the dissecting table of sight.

In the 1830s, Realism had invented a set of refutations of just these placings; though it should be admitted that the refutations were intermittent and unstable. Perhaps it would be better to say that in certain paintings by Courbet there appeared the first forms, the first suggestions, of ways in which the placings of the nude might be negated. Courbet's *The Bathers* of 1853 is the strongest case [Plate 7], since it seems to have been such a deliberate sabotage: a travesty of the normal canons of 'Beauty', obviously, and an attempt to make the nude, of all unlikely genres, exemplify the orders of social class. *The Bathers* was meant to be read as a *bourgeoise*, not a nude: she was intended to register as the unclothed opposite and opponent of male proletarian nakedness; and so Courbet displayed the painting in the *Salon* alongside another of roughly equal size, in which a pair of gnarled and exhausted professional wrestlers went through their paces in the *Hippodrome des Champs-Elysées*.

But *The Bathers* broke the rules of the nude in other ways, which were hardly more subtle, but perhaps more effective. It seemed to be searching for ways to establish the nude in opposition to the spectator, in active refusal of his sight. It did so grossly, clumsily, but not without some measure of success, so that the critic at the time who called the woman 'this heap of matter, powerfully rendered, who turns her back with cynicism on the spectator' had got the matter right. The pose and the scale and the movement of the figure end up being a positive aggression, a resistance to vision in normal terms.

[...] But *Olympia*, I would argue, takes up neither the arrangements by which the canonical images of the nude establish access, nor Realism's knock-about refutations. What it contrives is stalemate, a kind of baulked invitation, in which the spectator is given no established place for viewing

7 Gustave Courbet, *The Bathers*, 1853.
Oil on canvas, 227 × 193 cm. Musée Fabre,
Montpellier. Photo: Frédéric Jaulmes.

and identification, nor offered the tokens of exclusion and resistance. This is done most potently, I suppose, by the woman's gaze – the jet-black pupils, the slight asymmetry of the lids, the smudged and broken corner of the mouth, the features half-adhering to the plain oval of the face. It is a gaze which gives nothing away, as the reader attempts to interpret its blatancy; a look direct and yet guarded, poised very precisely between address and resistance. So precisely, so deliberately, that it comes to be read as a *production* of the depicted person herself; there is an inevitable elision between the qualities of precision and contrivance in the image and those qualities as inhering in the fictive subject; it is *her* look, her action on us, her composure, her composition of herself. But the gaze would not function as it does – as the focus of other uncertainties – were it not aided and abetted by the picture's whole composition. Pre-eminently, if it is access that is in question, there is the strange indeterminate scale of the image, neither intimate nor monumental; and there is the disposition of the unclothed body in relation to the spectator's imaginary position: she is put at a certain, deliberate marked height, on the two great mattresses and the flounced-up pillows; in terms of the tradition, she is at a height which is just too high, suggesting the stately, the body *out of relation* to the viewer's body; and yet not stately either, not looking down at us, not hieratic, not imperial: looking directly out and across, with a steadying, dead level interpellation. The stalemate of 'placings' is impeccable and *typical*, that is my point. If at this primary level – the arrangement within the rectangle, so to speak, the laying-out in illusory depth – the spectator is offered neither access nor exclusion, then the same applies, as I shall try to

show, to the picture's whole representation of the body.

(b) What the critics indicated by talk of 'incorrectness' in the drawing of Olympia's body, and a wilder circuit of figures of dislocation and physical deformity, is, I would suggest, the way the body is constructed in two inconsistent graphic modes, which once again are allowed to exist in too perfect and unresolved an equilibrium. One aspect of the drawing of Olympia's body is emphatically linear: it was the aspect seized on by the critics, and given a metaphorical force, in phrases like 'cernés de noir', 'dessinée au charbon', 'raies de cirage' 'avec du charbon tout autour', 'le gros matou noir ... ait déteint sur les contours de cette belle personne, après s'être roulé sur un tas de charbon'.[8] (These are figures which register also a reaction to Manet's elimination of half-tones, and the abruptness of the shadows at the edges of his forms: but this, of course, *is* an aspect of his drawing, taken in its widest sense.) The body is composed of smooth hard edges, deliberate intersections: the lines of the shoulders, singular and sharp; the far nipple breaking the contour of the arm with an artificial exactness; the edge of thigh and knee left flat and unmodulated against the dark green and pink; the central hand marked out on a dark grey ground, 'impudiquement crispée' – in other words, as Pierrot implies, refusing to fade and elide with the sex beneath, in the metaphoric way of Titian and Giorgione. Yet this is an incomplete account. The critics certainly conceived of Olympia as too definite – full of 'lignes heurtées qui brisent les yeux'[9] – but at the same time the image was accused of *lacking* definition. It was 'unfinished', and drawing 'does not exist in it'; it was 'impossible', elusive, 'informe'. Olympia was disarticulated, but she was also inarticulate. I believe that this is a reaction on the critics' part to other aspects of the drawing: the suppression of demarcations and definitions of parts: the indefinite contour of Olympia's right breast, the faded bead of the nipple; the sliding, dislocated line of the far forearm as it crosses (touches?) the belly; the elusive logic of the transition from breast to ribcage to stomach to hip to thigh. There is a lack of articulation here. It is not unprecedented, this refusal; and in a sense it tallies well with the conventions of the nude, where the body is regularly offered as a fluid, infinite territory on which spectators are free to impose their imaginary definitions. But the trouble here is the incompatibility of this uncertainty and fullness with the steely precision of the edges which contain it. The body is, so to speak, tied down by drawing, held in place – by the hand, by the black tie around the neck, by the brittle inscription of grey wherever flesh is to be distinguished from flesh, or from the white of a pillow or the colour of a cashmere shawl. The way in which this kind of drawing qualifies, or relates to, the other is unclear: it does not qualify it, because it does not relate: the two systems coexist: they describe aspects of the body, and point to aspects of that body's sexual identity, but they do not bring those aspects together into some single economy of form.

(c) The manipulation of the signs of hair and hairlessness is a delicate matter for a painter of the nude. Peculiar matters of decorum are at stake, since hair let down is decent, but unequivocal: it is some kind of allowed disorder, inviting, unkempt, a sign of Woman's sexuality – a permissible sign, but quite

a strong one. Equally, hairlessness is a hallowed convention of the nude: ladies in paintings do not have hair in indecorous places, and that fact is one guarantee that in the nude sexuality will be displayed but contained: naked-ness in painting is not like nakedness in the world. There was no question of *Olympia* breaking the rules entirely; pubic hair, for Manet as much as Cabanel and Giacomotti, was indicated by its absence. But *Olympia* offers us various substitutes. The hand itself, which insists so tangibly on what it hides; the trace of hair in the armpit; the grey shadow running up from the navel to the ribs; even, another kind of elementary displacement, the frothing grey, white and yellow fringe of the shawl, falling into the grey folds of pillow and sheet – the one great accent in that open surface of different off-whites.

There are these kinds of displacement, discreetly done; and then there is an odd and fastidious reversal of terms. *Olympia*'s face is framed, mostly, by the brown of a Japanese screen, and the neutrality of that background is one of the things which makes the address and concision of the woman's face all the sharper. But the neutrality is an illusion: to the right of *Olympia*'s head there is a shock of auburn hair, just marked off enough from the brown of the screen to be visible, with effort. Once it is seen, it changes the whole dispo-sition of head and shoulders: the flat, cut-out face is surrounded and rounded by the falling hair, the flower converts from a plain silhouette into an object resting in the hair below; the head is softened, given a more familiar kind of sexuality. The qualification remains, however: once it is seen, this happens: but in 1865 it was not seen, or certainly not seen to do the things I have just described. And even if it is noticed – the connoisseur's small reward for looking closely - it cannot, I would argue, be held in focus. Because, once again, we are dealing with incompatibilities precisely tuned: there are two faces, one produced by a ruthless clarity of edge and a pungent certainty of eyes and mouth, and the other less clearly demarcated, opening out into the surrounding spaces. Neither reading is suppressed by the other, nor can they be made into aspects of the *same* image, the same imaginary shape. There is plenty of evidence of how difficult it was to see, or keep seeing, this device. No critic mentioned it in 1865; the cartoonists eliminated it and seized, quite rightly, on the *lack* of loosened hair of *Olympia*'s distinctive feature; even Gauguin, when he did a respectful copy of *Olympia* later, failed to include it. The difficulty is visual: a matter of brown against brown. But that difficulty cannot be disentangled from the other: the face and the hair cannot be fitted together because they do not obey the usual set of equations for sexual con-sistency, equations which tell us what bodies are like, how the world of bodies is divided, into male and female, resistant and yielding, closed and open, aggressive and vulnerable, repressed and libidinous.

[...] Hair, pubic or otherwise, is a detail in *Olympia*, and should not be pro-moted unduly. But the detail is significant, and it obeys the larger rule I wish to indicate. The signs of sex are there in the picture, in plenty, but drawn up in contradictory order; one that is unfinished, or rather, more than one; *orders* interfering with each other, signs which indicate quite different places for *Olympia* in the taxonomy of Woman; and none of which she occupies.

117

VII

A word on effectiveness, finally. I can see a way in which most of what I have said about *Olympia* could be reconciled with an enthusiasm, in *Screen* and elsewhere, for the 'dis-identificatory practices' of art, 'those practices which displace the agent from his or her position of subjective centrality', and, in general, with 'an emphasis on the body and the impossibility of its exhaustion in its representations'.[10] It would be philistine not to take that enthusiasm seriously, but there are all kinds of nagging doubts – above all, about whether 'dis-identificatory practices' *matter*. [...]

Is there a difference – a difference with immediate, tactical implications – between an allowed, arbitrary and harmless play of the signifier and a kind of play which contributes to a disruption of the smooth functioning of the dominant ideologies? If so [...] artistic practice will have to *address itself to* 'the specific positioning of the body in the economic, political and ideological practices'; it cannot take its own disruptions of the various signifying conventions as somehow rooted, automatically, in the struggle to control and position the body in political and ideological terms; it has to articulate the relations between its own minor acts of disobedience and the major struggles – the class struggle – which define the body and dismantle and renew its representations. Otherwise its acts will be insignificant – as Manet's were, I believe, in 1865. [...]

It is admirable in 1865 for a picture *not* to situate Woman in the space – the dominated and derealized space – of male fantasy. But this refusal – to sound again the demanding note – is compatible with situating Woman somewhere else: making her part of a fully coded, public and familiar world, to which fantasy has entry only in its real, uncomfortable, dominating and dominated form. One could imagine a different picture of a prostitute, in which there would be depicted the production of the sexual subject (the subject 'subjected', subject to and subject of fantasy). Even, perhaps, the production of the sexual Subject in a particular class formation. But to do that – to put it crudely – Manet would have had to put a far less equivocal stress on the signs of social identity in this body and this locale. In fact, as we have seen, the signs of social identity are as unstable as all the rest. Olympia has a maid, which seems to situate her *somewhere* on the social scale; but the maid is black, convenient sign, stock property of any harlot's progress, derealized, telling us little or nothing of social class. She receives elaborate bouquets of flowers, but they are folded up in old newspaper; she is *faubourienne*, Ravenel is right, in her face and her disabused stare, but *courtisane* in her stately pose, her delicate shawl, her precious slippers.

Let me make what I am saying perfectly clear. Olympia refuses to signify – to be read according to the established codings for the nude, and take her place in the Imaginary. But if the picture were to do anything more than that, it (she) would have to be given, much more clearly, a place in another classed code – a place in the code of classes. She would have to be given a place in the world which *manufactures* the Imaginary, and repro-

duces the relations of dominator/dominated, fantasizer/fantasized.

The picture would have to construct itself a position – it would be neces-
sarily a complex and elliptical position, but it would have to be readable
somehow – within the actual conflict of images and ideologies surrounding
the practice of prostitution in 1865. What that conflict consisted in was indi-
cated, darkly, by the critics' own fumbling for words that year – the shift
between *petite faubourienne* and *courtisane*. In other words, between the pros-
titute as proletarian, recognized as such and recognizing herself as such, and
the other, 'normal' Second Empire situation: the endless exchange of social
and sexual meanings, in which the prostitute is alternately – fantastically –
recognized as proletarian, as absolutely abject, shameless, seller of her own
flesh, and then, in a flash, misrecognized as *dominator*, as *femme fatale*, as imag-
inary ruler. (This dance of recognition and misrecognition is one in which
the prostitute shares, to a certain degree. But she is always able – indeed liable
– to flip back to the simple assessment of herself as just another seller of an
ordinary form of labour power. She has to be constantly re-engaged in the
dance of ideology, and made to collude again in her double role.)

[...] In the end *Olympia* lends its peculiar confirmation to the latter struc-
ture, the dance of ideology. It erodes the *terms* in which the normal recogni-
tions are enacted, but it leaves the structure itself intact. The prostitute is still
double, abject and dominant, equivocal, unfixed. To escape that structure
what would be needed would be, exactly, another set of terms – terms which
would be discovered, doubtless, in the act of unsettling the old codes and
conventions, but which would have themselves to be *settled*, consistent,
forming a finished sentence.

It may be that I am asking for too much. Certainly I am asking for the
difficult, and equally certainly for something Manet did not do. I am point-
ing to the fact that there are always *other* meanings in any given social space –
counter-meanings, alternative orders of meaning, produced by the culture
itself, in the clash of classes, ideologies and forms of control. [...] Ultimately,
[...] any critique of the established, dominant systems of meaning will degen-
erate into a mere refusal to signify unless it seeks to found its meanings – dis-
cover its contrary meaning – not in some magic re-presentation, on the other
side of negation and refusal, but in signs which are already present, fighting
for room – meanings rooted in actual forms of life; repressed meanings, the
meanings of the dominated.

[...] A clue to Manet's tactics in 1865, and their limitations, might come if
we widened our focus for a moment and looked not just at *Olympia* but its
companion painting in the Salon, *The Mocking of Christ* [Plate 8]. This picture
was also unpopular in 1865: some critics held it to be worse than *Olympia*,
even; and many agreed in seeing it as a deliberate caricature of religious art.
But the operative word here is *art*: if the *Jesus* is paired with the *Olympia*, the
effect of the pairing is to entrench both pictures in the world of painting: they
belong together only as contrasting artistic categories, as bizarre versions of
the nude and the altarpiece. [...] The ambiguities of Manet's strategy are
clear. What gives his work in the 1860s its peculiar force, and perhaps its con-

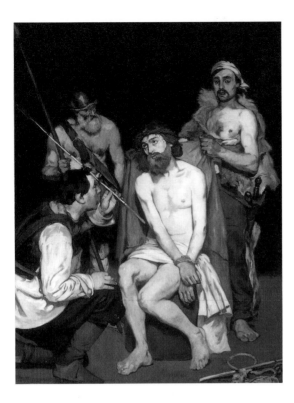

8 Edouard Manet, *The Mocking of Christ*, 1865. Oil on canvas, 190.3 × 148.3 cm. The Art Institute, Chicago, Gift of James Deering, 1925.703.

tinuing power of example, is that at the same time as his art turns inward on its own means and materials – clinging, with a kind of desperation, to the fragments of tradition left to it – it encounters and engages a whole contrary iconography. Its subjects are vulgar; the fastidious action of paint upon them does not soften, but rather intensifies, their awkwardness; the painting's purpose seems to be to show us the artifice of this familiar repertoire of modern life, and call in question the forms in which the city contrives its own appearance. Doing so, as we have seen, excluded Manet's art from the care and comprehension of almost all his contemporaries; though whether that is matter for praise or blame depends, in the end, on our sense of the possible, now and then.

Notes

1 [See chapter 2 of T.J. Clark, *The Painting of Modern Life*, London, 1985].

2 C. MacCabe, 'The Discursive and the Ideological in Film', *Screen*, vol. 19, no. 4, p. 36.

3 A Corbin, *Les Filles de noces. Misère sexuelle et prostitution aux 19e et 20e siècles*, Paris, 1978.

4 Pierrot, 'Histoire de la Semaine – Une première visite au Salon', *Les Tablettes de Pierrot*, 14 May 1865, p. 11; A. J. Lorentz, *Dernier Jour de l'Exposition de 1865*, p. 13.

5 See B. Farwell, *Manet and the Nude, A Study in Iconography in the Second Empire*, unpublished PhD thesis, University of California at Los Angeles, 1973, pp. 199-204.

6 21 May 1865.

7 7 June 1865.

8 L. de Laincel, *L'Echo de Provinces*, 25 June 1865, p 3.

9 P. Gille, *L'International*, 1 June 1865.

10 C. MacCabe, 'On Discourse', *Economy and Society*, vol. 8. no. 3, pp. 303, 307, 308.

Griselda Pollock
Modernity and the Spaces
of Femininity

Source: Griselda Pollock, 'Modernity and the
Spaces of Femininity', *Vision and Difference:
Femininity, Feminism and the Histories of Art,*
London and New York, Routledge, 1988,
pp. 50–90 and pp. 205–9. This text has been
edited and footnotes renumbered accordingly.
Fifteen plates have been omitted.

[...] The schema which decorated the cover of Alfred H. Barr's catalogue for the exhibition *Cubism and Abstract Art* at the Museum of Modern Art, New York, in 1936 is paradigmatic of the way modern art has been mapped by modernist art history [Plate 9]. Artistic practices from the late nineteenth century are placed on a chronological flow chart where movement follows movement connected by one-way arrows which indicate influence and reaction. Over each movement a named artist presides. All those canonized as the initiators of modern art are men. Is this because there were no women involved in early modern movements? No.[1] Is it because those who were, were without significance in determining the shape and character of modern art? No. Or is it rather because what modernist art history celebrates is a selective tradition which normalizes, as the *only* modernism, a particular and gendered set of practices? I would argue for this explanation. As a result any attempt to deal with artists in the early history of modernism who are women necessitates a deconstruction of the masculinist myths of modernism.

These are, however, widespread and structure the discourse of many counter-modernists, for instance in the social history of art. The recent publication *The Painting of Modern Life: Paris in the Art of Manet and his Followers,* by T. J. Clark,[2] offers a searching account of the social relations between the emergence of new protocols and criteria for painting – modernism – and the myths of modernity shaped in and by the new city of Paris remade by capitalism during the Second Empire. [...] Clark puzzles at what structured the notions of modernity which became the territory for Manet and his followers. He thus indexes the Impressionist painting practices to a complex set of negotiations of the ambiguous and baffling class formations and class identities which emerged in Parisian society. Modernity is presented as far more than a sense of being 'up to date' – modernity is a matter of representations and major myths – of a new Paris for recreation, leisure and pleasure, of nature to be enjoyed at weekends in suburbia, of the prostitute taking over and of fluidity of class in the popular spaces of entertainment. The key markers in this mythic territory are leisure, consumption, the spectacle and money. And we can reconstruct from Clark a map of Impressionist territory which stretches from the new boulevards via Gare St Lazare out on the sub-

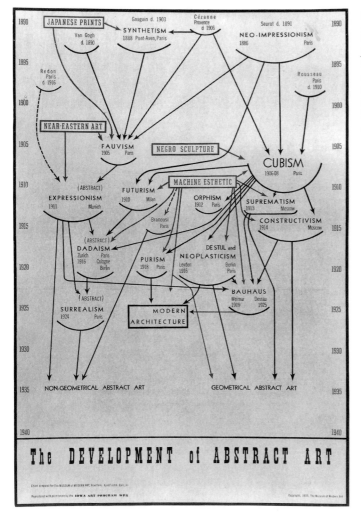

9 *The Development of Abstract Art*, chart prepared by Alfred H. Barr Jr for the jacket cover of the exhibition catalogue *Cubism and Abstract Art*, Museum of Modern Art, New York, 1936. Photograph courtesy, The Museum of Modern Art, New York.

urban train to La Grenouillère, Bougival or Argenteuil. In these sites, the artists lived, worked and pictured themselves [Plate 1]. But in two of the four chapters of Clark's book, he deals with the problematic of sexuality in bourgeois Paris and the canonical paintings are *Olympia,* 1863, [Plate 4] and *A Bar at the Folies-Bergère,* 1881–2 [Plate 10].

It is a mighty but flawed argument on many levels but here I wish to attend to its peculiar closures on the issue of sexuality. For Clark the founding fact is class. Olympia's nakedness inscribes her class and thus debunks the mythic classlessness of sex epitomized in the image of the courtesan.[3] The fashionably blasé barmaid at the Folies evades a fixed identity as either bourgeois or proletarian but none the less participates in the play around class that constituted the myth and appeal of the popular.[4]

Although Clark nods in the direction of feminism by acknowledging that

these paintings imply a masculine viewer/consumer, the manner in which this is done ensures the normalcy of that position leaving it below the threshold of historical investigation and theoretical analysis. To recognize the gender specific conditions of these paintings' existence one need only imagine a female spectator and a female product of the works. How can a woman relate to the viewing positions proposed by either of these paintings? Can a woman be offered, in order to be denied, imaginary possession of Olympia or the barmaid? Would a woman of Manet's class have a familiarity with either of these spaces and its exchanges which could be evoked so that the painting's modernist job of negation and disruption could be effective? Could Berthe Morisot have gone to such a location to canvass the subject? Would it enter her head as a site of modernity as she experienced it? Could she as a woman experience modernity as Clark defines it at all? [...]

So we must enquire why the territory of modernism so often is a way of dealing with masculine sexuality and its sign, the bodies of women – why the nude, the brothel, the bar? What relation is there between sexuality, modernity and modernism. If it is normal to see paintings of women's bodies as the territory across which men artists claim their modernity and compete for leadership of the avant-garde, can we expect to rediscover paintings by women in which they battled with their sexuality in the representation of the male nude? Of course not; the very suggestion seems ludicrous. But why? Because there is a historical asymmetry – a difference socially, economically, subjectively between being a woman and being a man in Paris in the late nineteenth century. This difference – the product of the social structuration

10 Edouard Manet, *A Bar at the Folies-Bergère*, 1881–2. Oil on canvas, 95 × 130 cm. Courtauld Institute Galleries, London, Courtauld Gift 1934.

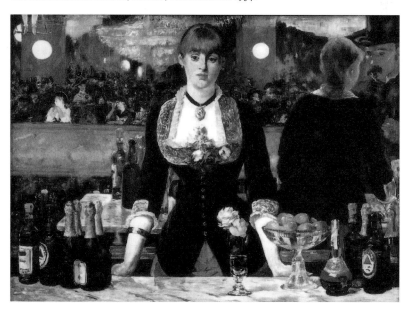

of sexual difference and not any imaginary biological distinction – determined both what and how men and women painted.

I have long been interested in the work of Berthe Morisot (1841-96) and Mary Cassatt (1844-1926), two of the four women who were actively involved with the Impressionist exhibiting society in Paris in the 1870s and 1880s who were regarded by their contemporaries as important members of the artistic group we now label the Impressionists.[5] But how are we to study the work of artists who are women so that we can discover and account for the specificity of what they produced as individuals while also recognizing that, as women, they worked from different positions and experiences from those of their colleagues who were men?

Analysing the activities of women who were artists cannot merely involve mapping women on to existing schemata, even those which claim to consider the production of art socially and address the centrality of sexuality. We cannot ignore the fact that the terrains of artistic practice and of art history are structured in and structuring of gender power relations. [...]

This leads to a major aspect of the feminist project, the theorization and historical analysis of sexual difference. Difference is not essential but understood as a social structure which positions male and female people asymmetrically in relation to language, to social and economic power and to meaning. Feminist analysis undermines one bias of patriarchal power by refuting the myths of universal or general meaning. Sexuality, modernism or modernity cannot function as given categories to which we add women. That only identifies a partial and masculine viewpoint with the norm and confirms women as other and subsidiary. Sexuality, modernism or modernity are organized by and organizations of sexual difference. To perceive women's specificity is to analyse historically a particular configuration of difference.

This is my project here. How do the socially contrived orders of sexual difference structure the lives of Mary Cassatt and Berthe Morisot? How did that structure what they produced? The matrix I shall consider here is that of space.

Space can be grasped in several dimensions. The first refers us to spaces as locations. What spaces are represented in the paintings made by Berthe Morisot and Mary Cassatt [Plates 11 and 12]? And what are not? A quick list includes:

dining-rooms
drawing-rooms
bedrooms
balconies/verandas
private gardens

The majority of these have to be recognized as examples of private areas or domestic space. But there are paintings located in the public domain, scenes for instance of promenading, driving in the park, being at the theatre, boating. They are the spaces of bourgeois recreation, display and those social rituals which constituted polite society, or Society, Le Monde. In the case of Mary Cassatt's work, spaces of labour are included, especially those involving

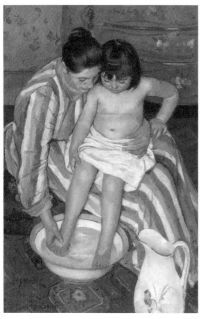

11 Mary Cassatt, *The Bath*, 1892. Oil on canvas, 99.2 × 66.1 cm.
The Art Institute, Chicago, Robert A. Waller Fund, 1910.2.

12 Berthe Morisot, *In the Dining Room*, 1886. Oil on canvas, 61.3 × 50 cm.
National Gallery of Art, Washington, Chester Dale Collection.

child care [Plate 11]. In several examples, they make visible aspects of
working-class women's labour within the bourgeois home.

[...] A range of places and subjects was closed to them while open to their
male colleagues who could move freely with men and women in the socially
fluid public world of the streets, popular entertainment and commercial or
casual sexual exchange.

The second dimension in which the issue of space can be addressed is that
of the spatial order within paintings. Playing with spatial structures was one
of the defining features of early modernist painting in Paris, be it Manet's
witty and calculated play upon flatness or Degas's use of acute angles of
vision, varying viewpoints and cryptic framing devices. With their close per-
sonal contacts with both artists, Morisot and Cassatt were no doubt party to
the conversations out of which these strategies emerged and equally subject
to the less conscious social forces which may well have conditioned the pre-
disposition to explore spatial ambiguities and metaphors. Yet although there
are examples of their using similar tactics, I would like to suggest that spatial
devices in the work of Morisot and Cassatt work to a wholly different effect.

A remarkable feature in the spatial arrangements in paintings by Morisot is
the juxtaposition on a single canvas of two spatial systems – or at least of two
compartments of space often obviously boundaried by some device such as a
balustrade, balcony, veranda or embankment whose presence is underscored

by facture. [...] What Morisot's balustrades demarcate is not the boundary between public and private but between the spaces of masculinity and of femininity inscribed at the level of both what spaces are open to men and women and what relation a man or woman has to that space and its occupants.

In Morisot's paintings, moreover, it is as if the place from which the painter worked is made part of the scene, creating a compression or immediacy in the foreground spaces. This locates the viewer in that same place, establishing a notional relation between the viewer and the woman defining the foreground, therefore forcing the viewer to experience a dislocation between her space and that of a world beyond its frontiers.

Proximity and compression are also characteristic of the works of Cassatt. Less often is there a split space but it occurs, as in *Susan on a Balcony*, 1883 [Plate 14]. More common is a shallow pictorial space which the painted figure dominates: *Young Woman in Black (Mrs Gardner Cassatt)*, 1883 [Plate 13]. The viewer is forced into a confrontation or conversation with the painted figure while dominance and familiarity are denied by the device of the averted head of concentration on an activity by the depicted personage. What are the conditions for this awkward but pointed relation of the figure to the world? Why this lack of conventional distance and the radical disruption of what we take as the normal spectator-text relations? What has disturbed the 'logic of the gaze'?

In a previous monograph on Mary Cassatt I tried to establish a correspondence between the social space of the represented and the pictorial space of the representation.[6] Considering the painting *Lydia, at a Tapestry Frame*, 1881 [Plate 15], I noted the shallow space of the painting which seemed inadequate to contain the embroidery frame at which the artist's sister works. I tried to explain its threatened protrusion beyond the picture's space into that of the viewer as a comment on the containment of women and read the painting as a statement of resistance to it. In *Lydia Crocheting in the Garden*, 1880, the woman is not placed in an interior but in a garden. Yet this outdoor space seems to collapse towards the picture plane, again creating a sense of compression. The comfortable vista beyond the figure, opening out to include a view and the sky beyond as in Caillebotte's *Garden at Petit Gennevilliers with Dahlias*, 1893, is decisively refused. [...]

In the case of Mary Cassatt I would now want to draw attention to the disarticulation of the conventions of geometric perspective which had normally governed the representation of space in European painting since the fifteenth century. Since its development in the fifteenth century, this mathematically calculated system of projection had aided painters in the representation of a three-dimensional world on a two-dimensional surface by organizing objects in relation to each other to produce a notional and singular position from which the scene is intelligible. It establishes the viewer as both absent from and indeed independent of the scene while being its mastering eye/I.

It is possible to represent space by other conventions. Phenomenology has been usefully applied to the apparent spatial deviations of the work of Van

13 Mary Cassatt, *Young Woman in Black (Mrs Gardner Cassatt)*, 1883. Oil on canvas,
80.6 × 64.6 cm. The Peabody Institute of the City of Baltimore on extended loan to
The Baltimore Museum of Art L.1964.018.

14 Mary Cassatt, *Susan on a Balcony Holding a Dog*, 1883. Oil on canvas, 100.3 × 64.7. In the
collection of The Corcoran Gallery of Art, Washington, Museum Purchase, Gallery Fund.

15 Mary Cassatt, *Lydia, at a Tapestry Frame*, c.1881. Oil on canvas, 65.5 × 92 cm.
Flint Institute of Arts, Flint, Michigan, Gift of the Whiting Foundation.

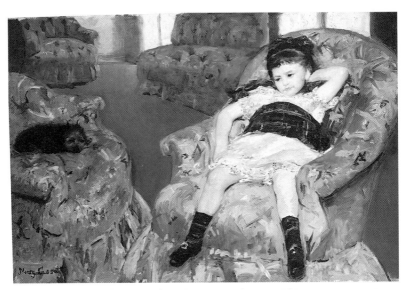

16 Mary Cassatt, *Young Girl in a Blue Armchair*, 1878. Oil on canvas, 89.5 × 129.8 cm. National Gallery of Art, Washington, Collection of Mr and Mrs Paul Mellon.

Gogh and Cézanne.[7] Instead of pictorial space functioning as a notional box into which objects are placed in a rational and abstract relationship, space is represented according to the way it is experienced by a combination of touch, texture, as well as sight. Thus objects are patterned according to subjective hierarchies of value for the producer. Phenomenological space is not orchestrated for sight alone but by means of visual cues refers to other sensations and relations of bodies and objects in a lived world. As experiential space this kind of representation becomes susceptible to different ideological, historical as well as purely contingent, subjective inflections.

These are not necessarily unconscious. For instance in *Young Girl in a Blue Armchair*, 1878 [Plate 16] by Cassatt, the viewpoint from which the room has been painted is low so that the chairs loom large as if imagined from the perspective of a small person placed amongst massive upholstered obstacles. The background zooms sharply away indicating a different sense of distance from that a taller adult would enjoy over the objects to an easily accessible back wall. The painting therefore not only pictures a small child in a room but evokes that child's sense of the space of the room. It is from this conception of the possibilities of spatial structure that I can now discern a way through my earlier problem in attempting to relate space and social processes. For a third approach lies in considering not only the spaces represented, or the spaces *of* the representation, but the social spaces from which the representation is made and its reciprocal positionalities. The producer is herself shaped within a spatially orchestrated social structure which is lived at both psychic and social levels. The space of the look at the point of production will to some extent determine the viewing point of the spectator at the point of con-

sumption. This point of view is neither abstract nor exclusively personal, but ideologically and historically construed. It is the art historian's job to re-create it – since it cannot ensure its recognition outside its historical moment.

The spaces of femininity operated not only at the level of what is represented, the drawing-room or sewing-room. The spaces of femininity are those from which femininity is lived as a positionality in discourse and social practice. They are the product of a lived sense of social locatedness, mobility and visibility, in the social relations of seeing and being seen. Shaped within the sexual politics of looking they demarcate a particular social organization of the gaze which itself works back to secure a particular social ordering of sexual difference. Femininity is both the condition and the effect.

How does this relate to modernity and modernism? As Janet Wolff has convincingly pointed out, the literature of modernity describes the experience of men.[8] It is essentially a literature about transformations in the public world and its associated consciousness. It is generally agreed that modernity as a nineteenth-century phenomenon is a product of the city. It is a response in a mythic or ideological form to the new complexities of a social existence passed amongst strangers in an atmosphere of intensified nervous and psychic stimulation, in a world ruled by money and commodity exchange, stressed by competition and formative of an intensified individuality, publicly defended by a blasé mask of indifference but intensely 'expressed' in a private, familial context.[9] Modernity stands for a myriad of responses to the vast increase in population leading to the literature of the crowds and masses, a speeding up of the pace of life with its attendant changes in the sense and regulation of time and fostering that very modern phenomenon, fashion, the shift in the character of towns and cities from being centres of quite visible activities – manufacture, trade, exchange – to being zoned and stratified, with production becoming less visible while the centres of cities such as Paris and London become key sites of consumption and display producing what Sennett has labelled the spectacular city.[10]

All these phenomena affected women as well as men, but in different ways. What I have described above takes place within and comes to define the modern forms of the public space changing, as Sennett argues in his book significantly titled *The Fall of Public Man*, from the eighteenth-century formation to become more mystified and threatening but also more exciting and sexualized. One of the key figures to embody the novel forms of public experience of modernity is the flâneur or impassive stroller, the man in the crowd who goes, in Walter Benjamin's phrase, 'botanizing on the asphalt'.[11] The flâneur symbolizes the privilege or freedom to move about the public arenas of the city observing but never interacting, consuming the sights through a controlling but rarely acknowledged gaze, directed as much at other people as at the goods for sale. The flâneur embodies the gaze of modernity which is both covetous and erotic.

But the flâneur is an exclusively masculine type which functions within the matrix of bourgeois ideology through which the social spaces of the city were reconstructed by the overlaying of the doctrine of separate spheres on

to the division of public and private which became as a result a gendered division. In contesting the dominance of the aristocratic social formation they were struggling to displace, the emergent bourgeoisies of the late eighteenth century refuted a social system based on fixed orders of rank, estate and birth and defined themselves in universalistic and democratic terms. The pre-eminent ideological figure is MAN which immediately reveals the partiality of their democracy and universalism. The rallying cry, liberty, equality and fraternity (again note its gender partiality) imagines a society composed of free, self-possessing male individuals exchanging with equal and like. Yet the economic and social conditions of the existence of the bourgeoisie as a class are structurally founded upon inequality and difference in terms both of socio-economic categories and of gender. The ideological formations of the bourgeoisie negotiate these contradictions by diverse tactics. One is the appeal to an imaginary order of nature which designates as unquestionable the hierarchies in which women, children, hands and servants (as well as other races) are posited as naturally different from and subordinate to white European man. Another formation endorsed the theological separation of spheres by fragmentation of the problematic social world into separated areas of gendered activity. This division took over and reworked the eighteenth-century compartmentalization of the public and private. The public sphere, defined as the world of productive labour, political decision, government, education, the law and public service, increasingly became exclusive to men. The private sphere was the world of home, wives, children and servants. [...]

Woman was defined by this other, non-social space of sentiment and duty from which money and power were banished.[12] Men, however, moved freely between the spheres while women were supposed to occupy the domestic space alone. Men came home to be themselves but in equally constraining roles as husbands and fathers, to engage in affective relationships after a hard day in the brutal, divisive and competitive world of daily capitalist hostilities. We are here defining a mental map rather than a description of actual social spaces. [...]

There was none the less an overlap between the purely idological maps and the concrete organization of the social sphere. [...]

As both ideal and social structure, the mapping of the separation of the spheres for women and men on to the division of public and private was powerfully operative in the construction of a specifically bourgeois way of life. [...]

[...] For bourgeois women, going into town mingling with crowds of mixed social composition was not only frightening because it became increasingly unfamiliar, but because it was morally dangerous. It has been argued that to maintain one's respectability, closely identified with femininity, meant *not* exposing oneself in public. The public space was officially the realm of and for men; for women to enter it entailed unforeseen risks. For instance in *La Femme* (1858-60) Jules Michelet exclaimed:

How many irritations for the single woman! She can hardly ever go out in the evening; she would be taken for a prostitute. There are a thousand places where only

men are to be seen, and if she needs to go there on business, the men are amazed, and laugh like fools. For example, should she find herself delayed at the other end of Paris and hungry, she will not dare to enter into a restaurant. She would constitute an event; she would be a spectacle: All eyes would be constantly fixed on her, and she would overhear uncomplimentary and bold conjectures.[13]

The private realm was fashioned for men as a place of refuge from the hurly-burly of business, but it was also a place of constraint. The pressures of intensified individuality protected in public by the blasé mask of indifference, registered in the equally socially induced roles of loving husband and responsible father, led to a desire to escape the overbearing demands of masculine domestic personae. The public domain became also a realm of freedom and irresponsiblity if not immorality. This, of course, meant different things for men and for women. For women, the public spaces thus construed were where one risked losing one's virtue, dirtying oneself; going out in public and the idea of disgrace were closely allied. For the man going out in public meant losing oneself in the crowd away from both demands of respectability. Men colluded to protect this freedom. Thus a woman going out to dine at a restaurant even with her husband present was scandalous, whereas a man dining out with a mistress, even in the view of his friends, was granted a fictive invisibility.[14] [...]

[...] These territories of the bourgeois city were, however, not only gendered on a male/female polarity. They became the sites for the negotiation of gendered class identities and class gender positions. The spaces of modernity are where class and gender interface in critical ways, in that they are the spaces of sexual exchange. The significant spaces of modernity are neither simply those of masculinity, nor are they those of femininity which are as much the spaces of modernity for being the negative of the streets and bars. They are, as the canonical works indicate, the marginal or interstitial spaces where the fields of the masculine and feminine intersect and structure sexuality within a classed order. [...]

Women and the Public Modern

[Mary Cassatt's] *Lydia at the Theatre*, 1879 and *The Loge*, 1882 [Plate 17] situate us in the theatre with the young and fashionable but there could hardly be a greater difference between these paintings and the work by Renoir on this theme, *The First Outing*, 1876 (London, National Gallery), for example.

The stiff and formal poses of the two young women in the painting by Cassatt were precisely calculated as the drawings for the work reveal. Their erect posture, one carefully grasping an unwrapped bouquet, the other sheltering behind a large fan, create a telling effect of suppressed excitement and extreme constraint, of unease in this public place, exposed and dressed up, on display. They are set at an oblique angle to the frame so that they are not contained by its edges, not framed and made a pretty picture for us as in *The Loge* [Plate 18] by Renoir, where the spectacle at which the scene is set and the

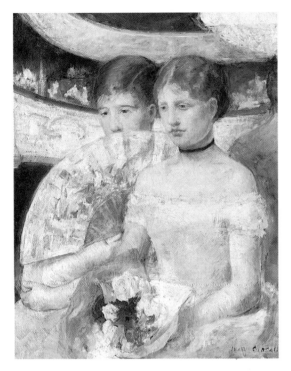

17 Mary Cassatt, *The Loge*, 1882. Oil on canvas, 79.9 × 63.9 cm. National Gallery of Art, Washington, Chester Dale Collection.

18 Auguste Renoir, *The Loge*, 1874. Oil on canvas, 80 × 63.5 cm. Courtauld Institute Galleries, London.

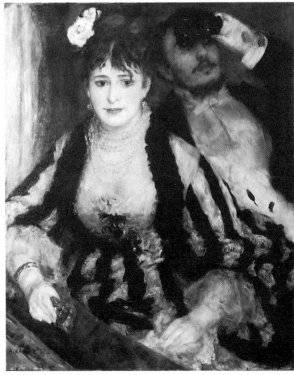

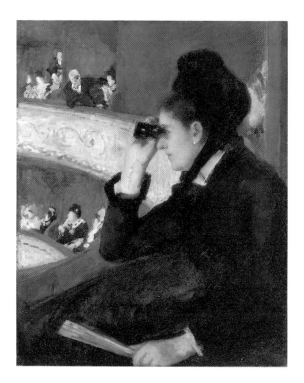

19 Mary Cassatt, *At the Opera*, 1879.
Oil on canvas, 80 × 64.8 cm. Courtesy,
Museum of Fine Arts, Boston, The
Hayden Collection.

spectacle the woman herself is made to offer, merge for the unacknowledged
but presumed masculine spectator. In Renoir's *The First Outing* the choice of
a profile opens out the spectator's gaze into the auditorium and invites
her/him to imagine that she/he is sharing in the main figure's excitement,
while she seems totally unaware of offering such a delightful spectacle. The
lack of self-consciousness is, of course, purely contrived so that the viewer
can enjoy the sight of the young girl.

The mark of difference between the paintings by Renoir and Cassatt is the
refusal in the latter of that complicity in the way the female protagonist is
depicted. In a later painting, *At the Opera,* 1879 [Plate 19], a woman is repre-
sented dressed in daytime or mourning black in a box at the theatre. She
looks from the spectator into the distance in a direction which cuts across the
plane of the picture, but as the viewer follows her gaze another look is
revealed steadfastly fixed on the woman in the foreground. The picture thus
juxtaposes two looks, giving priority to that of the woman who is, remark-
ably, pictured actively looking. She does not return the viewer's gaze, a con-
vention which confirms the viewer's right to look and appraise. Instead we
find that the viewer outside the picture is evoked by being as it were the
mirror image of the man looking in the picture.

This is, in a sense, the subject of the painting – the problematic of women
out in public being vulnerable to a compromising gaze. The witty pun on the
spectator outside the painting being matched by that within should not dis-

guise the serious meaning of the fact that social spaces are policed by men's watching women, and the positioning of the spectator outside the painting in relation to the man within it serves to indicate that the spectator participates in that game as well. The fact that the woman is pictured so actively looking, signified above all by the fact that her eyes are masked by opera glasses, prevents her being objectified and she figures as the subject of her own look. [...]

[...] In the ideological and social spaces of femininity, female sexuality could not be directly registered. This has a crucial effect with regard to the use artists who were women could make of the positionality represented by the gaze of the flâneur – and therefore with regard to modernity. The gaze of the flâneur articulates and produces a masculine sexuality which in the modern sexual economy enjoys the freedom to look, appraise and possess, in deed or in fantasy. Walter Benjamin draws special attention to a poem by Baudelaire, 'A une passante' ('To a passer-by'). The poem is written from the point of view of a man who sees in the crowd a beautiful widow; he falls in love as she vanishes from sight. Benjamin's comment is apt: 'One may say that the poem deals with the function of the crowd not in the life of a citizen but in the life of an erotic person.'[15]

It is not the public realm simply equated with the masculine which defines the flâneur/artist but access to a sexual realm which is marked by those interstitial spaces, the spaces of ambiguity, defined as such not only by the relatively unfixed or fantasizable class boundaries Clark makes so much of but because of cross-class sexual exchange. Women could enter and represent selected locations in the public sphere – those of entertainment and display. But a line demarcates not the end of the public/private divide but the frontier of the spaces of femininity. Below this line lies the realm of the sexualized and commodified bodies of women, where nature is ended, where class, capital and masculine power invade and interlock. It is a line that marks off a class boundary but it reveals where new class formations of the bourgeois world restructured gender relations not only between men and women but between women of different classes. [...]

[...] I hope it will by now be clear that the significance of this argument extends beyond issues about Impressionist painting and parity for artists who are women. Modernity is still with us, ever more acutely as our cities become, in the exacerbated world of postmodernity, more and more a place of strangers and spectacle, while women are ever more vulnerable to violent assault while out in public and are denied the right to move around our cities safely. The spaces of femininity still regulate women's lives – from running the gauntlet of intrusive looks by men on the streets to surviving deadly sexual assaults. In rape trials, women on the street are assumed to be 'asking for it'. The configuration which shaped the work of Cassatt and Morisot still defines our world. It is relevant then to develop feminist analyses of the founding moments of modernity and modernism, to discern its sexualized structures, to discover past resistances and differences, to examine how women producers developed alternative models for negotiating modernity and the spaces of femininity.

Notes

1 For substantive evidence see Lea Vergine, *L'Autre moitié de l'avant-garde, 1910-1940*, translated by Mireille Zanuttin, (Italian edn. 1980), Paris, 1982.

2 T. J. Clark, *The Painting of Modern Life: Paris in the Art of Manet and his Followers*, New York and London, 1984.

3 Clark, op. cit., p. 146.

4 ibid., p. 253.

5 Tamar Garb, *Women Impressionists*, Oxford, 1987. The other two artists involved were Marie Bracquemond and Eva Gonzales.

6 Griselda Pollock, *Mary Cassatt*, London, Jupiter Books, 1980. Contrast G. Caillebotte, *Portraits*, 1877 (New York, private collection).

7 See, for instance, M. Merleau-Ponty, 'Cézanne's Doubt', in *Sense and Nonsense*, translated by Hubert L. Dreyfus and Patricia Allen Dreyfus, Evanston, Illinois, 1961.

8 Janet Wolff, 'The Invisible Flâneuse; Women and the Literature of Modernity', *Theory, Culture and Society*, 2 (3), 1985, pp. 37-48.

9 See George Simmel, 'The metropolis and mental life', in Richard Sennett (ed.), *Classic Essays in the Culture of the City*, New York, 1969.

10 Richard Sennett, *The Fall of Public Man*, Cambridge, 1977, p. 126.

11 Walter Benjamin, *Charles Baudelaire; Lyric Poet in the Era of High Capitalism*, London, 1973, chapter II, 'The flâneur', p. 36.

12 [...] See Bonnie G. Smith, *Ladies of the Leisure Class: The Bourgeoises of Northern France in the Nineteenth Century*, Princeton, 1981.[...]

13 Jules Michelet, *La Femme*, in *Oeuvres complètes* (vol. XVIII, 1858-60), Paris, 1985, p. 413.

14 Sennett, op. cit., p. 23.

15 Benjamin op. cit., p.45.

Author's note Because of editorial constraints, this article has had to be substantially shortened; the author's full argument is to be found in chapter 3 of the original publication, cited on p. 121 above

14 Edward Said
Orientalism

Source: Edward Said, 'Introduction',
Orientalism, London, Routledge and Kegan
Paul, 1978, as reprinted by Penguin Books,
1991, pp. 1–28. Extract from pp. 1–11 and
p. 329. This text has been edited and footnotes
renumbered accordingly.

On a visit to Beirut during the terrible civil war of 1975–6 a French journalist wrote regretfully of the gutted downtown area that 'it had once seemed to belong to ... the Orient of Chateaubriand and Nerval.'[1] He was right about the place, of course, especially so far as a European was concerned. The Orient was almost a European invention, and had been since antiquity a place of romance, exotic beings, haunting memories and landscapes, remarkable experiences. Now it was disappearing; in a sense it had happened, its time was over. Perhaps it seemed irrelevant that Orientals themselves had something at stake in the process, that even in the time of Chateaubriand and Nerval Orientals had lived there, and that now it was they who were suffering; the main thing for the European visitor was a European representation of the Orient and its contemporary fate, both of which had a privileged communal significance for the journalist and his French readers.

Americans will not feel quite the same about the Orient, which for them is much more likely to be associated very differently with the Far East (China and Japan, mainly). Unlike the Americans, the French and the British – less so the Germans, Russians, Spanish, Portuguese, Italians, and Swiss – have had a long tradition of what I shall be calling *Orientalism*, a way of coming to terms with the Orient that is based on the Orient's special place in European Western experience. The Orient is not only adjacent to Europe; it is also the place of Europe's greatest and richest and oldest colonies, the source of its civilizations and languages, its cultural contestant, and one of its deepest and most recurring images of the Other. In addition, the Orient has helped to define Europe (or the West) as its contrasting image, idea, personality, experience. Yet none of this Orient is merely imaginative. The Orient is an integral part of European *material* civilization and culture. Orientalism expresses and represents that part culturally and even ideologically as a mode of discourse with supporting institutions, vocabulary, scholarship, imagery, doctrines, even colonial bureaucracies and colonial styles. In contrast, the American understanding of the Orient will seem considerably less dense, although our recent Japanese, Korean, and Indochinese adventures ought

now to be creating a more sober, more realistic 'Oriental' awareness. Moreover, the vastly expanded American political and economic role in the Near East (the Middle East) makes great claims on our understanding of that Orient.

It will be clear to the reader [...] that by Orientalism I mean several things, all of them, in my opinion, interdependent. The most readily accepted designation for Orientalism is an academic one, and indeed the label still serves in a number of academic institutions. Anyone who teaches, writes about, or researches the Orient – and this applies whether the person is an anthropologist, sociologist, historian, or philologist – either in its specific or its general aspects, is an Orientalist, and what he or she does is Orientalism. Compared with *Oriental studies* or *area studies*, it is true that the term *Orientalism* is less preferred by specialists today, both because it is too vague and general and because it connotes the high-handed executive attitude of nineteenth-century and early twentieth-century European colonialism. Nevertheless books are written and congresses held with 'the Orient' as their main focus, with the Orientalist in his new or old guise as their main authority. The point is that even if it does not survive as it once did, Orientalism lives on academically through its doctrines and theses about the Orient and the Oriental.

Related to this academic tradition, whose fortunes, transmigrations, specializations, and transmissions are in part the subject of this study, is a more general meaning for Orientalism. Orientalism is a style of thought based upon an ontological and epistemological distinction made between 'the Orient' and (most of the time) 'the Occident'. Thus a very large mass of writers, among whom are poets, novelists, philosophers, political theorists, economists, and imperial administrators, have accepted the basic distinction between East and West as the starting point for elaborate theories, epics, novels, social descriptions, and political accounts concerning the Orient, its people, customs, 'mind', destiny, and so on. *This* Orientalism can accommodate Aeschylus, say, and Victor Hugo, Dante and Karl Marx. [...]

The interchange between the academic and the more or less imaginative meanings of Orientalism is a constant one, and since the late eighteenth century there has been a considerable, quite disciplined – perhaps even regulated – traffic between the two. Here I come to the third meaning of Orientalism, which is something more historically and materially defined than either of the other two. Taking the late eighteenth century as a very roughly defined starting point Orientalism can be discussed and analysed as the corporate institution for dealing with the Orient – dealing with it by making statements about it, authorizing views of it, describing it, by teaching it, settling it, ruling over it: in short, Orientalism as a Western style for dominating, restructuring, and having authority over the Orient. I have found it useful here to employ Michel Foucault's notion of a discourse, as described by him in *The Archaeology of Knowledge* and in *Discipline and Punish*, to identify Orientalism. My contention is that without examining Orientalism as a discourse one cannot possibly understand the enormously systematic

discipline by which European culture was able to manage – and even produce – the Orient politically, sociologically, militarily, ideologically, scientifically, and imaginatively during the post-Enlightenment period. Moreover, so authoritative a position did Orientalism have that I believe no one writing, thinking, or acting on the Orient could do so without taking account of the limitations on thought and action imposed by Orientalism. In brief, because of Orientalism the Orient was not (and is not) a free subject of thought or action. This is not to say that Orientalism unilaterally determines what can be said about the Orient, but that it is the whole network of interests inevitably brought to bear on (and therefore always involved in) any occasion when that peculiar entity 'the Orient' is in question. How this happens is what this book tries to demonstrate. It also tries to show that European culture gained in strength and identity by setting itself off against the Orient as a sort of surrogate and even underground self.

Historically and culturally there is a quantitative as well as a qualitative difference between the Franco-British involvement in the Orient and – until the period of American ascendancy after the Second World War – the involvement of every other European and Atlantic power. To speak of Orientalism therefore is to speak mainly, although not exclusively, of a British and French cultural enterprise, a project whose dimensions take in such disparate realms as the imagination itself, the whole of India and the Levant, the Biblical texts and the Biblical lands, the spice trade, colonial armies and a long tradition of colonial administrators, a formidable scholarly corpus, innumerable Oriental 'experts' and 'hands', an Oriental professorate, a complex array of 'Oriental' ideas (Oriental despotism, Oriental splendour, cruelty, sensuality), many Eastern sects, philosophies, and wisdoms domesticated for local European use – the list can be extended more or less indefinitely. My point is that Orientalism derives from a particular closeness experienced between Britain and France and the Orient, which until the early nineteenth century had really meant only India and the Bible lands. From the beginning of the nineteenth century until the end of the Second World War France and Britain dominated the Orient and Orientalism; since the Second World War America has dominated the Orient, and approaches it as France and Britain once did. Out of that closeness, whose dynamic is enormously productive even if it always demonstrates the comparatively greater strength of the Occident (British, French, or American), comes the large body of texts I call Orientalist. [...]

II

I have begun with the assumption that the Orient is not an inert fact of nature. It is not merely *there*, just as the Occident itself is not just *there* either. We must take seriously Vico's great observation that men make their own history, that what they can know is what they have made, and extend it to

geography: as both geographical and cultural entities – to say nothing of historical entities – such locales, regions, geographical sectors as 'Orient' and 'Occident' are man-made. Therefore as much as the West itself, the Orient is an idea that has a history and a tradition of thought, imagery, and vocabulary that have given it reality and presence in and for the West. The two geographical entities thus support and to an extent reflect each other.

Having said that, one must go on to state a number of reasonable qualifications. In the first place, it would be wrong to conclude that the Orient was *essentially* an idea, or a creation with no corresponding reality. When Disraeli said in his novel *Tancred* that the East was a career, he meant that to be interested in the East was something bright young Westerners would find to be an all-consuming passion; he should not be interpreted as saying that the East was *only* a career for Westerners. There were – and are – cultures and nations whose location is in the East, and their lives, histories, and customs have a brute reality obviously greater than anything that could be said about them in the West. About that fact this study of Orientalism has very little to contribute, except to acknowledge it tacitly. But the phenomenon of Orientalism as I study it here deals principally, not with a correspondence between Orientalism and Orient, but with the internal consistency of Orientalism and its ideas about the Orient (the East as career) despite or beyond any correspondence, or lack thereof, with a 'real' Orient. My point is that Disraeli's statement about the East refers mainly to that created consistency, that regular constellation of ideas as the pre-eminent thing about the Orient, and not to its mere being, as Wallace Stevens's phrase has it.

A second qualification is that ideas, cultures, and histories cannot seriously be understood or studied without their force, or more precisely their configurations of power, also being studied. To believe that the Orient was created – or, as I call it, 'Orientalized' – and to believe that such things happen simply as a necessity of the imagination, is to be disingenuous. The relationship between Occident and Orient is a relationship of power, of domination, of varying degrees of a complex hegemony, and is quite accurately indicated in the title of K. M. Panikkar's classic *Asia and Western Dominance*.[2] The Orient was Orientalized not only because it was discovered to be 'Oriental' in all those ways considered commonplace by an average nineteenth-century European, but also because it *could be* – that is, submitted to being – *made* Oriental. There is very little consent to be found, for example, in the fact that Flaubert's encounter with an Egyptian courtesan produced a widely influential model of the Oriental woman; she never spoke of herself, she never represented her emotions, presence, or history. *He* spoke for and represented her. He was foreign, comparatively wealthy, male, and these were historical facts of domination that allowed him not only to possess Kuchuk Hanem physically but to speak for her and tell his readers in what way she was 'typically Oriental'. My argument is that Flaubert's situation of strength in relation to Kuchuk Hanem was not an isolated instance. It fairly stands for the pattern of relative strength between East and West, and the discourse about the Orient that it enabled.

139

This brings us to a third qualification. One ought never to assume that the structure of Orientalism is nothing more than a structure of lies or of myths which, were the truth about them to be told, would simply blow away. I myself believe that Orientalism is more particularly valuable as a sign of European-Atlantic power over the Orient than it is as a veridic discourse about the Orient (which is what, in its academic or scholarly form, it claims to be). Nevertheless, what we must respect and try to grasp is the sheer knitted-together strength of Orientalist discourse, its very close ties to the enabling socio-economic and political institutions, and its redoubtable durability. After all, any system of ideas that can remain unchanged as teachable wisdom (in academies, books, congresses, universities, foreign-service institutes) from the period of Ernest Renan in the late 1840s until the present in the United States must be something more formidable than a mere collection of lies. Orientalism, therefore, is not an airy European fantasy about the Orient, but a created body of theory and practice in which, for many generations, there has been a considerable material investment. Continued investment made Orientalism, as a system of knowledge about the Orient, an accepted grid for filtering through the Orient into Western consciousness, just as that same investment multiplied – indeed, made truly productive – the statements proliferating out from Orientalism into the general culture.

Gramsci has made the useful analytic distinction between civil and political society in which the former is made up of voluntary (or at least rational and non-coercive) affiliations like schools, families, and unions, the latter of state institutions (the army, the police, the central bureaucracy) whose role in the polity is direct domination. Culture, of course, is to be found operating within civil society, where the influence of ideas, of institutions, and of other persons works not through domination but by what Gramsci calls consent. In any society not totalitarian, then, certain cultural forms predominate over others, just as certain ideas are more influential than others; the form of this cultural leadership is what Gramsci has identified as *hegemony*, an indispensable concept for any understanding of cultural life in the industrial West. It is hegemony, or rather the result of cultural hegemony at work, that gives Orientalism the durability and the strength I have been speaking about so far. Orientalism is never far from what Denys Hay has called the idea of Europe,[3] a collective notion identifying 'us' Europeans as against all 'those' non-Europeans, and indeed it can be argued that the major component in European culture is precisely what made that culture hegemonic both in and outside Europe: the idea of European identity as a superior one in comparison with all the non-European peoples and cultures. There is in addition the hegemony of European ideas about the Orient, themselves reiterating European superiority over Oriental backwardness, usually overriding the possibility that a more independent, or more sceptical, thinker might have had different views on the matter.

In a quite constant way, Orientalism depends for its strategy on this flexible *positional* superiority, which puts the Westerner in a whole series of possible

relationships with the Orient without ever losing him the relative upper hand. And why should it have been otherwise, especially during the period of extraordinary European ascendancy from the late Renaissance to the present? The scientist, the scholar, the missionary, the trader, or the soldier was in, or thought about, the Orient because he *could be there*, or could think about it, with very little resistance on the Orient's part. Under the general heading of knowledge of the Orient, and within the umbrella of Western hegemony over the Orient during the period from the end of the eighteenth century, there emerged a complex Orient suitable for study in the academy, for display in the museum, for reconstruction in the colonial office, for theoretical illustration in anthropological, biological, linguistic, racial, and historical theses about mankind and the universe, for instances of economic and sociological theories of development, revolution, cultural personality, national or religious character. Additionally, the imaginative examination of things Oriental was based more or less exclusively upon a sovereign Western consciousness out of whose unchallenged centrality an Oriental world emerged, first according to general ideas about who or what was an Oriental, then according to a detailed logic governed not simply by empirical reality but by a battery of desires, repressions, investments, and projections. [...]

And yet, one must repeatedly ask oneself whether what matters in Orientalism is the general group of ideas overriding the mass of material – about which who could deny that they were shot through with doctrines of European superiority, various kinds of racism, imperialism, and the like, dogmatic views of 'the Oriental' as a kind of ideal and unchanging abstraction? – or the much more varied work produced by almost uncountable individual writers, whom one would take up as individual instances of authors dealing with the Orient. In a sense the two alternatives, general and particular, are really two perspectives on the same material: in both instances one would have to deal with pioneers in the field like William Jones, with great artists like Nerval or Flaubert. And why would it not be possible to employ both perspectives together, or one after the other? Isn't there an obvious danger of distortion (of precisely the kind that academic Orientalism has always been prone to) if either too general or too specific a level of description is maintained systematically?

My two fears are distortion and inaccuracy, or rather the kind of inaccuracy produced by too dogmatic a generality and too positivistic a localized focus. In trying to deal with these problems I have tried to deal with three main aspects of my own contemporary reality that seem to me to point the way out of the methodological or perspectival difficulties I have been discussing, difficulties that might force one, in the first instance, into writing a coarse polemic on so unacceptably general a level of description as not to be worth the effort, or in the second instance, into writing so detailed and atomistic a series of analyses as to lose all track of the general lines of force informing the field, giving it its special cogency. How then to recognize individuality and to reconcile it with its intelligent, and by no means passive or merely dictatorial, general and hegemonic context?

III

[...] It is very easy to argue that knowledge about Shakespeare or Wordsworth is not political whereas knowledge about contemporary China or the Soviet Union is. My own formal and professional designation is that of 'humanist', a title which indicates the humanities as my field and therefore the unlikely eventuality that there might be anything political about what I do in that field. Of course, all these labels and terms are quite unnuanced as I use them here, but the general truth of what I am pointing to is, I think, widely held. One reason for saying that a humanist who writes about Wordsworth, or an editor whose speciality is Keats, is not involved in anything political is that what he does seems to have no direct political effect upon reality in the everyday sense. A scholar whose field is Soviet economics works in a highly charged area where there is much government interest, and what he might produce in the way of studies or proposals will be taken up by policy makers, government officials, institutional economists, intelligence experts. The distinction between 'humanists' and persons whose work has policy implications, or political significance, can be broadened further by saying that the former's ideological colour is a matter of incidental importance to politics (although possibly of great moment to his colleagues in the field, who may object to his Stalinism or fascism or too easy liberalism), whereas the ideology of the latter is woven directly into his material – indeed, economics, politics, and sociology in the modern academy are ideological sciences – and therefore taken for granted as being 'political'.

Nevertheless the determining impingement on most knowledge produced in the contemporary West (and here I speak mainly about the United States) is that it be non-political, that is, scholarly, academic, impartial, above partisan or small-minded doctrinal belief. One can have no quarrel with such an ambition in theory, perhaps, but in practice the reality is much more problematic. No one has ever devised a method for detaching the scholar from the circumstances of life, from the fact of his involvement (conscious or unconscious) with a class, a set of beliefs, a social position, or from the mere activity of being a member of a society. These continue to bear on what he does professionally, even though naturally enough his research and its fruits do attempt to reach a level of relative freedom from the inhibitions and the restrictions of brute, everyday reality. For there is such a thing as knowledge that is less, rather than more, partial than the individual (with his entangling and distracting life circumstances) who produces it. Yet this knowledge is not therefore automatically non-political.

[...] What I am interested in doing now is suggesting how the general liberal consensus that 'true' knowledge is fundamentally non-political (and conversely, that overtly political knowledge is not 'true' knowledge) obscures the highly if obscurely organized political circumstances obtaining when knowledge is produced. No one is helped in understanding this today when the adjective 'political' is used as a label to discredit any work for daring to violate the protocol of pretended suprapolitical objectivity. We may say,

first, that civil society recognizes a gradation of political importance in the various fields of knowledge. To some extent the political importance given a field comes from the possibility of its direct translation into economic terms; but to a greater extent political importance comes from the closeness of a field to ascertainable sources of power in political society. Thus an economic study of long-term Soviet energy potential and its effect on military capability is likely to be commissioned by the Defence Department, and thereafter to acquire a kind of political status impossible for a study of Tolstoy's early fiction financed in part by a foundation. Yet both works belong in what civil society acknowledges to be a similar field, Russian studies, even though one work may be done by a very conservative economist, the other by a radical literary historian. My point here is that 'Russia' as a general subject-matter has political priority over nicer distinctions such as 'economics' and 'literary history', because political society in Gramsci's sense reaches into such realms of civil society as the academy and saturates them with significance of direct concern to it.

I do not want to press all this any further on general theoretical grounds: it seems to me that the value and credibility of my case can be demonstrated by being much more specific, in the way, for example, Noam Chomsky has studied the instrumental connection between the Vietnam War and the notion of objective scholarship as it was applied to cover state-sponsored military research.[4] Now because Britain, France and recently the United States are imperial powers, their political societies import to their civil societies a sense of urgency, a direct political infusion as it were, where and whenever matters pertaining to their imperial interests abroad are concerned. I doubt that it is controversial, for example, to say that an Englishman in India or Egypt in the later nineteenth century took an interest in those countries that was never far from their status in his mind as British colonies. To say this may seem quite different from saying that all academic knowledge about India and Egypt is somehow tinged and impressed with, violated by, the gross political fact – and yet *that is what I am saying* in this study of Orientalism. For if it is true that no production of knowledge in the human sciences can ever ignore or disclaim its author's involvement as a human subject in his own circumstances, then it must also be true that for a European or American studying the Orient there can be no disclaiming the main circumstances of *his* actuality: that he comes up against the Orient as a European or American first, as an individual second. And to be a European or an American in such a situation is by no means an inert fact. It meant and means being aware, however dimly, that one belongs to a power with definite interests in the Orient, and more important, that one belongs to a part of the earth with a definite history of involvement in the Orient almost since the time of Homer.

Put this way, these political actualities are still too undefined and general to be really interesting. Anyone would agree to them without necessarily agreeing also that they mattered very much, for instance, to Flaubert as he wrote *Salammbô*, or to H. A. R. Gibb as he wrote *Modern Trends in Islam*. The trouble is that there is too great a distance between the big dominating fact,

143

as I have described it, and the details of everyday life that govern the minute discipline of a novel or a scholarly text as each is being written. Yet if we eliminate from the start any notion that 'big' facts like imperial domination can be applied mechanically and deterministically to such complex matters as culture and ideas, then we will begin to approach an interesting kind of study. My idea is that European and then American interest in the Orient was political according to some of the obvious historical accounts of it that I have given here, but that it was the culture that created that interest, that acted dynamically along with brute political, economic, and military rationales to make the Orient the varied and complicated place that it obviously was in the field I call Orientalism.

Therefore, Orientalism is not a mere political subject-matter or field that is reflected passively by culture, scholarship, or institutions; nor is it a large and diffuse collection of texts about the Orient; nor is it representative and expressive of some nefarious 'Western' imperialist plot to hold down the 'Oriental' world. It is rather a *distribution* of geopolitical awareness into aesthetic, scholarly, economic, sociological, historical, and philological texts; it is an *elaboration* not only of a basic geographical distinction (the world is made up of two unequal halves, Orient and Occident) but also of a whole series of 'interests' which, by such means as scholarly discovery, philological reconstruction, psychological analysis, landscape and sociological description, it not only creates but also maintains; it *is*, rather than expresses, a certain *will* or *intention* to understand, in some cases to control, manipulate, even to incorporate, what is a manifestly different (or alternative and novel) world; it is, above all, a discourse that is by no means in direct, corresponding relationship with political power in the raw, but rather is produced and exists in an uneven exchange with various kinds of power, shaped to a degree by the exchange with power political (as with a colonial or imperial establishment), power intellectual (as with reigning sciences like comparative linguistics or anatomy, or any of the modern policy sciences), power cultural (as with orthodoxies and canons of taste, texts, values), power moral (as with ideas about what 'we' do and what 'they' cannot do or understand as 'we' do). Indeed, my real argument is that Orientalism is — and does not simply represent — a considerable dimension of modern political-intellectual culture, and as such has less to do with the Orient than it does with 'our' world. [...]

Notes

1 Thierry Desjardins, *Le Martyre du Liban*, Paris, 1976, p. 14.
2 K. M. Panikkar, *Asia and Western Dominance*, London, 1959.
3 Denys Hay, *Europe: The Emergence of an Idea*, 2nd edn, Edinburgh, 1968.
4 Principally in his *American Power and the New Mandarins: Historical and Political Essays*, New York, 1969 and *For Reasons of State*, New York, 1973.

15

Laura Mulvey and Peter Wollen
Frida Kahlo and Tina Modotti

Source: Laura Mulvey and Peter Wollen, *Frida Kahlo and Tina Modotti*, London, Whitechapel Art Gallery, 1982, pp. 7-27, as reprinted in Laura Mulvey, *Visual and Other Pleasures*, Houndsmills, Macmillan, 1989, pp. 81-107. This text has been edited and footnotes renumbered accordingly. Sixteen plates from the original catalogue have been omitted.

On the Margins

André Breton went to Mexico, as to a dreamland, to find there that magic 'point of intersection between the political and the artistic lines beyond which we hope that they may unite in a single revolutionary consciousness while still preserving intact the identities of the separate motivating forces that run through them'.[1] Fatal point, we may think as we survey its histories in this century: art corroded and destroyed by politics; politics smothered and sweetened by art. Yet the hope is necessary. Breton found it particularly in the paintings of Frida Kahlo, in Mexico, in 1938, work which blended reverie, cruelty and sexuality – the surrealist virtues, whose enchantment was heightened for Breton by the connection with Trotsky (then living in Frida Kahlo's 'Blue House', her self-portrait hanging on his study wall).[2]

Others found the point of intersection elsewhere. The critic of *30/30*,[3] reviewing an exhibition of Tina Modotti's photographs in Mexico City, in 1929, described how she had found 'a clear and concrete solution' to the problem of joining art with propaganda in her emblematic photographs of sickle, corn-cob and bandolier, and other combinations with guitar [see Plate 27, below] or the numbers 27 and 123, referring to the articles in the Mexican Constitution concerning the ownership of land and the rights of labour. She had shown how 'we can make a social art without giving up pure art', how the production of a 'pure aesthetic emotion' through plastic form can be combined with 'revolutionary anecdotism'. Modotti took the formal lessons she had learned from Edward Weston and found a point of intersection with the revolutionary politics she had learned in Mexico.

Breton's hope, the dialectical unity of art and revolution, is one that has haunted the modern period. The fact that it is still no more than a hope for us today demonstrates that none of the solutions sought, by Breton or by others of different tendencies, succeeded with any degree of permanence. The initial *élan* at the moment of intersection has not persisted or been generalized. We are left with a series of talismans, clustered most often at certain places and certain periods -Soviet art of the immediate post-revolutionary years, Berlin Dadaism, French Surrealism, the Mexico renaissance – to which

we may turn back for encouragement and understanding. We need to know what has been achieved and how it was checked and deflected, to construct our own history in its own incompleteness. That is the purpose of this exhibition.

Why Mexico? An exhibition of work by Frida Kahlo and Tina Modotti automatically invites questions about 'marginality' – the status, in terms of mainstream art history as presented in books and museum displays, assigned to Mexican art and to women's art and (in Modotti's case) to photography. The centres of art history are in Europe and the United States; Paris and New York are the last links in a chain which reaches back through Rome and Florence to the classical civilizations of antiquity. Breaks and diversions are to be smoothed over or bracketed off, the 'heterogeneous' to be admitted only as an influence. In this way the originality, scope and richness of Mexican art have been overlooked or underestimated. [...]

Women, Art and Politics

The second issue of marginality posed by this exhibition is that of women's art. At this point, the focus of attention shifts away from the actual historical context in Mexico that influenced Tina Modotti and Frida Kahlo and moves towards the debates which have developed around feminist aesthetics. It is here that the importance of the juxtaposition between the two artists comes into relief. An exhibition of either artist alone would have asserted her individual importance, her specific contribution to an artistic practice (painting or photography) and to women's cultural traditions. But the decision to bring the work of Frida Kahlo and Tina Modotti together is based on something more than the fact that they have been unjustly neglected and that their art and their lives are of great intrinsic interest. The juxtaposition is designed to raise a series of ideas and arguments that are relevant to questions about women's art and feminist aesthetics.[4]

Thus the contrasts, as well as the parallels, suggested by the work of both artists provide a starting-point for the exhibition's line of interest to anyone concerned with art from a feminist perspective. Both were influenced by radical tendencies in contemporary Mexican politics and culture. They were both politically militant. Both found or developed their own aesthetic from under the shadow of a male artist of international repute. Both implicitly challenge 'high art', dominant traditions. It is here that their work has an immediate excitement and interest.

Feminism has always been deeply concerned with questions about representation, with the politics of images. This concern is with the way that 'woman' has been used in male representation, and (the necessary other side of the coin) with women's relegation to a marginal area of culture, specifically excluded from 'high art'. So work on women's art has proceeded on two fronts, both of which are relevant here. First comes a process of archaeological excavation, uncovering women artists overlooked and forgot-

20 Frida Kahlo, *Self-Portrait With Cropped Hair*, 1940. Oil on canvas, 40 × 27.9 cm. Collection, The Museum of Modern Art, New York. Gift of Edgar Kauffmann, Jr.

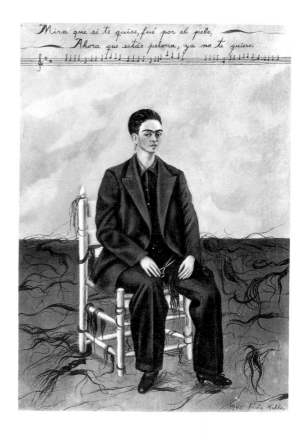

ten by male-dominated criticism. Secondly, there is the confrontation of the questions of value posed by the split between high art and applied arts and the examination of the rationale behind the unbridgeable gap that seems to divide them. In the present context this last point doubles with the discovery of popular traditions of Mexican art during this period (the background to Kahlo's work) and with an avant-garde desire to bring art into dialogue with the modern world and its technology (a contributing factor to Modotti's use of photography as political reportage).

Both Kahlo and Modotti worked in 'dialects' rather than the language of high art. Modotti learnt photography from Edward Weston, whose aesthetic was based on the desire to raise photography from a lesser art and give it the status of high art. Tina's own work shows a steady movement away from this principle. She returned rather to the documentary aspects of photography. The content changed as her work developed but she never lost or compromised her formal aesthetic position. Frida Kahlo's 'dialect' was drawn from folk art and naïve painting, both as part of a contemporary movement to the popular but also as a source of imagery and emotion that was very close to her own preoccupations. The contemporary political and cultural background is essential for an understanding of Frida Kahlo and Tina Modotti's work. But it is the present interest in radical aesthetics, in the breakdown of high art, in

the break-up of art under the impact of other media such as photography, that gives the Mexican background an immediate relevance.

The relationship between the lives and work of both women raises the question of how women come to be artists. The Mexican revolution provided a special context, a stimulus. This is the contribution of history. But in each case, an arbitrary element entered into their lives, changing its normal course and directing them towards unusual choices. This arbitrary element introduces the question of the woman's body, its place in representation and the woman artist's relation to the woman's body in representation [Plate 20]. Kahlo had an accident as a teenager that left her permanently in pain and unable to have children. Her paintings are a visual record of the effect this had on her. Modotti was a great beauty; Edward Weston fell in love with her and used her as a model [Plate 21]. It was her journey to Mexico with him that changed her life. When he went back to the United States, she stayed on, joining the Communist Party and becoming a photographer in her own right. The perspective offered by feminism is in terms of this emphasis on the body, on woman's body as a particular *problem* both as the vehicle for childbearing and as an object of beauty.[5] This perspective takes the arbitrary or chance element back into the political context of history.

Their relationship to the Mexican cultural background was necessarily rather different. Kahlo was an important Mexican artist, given added prominence by the fact that she was married to Diego Rivera, the leading mural artist. Modotti was a foreigner, drawn to Mexico by the events taking place there (as so many foreigners were), arriving as Weston's companion, and then utterly changed by what she found. But this point only highlights the series

21 Edward Weston, *Tina, Mexico,* 1923. Photograph © 1981. Center For Creative Photography, Arizona Board of Regents, University of Arizona, Tucson.

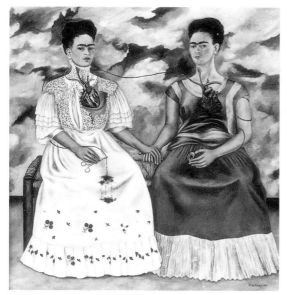

22 Frida Kahlo, *The Two Fridas*, 1939. Oil on canvas, 167 × 167 cm. Museo de Arte Moderno, Mexico City. Photograph by courtesy of CENIDIAP, reproduction authorized by Instituto Nacional de Bellas Artes.

23 Tina Modotti, *Pregnant Woman Carrying a Child*, c.1929. Photograph, Collection Carlos Vidali Carbajal, Mexico

of contrasts and differences that provide the basis for the second level of argument at stake here. It is here that the juxtaposition between the two became crucial. Through their differences they can spark off a new line of thought or argument (like montage in the cinema, where bringing two images together can produce a third idea in the mind of the spectator).

Looking at the work of Tina Modotti and Frida Kahlo side by side, with this hindsight, one is struck immediately by the contrasts between them. While both produced work that is recognizably that of a woman (Modotti sometimes less so than Kahlo), the stance taken up by each as an *artist* is very different. On the one hand Frida Kahlo's work concentrates primarily on the personal, the world of the interior [Plate 22], while Modotti's looks outward, to the exterior world. She photographed the street, women and children in the streets, men at public political meetings [Plates 23 and 24]. In total contrast, Kahlo's subject is herself. She painted her private world of emotional relationships, she found images for her personal experience of pain and her tortured relationship with her body, her obsession with her own image [Plates 25, 26 and 28]. The types of work they produced, therefore, stand in apparent opposition to each other, suggesting two different roads for feminist art; a concern with social problems on the one hand, and private ones on the other. Two points can be introduced here to break down this apparent polarity. First of all, the feminist slogan 'the personal *is* political' recasts Kahlo's private world in a new light. Secondly, Modotti's work as a photographer

24 Tina Modotti, *Workers Reading 'El Machete'*, *c.*1924. Photograph, Collection Carlos Vidali Carbajal, Mexico.

can only be understood in the context of *her* private life and position as a woman. The intention here, then, is to switch over, or rather to blur the distinctions set up by the polarity between them and to bring out the ways in which Kahlo's work is political and Modotti's is personal.

Looking at Frida Kahlo and Tina Modotti's work in relation to their lives and experience as women it is clear that conscious decisions about artistic stance are only to a limited extent the result of conscious, controllable choice. Two other forces are of utmost importance: that of historical heritage and that of individual accident. The relation between these two can be described as that between the necessary and the contingent. The differences between a working-class Italian immigrant to California and a Mexican bourgeois intellectual are of great importance. These social-historical conditions contribute to the artist's stance, to Kahlo's desire to explore herself and her colonized cultural roots through her art, and to Modotti's desire to change the conditions of exploitation and oppression she saw around her, then to devote herself to the international working-class movement. These differences are clear and visible in the two women's places of birth and death. [...]

The Interior and the Exterior

The slogan 'the personal is political' dates back to the days when the Women's Movement was organized around consciousness-raising. The phrase is emphatic and assertive. But in announcing what now *is*, it contains within it the residual ashes, the memory, of what previously *was not*. This argument has been forcefully restated in *Beyond the Fragments*:

Before the women's movement, socialist politics, like all other sorts of politics, seemed something separate from everyday life, something unconnected with looking after children, worrying about the meas and the housework, finding ways of enjoying

yourself with your friends and so on. It was something professional for men among men, for the shop steward or the party activist. The activities of the women's movement have begun to change that as far as women are concerned . But it's meant a different way of organizing which does not restrict political activity to the 'professional'.[6]

The phrase 'the personal is political' rejects the traditional exclusion and repression of the personal in male-dominated politics. And it also asserts the *political* nature of women's private individualized oppression. The main achievement of consciousness-raising lay in providing a structure for women to discover that their problems were no longer 'problems', no longer anybody's 'fault', but were political issues. Out of this immediate experience feminism revalued the private and the personal, challenging the division of the sexes into separate spheres.

These political arguments also influenced feminist aesthetics, and are relevant to any attempt to transform an experience of oppression into a theory of oppression. The principal question is this: what relationship should a new, feminist aesthetic have to the culture of oppression and marginality which has traditionally moulded women's artistic work? This marginality brings particular repercussions in its wake, when it is attached to an ideological concept of femininity and the 'feminine sphere'. Here a metonymic chain of meanings and resonances come into play, fettering women's cultural possibilities. The chain is a series of loose, associative links: woman, stability, the home, private emotion, family, domestic labour and decorative arts. But these links can only acquire meaning in opposition to another chain: man, mobility, work, transcendence, politics, productive labour and art. Thus an opposition develops between the interior and the exterior, the private female and public male as though the feminine sphere was there primarily to give meaning and public significance to its opposite.[7]

Walter Benjamin comments on the institutionalization of the public private distinction around the home:

Under Louis-Philippe the private citizen was born ... For the private citizen, for the first time the living-space became distinguished from the place of work. The former constituted itself as the interior. The office was its complement. The private citizen who in the office took reality into account, required of the interior that it should support him in his illusions. The necessity was all the more pressing since he had no intention of adding social preoccupations to his business ones. In the creation of his private environment he suppressed them both. From this sprang the phantasmagorias of the interior.[8]

Benjamin omits to mention that these phantasmagorias could only exist under the management of a wife. The home, on the scale envisaged here by the private citizen, only materializes as an effect of marriage.

It can be argued that, as women had been 'relegated', so had their creativity. Woman decorated her sphere with applied arts; the personal, private and domestic are the raw material of her self-expression. There is a danger here that a creativity produced by a social condition (the interior/exterior split) should then be theorized as *specific* to women and naturally expressive of

'femininity' as such. There is an important difference between 'femininity as such' and exploring a sphere which is not only assigned to women in a social division of labour, but is neglected and despised by men. In this sense the domestic, and the private lives it generates, are like uncolonized territory or virgin soil, untouched by the masculine. There are several positions that feminist aesthetics can adopt in response to this quandary. Women artists can embrace the domestic and personal, accepting their sphere and using it as a source of imagery and experience, simultaneously paying tribute to the historic relegation of women. But this position can, and should, lead very quickly to analysis of the female condition rather than a celebration of it.

Frida Kahlo's paintings emerge directly out of her life – her physical suffering and her emotional suffering. Living and working within the confines of her childhood home, she took herself as the main subject matter of art and painted her own image and her immediate relationships. Her art forms a material manifestation of her interior experiences, dreams and fantasies. it also seems to act as a 'decoration' of her life and relationships in a similar manner to the way she decorated herself and her house with the colours and objects of Mexican folk art. She painted her friends' portraits and gave her self-portraits (such as the one she painted for Trotsky) to her friends.

This private, personalized world that gave rise to her art seems encapsulated by the fact that she often actually painted from her bed, the most private part of the private world of the home. Kahlo continually gives the impression of consciously highlighting the interface of women's art and domestic space, as though in her life (and in her dress) she was drawing attention to the impossibility of separating the two. However, her art also acts as an ironic, bitter comment on women's experience. The feminine sphere is stripped of reassurance. The haven of male fantasy is replaced by the experience of pain, including the pain associated with her physical inability to live out a feminine role in motherhood. This pain is shown not only in *Childbirth* (1932) and *Henry Ford Hospital* (1932) [Plate 25] but also in the theme of a 'mask' inherent in her self-portraits. The masks fall away, revealing the wounds inflicted by physical illness and accident (her damaged spine, her fractured leg) merging with the wounds inflicted by Rivera, the pain caused by his infidelities, as, for instance, in *Unos Cuantos Piquetitos* (*A Few Small Nips*) (1935) [Plate 26], where a man is shown inflicting the wounds on a woman's body.

In her *Self-Portrait with Cropped Hair* (1940) [Plate 20], painted after Rivera left her in 1939, she makes yet another leap forward from the interior pain caused by her love for Diego to the wound left on the female body by castration. Here, surely, is a direct reference to Freud. Kahlo's painting seems to move through a process of stripping away layers, that of the actual skin over a wound, that of the mask of beauty over the reality of pain, then moving, like an infinite regress, out of the physical into the interior world of fantasy and the unconscious. Perhaps the most important aspect of this stripping away is its implicit rejection of any separation between the real and the psychoanalytic, an assertion of the reality of forces and fantasies that are of all the

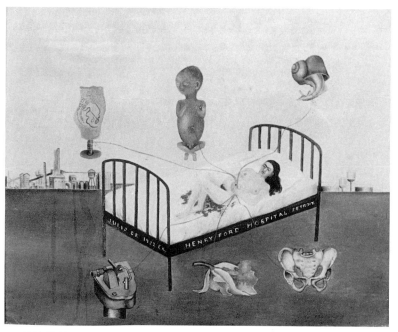

25 Frida Kahlo, *Henry Ford Hospital*, 1932. Oil on metal, 30 × 38 cm. Collection of Dolores Olmedo Foundation, Mexico City. Photograph by courtesy of CENIDIAP, reproduction authorized by Instituto Nacional de Bellas Artes.

26 Frida Kahlo, *A Few Small Nips*, 1935. Oil on plywood, 37.5 × 47.5 cm. Collection of Dolores Olmedo Foundation, Mexico City. Photograph by courtesy of CENIDIAP, reproduction authorized by Instituto Nacional de Bellas Artes.

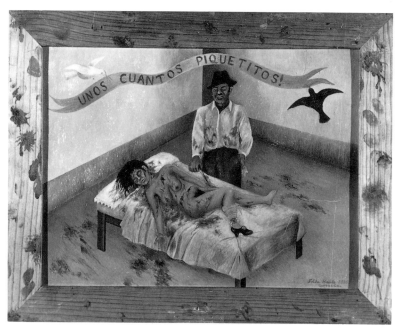

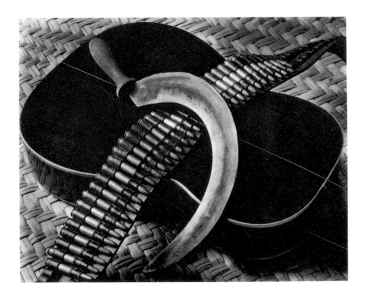

27 Tina Modotti, *Bandolier, Guitar and Sickle,* 1928. Photograph, Collection of Carlos Vidali Carbajal, Mexico.

greater significance because they cannot be seen. Her use of metaphor and iconography is the means that enables her to give concrete form, in art, to interior experience. In this sense she takes the 'interior', offered as the feminine sphere, the male retreat from public life, and reveals the other 'interior' behind it, that of female suffering, vulnerability and self-doubt. Frida Kahlo provides an extremely rare voice for this sphere which, almost by definition, lacks an adequate means of expression or a language.

Tina Modotti gradually transformed herself from an object of beauty, used in the art of others, into a professional photographer. As Weston's model, assistant and, finally, artistic apprentice, her concept of photography was initially dominated by his aestheticism. Gradually her work shows her searching for her own direction, and gaining confidence as her political commitment changed her way of looking at the world. Her photographs do not lose their sense of form; but her priorities change.

During the period when she was deeply absorbed in Mexican political life, Tina's photographs reveal two rather different strands. These different approaches seem to reflect and comment on both the social and political division between the sexes and Tina's own position as a woman photographer. Politics was primarily the sphere of men. In her photographs of Mexican political life, Tina used her background of formal aestheticism to produce an ordered and abstract rhetoric of revolutionary imagery [Plate 27]. Her 'slogan' photographs reflect this aspect of her work, but her photographs of workers and political meetings show the same approach [Plate 24]. The use of formal patterns gives a sense of detachment from the people photographed and a commitment to the political ideas expressed. She must very often have been the only woman at the meetings she photographed. On the other hand, a different approach produces another strand of work in her photographs of women and children. The images of hunger, the oppression of being a child

and childbearing speak for themselves. The images are posed and composed but the gaze of the subjects themselves strikes directly into the camera and out of the print.

Tina's photographs are predominantly of people in public, exterior space. In her own life she was continually on the move: an immigrant in one country, adopting the politics and culture of another, then, as an exile, travelling through Europe as a Communist Party militant. She did not decorate the places she lived in. Manual Alvarez Bravo recalled, 'The walls of her studio were white and clean. Later she started to write some of Lenin's and Marx's phrases on them.'⁹

The fact that Kahlo and Modotti's choices were not developed within a consciousness of women's art diffuses a polemic or antagonism between them. Furthermore the choices they made, consciously or unconsciously, were clearly linked to their own conditions of existence, class, sex, history, even chance, showing up the contingent aspects of artists' work that can so easily disappear under a cloud of genius. Particularly, what they wanted to do and what was possible for them to do, their desires and limitations, were defined by the fact that they were women, however different the kinds of work they produced may have been. [...]

155

The Discourse of the Body

The art of both Kahlo and Modotti had a basis in their bodies: through injury, pain and disability in Frida Kahlo's case, through an accident of beauty in Tina Modotti's. Frida Kahlo sought an iconic vocabulary which could both express and mask the reality of the body. Tina Modotti, whose career began as a film-actress and a model, redirected the look which had focused on her outwards when she herself became a photographer. Kahlo's art became predominantly one of self-portraiture; Modotti's one of depiction of others – predominantly women, but seen with an eye quite different from the one that had looked at her.

Frida Kahlo had about thirty operations in the years between her accident in 1925 and her death in 1954. In the accident her spine was fractured, her pelvis shattered and her foot broken. For long periods she was bed-ridden, in pain and incapacitated. She was unable to have the child she desired and suffered miscarriages and medical abortions. In some respects her painting was a form of therapy, a way of coping with pain, warding off despair and regaining control over the image of her crushed and broken body. Painting brought pleasure, hope and power over herself. It made possible both a triumphant reassertion of narcissism and a symbolization of her pain and suffering. She painted originally for herself and it was not really till Breton recognizd the value and fascination of her work for others that she conceived the possibility of holding exhibitions and marketing the paintings.

The vocabulary which Frida Kahlo found and used was primarily that of traditional Mexican Catholic art, especially depictions of martyrdom and of

the Passion. There is an explicit use of the imagery of the Passion; the wounds of the scourging and the Cucifixion, the knotted cord, the ring of thorns, the simultaneous shining of sun and moon during the tenebrae. The style and iconography are those of popular baroque, in which intensity of expression is given precedence over beauty or dignity, and like most popular forms there is an archaic, almost medieval aspect to the representation, a love of minute detail, a disparity between foreground figure and background setting, a disregard for proportion and perspective. The graphic is systematically favoured rather than the perceptually realistic.

In particular, Kahlo uses the device of the 'emblem'. In *Henry Ford Hospital* [Plate 25] her body on the bed is surrounded by a set of emblematic objects, like those surrounding the crucified Christ in an allegory of redemption. Emblems and attributes are graphic signs which carry a conventional meaning, often in reference to a narrative subtext (attributes) or a common set of beliefs (emblems). At times, Frida Kahlo used complex allegorical schemes, as in *Moses* (1945), with an idiosyncratic personal iconography. Through the resources of emblems, she was able to transcribe her physical pain and suffering into a form of graphic language, which could be read by the spectator. The appeal is not to an imaginary identification with herself as subject of pain but as a symbolic reading of herself as vehicle for suffering as in *The Little Deer* (1946).[10] Hence the common reaction of horror rather than pity, itself associated more with 'low' than 'high' art.

Another mode of representing the body which she used was to draw detailed imagery from anatomical textbooks. Before her accident she had intended to study medicine and her injuries gave her a further reason for studying anatomy. Anatomical organs are often used as emblems – the bleeding heart of Catholic tradition, or the pelvis in *Henry Ford Hospital*. The accuracy of anatomical depiction contrasts with other stylistic aspects of her painting, drawn from an epoch and a milieu without precise anatomical knowledge. The effect produced is not only one of physical fragmentation and dislocation but also a kind of anachronism.

Beauty is another form of accident, one that is prized rather than feared. Yet it is one which can bring with it its own burdens. After her expulsion from Mexico, the ship on which Tina Modotti was deported docked in New Orleans and she was detained for eight days in the Immigration Station there. She wrote to Weston:

The newspapers have followed me, and at time preceded me, with wolf-like greediness – here in the United States everything is seen from the 'beauty' angle – a daily here spoke of my trip and referred to me as 'a woman of striking beauty' – other reporters to whom I refused an interview tried to convince me by saying they would just speak of 'how pretty I was' – to which I answered that I could not possibly see what 'prettiness' had to do with the revolutionary movement nor with the expulsion of Communists – evidently women here are measured by a motion picture standard.[11]

It is ironic, in a way, that this letter should have gone to Weston who did more than anyone else to promote and perpetuate the legend of Tina Modotti's beauty, both through his daybooks and through the photographs

for which she was model, culminating with the famous series of her lying nude on the *azotea* in 1924 [Plate 21]. Tina Modotti also acted as a model for Diego Rivera when he was painting murals in the Agricultural College at Chapingo in 1926. Earlier she had been an actress – playing the fiery Latin vamp in early Hollywood Westerns. When Tina Modotti herself became a photographer she photographed primarily women, but the contrast with Weston's approach could not be greater.

Weston became famous as a photographer of the female nude. He claimed that it was the formal quality of the shape of the female body which interested him and that any erotic motive (and there certainly was one, because he had affairs with the great majority of his models) was suspended in the photographic work. His particular form of voyeurism, of taking woman as an object of gaze, was justified in the terms of pure aesthetic form. About the comments of others on the erotic quality of his work he wrote: 'Others must get from them what they bring to them: evidently they do!'[12] implying also that an erotic interpretation might follow from the 'sexual suppression' he himself did not suffer from. The fact remains, however, that his nude photographs of Tina Modotti are often taken from above, looking down on her as she lies passively, sunbathing or asleep, on the ground, in a conventional pose.

Tina Modotti's photographs were not of 'beauties' but of peasant and proletarian women, marked by the conditions of their life. Often they are mothers with small children, their bodies framed to emphasize not their own form but that of their interaction with the children [Plate 23]. That is to say, they are represented in the process of activity and work, rather than isolated in a pose for the camera. The camera position is often below head height (it is only men who are photographed from above, partly to bring out the circular shape of their hat-brims)[Plate 24]. In her photographs of women especially the careful organization of the composition is not allowed to override the directness of the look.

For Frida Kahlo beauty was inextricably bound up with masquerade. In her self-portraits[Plates 20, 22 and 28], whatever the degree of pain implied, by tears or even wounds, her face remains severe and expressionless with an unflinching gaze. At the same time the mask-like face is surrounded by luxuriant growths, accoutrements, ornaments and familiars – a monkey, a doll, a hairless dog. The ornament borders on fetishism, as does all masquerade, but the imaginary look is that of self-regard, therefore a feminine, non-male and narcissistic look. There is neither coyness nor cruelty, none of the nuance necessary to the male eroticization of the female look. The masquerade serves the purpose of displacement from a traumatic childhood of the subject herself, ever-remembered, ever-repeated.

Throughout Kahlo's work there is a particular fetishization of nature, an imagery of fecundity and luxuriant generation which is clearly a defence against her knowledge of her own barrenness, one of the products of her childhood accident. Veins, fronds and vines often merge in the body itself. There are three modes of self-portraiture: the body damaged, the body

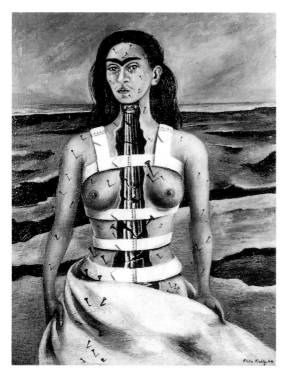

28 Frida Kahlo, *The Broken Column*, 1944.
Oil on masonite, 40 × 32.5 cm. Collection of
Dolores Olmedo Foundation, Mexico City.
Photograph by courtesy of CENIDIAP,
reproduction authorized by Instituto
Nacional de Bellas Artes.

masked and ornamented, the body twined and enmeshed with plants. In
some paintings even the rays of the sun are incorporated in the web. Fruit in
still lifes become part of the body, flesh-like, or like skulls with vacant eyes.
It is as though compensation for her barrenness, and a defence against trauma,
are condensed in pullulating images of cosmic and natural vitality sometimes
counterposed with images of barrenness itself, of lava rock and broken lig-
neous forms.

In a sense, nature is being turned into a complex of signs. Similarly the
body itself becomes a bearer of signs, some legible, some esoteric.
Masquerade becomes a mode of inscription, by which the trauma of injury
and its effects are written negatively in metaphor. It is as if the intensity of the
trauma brings with it a need to transfer the body from the register of image
to that of pictography. Thus faces are read as masks, and ornaments as
emblems and attributes. This discourse of the body is itself inscribed with a
kind of codex of nature and cosmos, in which sun and moon, plant and
animal, are pictograms. At the same time this pictographic effect de-eroti-
cizes the imagery.

Hayden Herrera, writing about Frida Kahlo, writes of 'her nearly beauti-
ful face in the mirror'.[13] The aptness of 'nearly' carries with it a covert recog-
nition of the overt ruin seen in *The Broken Column* [Plate 28] against which
beauty has been constructed as a defence. It is the artifice, the masquerade,
which produces the uneasy feeling of slight mismatch between ostensible fea-
tures and ostensible subject.

Tina Modotti, on the other hand, suffered from the inscription of beauty on her body by others. It is somehow appropriate that while Frida Kahlo is remembered for her jewellery and her extravagant costumes, Tina Modotti is remembered as one of the first women in Mexico to wear jeans.

It is the discourse of the body, together with its political and psychoanalytic implications, which provides a continuity for us with Mexico between the wars. The history of art, as Viktor Shklovsky observed, proceeds by knight's moves, through the oblique and unexpected rather than the linear and predictable. If the art of Frida Kahlo and Tina Modotti has appeared to be detached from the mainstream, this by no means entails any loss of value. In many ways their work may be more relevant than the central traditions of modernism, at a time when, in the light of feminism, the history of art is being revalued and remade.

Notes

1 André Breton, 'Frida Kahlo de Rivera', in *Surrealism and Painting*, New York, 1972.

2 Trotsky arrived in Mexico on 9 January 1937. he was met at the port of Tampico by Frida Kahlo, and stayed with her in the 'Blue House' until May 1939.

3 'Las Fotos de Tina Modotti, El Anecdotismo Revolucionario', *30/30*, 10, 1929.

4 See, for instance, the periodical *Heresies*, New York, from 1977, which still provides the principal forum for debate on women's art and feminist aesthetics.

5 See the periodical *m/f*, London, from 1978, for a continuing debate on 'the discourse of the body'.

6 Sheila Rowbotham, Lynne Segal and Hilary Wainright, *Beyond the Fragments*, London, 1981. For another approach, see Elizabeth Fox-Genovese, 'The Personal is Not Political Enough', *Marxist Perspectives*, 8, Winter 1979-80.

7 In *Old Mistresses*, Routledge and Kegan Paul, London, 1981, Roszika Parker and Griselda Pollock argue that this secondary organization of masculine/feminine antinomy into social and cultural spheres dates from the Victorian period, and comment, 'for women artists have not acted outside cultural history, as many commentators seem to believe, but rather they have been impelled to act within it from a place other than that occupied by men'.

8 Walter Benjamin, 'Louis-Philippe or the Interior', *Charles Baudelaire: Lyric Poet in the Era of High Capitalism*, London, 1973.

9 Manuel Alvarez Bravo, quoted in Mildred Constantine, *Tina Modotti: A Fragile Life*, New York and London, 1975.

10 The metaphor of the 'stricken deer' has a tradition in Mexican poetry. See, for instance, 'Verses Expressing the Feelings of a Lover' by Sor Juana Inez de La Cruz (Juana de Asbaje, 1651-95):

> If thou seest the wounded stag
> that hastens down the mountain-side
> seeking, stricken, in icy stream
> ease for its hurt,
> and thirsting plunges in the crystal waters,
> not in ease, in pain it mirrors me.

Translated by Samuel Beckett in Octavio Paz (ed.), *Anthology of Mexican Poetry*, London, 1959. On the theory of the emblem, and Sor Juana's practice of it, see Robert J. Clements, *Picta Poesis*, Rome, 1960.

11 Letter from Tina Modotti to Edward Weston, quoted in Constantine, *Tina Modotti: A Fragile Life*, p. 175.

12 *The Daybooks of Edward Weston*, vol. 2, p. 32.

13 Herrera, in *Frida Kahlo*, New York, 1982.

Lucy R. Lippard
Mapping

Source: Lucy R. Lippard, 'Mapping', *Mixed Blessings: New Art in a Multicultural America*, New York, Pantheon Books, 1990, pp. 3-18. This text has been edited and footnotes renumbered accordingly. Three plates have been omitted.

[...] This is a time of tantalizing openness to (and sometimes untrustworthy enthusiasms about) 'multiculturalism'. The context does not exist for a nice, seamless narrative and probably never will. I can't force a coherence that I don't experience, and I write with the relational, unfixed feminist models of art always in the back of my mind. As the East Indian scholar Kumkum Sangari has observed, we are now 'poised in a liminal space and an in-between time, which, having broken out of the binary opposition between circular and linear, gives a third space and a different time the chance to emerge.'[1] I write in what white ethnographer James Clifford has called 'that moment in which the possibility of comparison exists in unmediated tension with sheer incongruity ... a permanent ironic play of similarity and difference, the familiar and the strange, the here and the elsewhere'; and I have tried, as he suggests, not to 'explain away those elements in the foreign culture that render the investigator's own culture newly incomprehensible'.[2]

I have followed the lead of Henry Louis Gates, Jr., and others in putting the term 'race' in actual or implied quotation marks, with the understanding that this is a historical rather than a scientific construct. Race is still commonly used when culture is meant, to connote, as Gates observes, some unspecific essence or feeling, the 'ultimate, irreducible difference between cultures, linguistic groups, or adherents of specific belief systems which – more often than not – also have fundamentally opposed economic interests'. Although arbitrary and biologically unsupportable, it is carelessly used 'in such a way as to *will* this sense of *natural* difference into our formulations. To do so is to engage in a pernicious act of difference, one which exacerbates the complex problem of cultural or ethnic difference, rather than to assuage or redress it.'[3] The word 'racism', alas, describes a social phenomenon that is less questionable.

The fact that almost all of the artists whose work is discussed here are people of colour, or 'mixed race', is, however, no coincidence. Without minimizing the economic and psychological toll of racism in this country, and without exaggerating the strengths that have resulted in survival, it is still possible to recognize the depth of African, Native American, Asian, and Latino cultural contributions to an increasingly confused, shallow, and

homogenized Euro-American society. The exclusion of those cultures from the social centres of this country is another mixed blessing. Drawn to the illusory warmth of the melting pot, and then rejected from it, they have frequently developed or offered sanctuary to ideas, images, and values that otherwise would have been swept away in the mainstream.

It is only recently that the ways different cultures cross and fail to cross in the United States have come under scrutiny. More or less taken for granted for two hundred years, the concept of the monotone meltdown pot, which assumed that everyone would end up white, is giving way to a salad, or an *ajiaco* – the flavourful mix of a Latin American soup in which the ingredients retain their own forms and flavours. This model is fresher and healthier; the colours are varied; the taste is often unfamiliar. The recipe calls for an undetermined simmering period of social acclimation.

Demographics alone demand that a society change as its cultural make-up changes. But the contemporary art world, a somewhat rebellious satellite of the dominant culture, is better equipped to swallow cross-cultural influences than to savour them. Its presumed inventiveness occurs mainly within given formal and contextual parameters determined by those who control the markets and institutions. It is not known for awareness of or flexibility in relation to the world outside its white-walled rooms. African American and Latino American artists have been waiting in the wings since the 1960s, when political movements nurtured a new cultural consciousness. Only in the 1980s have they been invited again, provisionally, to say their pieces on a national stage. In the early 1980s the presence of Asian Americans as artists was acknowledged, although they too had been organizing since the early 1970s. Ironically, the last to receive commercial and institutional attention in the urban art worlds have been the 'first Americans', whose land and art have both been colonized and excluded from the realms of 'high art', despite their cultures' profound contributions to it.

The boundaries being tested today by dialogue are not just 'racial' and national. They are also those of gender and class, of value and belief systems, of religion and politics. The borderlands are porous, restless, often incoherent territory, virtual minefields of unknowns for both practitioners and theoreticians. Cross-cultural, cross-class, cross-gender relations are strained, to say the least, in a country that sometimes acknowledges its overt racism and sexism, but cannot confront the underlying xenophobia – fear of the other – that causes them. Participation in the cross-cultural process, from all sides, can be painful and exhilarating. I get impatient. A friend says: remember, change is a process, not an event. [...]

Ethnocentrism in the arts is balanced on a notion of Quality that 'transcends boundaries' – and is identifiable only by those in power. According to this lofty view, racism has nothing to do with art; Quality will prevail; so-called minorities just haven't got it yet. The notion of Quality has been the most effective bludgeon on the side of homogeneity in the modernist and postmodernist periods, despite twenty-five years of attempted revisionism. The conventional notion of good taste with which many of us were raised

and educated was based on an illusion of social order that it is no longer pos-
sible (or desirable) to believe in. We now look at art within the context of
disorder – a far more difficult task than following institutionalized regula-
tions. Time and again, artists of colour and women determined to revise the
notion of Quality into something more open, with more integrity, have been
fended off from the mainstream strongholds by this garlic-and-cross strategy.
Time and again I have been asked, after lecturing about this material, 'But
you can't really think this is Quality?' Such sheep-like fidelity to a single cri-
terion for good art – and such ignorant resistance to the fact that criteria can
differ hugely among classes, cultures, even genders – remains firmly embed-
ded in educational and artistic circles, producing audiences who are afraid to
think for themselves. As African American artist Adrian Piper explains:

> Cultural racism is damaging and virulent because it hits its victims in particularly vul-
> nerable and private places: their preferences, tastes, modes of self-expression, and self-
> image.... When cultural racism succeeds in making its victims suppress, denigrate, or
> reject these means of cultural self-affirmation [the solace people find in entertainment,
> self-expression, intimacy, mutual support, and cultural solidarity], it makes its victims
> hate themselves.[4]

One's own lived experience, respectfully related to that of others, remains
for me the best foundation for social vision, of which art is a significant part.
Personal associations, education, political and environmental contexts, class
and ethnic backgrounds, value systems and market values, all exert their pres-
sures on the interaction between eye, mind, and image. In fact, cross–cultural
perception demands the repudiation of many unquestioned, socially received
criteria and the exhumation of truly 'personal' tastes. It is not easy to get
people to think for themselves when it comes to art because the field has
become mystified to the point where many people doubt and are even
embarrassed by their own responses; artists themselves have become sepa-
rated from their audiences and controlled by the values of those who buy
their work. Art in this country belongs to and is controlled by a specific
group of people. This is not to say that there isn't art being made and loved
by other people, but it has not been consecrated by a touch of the Quality
wand; many of those whose tastes or work differ from mainstream criteria are
either unaware of their difference or don't dare argue with the 'experts';
others, who devote themselves to dissent, remain largely unheard due to
official and self-censorship.

One of the major obstacles to equal exposure is the liberal and conserva-
tive taboo against any and all 'political' statements in art, often exacerbated by
ignorance of and indifference to any other cultural background or context.
Sometimes there is a condescending amazement that powerful work can
actually come from 'foreign' sources. Good or competent mainstream art by
people of colour is often greeted either with silence or with cries of exagger-
ated pleasure: 'Well, what do you know, here's art by an Asian (or African or
Latino or Native) American that doesn't fit our stereotypes!' (or the low
expectations held for it). The dominant culture responds like condescending

parents whose children have surprised them, affording a glimpse of the darker facets of future separation and competition.

Artists often act in the interstices between old and new, in the possibility of spaces that are as yet socially unrealizable. There they create images of a hopeful or horrible future that may or may not come to be. But artists are also often distanced from the world and from the people they hope to be envisioning for and with. The challenge to represent oneself and one's community is sometimes ignored in favour of denial of difference. Confronted by the overwhelming responsibility of self-representation, yet often deprived of the tools with which to achieve it, some deracinated artists of colour escape into the obfuscatory 'personal' and political apathy, distancing themselves from the 'ghettos' of ethnic identity seen by the mainstream as parochial and derivative. Brainwashed by the notion that 'art speaks for itself', artists of all races have often been silenced, abdicating responsibility, doing little to resist the decontextualization of their works (and thus themselves). Others, in an attempt to preserve their identity, fall into the trap of wishful, idealized stereotyping of self and community, or into a rage that is disarmed by borrowed rhetoric.

Recent cracks in the bastions of high culture now allow a certain seepage, the trickle-up presence of a different kind of authenticity that is for the moment fundamentally unfamiliar and therefore genuinely disturbing. Advocates of cultural democracy, of respect for differences and a wider definition of art, are often taunted with the spectre of 'the lowest common denominator'. But art does not become 'worse' as it spreads out and becomes accessible to more people. In fact, the real low ground lies in the falsely beneficent notion of a 'universal' art that smooths over all rough edges, all differences, but remains detached from the lives of most people. The surprises lie along the bumpy, curving side roads, bypassing highways so straight and so fast that we can't see where we are or where we are going. Bruce Chatwin tells the story of an Australian aboriginal man trying desperately to 'sing' or pay homage to the individual features of the land he is driven through by truck at such a speed that both sight and song are blurred beyond recognition.[5]

Modernism opened art up to a broad variety of materials and techniques as well as cultures. Nevertheless, knowledge of one's sources, respect for the symbols, acts, or materials sacred to others cannot be separated from the artistic process, which is – or should be – a process of *consciousness*. Well-meaning white artists and writers who think we are ultra-sensitive often idealize and romanticize indigenous cultures on one hand, or force them into a Western hegemonic analysis on the other hand. And while it is difficult *not* to be moved by the anti-materialism, spirituality, formal successes, and principled communal values of much traditional art, there is no 'proper' or 'politically correct' response by white artists that does not leave something out. But there is a difference between homage and robbery, between mutual exchange and rape. I am not suggesting that every European and Euro-American artist influenced by the power of cultures other than their own

163

should be overwhelmed with guilt at every touch. But a certain humility, an awareness of other cultures' boundaries and contexts, wouldn't hurt. Not to mention a certain tolerance of those with different concerns. As white Australians Tony Fry and Anne-Marie Willis note:

The so-called cultural relativism of the First-World art world that encourages difference is in reality a type of ethnocentrism, for while the value system of the other is acknowledged as different, it is never allowed to function in a way that would challenge the dominant culture's values. ... difference is constructed almost exclusively on a binary model and is therefore bound up with the West's internal dialogues and is a manifestation of its crises and anxieties.[6]

164

Among the pitfalls of writing about art made by those with different cultural backgrounds is the temptation to fix our gaze solely on the familiarities and the unfamiliarities, on the neutral and the exotic, rather than on the area in between – that fertile, liminal ground where new meanings germinate and where common experiences in different contexts can provoke new bonds. The location of meaning too specifically on solider ground risks the loss of those elements most likely to carry us across borders. The uneasy situation of First-World critics acting within or on the dominant culture is sharpened and enlivened by the artists' strategies to disabuse us of our static, long-held, and sometimes treasured illusions concerning the nature of Third-World art. Caren Kaplan, challenging feminist critics to work cross-culturally, warns against 'theoretical tourism ... where the margin becomes a linguistic or critical vacation, a new poetics of the exotic' and suggests that we examine our own 'location in the dynamic of centres and margins. Any other strategy merely consolidates the illusion of marginality while glossing over or refusing to acknowledge centralities.'[7] [...]

Postmodern analysis has raised important questions about power, desire, and meaning that are applicable to cross-cultural exchange (although there are times when it seems to analyse everything to shreds, wallowing in textual paranoia). The most crucial of these insights is the necessity to avoid thinking of other cultures as existing passively in the past, while the present is the property of an active 'Western civilization'.

Both women and artists of colour are struggling to be perceived as subject rather than object, independent participants rather than socially constructed pawns. Since the late 1960s, the feminist movement's rehabilitation of subjectivity in the face of the dominant and loftily 'objective' stance has been one model in the ongoing search for identity within so-called minority groups. It is precisely the false identities to which deconstructionism calls attention that have led women and people of colour to an obsession with self-definition, to a re-creation of identity from the inside out. On the other hand, over-emphasis on static or originary identity and notions of 'authenticity' imposed from the outside can lead to stereotypes and false representations that freeze non-Western cultures in an anthropological present or an archaeological past that denies their heirs a modern identity or political reality on an equal basis with Euro-Americans.

Acknowledgment of existing fragmentation is basically unavoidable, even as the prospect of permanent fragmentation may prove unbearable. The blanket denial of 'totality' and a metaphorical 'essence' encouraged by some deconstructionist theoreticians can be seen as another form of deracination, destabilizing potentially comforting communal identities, pulling the floor (hearth) out from under those who may have just found a home, and threatening the permanent atomization of hard-earned self-respect. 'Such scepticism', says Kumkum Sangari, 'does not take into account either the fact that the post-modern preoccupation with the crisis of meaning is not everyone's crisis (even in the West) or that there are different modes of de-essentialization which are socially and politically grounded and mediated by separate perspectives, goals, and strategies for change in other countries.'[8] A number of artists of colour are creating from the basis of their own lives and experiences despite their understanding of the post-structuralist distrust of the resubjectification of art. 'Without "totality", our politics become emaciated, our politics become dispersed, our politics become nothing but existential rebellion', says African American theologian Cornel West. 'Watch out for the colonization of "decentering"!' At the same time, he calls for

165

a new historiography, a structural analysis beyond the postmodernist base. ... There are still homogeneous representations of our communities, and we must go beyond that to their diversity and heterogeneity. But we also need to get beyond *that* – beyond mainstream and malestream, even beyond the 'positive images' – to undermine binary oppositions of positive and negative: male/female, Black/white, straight/gay, etc. ... Maybe the next step is to see how the dominant notions of whiteness are *parasitic* of blackness. ... I'm as much concerned with how we understand modernity and the dominant culture as with the African-American experience.[9]

White scholar Nancy Hartsock, remarking on the most recent manifestations of self-determination, observes:

Somehow it seems highly suspicious that it is at this moment in history, when so many groups are engaged in 'nationalisms' which involve redefinitions of the marginalized Others, that doubt arises in the academy about the nature of the 'subject'. ... Why is it, exactly at the moment when so many of us who have been silenced begin to demand the right to name ourselves, to act as subjects rather than objects of history, that just then the concept of subjecthood becomes 'problematic'?[10]

The question of difference and separation is not only being played out on the level of personal subjectivity, but is also paramount in discussions of the relationship between 'First' and 'Third' World cultures, especially in the context of a newly aware anthropology, which has been particularly useful in its auto-critical models. This debate is extremely complex, given the multi-levelled tensions within the conservative and the radical discourses, the ongoing, if eroding, hegemony of Western culture, and its current soul-searchings about the appropriate degrees of neo-colonialism with which to approach different cultures. Once the crucial permeability of such encounters is recognized, contradictions are exposed by the very presence of the 'Other', and we see the ways in which the Third World can disrupt the

aesthetic complacency of the First World as it rides precariously on the Western crisis of cultural superiority. [...]

In the art world there remains a divisive either/or attitude toward people of colour, women, gays and lesbians, working people, the poor. This is often as obvious in the Marxist and social-democratic rhetoric of some 'deconstructionists' as it is in the less rigorous rhetoric of conventionally liberal art historians.[11]

Yet I'm inclined to welcome any approach that destabilizes, sometimes dismantles, and looks to the reconstruction or invention of an identity that is both new and ancient, that elbows its way into the future while remaining conscious and caring of its past. Third World intellectuals, wherever they live, are showing the way toward the polyphonous 'oppositional consciousness', or the ability to read and write culture on multiple levels, as Chela Sandoval puts it,[12] or to 'look from the outside in and from the inside out', in the words of Bell Hooks.[13] Maxine Hong Kingston says in *The Woman Warrior*, 'I learned to make my mind large, as the universe is large, so that there is room for paradoxes.'[14]

At the vortex of the political and the spiritual lies a renewed sense of function, even a mission, for art. The new fuels the avant-garde, where 'risk' has been a byword. But new need not mean unfamiliar, or another twist of the picture plane. It can mean a fresh way of looking at shared experience. The real risk is to venture outside of the imposed art contexts, both as a viewer and as an artist, to live the connections with people like and unlike oneself. When culture is perceived as the entire fabric of life – including the arts with dress, speech, social customs, decoration, food – one begins to see art itself differently. In the process of doing so, I have become much more sensitive to, and angered by, the absence of meaning in any of the most beautifully made or cleverly stylized art objects. When it is fashionable for art world insiders to celebrate meaninglessness and the parodists operate on the same level as the parodied, perhaps only those who have been forced outside can make a larger, newly meaningful contribution.

The negation of a single ideal in favour of a multiple viewpoint and the establishment of a flexible approach to both theory and practice in the arts are not the tasks of any single group. Stylistically the artists in this book share little. But they have in common an intensity and a generosity associated with belief, with hope, and even with healing. Whether they are mapping, naming, telling, landing, mixing, turning around, or dreaming, they are challenging the current definitions of art and the foundations of an ethnocentric culture.

The terminology[15] in which an issue is expressed is indicative of the quality of the discourse, and the fact that there are no euphonious ways to describe today's cross-cultural exchange reflects the deep social and historical awkwardness underlying that exchange. [...]

A vital, sensible, and imaginative vocabulary can only be self-generated during the process of self-naming. Even then, consensus is unlikely. Inevitably, there is division in the ranks because frustration, contradiction, and growth are the gears by which the continuing cross-cultural education grinds ahead. From the inside, artists get restless, begin to feel imprisoned or ghettoized by the simplistic aspects even of self-imposed categories. ('Black Art' is so far the most examined example.) From the outside, after an initial period of surprise and dislike, the same categories begin to seem convenient places to keep the image of women, or black people, or Asian Americans. Yet the naming process must continue, if it is to mean anything deeper than internal or external name calling. [...]

At the moment, artists 'of colour' has replaced 'Third-World' artists, which was more or less acceptable to all concerned in the 1970s. Although still used to describe artists living in Third-World countries, it has proved confusing when applied to people of colour born in, or citizens of, the United States. As Vietnamese American film-maker Trinh T. Minh-ha has insisted, 'There is a Third World in every First World and vice-versa.'[16] Like 'the West', the term 'Third World' has now most often a geographical and economic connotation. Artist Paul Kagawa offers a new and radical definition of Third-World art:

Artists who create works which support the values of the ruling-class culture are ruling-class artists, no matter what their colour. The 'Third-World Artist' (hereafter T.W.A.) is one who produces in conscious opposition to the art of the ruling class, not just to cause trouble or to be 'different', but because the artist is sympathetic with 'Third-World' people in other sectors of society and the world. Not all 'Third-World' people are aware of their oppression (or its cause), but all T.W.A.s must be because they are, by our definition, a voice of the oppressed.[17]

Kumkum Sangari objects to 'Third World' on the grounds that it 'both signifies and blurs the functioning of an economic, political, and imaginary geography able to unite vast and vastly differentiated areas of the world into a single "underdeveloped" terrain.'[18]

Is Japan a Third-World country? Is Korea? When the question of definitions came up at a panel discussion in 1988, Korean American artist Yong Soon Min pointed out that even within economically developed countries, Third World remained politically valid because it indicated resistance to Western imperialism and referred to the experience of colonialism.

Similarly, 'American', hemispherically, does not mean from the United States, but from the entire Western hemisphere. 'Anglo America' might once have been a justifiable counterpart to 'Latin America', but now it is becoming demographically outdated, and we have yet to find the phrase that expresses José Marti's bicontinental concept of *Nuestra America* (Our America) with its equal emphasis on indigenous populations. Logically, only Native peoples should be called Americans, and everyone else should be a 'hyphenated' American. (To complicate matters, the hyphen – in 'African-American', for example – is sometimes construed as a divisive insult, as another imposed separation.)

'Minority' artists is another outdated phrase; I use it now and then in anti-repetitive desperation (at least it's one word instead of three). In this hemisphere, of course, people of colour are the minority only in the United States and Canada. Globally, Caucasians are distinctly in the minority. The fact has been a source of empowerment for people of colour in the United States. However, the force of our shared vocabulary is such that, as Sylvia Wynters observes, 'we all know what we mean when we use the category *minority* to apply to an empirical *majority*':

Bill Strickland was the first scholar to note, in a talk given at Stanford in 1980, the strategic use of the term *minority* to *contain* and defuse the *Black* challenge of the sixties.... The term *minority*, however, is an *authentic* term for hitherto repressed Euro-American ethnic groups who, since the sixties, have made a bid to displace Anglo-American cultural dominance with a more inclusive Euro-American mode of hegemony.[19]

Then there is the increasingly popular 'multicultural', which many of us have used for years in grass-roots and academic organizing, although it has already been co-opted in institutional and decidedly non-activist rhetoric. It is confusing because it can be used interchangeably with 'multiracial' (voluntary and conscious, or involuntary mixing); or it can be used to denote biculturalism, as in 'Asian American'.[20] I use it to describe mixed or cross-cultural groups or as a general term for all of the various communities when they are working together, including white.

Finally, the word 'ethnic', which is ambiguous in its application to any group of people anywhere (though it is, significantly, rarely applied to WASPs) who maintain a certain habitual, religious, or intellectual bond to their originary cultures. It sometimes serves as a euphemism for people of colour or 'the Other', and has also been condemned as a vehicle for exclusion.

The vocabulary continues to evolve. 'Cross-cultural', 'transcultural', and 'intercultural', for instance, have not been sorted out and remain interchangeable. While they should apply to culture rather than race (itself a cultural construct), they have all been used euphemistically for cross-racial. I prefer cross-cultural to transcultural, although they mean the same thing, because 'trans' to me implies 'beyond', 'over and above', as in 'transcend', and the last thing we need is another 'universalist' concept that refuses once again to come to grips with difference. Intercultural, suggesting a back-and-forth motion, might be an improvement on cross-cultural, which implies a certain finality – a cross-over or one-way trip from margins to centre, from lower to middle class, rather than a flexible interchange.

Notes

1 Kumkum Sangari, 'The Politics of the Possible', *Cultural Critique*, no. 7, Fall 1987, p. 176.

2 James Clifford, *Predicament of Culture: Twentieth Century Ethnography, Literature and Art*, Cambridge, Mass., 1988, p. 146.

3 Henry Louis Gates, Jr., *'Race', Writing and Difference*, Chicago 1986, p. 5.

4 Adrian Piper, 'Ways of Averting One's Gaze', 1987 (unpublished).

5 Bruce Chatwin, *The Songlines*, New York, 1987.

6 Tony Fry and Anne-Marie Willis, 'Aboriginal Art: Symptom or Success?', *Art in America*, July 1989, pp. 114-15.

7 Caren Kaplan, 'Deterritorializations: The Rewriting of Home and Exile in Western Feminist Discourse', *Cultural Critique* no. 6, Spring 1987, pp. 188-9, 191.

8 Sangari, 'Politics of the Possible', p. 184.

9 Cornel West, interview by Stephanson, p. 51; my notes from 'Show the Right Thing' conference at New York University, Fall 1989, as published in *Z*, November 1989, p. 80.

10 Nancy Hartsock, 'Rethinking Modernism: Minority vs. Majority Theories', from '*The Nature and Context of Minority Discourse*', ed. A. JanMohammed and D. Lloyd, New York, 1990, p. 26.

11 See, for instance, the dialogue between German American art historian Benjamin Buchloh and curator Jean-Hubert Martin of the Pompidou Centre in Paris, in regard to the 'Magiciens de la terre' exhibition at the Pompidou in 1989 (*Art in America*, May 1989, pp. 150-9, 211, 213).

12 Chela Sandoval, quoted in Kaplan, 'Deterritorialization', p. 187.

13 Bell Hooks, *Feminist Theory: From Margin to Centre*, Boston, 1984, p. 27.

14 Maxine Hong Kingston, *The Woman Warrior*, New York, 1977, p. 35.

[**15** In the original publication the part of the text starting with this paragraph forms a separate section devoted to the discussion of terminology and distinguished by a different typeface.]

16 Trinh T. Minh-ha, introduction, *Discourse*, no. 8, 1986.

17 Paul Kagawa, in *Other Sources: An American Essay*, ed. Carlos Villa, San Francisco, San Francisco Institute, 1976, p. 9; somewhat similarly, anthropologist Sally Price goes so far as to define 'Westerners' as 'people with a substantial set of European-derived cultural assumptions', no matter where they are from (letter to the author, 1988).

18 Sangari, 'Politics of the Possible', p. 158.

19 Sylvia Wynters, 'On Disenchanting Discourse: 'Minority' Literary Criticism and Beyond', from '*The Nature and Context of Minority Discourse*', ed. A. JanMohammed and D. Lloyd, New York, 1990, p. 459.

20 The bicultural connotation is that used in Jeff Jones's and Russell T. Cramer's influential 1989 report on 'Institutionalized Discrimination in San Francisco's Funding Patterns'.

169

Part III
Historical Methods
and Critical Perspectives:

Introduction to Part III

During the past twenty five-years the discipline of art history has assimilated concepts and modes of analysis generated within other fields of study: notably, social theory and sociology, psychoanalysis, and forms of structuralist thinking developed within linguistics and anthropology. This intellectual extension beyond the traditional forms of art-historical scholarship (typically based on the writing of monographs, formal analysis of art objects, and histories of style and 'art in social context') has also been accompanied by a series of post-1968 Marxist, feminist and anti-colonial/anti-racist formations active within European and North American societies. The selection of texts within this section reflects and embodies the interaction between conventional modes of art-historical analysis and the conceptual and political developments outlined above.

At the same time, it is important to state that the forms of inquiry identified as belonging to 'traditional' art history have always been various and contrasting. Historiography, understood as the critical examination of the writing of history, has been a feature of art-historical scholarship for many decades. The articles by Richard Shiff and Stephen Eisenman [Texts 18 and 19] represent recent continuations of the historiography of Impressionism and do not rely on methods or theories imported from other disciplinary areas for their force and focus. At the same time, however, the 'naming activity' within art history, for example, the naming of styles, groups of artists, or periods, has been taken up as an issue by writers influenced by linguistics, anthropology and psychoanalysis. Texts by Hal Foster, Rosalind Krauss and Benjamin Buchloh [Texts 20 to 22] show, in different ways, how the operation of 'naming' within art history includes the ascriptions of value and meaning. The three 'P's' discussed within these articles, 'Primitivism', 'Picasso' and 'Painting', articulate dense layers of historical and ideological meaning, tying art-historical discourse into many other areas of human activity and understanding. These include, as the articles show, the Western conception of its non-Western 'other' or 'primitive' [see Said, Text 14], the ideological investment in the notion of individual creation and transcendence signified by the term 'Picasso', and the attempt to order the meaning of social change and conflict through a fixing of 'painting' as the site for

authentic and absolute values. Within these accounts the naming activity is proposed not as a merely secondary activity which simply records the nature of the world, but as a primary act which helps to constitute and maintain particular and partial interpretations of culture and society. It is an open question whether such approaches transform the nature of inquiry and meaning or further elaborate and radicalize the art-historical Academy itself.

Implicated in the process of interpretation and judgement is the issue of power and its economic, political and ideological forms within social relationships. Texts by Serge Guilbaut, Barbara Reise and Anna Chave [Texts 23 to 25] attempt to chart the particular historical and social networks of power within which art and culture in the United States from the 1940s onwards was located. As a feature of the United States Cold War ideological liberalism, Guilbaut argues that Abstract Expressionist painting was mobilized as a vehicle within the United States Government's furtherance of its offensive against the Soviet Union and the 'Communist Threat'. Whatever the values or interests of actual artists or critics related to Abstract Expressionism, the explicit and covert representation of art as emblems of United States freedom, contrasted with the technical and iconographical conservatism of Soviet Socialist Realism, led to the group becoming a symbol of United States cultural superiority, with the concomitant implication (stated openly enough) that United States society was the final and finished form of human development.

Reise and Chave examine two particular, though related, features of the critical and institutional apparatuses imbricated in this network of power. Greenberg's critical ascendancy during the 1950s and 1960s, based on his account of art's essential separateness from social and ideological circumstances, dovetailed with the representation of Abstract Expressionism as the exemplification of this 'free' art in a 'free' society: the United States of America. Reise's history and critique of Greenberg's position and that of his 'group' constitutes one model for the social analysis of an intellectual tradition, shown to be anchored in particular types of personal and group relationships. Chave's more recent article, concerned with Minimalist art from the 1960s onwards, explores the relationship between art, criticism and gender relations, arguing that the power of rhetoric and the rhetoric of power necessarily invoke the status of masculinity as a feature of cultural production.

Both Bourdieu and Darbel and Wallach [Text 17 and 26] are concerned with the function and significance of museums and galleries and their role in the organization and dissemination of 'knowledge'. Both articles demonstrate that the museum, as an institutional form with a particular history, is also a cultural production and therefore open to analysis and evaluation. Rather than being an 'external' and merely supplementary apparatus which shows work and meanings for work made elsewhere, the museum is held to be an important, shaping institution in its own right, capable of exerting pressures and determining choices made by artists, critics and historians.

Wallach's historical account of the Museum of Modern Art, New York,

examines the role of the Museum as prime 'Keeper' for the Modernist art work. Its chief curators, including Alfred H. Barr Jr. and William Rubin, were themselves key 'namers', whose exhibitions and catalogues produced the history of modern art, making particular interpretations and allotting values to the art objects brought within the museum's canon. At the same time, Wallach presents a history of the way in which the Museum has changed and adjusted to the economic and social conditions of United States society in the post-war period. As such, the museum is shown to be both determining and determined by changes within the culture, mutating in the face of the reorganization of global capitalism and the eclipse of United States economic superiority.

Bourdieu and Darbel 'read' the museum through a sociological frame-work, arguing that the institution codifies significant ideological structures within modern Western societies. It operates as a key site for the articulation of Art as a form of consumption and display, mobilizing values and senses of identity within the museum visitor. As a form of sociological inquiry, however, it is important to point out that the 'public' should be conceived not in terms of individuals facing the work of art (as museums typically present the interaction) but rather as a phenomenon of group activity, involving specific social interests and ideologies.

17

**Pierre Bourdieu and
Alain Darbel**
The Love of Art

Source: Pierre Bourdieu and Alain Darbel with
Dominique Schnapper, 'Signs of the Times',
and 'Conclusion', from *The Love of Art:
European Art Museums and their Public*, translated
by Caroline Beattie and Nick Merriman,
Cambridge, Polity Press, 1991, pp. 1-4, 108-
13, 162 and 173. First published in France as
*L'Amour de l'art: les musées d'art européens et leur
public*, Paris, Les Editions de Minuit, 1969. This
text has been edited and footnotes renumbered
accordingly.

Signs of the Times

The religion of art also has its fundamentalists and its modernists, yet these
factions unite in raising the question of cultural salvation in the language of
grace. 'Broadly speaking', writes Pierre Francastel, 'it is an inescapable fact
that, although the existence of tone-deaf people is generally recognized,
everyone imagines they *see* shapes spontaneously and correctly. This is not at
all the case, however, and the number of intelligent people who simply *do not
see* shapes and colours is disconcerting, while other less cultivated individuals
have true vision.'[1] Does this not sound like the mysticism of salvation? 'The
heart has its own order; the intellect has its own order which operates by
means of principle and demonstration.' This is the same logic which results
in granting the evidence and the resources of salvation only to a chosen few
and praising the saintly simplicity of children and of the ignorant: 'Wisdom
transports us to childhood: *nisi efficiamini sicut parvuli*'. 'Do not be surprised at
the sight of simple people who believe without argument.'[2] In the same way,
the mystical representation of the aesthetic experience can lead some aristo-
cratically to reserve this gift of artistic vision they call 'the eye' for the selected
few and can lead others to grant it liberally to the 'poor in spirit'.

It follows that the contrast between the fundamentalists and the modernists
is more apparent than real. The former ask nothing more of the place and the
instruments of worship than that they render the faithful into a state whereby
they can receive grace. Bareness and lack of ornamentation encourage the
asceticism which leads to the beatific vision: 'Although it is good for the
visitor to be welcomed at the doors of the museum by a certain amount of
aching and excitement, as soon as he crosses the threshold he should find the
element without which he cannot have a profound encounter with the
plastic arts: silence.'[3] When it is all a matter of disposition and predispositions
– since there is no rational teaching of that which cannot be learned – how
else can the conditions favourable to the awakening of potentialities which
lie dormant within some people be created? Surely enquiring about the social
or cultural characteristics of visitors already implies that they can be separated
by other differences than those created by the arbitrary distribution of gifts?

Discriminating between visitors by their social class and by their nationality appears, on the one hand, fairly complicated and, on the other, seems to many not to be of much interest or use. Certain museums have even considered this question to be out-moded, in other words inconvenient. ... Many museums acknowledge that they still have not made any efforts or carried out any experiments in this direction and argue that it is impossible to do so.[4]

As Erwin Panofsky tells us:

Where Saint Bernard ... indignantly exclaims: 'What has gold to do in the sanctuary?', Suger requests that all the gorgeous vestments and altar vessels acquired under his administration be laid out in the church. ... Nothing could be further from Suger's mind than to keep secular persons out of the House of God: he wished to accommo-date as great a crowd as possible and wanted only to handle it without disturbances – therefore he needed a larger church. Nothing could seem less justified to him than not to admit the curious to the sacred objects: he wished to display his relics as 'nobly' and 'conspicuously' as he could and wanted only to avoid jostling and rioting.[5]

Thus, those who nowadays think that ritual asceticism and Cistercian starkness are not the only means of attaining communion with a work of art, and who would like to offer easier paths to the faithful, can invoke the patronage of one who, by his purchases of precious stones, rare vases, stained glass windows, enamels and fabrics 'anticipated the unselfish rapacity of the modern museum director'. But are they not inspired, as he was, with the conviction that the work of art contains enough miraculous persuasion within itself to convert or retain souls of noble birth by its power alone? Are they not adherents of this *anagogicus mos*, of this method of elevation which confers on the harmony and radiance (*compactio et claritas*) of material works of art the power to lead to enlightenment, 'transporting one from material objects to immaterial matters' (*de materialibus ad immaterialia transferendo*)?

'When objects have a plastic value, they hold such a suggestive power that it is easier to make it perceptible than to divert attention from it. ... In order to exist, the object must allow itself to be appreciated'.[6] 'A museum should be a place where a drowsy visitor is thrilled by contact with sublime works of art.'[7] 'The real magnet for tourism is historical and artistic curiosity.'[8] 'Instead of taking advantage of this unique and incomparable opportunity of teaching through direct contact with objects, one loses one's way in the series of other educational processes which aim to transmit more or less superficial knowl-edge by means of purely intellectual concepts. Moreover, the lower social classes will never be reached by these didactic methods.'[9] The most lyrical witnesses use the prestige which our civilization bestows on the visual image to convince themselves that the power of attraction of pictorial art has nowa-days correspondingly increased: 'Art', writes René Huyghe, 'has never seemed so important, to the point of becoming an obsession, as in our own day. Never before has it been so widely accessible, so greatly appreciated. Never before has it been so intensively analysed and explained. In this it benefits (particularly as regards painting) from the major role visual images have come to play in our civilization.'[10] Surely someone from this culture of the image is immediately endowed with the necessary culture to decipher the

pictorial work of art, the image of all images? 'The museum has the privilege of speaking the language of the times, which is a language intelligible to all and the same in every country. ... The museum has become part of our way of life. Soon it will be the necessary complement and parallel to all our activities.'[11] In any case, is it not possible to make the power of images serve the cult of the image? 'It is only intelligently organized publicity that can bring a new following, on a previously undreamt-of scale, to our art collections.'[12]

The time has come and the advent of the Kingdom of Art on earth can already be glimpsed: 'It seems immediately and seriously urgent to draw the attention of the authorities to this matter, so that they respond to the new needs and demands of modern populations, which are, as it were, gripped by a new, spiritual, hunger and which are calling for a new terrestrial nourishment.'[13] Eschatological prophecy is the natural crowning of this mystical approach to salvation.

In short, the ancients and the moderns agree in entirely abandoning the fortunes of cultural salvation to the inexplicable vagaries of grace, or to the arbitrary distribution of 'gifts'. It is as if those who speak of culture, for themselves and for others, in other words cultivated people, could not think of cultural salvation in terms other than of the logic of predestination, as if their virtues would be devalued if they had been acquired, and as if all their representation of culture was aimed at authorizing them to convince themselves that, in the words of one highly cultivated elderly person, 'education is innate'. [...]

Conclusion

The same people who will no doubt be amazed that so much trouble has been taken to express a few obvious truths will be annoyed at not recognizing in these truisms the flavour, at once obvious and inexpressible, of their experience of works of art. What is the point, they will say, of knowing where and when Van Gogh was born, of knowing the ups and downs of his life and the periods of his work? When all is said and done, what counts for true art lovers is the pleasure they feel in seeing a Van Gogh painting. And isn't this the very thing that sociology desperately tries to ignore through a sort of reductive and disillusioning agnosticism? In fact, the sociologist is always suspected (according to a logic which is not his or her own, but that of the art lover) of disputing the authenticity and sincerity of aesthetic pleasure by simply describing its conditions of existence. This is because, like any kind of love, the love of art is loath to acknowledge its origins and on the whole it prefers strange coincidences, which can be interpreted as predestined, to collective conditions and conditionings.

A vague awareness of the arbitrary nature of admiration for works of art haunts the experience of aesthetic pleasure. The history of individual or collective taste is sufficient to refute any belief that objects as complicated as works of learned culture, produced according to rules of construction devel-

oped in the course of a relatively autonomous history, should be capable of creating natural preferences by their own power. Only a pedagogic authority can break the circle of 'cultural needs' which allow a lasting and assiduous disposition to cultural practice to be formed only by regular and prolonged practice: children from cultivated families who accompany their parents on their visits to museums or special exhibitions in some way borrow from them their disposition to cultural practice for the time it takes them to acquire in turn their own disposition to practice which will give rise to a practice which is both arbitrary and initially arbitrarily imposed. By designating and consecrating certain works of art or certain places (the museum as well as the church) as worthy of being visited, the authorities invested with the power to impose a cultural arbitrary, in other words, in this specific case, a certain demarcation between what is worthy or unworthy of admiration, love or reverence, can determine the level of visiting of which these works will seem intrinsically, or rather, naturally worthy of admiration and enjoyment. Inasmuch as it produces a culture which is simply the interiorization of the cultural arbitrary, family or school upbringing, through the inculcation of the arbitrary, results in an increasingly complete masking of the arbitrary nature of the inculcation. The myth of an innate taste which owes nothing to the constraints of apprenticeship or to chance influences since it has been bestowed in its entirety since birth, is just one of the expressions of the recurrent illusion of a cultivated nature predating any education, an illusion which is a necessary part of education as the imposition of an arbitrary capable of imposing a disregard of the arbitrary nature of imposed meanings and of the manner of imposing them.

The sociologist does not intend to refute Kant's phrase that 'the beautiful is that which pleases without concept', but rather he or she sets out to define the social conditions which make possible both this experience and the people for whom it is possible (art lovers or 'people of taste') and thence to determine the limits within which it can exist. The sociologist establishes, theoretically and experimentally, that the things which please are the things whose concept is understood or, more precisely, that it is only things whose concept is understood which can give pleasure. He or she also establishes that, consequently, in its learned form, aesthetic pleasure presupposes learning and, in any particular case, learning by habit and exercise, such that this pleasure, an artificial product of art and artifice, which exists or is meant to exist as if it were entirely natural, is in reality a cultivated pleasure.

If what Kant called 'barbarous taste', that is, popular taste, seems to be at variance with the Kantian description of cultivated taste on all points and especially in its insistence on relying on concepts,[14] in reality it simply demonstrates clearly the hidden truth of cultivated taste. Just as Hegel set against the ethics of pure intention, the ethos as 'realized ethics', the pure aesthetic can be opposed in the name of the aesthetic realized in cultivated taste which, as a permanent mode of being, is no less than a 'second nature', in the sense that it surpasses and sublimates primary nature. It is because it is the 'realized aesthetic' or, more precisely, culture (of a class or era) become nature, that the

judgement of taste (and its accompanying aesthetic pleasure) can become a subjective experience which appears to be free and even won over in the face of common culture. The contradictions and ambiguities in the relationship of cultivated individuals with their culture are both promoted and sanctioned by the paradox which defines the realization of culture *as naturalization*. If culture is only achieved by denying itself as such, namely as artificial and artificially acquired, then it is understandable that masters of the judgement of taste seem to attain an experience of aesthetic grace so completely free from the constraints of culture (which it never fulfils so completely as when it surpasses it) and showing so little sign of the long and patient process of apprenticeship of which it is the product, that a reminder of the social conditions and conditionings which made it possible seems at the same time both an obvious fact and an outrage.

178

For culture to fulfil its function of enhancement, it is necessary and sufficient that the social and historical conditions which make possible both the complete possession of culture – a second nature where society recognizes human excellence and which is experienced as a natural privilege – and cultural dispossession, a state of 'nature' in danger of appearing as if it is part of the nature of the people condemned to it, should remain unnoticed.

The deliberate neglect of the social conditions which make possible culture and culture become nature, a cultivated nature with all the appearances of grace and talent but nevertheless learned and therefore 'deserved', is the condition for the existence of the charismatic ideology, which allows culture and especially 'the love of art' to be given the central place they occupy in the bourgeois 'sociodicy'. The heir of bourgeois privileges, not being able to invoke rights of birth (which his or her class historically denied the aristocracy) or the rights of nature, a weapon in the past levelled against nobiliary distinctions which would run the risk of backfiring against bourgeois 'distinction', or the ascetic virtues which allowed the first generation of entrepreneurs to justify their success by their merit, can call on cultivated nature and naturalized culture, on what is sometimes called 'class', by a sort of Freudian slip, on 'education', in the sense of a product of education which seems to owe nothing to education, on '*distinction*', a grace which is merit and a merit which is grace, an unacquired merit which justifies unmerited attainments, namely heritage. In order for culture to fulfil its function of legitimating inherited privileges, it is necessary and sufficient that the link between culture and education, at once obvious and hidden, should be *forgotten* or *denied*. The unnatural idea of a culture given at birth, a cultural gift bestowed on certain people by nature, supposes and produces a blindness to the functions of the institution which ensures the profitability of the cultural inheritance, and legitimates its transmission by hiding the fact that it fulfils this function. The school is in fact the institution which, by its positively irreproachable verdicts, transforms socially conditioned inequalities in matters of culture into inequalities of success, interpreted as inequalities of talent, which are also inequalities of merit.

By symbolically shifting the principle distinguishing them from the other

classes in the fields of economy or culture, or rather, by increasing the strictly economic differences created by the pure possession of material goods through the differences created by the possession of symbolic goods such as works of art or through the search for symbolic distinctions in the manner of using these goods (economic or symbolic) – in short, by making a fact of nature everything which defines their 'worth', in other words, to use the word in the sense used by linguists, their *distinction*, a mark of difference which, as Littré said, is separated from the vulgar 'by a character of elegance, nobility and good form' – the privileged classes of bourgeois society replace the difference between two cultures, products of history reproduced by education, with the basic difference between two natures, one nature naturally cultivated, and the other nature naturally natural. Thus, the sanctification of culture and art, this 'currency of the absolute' which is worshipped by a society enslaved to the absolute of currency, fulfils a vital function by contributing to the consecration of the social order. So that cultured people can believe in barbarism and persuade the barbarians of their own barbarity, it is necessary and sufficient for them to succeed in hiding both from themselves and from others the social conditions which make possible not only culture as a second nature, in which society locates human excellence, and which is experienced as a privilege of birth, but also the legitimated hegemony (or the legitimacy) of a particular definition of culture. Finally, for the ideological circle to be complete, it is sufficient that they derive the justification for their monopoly of the instruments of appropriation of cultural goods from an essentialist representation of the division of their society into barbarians and civilized people.

If this is the function of culture, and if the love of art is the clear mark of the chosen, separating, by an invisible and insuperable barrier, those who are touched by it from those who have not received this grace, it is understandable that in the tiniest details of their morphology and their organization, museums betray their true function, which is to reinforce for some the feeling of belonging and for others the feeling of exclusion. In these sacred places of art such as ancient palaces or large historic residences, to which the nineteenth century added imposing edifices, often in the Greco-Roman style of civic sanctuaries, where bourgeois society deposits relics inherited from a past which is not its own, everything leads to the conclusion that the world of art opposes itself to the world of everyday life, just as the sacred does to the profane: the untouchability of objects, the religious silence which imposes itself on visitors, the puritan asceticism of the amenities, always sparse and rather uncomfortable, the quasi-systematic absence of any information, the grandiose solemnity of decor and decorum, colonnades, huge galleries, painted ceilings, monumental stairways, all seem to serve as reminders that the transition from the profane to the sacred world implies, as Durkheim says, 'a veritable metamorphosis', a radical transformation of the mind, that the establishment of relations between two worlds 'is always a delicate operation in itself, demanding great precautions and a more or less complicated initiation', which 'is quite impossible, unless the profane is to lose its specific character-

istics and become sacred after a fashion and to a certain degree in itself'.[15] If, by its sacred nature, the work of art requires particular dispositions or predispositions, in return it bestows its sanction on those who satisfy these requirements, on the chosen who are themselves chosen by their ability to respond to its call. To grant the work of art the power to awaken the grace of aesthetic inspiration in all people, however culturally disadvantaged they may be, and to produce through itself the conditions of its own diffusion, in accordance with the principle of the emanational mystics, *omne bonum est diffusivum sui*, is to sanction the attribution of all abilities to the unfathomable fates of grace or to the arbitrary of 'talent', whereas in reality they are always the product of unequal education, and thus it is to regard inherited aptitudes as if they were virtues inherent to the person, simultaneously natural and commendable.

The museum presents to all, as a public heritage, the monuments of a past splendour, instruments for the extravagant glorification of the great people of previous times: false generosity, since free entry is also optional entry, reserved for those who, equipped with the ability to appropriate the works of art, have the privilege of making use of this freedom, and who thence find themselves legitimated in their privilege, that is, in their ownership of the means of appropriation of cultural goods, or to paraphrase Max Weber, in their *monopoly* of the manipulation of cultural goods and the institutional signs of cultural salvation.

Notes

1 P. Francastel, 'Problèmes de la sociologie de l'art', in G. Gurvitch, *Traité de sociologie*, Paris, 1960, vol. II, p. 279. [...]

2 *Pascal's Pensées*, tr. Martin Turnell, London, 1962, pp. 281 and 330.

3 *Avant-projet de programme pour le musée du XXème siècle*, photocopy, p.5; cf. also P. Gazzola in *Musées et collections publiques de France*, April-June 1961, pp. 84-5: 'Works on exhibition can only display their expressive meaning freely in a "neutral" setting. It is this atmosphere, which should of course be abstract to the point of being impersonal, but at the same time scrupulously finished in order to guard against introducing irrelevant associations, which creates the ideal psychological conditions for the visitor.' Cf. also M. Nicolle in 'Musées', *Les cahiers de la république des lettres, des sciences et des arts*, XIII, p. 141 : 'The inconvenience of these public classes, gallery talks and guided walks, whose noise so disagreeably disturbs peaceful workers, has already been pointed out.'

4 UNESCO, CUA/87, p.4.

5 E. Panofsky, 'Abbot Suger of St.-Denis', in *Meaning in the Visual Arts*, New York, 1955, pp. 121-3.

6 G. Salles, *Le regard*, 1939, cited by G. Wildenstein, in *Supplément à la Gazette des Beaux-Arts*, no. 1110-11, July-August 1965.

7 A. Lhote, in *Les cahiers*, p. 273.

8 G. Douassain, in *Les cahiers*, p. 368.

9 G. Swarzenski, in *Les cahiers*, p. 153.

10 R. Huyghe, *Discovery of Art*, London, 1959, p. 8.

11 G. Salles, in *Musées et collections publiques de France*, July-September 1956, pp. 138 and 139.

12 G. Pascal, in *Les cahiers*, p. ll7.

13 UNESCO, CUA/87, p. l6.

14 Cf. P. Bourdieu et al., *Photography: A Middle-brow Art*, Cambridge, 1990.

15 E. Durkheim, *The Elementary Forms of the Religious Life*, tr. J.W. Swain, London, 1915, pp. 39-40.

Richard Shiff
Defining 'Impressionism' and
the 'Impression'

Source: Richard Shiff, 'Defining
"Impressionism" and the "Impression"',
*Cézanne and the End of Impressionism A Study of
The Theory, Technique, and Critical Evaluation of
Modern Art*, Chicago and London, The
University of Chicago Press, 1984, pp. 14-20
and 237-9. This text has been edited and foot-
notes renumbered accordingly.

There are two ways to avoid defining a term: withdrawing from the diffi-
culty, or assuming it unnecessary. Proper names and general classifications
render things familiar. Often a name or term becomes so widely used that
one thinks its range of reference could be no clearer. 'Impressionist' is such a
title, employed by art historians and critics with great ease and rarely if ever
given the exclusive definition that one assumes it could readily receive. The
historical record, however, reveals no single moment at which a definition of
the term became bounded and fixed. Indeed, partial or non-exclusive
definitions have been derived from several areas of study; and these interre-
late in a confusing manner. In order to determine exactly who might be a
genuine 'impressionist', both the initial and the more recent commentators
have considered one or more of the following: (1) the social group to which
the artist belonged; (2) the artist's subject-matter; (3) style or technique; and
(4) the artistic goal or purpose. Each category has presented its own peculiar
difficulties.

First, the social group. While this area provides some clear distinctions,
they are of only limited application to the general problem of definition. An
artist might be labelled a genuine impressionist in recognition of his having
voluntarily united with others; in effect, he demonstrates that he considers
himself an impressionist by participating in one or more of the eight inde-
pendent exhibitions called 'impressionist' by the press and by the artists
themselves. In other words, the title 'impressionist' is conferred on anyone
who associates with the group; and, by a principle of commutation, such an
individual's style becomes exemplary of the group style (unless it is radically
deviant). Given a strict application of this criterion of professional affiliation
and personal sympathy, Degas remains an impressionist, even though some
nineteenth-century critics claimed that his style necessarily excluded him;
and Cézanne must be included even though, for many twentieth-century
viewers, his style appears antithetical to impressionism. Acknowledging how
problematic these two cases have always been, one might argue that, at the
very least, the emergence of the loosely organized exhibiting group provided
a focus for the original definition of the impressionist position. 'Impression-
ism', however, also existed outside this social boundary, even within the élite

society of the 'Salon', the annual government-sanctioned presentation of works for public viewing. Ironically, it appeared there in the person of the elderly Corot, who gave moral support to the young independent painters but continued to exhibit among the officially honoured and privileged. On the basis of elements of both subject-matter and style, Corot was described in 1875 as a superior, poetic kind of 'impressionist'.[1] And he was not alone in introducing aspects of the 'new' art to the Salon audience; in 1877, a critical review bearing the title 'L'Impressionnisme au Salon' discussed an extensive movement with almost no reference to the members of the independent group.[2] A somewhat later review distinguished members of two parallel movements, the impressionists of the Salon and 'les impressionnistes purs des expositions indépendantes'.[3] During the 1870s and 1880s, much of what could be seen in Monet, Pissarro, or Degas apparently could also be seen elsewhere. Categorization based on membership in an exhibiting group could never have been definitive since it was from the very start confused by independent considerations of subject-matter and style. Once named, 'impressionism' seemed ubiquitous.

Second, subject-matter. Definitions of impressionism determined by subject-matter, just as those based on social affiliation, lead to awkward inclusions and exclusions. Critics and historians alike have stressed the significance of plein-air subjects – views of the sea, the landscape, city streets, and the *vie moderne* of Parisian cafés. By this standard, however, one would be forced to include a number of artists who at the Salon of 1872 exhibited views of the environs of Paris notable for their simple and direct execution.[4] One of them, Stanislas Lépine, showed later with the independent impressionists, the others did not; but even Lépine is today only rarely discussed as a genuine impressionist, for he lacks a major stylistic characteristic – unconventional bright colour. Théodore Duret, who tended to use stylistic criteria in order to classify the various painters, excluded Lépine for just this reason when he wrote his early, account of the impressionist movement.[5]

Third, style or technique. Like definitions determined by subject-matter, those dependent on observations of style present difficulties. Critics and historians have repeatedly called attention to the bright colour and sketch-like finish of impressionist paintings, but again too many works of the late nineteenth century display these same qualities. Some nineteenth-century critics, most notably Charles Bigot and Henry Houssaye, attempted to define impressionist colour more precisely, linking it to the elimination of effects of chiaroscuro; but such considerations led to the exclusion of Degas from the impressionist camp.[6] It was quite common for Degas to be denied any central role in the development of impressionism for reasons related to his technical procedure, despite his long association with the group that participated in the independent exhibitions and his innovative representation of motion and of modern urban life – clearly aspects of 'impressionist' vision.[7] When viewed in isolation, style does not identify impressionists with ease. [...]

Fourth, the artistic goal or purpose. It might seem consequently that an adequate definition of impressionism would have to be more comprehensive

and synthetic, the result perhaps of a determination of the artistic aim behind the formation of a group of artists who (along with others) shared an interest in a certain kind of subject-matter and certain stylistic innovations. The definition of the goals of impressionist art may indeed inform more purposeful distinctions in the other areas of investigation, but one must take into account the fact that early observers who knew the impressionist painters – among them Jules Castagnary, Théodore Duret, and Georges Rivière – either insisted that the aims of these artists were not unique at all or spoke hardly a word about aims. Instead, technique often became the focus of their commentary. Castagnary, for example, discussed the impressionist paintings exhibited in 1874 with regard to technical innovation: 'the object of art does not change, the means of translation alone is modified'; impressionism should be noted for its 'material means', not its 'doctrines'.[8] Similarly, in writings of the late 1870s, Théodore Duret and Georges Rivière, who were on close terms with the independent group of artists, stressed the technical innovations of the radically sketch-like surface, and noted especially the juxtapositions of touches of unusually bright colour. While Castagnary warned of the danger of such technique becoming idiosyncratic and 'idealized', Duret and Rivière implied that it had simply been necessitated by the concern for a more accurate observation of nature. In their different manners, both Duret and Rivière allowed for variation in an individual's sensation of nature but emphasized that impressionist colour was in fact derived from a nature directly observed, a nature that everyone could experience. In this sense impressionist colour was more 'natural' or 'true to nature'.[9] Neither critic explained openly how the notion of individualized sensation could be reconciled with that of an objective naturalism. This question remains unresolved, usually even unasked, and is of central importance to an understanding of both impressionism and symbolism.

How does one come to understand the apparent contradiction implicit in the notion of an art of specific and perhaps innovative techniques, which seems nevertheless to lack goals particular to itself? In investigating the aim or purpose of impressionism, one encounters in the early critical comments a substitution of means for ends. Critics distinguished impressionist art for the *manner* in which it attempted to render nature, or more specifically, to render the 'impression'. Of course, this manner or style was directed at something, at the expression of a fundamental truth, the 'vérité' so often mentioned in the theoretical and critical documents of the period. When impressionism was seen in the most general terms, as a naturalistic art aiming at truth, its purpose, as Castagnary and others recognized, could hardly be considered new. The independent artists' preoccupation with the 'impression', however, seemed to set them apart, so that their technical devices for rendering the impression – sketch-like brushwork, lack of conventional drawing as well as modelling and composition, and, especially, unconventionally bright, juxtaposed hues – were described as if sought as ends, effects difficult to achieve, having meaning in themselves.[10] These effects were often found in the work of naïve or untrained artists, yet they could be praised as the

product of a most scrupulous and 'advanced' observation of nature if seen in the context of an exhibition of 'naturalistic' painting. As Zola wrote of Jongkind's art in 1868, 'one must be particularly knowledgeable in order to render the sky and the land with this apparent disorder ... here ... everything is true [*vrai*].' [11]

In summary: if the art for which the term 'impressionist' is now usually reserved is to be defined with some precision, it must be understood with regard to specific technical devices applied to a very general problem of both discovery and expression, a problem so fundamental to the art of the late nineteenth century that it often went unstated. The problem is that of the individual's means of arriving at truth or knowledge, and the relation of this individual truth to a universal truth. Impressionists and symbolists shared this traditional concern. The impressionist artists distinguished themselves by the *manner* in which they conceived and responded to the issue. For the impressionist, as the name implies, the concept of the 'impression' provided the theoretical means for approaching the relation of individual and universal truth. The artists' characteristic technical devices, such as accentuated ('spontaneous') brushwork and bright colour, are signs of their practical application of the theory of the impression.

The term 'impression' can bear very physical signification, as when it is synonymous with 'imprint'. It suggests the contact of one material force or substance with another, resulting in a mark, the trace of the physical interaction that has occurred. Photographs are often referred to as impressions, as are the images of one's own vision. In both cases the term 'impression' evokes a mechanistic account of the production of images by means of light; light is conceived as rays or particles which leave their marks or traces upon a surface, whether the photographic film's chemical coating or the eye's retina. The impression is always a surface phenomenon – immediate, primary, undeveloped. Hence, the term was used to describe the first layer of an oil painting, the first appearance of an image that might subsequently become a composite of many such 'impressions'. [12]

As primary and spontaneous, the impression could be associated with particularity, individuality, and originality. Accordingly, any style, if regarded as the sign or trace of an individual artist, could also be the impression left by that artist's true nature upon any surfaces with which he came into contact. By following this line of reasoning, Émile Deschanel (in 1864) explained that the word 'style' derived from 'stylus', the writing tool which leaves a characteristic mark corresponding to the personal touch of the individual; and he could then consider style a true impression: 'Style is ... the mark of the writer, the impression of his natural disposition [*l'impression de son naturel*] in his writing.' [13] In Deschanel's usage, the term 'impression', which one might first regard as a reference to very concrete external events (one object striking another), is extended into the more internalized realm of character, personality, and innate qualities. [14] The romantic critic Théophile Thoré similarly allowed the term to bridge the gap between the external and the internal, the physical and the intellectual or spiritual, when he used it to explain how

'poetry' (the most transcendent artistic quality) differed from 'imitation'. Thoré associated imitation with a photographic imprinting that amounts to a mere copying; 'poetry', in contrast, is 'invention, it is originality, it is the manifested sign of an individual impression [*une impression particulière*]. Poetry is not nature, but the feeling that nature inspires in the artist. It is nature reflected in the human mind.'[15]

The impression, then, can be both a phenomenon of nature and of the artist's own being. In his study of the practice of painting in nineteenth-century France, Albert Boime defines the term 'impression' as it came to be used by painters and their critics, and stresses its dual association with an 'accurate' view of nature and an individualized or 'original' sensation belonging to a particular artist. Boime also notes the importance of the related concept of the 'effect' (*effet*) for both academic artists and independents such as Jongkind and Monet. He states that the term 'impression' was nearly interchangeable with 'effect'. Consequently, a painting entitled *Effect of Sunrise* might also be labelled *Impression of Sunrise*; but, as Boime writes, 'the distinction is this: the impression took place in the spectator-artist, while the effect was the external event. The artist-spectator therefore received an impression of the effect; but the effect seized at any given instant was the impression received.'[16] Boime proceeds to ask why impressionists such as Monet tended to describe their works as impressions rather than effects: 'The answer resides in the subjective connotation of this term.'[17] The impressionist, that is, wished to call attention to the particularity or originality of *his* sensation of nature. It was his sensation; yet, as Boime writes, it was considered to represent the external effect with 'accuracy'. Boime leaves aside the epistemological issue of the impression at this point in order to pursue the significance of the nineteenth-century notion of originality. [...] His discussion raises two perplexing questions which remain unanswered: To what extent can the rendering of an admittedly subjective impression be thought of as revealing an external effect? And how can the 'accuracy' of the presentation of this effect (and the artistic sincerity and originality associated with it) ever be evaluated by a critical observer? To deal with the first question entails an investigation of the concept of the impression as it is found outside artistic circles, in the field of psychology; and to approach the second involves a consideration of the concept of 'truth' (*vérité*) among painters and their critics.[18]

It was not until the nineteenth century that psychology, the study of sensation, emotion, and thought, came to be generally regarded not merely as a branch of metaphysics but as a natural science, an area of empirical research into the physiology of perception.[19] Terms such as 'physiologie psychique', 'psychophysiologie', and 'psychophysique' were commonly used. One of the standard definitions of the word 'impression', in accord with David Hume's use of the term, was of direct relevance to the new psychologists: the impression is the 'effect produced on the bodily organs by the action of external objects' or, more specifically, the 'more or less pronounced effect that external objects make upon the sense organs'.[20] The latter quotation is from the dictionary written by Émile Littré, the noted positivist who was himself

involved with studies in the new psychology. In 1860 he published a general statement on the problem of perception and knowledge of the external world. For Littré an external object cannot be known; only the individual's impression of it is known as real or true. In other words, one can never have absolute knowledge of the external world in the manner that one does have absolute knowledge (or experience) of an impression; one's view of the world is induced from one's experience of impressions and is necessarily relative.[21] The significance of Littré's argument for the questions under discussion lies in the implication that the most personal impression, if somehow presented publicly (say, by means of a painting), would reveal as much 'truth' about the world as would any other genuine impression.[22] As a result, the rendering of an impression could be an 'accurate' expression of both the artist and his natural environment.

Littré put special emphasis on the primacy of the impression:

Yes, there is something that is primordial, but it is neither the [internal] subject nor the [external] object, neither the self nor the nonself [non-moi]: it is the impression perceived [l'impression perçue]. A perceived impression does not in any sense constitute the idea of the subject or of the object, it is only the element of these ideas [which develop] only when the external impression [i.e., physical resistance or contact] and the internal impression [i.e., pleasure or pain] are repeated a certain number of times.[23]

The impression, in other words, is the embryo of both bodies of one's knowledge, subjective knowledge of self and objective knowledge of the world; it exists prior to the realization of the subject/object distinction. Once that distinction is made, the impression is defined as the interaction of a subject and an object. An art of the impression, the primordial experience, could therefore be seen as both subjective and objective. [...]

In 1904, a number of years after critics had begun to discuss specific impressionist works in terms associated with symbolist art, Fernand Caussy published an article entitled 'Psychologie de l'impressionnisme'. He identified impressionism as an art of rendering the first impression but made a basic distinction between Manet's 'visual realism' and the 'emotional realism' of Monet and Renoir. As Castagnary had done thirty years earlier, Caussy stated that Monet and Renoir presented a distorted idiosyncratic image in accord with their own emotional responses to nature; and for him, as for Castagnary, this would lead to a subjective 'idealism'. In other words, Manet's rendering of the impression was objective, while Monet's was subjective. Nevertheless Caussy argued, the two arts are intimately related, and differ only in that one is the product of an inactive nervous system passively recording visual observations, while the other is the product of irritability and attendant strong emotion.[24] In Caussy's over-extended analysis, one sees the full implications of Castagnary's original comment: '[These artists] are impressionists in the sense that they render not the landscape, but the sensation produced by the landscape.'[25]

The conclusion to be drawn from the writings of Deschanel, Littré, Castagnary, Caussy, and others is this: an art of the impression (or of sensa-

tion) may vary greatly from artist to artist, in accord with the individual's physiological or psychological state or, in other terms, with his temperament or personality. Whatever truth or reality is represented must relate to the artist himself as well as to nature. Indeed, one might say that the artist paints a 'self' on the pretext of painting 'nature'.

Notes

I Théodore Véron, *Salon de 1875: De l'art et des artistes de mon temps*, Paris, 1875, p. 35.

2 Frédéric Chevalier, 'L'Impressionnisme au Salon', *L'Artiste*, 1 July 1877, pp. 32-39. [...]

3 Henry Houssaye, 'Le Salon de 1882', *Revue des deux mondes*, 3 per, vol. 51, 1 June 1882, p. 563.

4 Paul Mantz, 'Salon de 1872', *Gazette des beaux-arts*, 2 per., vol. 6, July 1872, p. 45.

5 Théodore Duret, *Histoire des peintres impressionnistes*, Paris, 1906, pp.42-3.

6 Charles Bigot, 'La Peinture française en 1875', *Revue politique et littéraire*, 2 ser., vol. 8, 7 and 15 May 1875, pp. 1062-8, 1088-93; Houssaye, pp. 561-86.

7 See, e.g., in addition to Bigot and Houssaye, Félix Fénéon, 'L'Impressionnisme, 1887', *L'Émancipation sociale* (Narbonne), 3 April 1887, reprinted in Félix Fénéon, *Au-delà de l'impressionnisme*, ed. Françoise Cachin, Paris, 1966, p. 83; Félix Fénéon, 'Le Néo-Impresionnisme', *L'Art moderne* (Brussels), vol. 7, 1 May 1887, p. 138; W.C. Brownell, *French Art*, New York, 1892, p. 133; and Duret, *Histoire*, pp. 41-2. [...]

8 Jules Antoine Castagnary, 'L'Exposition du boulevard des Capucines: Les Impressionnistes', *Le Siècle*, 29 April 1874, reprinted in Hélène Adhémar, 'L'Exposition de 1874 chez Nadar (rétrospective documentaire)', *Centenaire de l'impressionnisme*, Paris, 1974, p. 265.

9 See Théodore Duret, 'Les Peintres impressionnistes', 1878, *Critique d'avant-garde*, Paris, 1885, pp. 64-9 ; and Georges Rivie're, *L'Impressionniste, Journal d'art*, 6 April 1877, reprinted in Lionello Venturi, *Les Archives de l'impressionnisme*, 2 vols., Paris, 1939, vol. 2, p. 312.

10 Paul Signac, for example, wrote in 1899 that the 'aim' of both impressionism and neo-impressionism was 'to give to colour the greatest possible force [*éclat*]'; see Signac, *D'Eugène Delacroix au néo-impressionnisme*, ed. Françoise Cachin, Paris, 1964, p. 113.

11 Émile Zola, 'Mon Salon' 1868, *Mon Salon, Écrits sur l'art*, ed. Antoinette Ehrard, Paris, 1970, p. 160. Cf. Duret, 'Les Peintres impressionnistes', pp. 65-6.

12 See, e.g., François-Xavier de Burtin, *Traité théorique et pratique des connaissances qui sont nécessaires à tout amateur de tableaux*, Valenciennes, 1846; orig. ed., Brussels, 1808, p. 45. The related technical definitions of the word 'Impression' from the fields of printing, dyeing, and photography also refer to primacy. On some aspects of the relationship between the visual 'impression' and the printer's 'impression', cf. Michel Melot, 'La Pratique d'un artiste: Pissarro graveure en 1880', *Histoire et critique des arts*, June 1977, p. 16.

13 Émile Deschanel, *Physiologie des écrivains et des artistes, ou essai de critique naturelle*, Paris, 1864, p.9. [...]

14 Thus 'impressionism' as a mode of critical writing was defined as the most subjective, relativistic manner of analysis, an appreciation that could never reach any objective conclusions; the 'Impressionist' critic would consider each work as the product of a unique personal view. See Ferdinand Brunetière, 'La Critique Impressionniste' (1891), *Essais sur la littérature contemporaine*, Paris, 1900, pp. 1-30.

15 Théophile Thoré (Thoré-Bürger), 'Salon de 1844', *Les Salons*, 3 vols., Brussels, 1893, vol.1, p. 20 [...]

16 Albert Boime, *The Academy and French Painting in the Nineteenth Century*, New York, 1971, p. 170. Cf. Félix Bracquemond, *Du dessin et de la couleur*, Paris, 1885, p. 139: 'L'effet est le but unique de l'art. Ce mot signifie d'abord sensation, Impression perçue.'

17 Boime, *Academy*, p. 172.

18 Impressionism has only rarely been studied in relation to nineteenth-century psychology. Teddy Brunius provides a brief but thoughtful discussion of the Impression in relation to Théodore Ribot and Hippolyte Taine in his *Mutual Aid in the Arts from the Second Empire to Fin de Siècle*, *Figura*, no.9, Uppsala, 1972, p. 102 . More recently, Marianne Marcussen and Hilde Olrik have signalled the importance of Taine's *De l'intelligence* in their article 'Le Réel chez

187

Zola et les peintres Impressionnistes: perception et représentation', *Revue d'histoire littéraire de la France,* 80, November-December 1980, pp. 965-77.

19 See, e.g., the account given in Jules Lachelier, 'Psychologie et métaphysique', 1885, *Du fondement de l'induction, Psychologie et métaphysique, Notes sur le pari de Pascal*, Paris, 1916, pp. 104-7. [...]

20 Pierre Larousse, *Grand Dictionaire universel du XIXe siècle*, vol. 9, Paris, 1873, p. 604; Émile Littré, *Dictionaire de la langue française*, vol. 3, Paris, 1866, p. 38. On Hume's use of the term 'impression', cf. Ian Watt, *Conrad in the Nineteenth Century,* Berkeley, 1979, p. 171.

21 Émile Littré, 'De quelques points de physiologie psychique', 1860, *La Science au point de vue philosophique*, Paris, 1876, pp. 312, 314. Cf. Auguste Laugel, *L'Optique et les arts*, Paris, 1869, pp. xiii, 1.

22 This reasoning is reflected in Émile Blémont's commentary on the second Impressionist exhibition. He wrote that the impressionists 'ne voient pas la nécessité de modifier suivant telle ou telle convention leur sensation personnelle et directe'. In other words, one view of the world may be as true as any other. See Émile Blémont, 'Les Impressionnistes', *Le Rappel*, 9 April 1876.

23 Littré, 'Quelques points', p. 315. The notion of the sensory Impression as primary is evidenced by the frequency of the phrase 'première Impression' in the critical literature.

24 Fernand Caussy, 'Psychologie de l'impressionnisme', *Mercure de France*, n.s., 52, December 1904, pp. 628-31. Caussy considered the entire oeuvres of Monet and Renoir, not just the later works.

25 Castagnary, 'Les Impressionnistes', p. 265. Cf. statements by Charles Bigot and Ernest Chesneau. Bigot: 'Ce n'est pas toujours la nature elle-même que représente Corot, c'est l'impression que la nature a faite en lui; 'Corot', 1875, *Peintres français contemporains*, Paris, 1888, p. 67. Chesneau: the Impressionists wish to 'traduire . . . non plus la nature comme elle est . . . mais la nature comme elle nous apparaît'; 'Les Peintres impressionnistes', *Paris-Journal*, 7 March 1882.

19

Stephen F. Eisenman
The Intransigent Artist *or* How
the Impressionists Got their Name

Source: Stephen F. Eisenman, 'The Intransigent
Artist *or* How the Impressionists Got their
Name', in Charles S. Moffett (ed.), *The New
Painting: Impressionism 1874-1886*, San Francisco,
The Fine Arts Museums of San Francisco,
1986, pp. 51-9. This text has been edited and
footnotes renumbered accordingly. One plate
has been omitted.

Most histories of Impressionism provide an account of how the movement
got its name; the formula is as follows.[1] On 15 April 1874 there opened at the
Paris studios of the photographer Nadar an exhibition billed as the *Première
exposition* of the *Société anonyme des artistes peintres, sculpteurs, graveurs, etc.*[2]
Thirty artists participated, including Claude Monet, who submitted a paint-
ing entitled *Impression, soleil levant*.[3] Within a week, the terms 'impression',
'effect of an impression', and 'quality of impressions' were employed in press
accounts of the exhibition, in particular referring to the paintings of Monet,
Renoir, Sisley, Degas, Pissarro, and Cézanne.[4] Louis Leroy was apparently
the first to speak of a school of 'Impressionists' in his now famous satirical dia-
logue published in *Le Charivari* on 25 April, while it was Jules Castagnary
who described 'Impressionism' for readers of *Le Siècle* on 29 April.[5] The name
apparently stuck, and three years later, in February 1877, the *Société* itself
accepted the sobriquet, voting to call its imminent third exhibition the
Exhibition of Impressionists.[6] The organization went on to have five more exhi-
bitions (the last in 1886), and its members to remain in loving art-historical
memory simply as the Impressionists.

Two aspects of this story of origins concern me. First, the basic accuracy of
the account – how common was the term *Impressionism* in the period
between April 1874 and February 1877, and why did the Société anonyme
adopt a name that apparently had been used in derision? Second, what was at
stake in naming the new art? Why did the artists and their critics attach such
importance to the matter? My answer to these questions is intended as a con-
tribution both to the history of an art movement narrowly conceived, and to
the ongoing debate over Modernism itself, of which Impressionism consti-
tutes a signal moment. [...]

The word *impression* entered the vocabulary of art criticism at about the
same time that the French positivists were undertaking their studies of per-
ception. Charles Baudelaire, for example, in 1863 described the 'Impression
produced by things on the spirit of M.G.[uys]'.[7] Other texts could be cited,
but the recent studies of Richard Shiff and Charles Stuckey permit a gener-
alization to be made at once. By 1870 it had become clear that any art based
upon Impressions, that is, upon unmediated sensory experience, must resem-

ble the coloured patchwork that it was believed constituted unreflective vision, what Ruskin had earlier called 'the innocence of the eye'.[8] In that year Théodore Duret said of Manet: 'He brings back from the vision he casts on things an impression truly his own. ... Everything is summed up, in his eyes, in a variant of coloration; each nuance or distinct colour becomes a definite tone, a particular note of the palette.'[9]

Duret thus detected two aspects in Manet's Impression(ism): first, its utter individuality, and second, its structure of discrete colour 'notes' juxtaposed against, but not blended with, their adjacent tone. The dual nature of Impressionism also underlay Castagnary's celebrated usage of 1874, cited above in part. 'They are *Impressionists* in the sense that they render not the landscape but the sensation produced by the landscape. ... [The Impressionists] leave reality and enter into full idealism.'[10] By 'Idealism', as Shiff has shown, Castagnary meant to signify the individualism of the artists, an individualism that corresponded to their technique of laying down a mosaic of colours and forms, which was determined by the impression of the exterior world upon their sense organs.[11]

Impressionism in 1874 thus connoted a vaguely defined *technique* of painting and an *attitude* of individualism shared by an assortment of young and middle-aged artists unofficially led by Manet. Yet if the word *Impressionism* offered only the merest coherence to the exhibition at Nadar's, it had one significant advantage over any other. Serving as a description of unbridled individualism, Impressionism assured politically moderate critics that the new art had both broken with increasingly discredited salon conventions, and remained unsullied by any troubling radical affiliations. 'Does it constitute a revolution?' asked Castagnary of Impressionism. 'No ... it is a manner. And manners in art remain the property of the man who invented them. ...'[12] To such supporters of the Third Republic as Castagnary, individualism was deemed an essential instrument for the emancipation of citizens from debilitating ties to former political, economic, or religious dogma. Individualism would be necessary in the massive work of reconstructing France after the disasters of the Franco-Prussian War and Commune.[13] We may conclude that the combination of painterly daring and political discretion suggested by the word *Impressionism* helps account for the surprisingly positive reception given the new art by many critics.

Not all critics, however, were sanguine about the political moderation of the new art. Indeed, *Impressionist* was not the only name given to the artists who exhibited at Nadar's studio in April 1874. The word *Intransigent* also appeared, and continued to gain in popularity until the Impressionists' self-naming in 1877. A critic for *Le Figaro*, writing two weeks after Leroy, described the 'brutality of the Intransigents'.[14] Jules Claretie commented that 'the skill of these Intransigents is nil', while Ernest Chesneau noted that 'this school has been baptized in a very curious fashion with the name of the group of Intransigents'.[15] Before citing other critical articulations, it is necessary to outline the derivation and meaning of this curious word *Intransigent*.

The French word *intransigeant*, like the English *Intransigent*, is derived from

the Spanish neologism *los intransigentes*, the designation for the anarchist wing of the Spanish Federalist Party of 1872.[16] The Intransigents were opposed to the compromises offered by the Federalist *Benevolos* (Benevolents), led by Pi y Margal, believing instead that the Spanish constitutional monarchy led by the Savoy Prince Amadeo could best be toppled by mass armed resistance and a general strike. When in fact Amadeo's fragile coalition finally collapsed in February 1873, the Intransigents pressed their claims for Cantonal independence against the newly empowered Benevolent Republicans. The dispute soon would escalate into civil war.

The French government led by President Thiers had in the meanwhile been watching the events in Spain with concern. The perception was widespread that the newly hatched Spanish Republic might degenerate into a radical Commune. Indeed the links between the two were direct, as it had been the Commune that helped inspire the Federalist challenge in Spain.[17] In addition, many Communards had found refuge there (including Karl Marx's son-in-law Paul Lafargue), precipitating the belief in France that Communard agitators were responsible for destabilizing the Spanish executive. In late February 1873 the correspondent for *Le Temps* sought to quash rumours that a contingent of Communards had arrived in Spain. 'As for those Communards who would come to Madrid seeking an audience for their new exploits, let them not doubt that they will receive here the welcome they deserve.'[18] The ex-Orleanist minister Marquis de Bouillé refused to recognize the new Benevolent Republic, and amid reports that the French might militarily intervene if the Intransigents gained control, the correspondent for *Le Temps* assured his readers that Spain remained stable. An attempted Intransigent coup in July 1873 ignited civil war, but without support of the International, the major Spanish cities, or France (its conservatism strengthened by the May election of Marshal MacMahon), the rebels were routed. The last Intransigent stronghold, Cartagena, submitted to the increasingly conservative Republic in January 1874. By the end of the year the Republic itself had been defeated and the Spanish Bourbons restored to power.

With the destruction of Intransigentism in Spain, the word *Intransigent* entered the political and cultural vocabulary of France. In the March 1875 preface to a catalogue for an auction of Impressionist paintings, Philippe Burty described the landscapes of the new group, 'who are here called the Impressionists, elsewhere the Intransigents'.[19] By 1876, the name Intransigent had grown considerably in popularity. In his 3 April review of the Second Impressionist Exhibition, Albert Wolff wrote, 'These self-proclaimed artists call themselves the Intransigents, the Impressionists. ... They barricade themselves behind their own inadequacy.'[20] At the same time Armand Silvestre spoke of Manet and 'the little school of Intransigents among whom he is considered the leader', while the Impressionist painter and patron Gustave Caillebotte composed a last will and testament that stipulated, 'I wish that upon my death the necessary sum be taken to organize, in 1878, under the best conditions possible, an exhibition of works by the painters called Intransigents or Impressionists.'[21] A more ominous note was sounded in the

Moniteur Universel. Responding to a favourable review by Emile Blémont in the radical *Le Rappel*, an anonymous critic wrote, 'Let us profit from this circumstance to understand that the "Impressionists" have found a complacent judge in *Le Rappel*. The Intransigents in art holding hands with the Intransigents in politics, nothing could be more natural.'[22] The assertion that the Impressionists had joined hands with the Intransigents in politics was given further support by Louis Enault in *Le Constitutionnel*. In his review of the second 'Exposition des Intransigeants', he recalled the origins of the word *Intransigent*:

If our memory is faithful, it is to Spain that we owe this new word whose importation is more recent than *mantilles* and less agreeable than *castagnettes*. It was, I believe, the Republicans from the southern peninsula who for the first time employed this expression whose meaning was not perfectly understood at the beginning. ... The political Intransigents admit no compromises, make no concession, accept no constitution. ... The terrain on which they intend to build their edifice must be a blank slate.[23]

The Intransigents of paint, Enault proceeds, similarly wished to begin with a clean slate, unburdened by the lines that the great draughtsmen used to mark the contours of figures, or by the harmonious colours that offered such 'delicacies to the eyes of dilettantes'.

A critic for *La Gazette [des Étrangers]*, Marius Chaumelin, was more precise about the politics of Intransigent Art and the appropriateness of its name:

At first they were called 'the painters of open air', indicating so well their horror of obscurity. They were then given a generous name, 'Impressionists', which no doubt brought pleasure to Mlle Berthe Morisot and to the other young lady painters who have embraced these doctrines. But there is a title which describes them much better, that is, the *Intransigents*. ... They have a hatred for classical traditions and an ambition to reform the laws of drawing and colour. They preach the separation of Academy and State. They demand an amnesty for the 'school of the daubs [*taches*]', of whom M. Manet was the founder and to whom they are all indebted.[24]

Chaumelin claimed that the principles of the new art – reform of the laws of colour and design, 'separation of Academy and State', and amnesty for daubers – were derived from the principles of the political Intransigents, that is, the radicals who had gained some thirty seats in the March 1876 elections to the Chamber of Deputies. Among the radical leaders was Georges Clemenceau representing Montmartre, whose campaign platform included reform of electoral laws, separation of Church and State, and amnesty for imprisoned or exiled Communards.[25] This latter issue of giving amnesty, highlighted by Chaumelin, was particularly controversial as it implied that the 1871 Commune had been a legitimate political contest between the classes and not, as conservatives or moderate Republicans claimed, a criminal insurrection whose brutal suppression was deserved. Chaumelin offered his readers little help, however, in determining just how political turned into artistic Intransigence, preferring like Enault to treat them both as largely nugatory affairs.

Not all the evaluations of the new art as Intransigent came from the political right, however. Indeed, it was no less a critic than Stéphane Mallarmé

who described with the greatest clarity as well as the greatest subtlety the link between radical, or Intransigent, art and politics. Mallarmé perceived the new art as an expression of working-class vision and ideology. His essay, long forgotten but now justly celebrated, was published in English in an issue of *The Art Monthly Review* of September 1876. Toward the end of the essay, Mallarmé wrote,

At a time when the romantic tradition of the first half of the century only lingers among a few surviving masters of that time, the transition from the old imaginative artist and dreamer to the energetic modern worker is found in Impressionism.

The participation of a hitherto ignored people in the political life of France is a social fact that will honour the whole of the close of the nineteenth century. A parallel is found in artistic matters, the way being prepared by an evolution which the public with rare prescience dubbed, from its first appearance, Intransigent, which in political language means radical and democratic. [26]

Mallarmé argued that, as Romantic fantasy and imagination characterized the art of the first half of the century, the new Impressionist art marked a significant new stage in social evolution. The Impressionist artist became the eyes of the 'energetic modern worker' and assisted him in his drive for a radical republic. Thus the individualism that some critics perceived in Impressionism may have been valuable to Mallarmé, but a collectivist impulse too was celebrated. He wrote,

Rarely have three workers [Manet, Sisley, and Pissarro] wrought so much alike and the reason of the similitude is simple enough, for they each endeavour to suppress individuality for the benefit of nature. Nevertheless the visitor would proceed from this first Impression . . . to perceiving that each artist has some favourite piece of execution analogous to the subject accepted rather than chosen by him. ... [27]

Impressionism was a movement with a radical co-operative programme, Mallarmé believed, and the currency of the name Intransigent signalled to him the widespread perception of that fact.

Mallarmé offered a set of homologies between Impressionist art and working-class, or radical, vision. As did Enault and Chaumelin, Mallarmé began by noting that intransigent art or politics stripped away outmoded principles, seeking a blank slate upon which to write a new cultural or political agenda. Yet, unlike these critics, Mallarmé suggested that this radical erasure was itself a positive style, akin to the popular art commonly supposed indigenous to the working classes. The key term in Mallarmé's dialectic was 'the theory of the open air', by which academic formulas were jettisoned in favour of a greater truth. He noted that 'contours, consumed by the sun and wasted by space, tremble, melt and evaporate into the surrounding atmosphere, which plunders reality from the figures, yet seems to do so in order to preserve their truthful aspect.' Mallarmé continued:

Open air: – that is the beginning and end of the question we are now studying. Aesthetically it is answered by the simple fact that there in open air alone can the flesh tints of a model keep their true qualities, being nearly equally lighted on all sides. On the other hand if one paints in the real or artificial half-light in use in the schools, it is this feature or that feature on which the light strikes and forces into undue relief,

affording an easy means for a painter to dispose a face to suit his own fancy and return to bygone styles. [28]

Open-air painting thus provides an objective justification for the discarding of academic traditions or individualist caprice. Yet Mallarmé further claims that the Impressionists' stripping away results in a pictorial clarity and flatness that mimics the look of the simple, popular art forms favoured by the rising class of workers and petit bourgeois: 'But today the multitude demands to see with its own eyes; and if our latter-day art is less glorious, intense and rich, it is not without the compensation of truth, simplicity and child-like charm.' [29] The poet's analysis of Manet's sea-pictures illuminates this vaunted simplicity, revealing how the artist's technique of cropping reiterates pictorial flatness. [...] Similarly, Mallarmé wrote that 'the function of the frame is to isolate [the picture]', thereby excluding from its concerns all that is non-pictorial. [30] One is reminded here of Renoir's remarks to Ambroise Vollard concerning Manet's simplicity:

 He was the first to establish a simple formula, such as we were all trying to find until we could discover a better. ... Nothing is so distracting as simplicity. ... You can imagine how those [Barbizon 'dreamers' and 'thinkers'] scorned us, because we were getting paint on our canvases, and because, like the old masters, we were trying to paint in joyous tones and carefully eliminate all 'literature' from our pictures. [31] [...]

Mallarmé's ideal Impressionist painter proclaims in conclusion, 'I have taken from [nature] only that which properly belongs to my art, an original and exact perception which distinguishes for itself the things it perceives with the steadfast gaze of a vision restored to its simplest perfection.' [32] [...]

Faced with the conflicting interpretations of such formidable writers as Castagnary and Mallarmé, the reader must by now be wondering whether the new art, between 1874 and 1877, was in fact Impressionist or Intransigent, that is, affirmative and individualist, or radical and democratic. The answer must be that it was neither and both. The essence of the new art was its insistent indeterminacy, or, put another way, its determined position between those polarities Impressionist/Intransigent. As such, the new art must be understood as a signal instance of Modernist dialectics. On the one hand, works that primarily explore their own physical origins or constituents (Renoir's 'simple formula', Mallarmé's 'simplest perfection'[...]) are Intransigent rebukes to a society that seeks to tailor all culture to its own interests. On the other hand, the apolitical self-regard of Modernist art creates an environment favourable to the eventual industrial appropriation of the works. The 'free space' desired by Modernism also is valuable to a culture industry that relies for its vitality upon the public generation of new desires. Yet there have been times when this latter process of appropriation has been sufficiently slowed that a semblance of autonomy (what Adorno has called 'the duty and liberty of [the mind's] own pure objectification') has been achieved. [33] Such was the case between 1874 and 1877 when the new art was definable only by the uncertainties in critical language.

The opposition between Impressionist and Intransigent art is unresolved in

the criticism of Claretie, Chesneau, Burty, Wolff, Silvestre, Blémont, Enault, Chaumelin, and Mallarmé. Indeed, even those critics who worked hardest to claim Impressionism for the moderate Republic were strangely compelled to call attention to its Intransigent alter-ego. Thus Emile Blavet writes in the conservative *Le Gaulois* of 31 March 1876: 'Let us consider the artists who for the second time are calling on the public directly; are they rebels as some are pleased to call them when they are not stupidly called Communards? Certainly not. A few dissidents have simply come together to show to the public the several styles and varieties of their work in finer exhibition conditions than the Salon can offer.'[34]

Blavet went still further in his effort to rescue Impressionism from the left, claiming that the new art represented 'the fruitful renovation of the French School, the affirmation, in a word, of a principle of art whose results may be considerable'. But once again the critic resurrects the radical bogey by suggesting that the new art offered the young Republic a chance to demonstrate its magnanimity, just as Courbet offered a chance to an earlier republic: 'When the *Burial at Ornans* appeared it was in fact [the academician] Flandrin who was the first to exclaim: "What beauty! What grandeur! What truth!" In a Republic there are no pariahs.' If the new art, as we have seen, embodied a 'theory of the open air', so too did its criticism, often seeming to 'tremble, melt and evaporate' into ideological unease, the critics on the left proving no more confident than those on the right. This uncertain art criticism was thus wholly appropriate to the ambiguities of the new art. May we suppose that the artists took *deliberate* steps to cultivate a zone of aesthetic autonomy that could remain free from the political polarizations disfiguring the art of the previous decades? The selection of the group's name in 1874 as the neutral Société anonyme suggests a high degree of premeditation. Renoir later explained:

195

The title fails to indicate the tendencies of the exhibitors; but I was the one who objected to using a title with more precise meaning. I was afraid that if we were called the 'Somebodies' or 'The So-and-Sos', or even 'The Thirty-Nine', the critics would immediately start talking about a 'new school', when all that we were really after, within the limits of our abilities, was to try to induce painters in general to get in line and follow the Masters, if they did not wish to see painting definitely go by the board. ... For in the last analysis, everything that was being painted was merely rule of thumb or cheap tinsel – it was considered frightfully daring to take figures from David and dress them up in modern clothes. Therefore it was inevitable that the younger generation should go back to simple things. How could it have been otherwise? It cannot be said too often that to practise an art, you must begin with the ABCs of that art. [35]

Indeed, Renoir's rejection of a name encouraged critical uncertainty over the new art, thereby prolonging the period during which it remained between ideological antinomies. Such a stance was considered by Renoir as part of the tradition of 'the Masters', essential if painting was not to 'definitely go by the board', that is, be absorbed into the 'cheap tinsel' or academicism that predominated in the Salon.

The success of the new art in evading either academicism or political ten-

dentiousness is thus attributable both to the refusal of a proper name and the articulation of a new style; it was apparently Renoir who was responsible for the former and Manet who, despite his refusal to join the Société, set the standard for the latter. If Romanticism had vested artists with the power symbolically to breach the Enlightenment fissure between subject and object or word and thing, Manet instead chose to expose these scissions through an art that called attention to its status as fiction; the refusal of tonal modelling and perspective, the purposeful cultivation of visual ambiguity, and the disrespectful highlighting of revered art-historical sources are all the well-known devices by which Manet refused academic closure. Yet it is equally well known that in rejecting Romantic symbolism, Manet did not adopt what may be called the Jacobin tradition – art as the purposely tendentious iteration of a predetermined political position. On the contrary, as T. J. Clark has shown in his study of Manet's *Argenteuil, les canotiers*,[36] what we most often find in Manet's work is an avoidance of the explicit signs of politics or class, achieved through blankness of human expression and an odd unreadability of gesture, posture, and physical place. Yet Manet has not thereby given in to abstraction, to the wilful effacement of the norms of anatomy and composition, but instead offers a different kind of rationality based upon the consonance between the flatness of the canvas, the flatness of those vertical and horizontal stripes of paint that comprise a woman's dress or a man's *chemise*, and a flatness actually perceived in the world – in the peculiar mass-produced costumes and places of urban entertainment of suburban leisure. [...]

Manet's art, it may generally be said, elided the oppositions that comprised contemporary ideology: work/leisure, city/country, artifice/authenticity, public/private – in short a whole rhetoric of binaries that seemed to assure political and class stability. Manet questioned this stability and did so with a Modernist style that compelled conviction. His painting revealed an undeniable finish, solidity, composure, and simple rationality *that signalled a real knowledge*, a knowledge that could not be overlooked by a people who took so seriously their own reasonableness. Now it seems to me that the Impressionist followers of Manet similarly succeeded in eliding ideological oppositions while still offering something that could approach knowledge. The evidence of that knowledge is in the pictures, for example, in the decomposition of figures and their resurrection as shapes; the evidence of the new painters' success in eliding comforting social oppositions provide the aporias that dominate criticism of the new art, that is, the free space between Impressionist and Intransigent. [...]

Notes

1 Three examples: Théodore Duret, *Histoire des peintres Impressionnistes*, Paris, 1939, p. 20; Lionello Venturi, *Les archives de l'Impressionnisme*, 2 vols, Paris and New York, 1939, vol.1, p. 22; John Rewald, *The History of Impressionism*, 4th rev. ed., New York, 1973, pp. 336-8.

2 Paul Tucker has recently recounted the facts of the First Impressionist Exhibition, and the implicit nationalism of Monet's *Impression, soleil levant* in 'The First Impressionist Exhibition and Monet's *Impression, Sunrise*: A Tale of Timing, Commerce and Patriotism', *Art History*, vol. 7, no. 4, December 1984, pp. 465-476. Also see Anne Dayez et al., *Centenaire de l'Impressionnisme*, exh. cat., Paris: Grand Palais, 1974.

3 The identity of this painting remains in doubt. See Tucker, pp. 470-1, and Rewald, p. 339, note 23.

4 Cited by Jacques Lethève, *Impressionnistes et symbolistes devant la presse*, Paris, 1959, pp. 64-9.

5 These reviews are reprinted in *Centenaire*, pp. 259-61; 264-5. Tucker cites nineteen reviews of the exhibition: 'Six were very positive; three were mixed, but generally positive; one was mixed but generally negative; four were negative; five were notices or announcements.' Tucker, pp. 469, 475-6, note 20.

6 Rewald, p. 390. The author does not document his suggestion that the name was definitively adopted in February. Also see Barbara Erlich White, *Renoir, His Life, Art and Letters*, New York, 1984, p. 74. The phrase 'Exposition des Impressionnistes' does not appear on the title page of the accompanying catalogue, but was placed above the door of the entrance to the galleries on the rue le Peletier. See G. Rivière, 'Explications', *L'Impressionniste*, 21 April 1877, p. 3; cited in Venturi, vol. 2, p. 322.

7 Charles Baudelaire, *Oeuvres complètes*, ed. Claude Pichois, Paris, 1976, vol. 2, p. 698.

8 John Ruskin, *The Complete Works*, ed. E.T. Cook and Alexander Wedderburn, London, 1904, vol.15, p. 27; cited in Stuckey, 'Monet's Art and the Act of Vision', *Aspects of Monet*, ed. John Rewald and Frances Weitzenhoffer, New York, 1984, p. 108

9 Théodore Duret, 'Salon de 1870', *Critique d'avant-garde*, Paris, 1885, p. 8; cited in Shiff, *Cézanne and the End of Impressionism*, Chicago, 1984, p.22.

10 Dayez et al., p. 265.

11 Shiff, p. 4.

12 Dayez et al., p. 265.

13 Tucker, p. 474.

14 Lethève, p. 72.

15 Jules Claretie, 'Salon de 1874 à Paris', *L'art et les artistes français contemporains*, Paris, 1876, p. 260; Ernest Chesneau, 'Le plein air, Exposition du boulevard des Capucines', *Paris-Journal*, 7 May 1874; cited in Dayez et al., p. 268.

16 E. Littré, *Dictionnaire de la langue française: Supplement*, Paris, 1897, p. 204; Centre National de la Recherche Scientifique, *Trésor de la langue française: Dictionnaire de la langue de XIX^e et XX^e siècle, 1789-1960*, Paris, 1983, vol. 10, p. 490; *The Oxford English Dictionary*, vol. 5, p. 435. The following account of intransigentism is largely based upon C.A.M. Hennessy, *The Federal Republic in Spain: Pi y Margal and the Federal Republican Movement, 1868-74*, Oxford, 1962. Also see Frederick Engels, 'The Bakunists at Work: Notes on the Spanish Uprising in the Summer of 1873', in Marx, Engels, Lenin, *Anarchism and Anarcho-Syndicalism*, New York, 1978, pp. 128-46.

17 'The Commune's aim is not an unrealizable utopia, but simply the autonomy of the Commune', *La Redencion Social*, 9 April 1871, in Hennessy, p. 149.

18 *Le Temps*, 23 February 1873. See the subsequent report, 24 February, that ex-Communards were reported to be arriving in Spain in the guise of journalists. Also see Hennessy, p. 181.

19 Cited in Venturi, vol. 2, p. 290.

20 Albert Wolff, 'Le calendrier parisien', *Le Figaro*, 3 April 1876.

21 Armand Silvestre, 'Les deux tableaux de Monsieur Manet', *L'Opinion Nationale*, 23 April 1876; cited in François Cachin et al., *Manet*, exh. cat., New York: The Metropolitan Museum of Art, 1983, p. 32; Marie Berhaut, *Caillebotte, sa vie et son oeuvre*, Paris, 1978, p. 251.

22 *Le Moniteur Universel*, 8 April 1876; cited in Lethève, p. 79.

23 Louis Enault, 'Mouvement artistique: L'exposition des intransigeants dans la galerie de Durand-Ruelle [*sic*]', *Le Constitutionnel*, 10 April 1876. [....]

24 Marius Chaumelin, 'Actualités: L'exposition des intransigeants', *La Gazette [des Étrangers]*, 8 April 1876. [...]

25 Jack D. Ellis, *The Early Life of Georges Clemenceau*, Lawrence, Kansas, 1980, p. 64. Clemenceau's Radical programme, fully articulated during his election campaign of 1881, was an expansion of the celebrated 'Belleville Programme' of Léon Gambetta from 1869. Clemenceau's text is translated and reproduced in Leslie Derfler, *The Third French Republic: 1870-1940*, Princeton, 1966, pp. 121-3. Also see R.D. Anderson, *France: 1870-1914, Politics and Society*, London, 1977, pp. 88-99, as well as his extensive bibliography, pp. 187-208. The internecine Republican struggles of 1876 are described in J.P.T. Bury, *Gambetta and the Making*

of the Third Republic, London, 1973, pp. 263-327.

26 Stéphane Mallarmé, 'The Impressionists and Edouard Manet', *Documents Stéphane Mallarmé*, ed. C.P. Barbier , Paris, 1968, p. 84.

27 Mallarmé, pp. 79-80.

28 Mallarmé, pp. 74-5.

29 Mallarmé, p. 84. [...]

30 Mallarmé, p. 77.

31 Vollard, *Renoir: An Inimate Record*, New York, 1934, p. 66.

32 Mallarmé, p. 86.

33 Theodor Adorno, 'Commitment' in *Aesthetics and Politics*, ed. Ronald Taylor, London, 1980, p. 177.

34 Emile Blavet, 'Avant le Salon: L'exposition des realistes', *Le Gaulois*, 31 March 1876. [....]

35 Vollard, pp. 62-3.

36 T.J. Clark, *The Painting of Modern Life: Paris in the Art of Manet and his Followers*, New York, 1984.

Hal Foster
The 'Primitive' Unconscious
of Modern Art

Source: Hal Foster, 'The "Primitive"
Unconscious of Modern Art', *October*, 34,
Fall 1985, pp. 45-70. This text has been edited
and footnotes renumbered accordingly.
Eight plates have been omitted.

At once eccentric and crucial, *Les Demoiselles d'Avignon* (1907) is the set piece
of the Museum of Modern Art: a bridge between modernist and premod-
ernist painting, a primal scene of modern primitivism. In this painting a step
outside the tradition is said to coincide with a leap within it. Yet one wonders
if this aesthetic breakthrough is not also a breakdown, psychologically regres-
sive, politically reactionary. The painting presents an encounter in which are
inscribed two scenes : the depicted one of the brothel and the projected one
of the heralded 1907 visit of Picasso to the collection of tribal artifacts in the
Musée d'Ethnographie du Trocadéro. This double encounter is tellingly
situated: the prostitutes in the bordello, the African masks in the Trocadéro,
both disposed for recognition, for use. Figured here, to be sure, are both
fear and desire of the other,[1] but is it not desire for mastery and fear of its
frustration?

In projecting the primitive on to woman as other, *Demoiselles* less resolves
than is riven by the threat to male subjectivity, displaying its own decentring
along with its defence. For in some sense Picasso did intuit one apotropaic
function of tribal objects – and adopted them as such, as 'weapons':

They were against everything – against unknown threatening spirits. ... I, too, I am
against everything. I, too, believe that everything is unknown, that everything is an
enemy! ... women, children ... the whole of it! I understood what the Negroes used
their sculptures for. ... All fetishes ... were weapons. To help people avoid coming
under the influence of spirits again, to help them become independent. Spirits, the
unconscious ... they are all the same thing. I understood why I was a painter. All alone
in that awful museum with the masks ... the dusty mannikins. *Les Demoiselles
d'Avignon* must have been born that day, but not at all because of the forms; because
it was my first exorcism painting – yes absolutely![2]

Apart from a (bombastic) avant-gardism, Picasso conveys the shock of this
encounter as well as the euphoria of his solution, an extraordinary psycho-
aesthetic move by which otherness was used to ward away others (woman,
death, the primitive) and by which, finally, a crisis in phallocentric culture
was turned into one of its great monuments.

If, in the *Demoiselles*, Picasso transgresses, he does so in order to mediate
the primitive in the name of the West (and it is in part for this that he remains

the hero of MOMA's narrative of the triumph of modern art). In this regard, the *Demoiselles* is indeed a primal scene of primitivism, one in which the structured relation of narcissism and aggressivity is revealed. Such confrontational identification is peculiar to the Lacanian imaginary, the realm to which the subject returns when confronted with the threat of difference.[3] Here, then, primitivism emerges as a fetishistic discourse, a recognition and disavowal not only of primitive difference but of the fact that the West – its patriarchal subjectivity and socius – is threatened by loss, by lack, by others.

Les Demoiselles d'Avignon was also the set piece of the recent MOMA exhibition-cum-book, *'Primitivism' in 20th Century Art: Affinity of the Tribal and the Modern*, in which the painting was presented, along with African masks often proposed as sources for the demoiselles, in such a way as to support the curatorial case for a modern/tribal affinity in art. (The argument runs that Picasso could not have seen these masks, that the painting manifests an intuitive primitivity or 'savage mind'.) This presentation was typical of the abstractive operation of the show, premised as it was on the belief that 'modernist primitivism depends on the autonomous force of objects' and that its complexities can be revealed 'in purely visual terms, simply by the juxtaposition of knowingly selected works of art'.[4] Though the exhibition did qualify the debased art-historical notion of causal influence (e.g., of the tribal on the modern), and did on another front demolish the more debased racist model of an evolutionist primitivism, it did so often only to replace the first with 'affinity' (in the form of the family of *homo artifex*) and the second with the empty universal, 'human creativity wherever found'.[5]

Based on the aesthetic concerns of the modern artists, the 'Primitivism' show cannot be condemned on ethnological grounds alone. Too often the contextualist rebuke is facile, a compensatory expression of a liberal-humanist remorse for what cannot be restored. It is, after all, the vocation of the modern art museum to decontextualize. (Levi-Strauss describes anthropology as a *technique du dépaysement*:[6] how much more is this true of art history?) And in the case of the tribal objects on display, the museum is but one final stage in a series of abstractions, of power-knowledge plays that constitute primitivism. Yet to acknowledge decontextualization is one thing, to produce ideas with it another. For it is this absolution of (con)textual meanings and ideological problems in the self-sufficiency of form that allowed for the humanist presuppositions of the show (that the final criterion is Form, the only context Art, the primary subject Man). In this way the show confirmed the colonial extraction of the tribal work(in the guise of its redemption as art) and rehearsed its artistic appropriation into tradition. No counterdiscourse was posed: the imperialist precondition of primitivism was suppressed, and 'primitivism', a metonym of imperialism, served as its disavowal.

This abstraction of the tribal is only half the story; no less essential to the production of affinity-effects was the decontextualization of the modern work. It, too, appeared without indices of its contextual mediations (i.e., the dialectic of avant-garde, kitsch, and academy by which it is structured: it

is, incidentally, the excision of this dialectic that allows for the formal-his-toricist model of modernism in the first place). The modern objects on view, most of which are preoccupied by a primitivist form and/or 'look', alone represented the way the primitive is thought. Which is to say that the modern/tribal encounter was mapped in mostly positivist terms (the surfaces of influence, the forms of affinity) – in terms of morphological coinci-dence, not conceptual displacement. (The 'transgressivity' of the encounter was largely disregarded, perhaps because it cannot be so readily *seen*.) In this way, the show abstracted and separated the modern and the tribal into two sets of objects that could then only be 'affined'. Thus reduced to form, it is no wonder they came to reflect one another in the glass of the vitrines, and one is tempted to ask, cynically enough, after such a double abstraction, such a double tropism toward modern (en)light(enment), what is left but 'affinity'? What part of this hypothesis-turned-show was discovery (of transcultural forms, innate structures, and the like) and what part (modernist) invention?

Elective Affinities, or Impressions d'Afrique (et d'Océanie)

[...] The exhibition commenced with displays of certain modernist involve-ments with tribal art: interest, resemblance, influence, and affinity proper – usually of a roughly analogous structure and/or conception. [...]

Otherwise, the affinities proposed in the show were mostly morphological – or were treated as such even when they appeared metaphorical or semio-logical (as in certain surrealist transformations wrung by Picasso). These for-mally coincidental affinities seemed to be derived in equal part from the formalist reception of the primitive read back into the tribal work and from the radical abstraction performed on both sets of objects. This production of affinity through projection and abstraction was exposed most dramatically in the juxtaposition of a painted Oceanic wood figure and a Kenneth Noland target painting (*Tondo*, 1961) [Plate 29], a work which, in its critical context at least, is precisely not about the anthropomorphic and asks not to be read iconographically. What does this pairing tell us about 'universals'? – that the circle is such a form, or that affinity is the effect of an erasure of difference. Here, universality is indeed circular, the specular image of the modern seen in the mask of the tribal.

Significantly, the show dismissed the primitivist misreading par excellence: that tribal art is intrinsically expressionistic or even psychologically expres-sive, when it is in fact ritualistic, apotropaic, decorative, therapeutic, and so forth. But it failed to question other extrapolations from one set of objects, one cultural context, to the other: to question what is at stake ideologically when the 'magical' character of tribal work is read (especially by Picasso) into modern art, or when modern values of intentionality, originality, and aes-thetic feeling are bestowed upon tribal objects. In both instances different orders of the socius and the subject, of the economy of the object, and of the

29 Kenneth Noland, *Tondo,* also described as *Untitled Target,* 1961. Acrylic on canvas, 148.6 cm diameter. Collection of Mr and Mrs A.E. Diamond. © Kenneth Noland/DACS, London/VAGA, New York 1993.

place of the artist are transposed with violence; and the result threatens to turn the primitive into a specular Western code whereby different orders of tribal culture are made to conform to one Western typology. (That the modern work can reveal properties in the tribal is not necessarily evolutionist, but it does tend to pose the two as different stages and thus to encompass the tribal within our privileged historical consciousness.)

No less than the formal abstraction of the tribal, this specular code of the primitive produces affinity-effects. For what do we behold here: a universality of form or an other rendered in our own image, an affinity with our own imaginary primitive? Though properly wary of the terms *primitive* and *tribal,* the first because of its Darwinist associations, the second because of its hypothetical nature, the curators used both as 'conventional counters'[7] – but it is precisely this conventionality that is in question. Rubin distinguished primitive style from archaic (e.g., Iberian, Egyptian, Mesoamerican) *diacritically* in relation to the West. The primitive is said to pertain to a 'tribal' socius with communal forms and the archaic to a 'court' civilization with static, hieratic, monumental art. This definition, which excludes as much as it includes, seems to specify the primitive/tribal, but in fact suspends it. Neither 'dead' like the archaic nor 'historical', the primitive is cast into a nebulous past and/or into an idealist realm of 'primitive' essences. (Thus the tribal objects, not dated in the show, are still not entirely free of the old evolutionist association with primal or ancient artifacts, a confusion entertained by the moderns.) In this way, the primitive/tribal is set adrift from specific referents and coordinates – which thus allows it to be defined in wholly Western terms. And one begins to see that one of the preconditions, if not of primitivism, then certainly of the 'Primitivism' show, is the mummification of the tribal and the museumification of its objects (which vital cultures like the Zuni have specifically protested against).

The founding act of this recoding is the repositioning of the tribal object as art. Posed against its use first as evolutionist trophy and then as ethnographic evidence, this aestheticization allows the work to be both decontextualized and commodified. It is this *currency* of the primitive among the moderns – its currency as sign , its circulation as commodity – that allows for the modern/tribal affinity-effect in the first place. The 'Primitivism' show exhibited this currency but did not theorize it. Moreover, it no more 'corrected' this primitivist code than it did the official formalist model of modernism. This code was already partly in place by the time of the MOMA 'African Negro Art' show in 1935, when James Johnson Sweeney wrote against its undue 'historical and ethnographic' reception: 'It is as sculpture we should approach it.'[8] Apart from anti-Darwinist motives, the imperative here was to confirm the formalist reading and new-found value of the African objects. With the African cast as a specifically plastic art, the counterterm – a pictorial art – was institutionally bestowed upon Oceanic work by the 1946 MOMA exhibition 'Arts of the South Seas', directed by René d'Harnoncourt. Although this exhibition did not mention the Surrealists directly, it noted an 'affinity' in the art with the 'dreamworld and subconscious'.[9] It then remained for Alfred Barr (in a 1950 letter to the *College Art Journal*) to historicize this purely diacritical, purely Western system as a 'discovery': 'It is worth noting, briefly, the two great waves of discovery: the first might be called Cubist-Expressionist. This was concerned primarily with formal, plastic and emotional values of a direct kind. The second wave, quasi-Surrealist, was more preoccupied with the fantastic and imaginative values of primitive art.'[10]

The 'Primitivism' show only extended this code, structured as it was around a 'Wölfflinian generalization'[11] of African tactility (sculptural, iconic, monochromatic, geometric) versus Oceanic visuality (pictorial, narrative, colourful, curvilinear), the first related to ritual, the second to myth, with ritual, Rubin writes, 'more inherently "abstract" than myth. Thus, the more ritually oriented African work would again appeal to the Cubist, while the more mythic content of the Oceanic/American work would engage the Surrealist'.[12] This aesthetic code is only part of a cultural system of paired terms, both within the primitive (e.g., malefic Africa versus paradisal Oceania) and within Primitivism (e.g., noble or savage or vital primitive versus corrupt or civilized or enervated Westerner), to which we will return. Suffice it to say here that the tribal/modern affinity is largely the effect of a decoding of the tribal (a 'deterritorializing' in the Deleuzian sense) and a recoding in specular modern terms. As with most formal or even structural approaches, the referent (the tribal socius) tends to be bracketed, if not banished, and the historical (the imperialist condition of possibility) disavowed.

Essentially, the Oxford English Dictionary distinguishes three kinds of 'affinity': resemblance, kinship, and spiritual or chemical attraction ('elective affinity'). As suggested, the affinities in the show, mostly of the first order, were used to connote affinities of the second order: an optical illusion induced the mirage of the (modernist) Family of Art. However progressive

203

this may once have been, this election to *our* humanity can now be seen as thoroughly ideological, for if evolutionism subordinated the primitive to Western history, affinity-ism recoups it under the sign of Western universality. ('Humanity', Lévi-Strauss suggests, is a modern Western concept.)[13] In this recognition difference is discovered only to be fetishistically disavowed, and in the celebration of 'human creativity' the dissolution of specific cultures is carried out: the Museum of Modern Art played host to the Musée de l'Homme indeed.

MOMAism

[...] The conflicted relation of 'Primitivism' to the modern and the present was evident in its contradictory point of view. At once immanent and transcendent, mystificatory and demystificatory, the show both rehearsed the modern reception of the tribal 'from the inside' and posited an affinity between the two 'from above'. It reproduced some modern (mis)readings (e.g., the formal, oneiric, 'magical'), exposed others (e.g., the expressionist), only to impose ones of its own (the intentional, original, 'aesthetic', problem-solving). The status of its objects was also ambiguous. Though presented as art, the tribal objects are manifestly the ruins of (mostly) dead cultures now exposed to our archaeological probes − *and so too are the modern objects*, despite the agenda to 'correct' the institutional reading of the modern (to keep it alive via some essential, eternal 'primitivism'?). [...]

But the exhibition did more than mark our distance from the modern and tribal objects; it also revealed the epistemological limits of the museum. How to represent the modern/tribal encounter adequately? How to map the intertextuality of this event? Rather than abstractly affine objects point by point, how to trace the mediations that divide and conjoin each term? If primitivism is in part an aesthetic construct, how to display its historical conditions? In its very lack, the show suggested the need of a Foucauldian archaeology of primitivism, one which, rather than speak from an academic 'post-colonial' place, might take its own colonialist condition of possibility as its object. Such an enterprise, however, is beyond the museum, the business of which is patronage − the formation of a paternal tradition against the transgressive outside, a documentation of civilization, not the barbarism underneath. In neither its epistemological space nor its ideological history can MOMA in particular engage these disruptive terms. Instead it recoups the outside dialectically − as a moment in its own history − and transforms the transgressive into continuity. With this show MOMA may have moved to revise its formal(ist) model of the modern now adjudged (even by it?) to be inadequate, but it did so only to incorporate the outside in its originary (modern) moment as primitivism. [...]

This recuperation of the primitive has its own history [...]. That the primitive was recognized only after innovations within the tradition is well documented: but what is the effectivity here, the ratio between invention and

recognition, innovation and assimilation? [...] For surely primitivism was generated as much to 'manage' the shock of the primitive as to celebrate its art or to use it 'counterculturally' (Rubin). As noted, the show argued 'affinity' and 'preparation'; yet here, beyond the abstraction of the first and the recuperation of the second, the primitive is *superseded*: 'the role of the objects Picasso saw on this first visit to the Trocadéro was obviously less that of providing plastic ideas than of sanctioning his even more radical progress along a path he was already breaking'.[14] This retrospective reading of the primitive 'role' tends not only to assimilate the primitive other *to* tradition but to recuperate the modernist break *with* tradition, all in the interests of progressive history. (As the very crux of MOMAism, analytic cubism in particular must be protected from outside influence; thus tribal art is assigned 'but a residual role'[15] in it.) What, apart from the institutional need to secure an official history, is the motive behind this desired supersession? What but the formation of a cultural identity, incumbent as this is on the simultaneous need and disavowal of the other? [...]

In the 'Primitivism' show, a transgressive model of modernism was glimpsed, one which, repressed by the formalist account, might have displaced the MOMA model – its 'Hegelian' history, its 'Bauhausian' ideals, its formal-historicist operation (e.g., of abstraction achieved by analytic reduction within the patriarchal line: Manet ... Cézanne ... Picasso: of the Western tradition). This displacement, however, was only a feint: this 'new' model – that the very condition of the so-called modern break with tradition is a break outside it was suggested, occluded, recouped. With transgression without rendered as dialectic within, the official model of modern art – a multiplicity of breaks reinscribed (by the artist/critic) into a synthetic line of formal innovations – is preserved, as is the causal time of history, the narrative space of the museum.

Seen as a genuine agenda, the show presents this conflicted scenario: MOMA moves to reposition the modern as transgressive but is blocked by its own premises, and the contradiction is 'resolved' by a formalist approach that reduces what was to be pronounced. Seen as a false agenda, this cynical scenario emerges: the show pretends to revise the MOMA story of art, to disrupt its formal and narrative unity, but only so as to re-establish it: the transgressive is acknowledged only to be again repressed. As suggested, that this 'correction' is presented now is extremely overdetermined. How better, in the unconscious of the museum, to 'resolve' these contradictions than with a show suggestive on the one hand of a transgressive modernism and on the other of a still active primitivism? Not only can MOMA then recoup the modern-transgressive, it can do so as if it had rejected its own formalist past. This manoeuvre also allows it at once to contain the return of its repressed and to connect with a neo-primitivist moment in contemporary art: MOMAism is not past after all! In all these ways, the critique posed by the primitive is contravened, absorbed within the body of modern art: 'As if we were afraid to conceive of the Other in the time of our own thought'.[16]

205

Primitivism

Historically, the primitive is articulated by the West in deprivative or sup-
plemental terms: as a spectacle of savagery or as a state of grace, as a socius
without writing or the Word, without history or cultural complexity; or as
a site of originary unity, symbolic plenitude, natural vitality. There is
nothing odd about this Eurocentric construction: the primitive has served as
a coded other at least since the Enlightenment, usually as a subordinate term
in its imaginary set of oppositions (light/dark, rational/irrational, civilized
/savage). This domesticated primitive is thus constructive, not disruptive,
of the binary *ratio* of the West; fixed as a structural opposite or a dialecti-
cal other to be incorporated, it assists in the establishment of a Western
identity, centre, norm, and name. In its modernist version the primitive
may appear transgressive, it is true, but it still serves as a limit: projected
within and without, the primitive becomes a figure of our unconscious and
outside (a figure constructed in modern art as well as in psychoanalysis and
anthropology in the privileged triad of the primitive, the child, and the
insane).

If Rubin presented the art-historical code of the primitive, Varnedoe
offered a philosophical reading of primitivism. In doing so, he reproduced
within it the very Enlightenment logic by which the primitive was first
seized, then (re)constructed. There are two primitivisms, Varnedoe argues, a
good, rational one and a dark, sinister one.[17] In the first, the primitive is rec-
onciled with the scientific in a search for fundamental laws and universal lan-
guage (the putative cases are Gauguin and certain Abstract Expressionists).
This progressive primitivism seeks enlightenment, not regressive escape into
unreason, and thinks of the primitive as a 'spiritual regeneration' (in which
'the Primitive is held to be spiritually akin to that of the new man'),[18] not as
a social transgression. Thus recouped philosophically, the primitive becomes
part of the internal reformation of the West, a moment within *its* reason: and
the West, culturally prepared, escapes the radical interrogation which it oth-
erwise poses.

But more is at stake here, for the reason that is at issue is none other than
the Enlightenment, which to the humanist Varnedoe remains knightlike;
indeed, he cites the sanguine Gauguin on the 'luminous spread of science,
which today from West to East lights up all the modern world'.[19] Yet in the
dialectic of the Enlightenment, as Adorno and Horkheimer argued, the lib-
eration of the other can issue in its liquidation; the enlightenment of 'affinity'
may indeed eradicate difference.[20] (And if this seems extreme, think of those
who draw a direct line from the Enlightenment to the Gulag.) Western man
and his primitive other are no more equal partners in the march of reason
than they were in the spread of the word, than they are in the marketing of
capitalism. The Enlightenment cannot be protected from its other legacy, the
'bad-irrational' primitivism (Varnedoe's dramatic example is Nazi Blood and
Soil, the swastika ur-sign), any more than the 'good-rational' primitivism
(e.g., the ideographic explorations of Picasso) can be redeemed from colonial

exploitation. Dialectically, the progressivity of the one is the regression of the other.

Varnedoe argues, via Gauguin, that 'modern artistic primitivism' is not 'antithetical to scientific knowledge'.[21] One can only agree, but not as he intends it, for primitivism is indeed instrumental to such power-knowledge, to the 'luminous spread' of Western domination. On the one hand, the primitivist incorporation of the other is another form of conquest (if a more subtle one than the imperialist extraction of labour and materials); on the other, it serves as its displacement, its disguise, even its excuse. Thus, to pose the relation of the primitive and the scientific as a benign dialogue is cruelly euphemistic: it obscures the real affiliations between science and conquest, enlightenment and eradication , primitivist art and imperialist power. (This can be pardoned of a romantic artist at the end of the last century who, immersed in the ideology of a scientistic avant-garde, could not know the effectivity of these ideas, but not of an art historian at the end of this century.)

Apart from the violence done to the other in the occlusion of the imperialist connection of primitivism and in the mystification of the Enlightenment as a universal good, this good/bad typology tends to mistake the disruption posed by the primitive and to cast any embrace of this disruption – any resistance to an instrumental, reificatory reason, any reclamation of cognitive modes repressed in its regime – as 'nihilistic', regressive, 'pessimistic'.[22] [...]

Primitivism, then, not only absorbs the potential disruption of the tribal objects into Western forms, ideas, and commodities, it also symptomatically manages the ideological nightmare of a great art inspired by spoils. More, as an artistic coup founded on military conquest, primitivism camouflages this historical event, disguises the problem of imperialism in terms of art, affinity, dialogue, to the point (the point of the MOMA show) where the problem appears 'resolved'. [...]

The Other is Becoming the Same; the Same is Becoming Different

[...] If the identity of the West is defined dialectically by its other, what happens to this identity when its limit is crossed, its outside eclipsed? (This eclipse may not be entirely hypothetical given a multinational capitalism that seems to know no limits, to destructure all oppositions, to occupy its field all but totally.) One effect is that the logic that thinks the primitive in terms of opposition or as an outside is threatened. [...] In the second narrative, this 'eclipsed' or sublated primitive re-emerges in Western culture as its scandal – where it links up genealogically with post-structuralist deconstruction and politically with feminist theory and practice. In this passage the primitive other is transformed utterly, and here in particular its real world history must be thought. For the historical incorporation of the outside might well be the condition that compels its eruption into the field of the same as difference. Indeed, the eclipse of otherness, posed as a metaphysical structure of opposites or as an outside to be recovered dialectically, is the beginning of

207

difference – and potential break with the phallocentric order of the West. [...]

On the one hand, then, the primitive is a modern problem, a crisis in cultural identity, which the West moves to resolve: hence the modernist construction 'primitivism', the fetishistic recognition-and-disavowal of the primitive difference. This ideological resolution renders it a 'non-problem' for us. On the other hand, this resolution is only a repression: delayed in our political unconscious, the primitive returns uncannily at the moment of its potential eclipse. The rupture of the primitive, managed by the moderns, becomes our postmodern event.

The first history of the primitive encounter with the West is familiar enough, the fatalistic narrative of domination. In this narrative 1492 is an inaugural date, for it marks the period not only of the discovery of America (and the rounding of the Cape of Good Hope) but also of the renaissance of antiquity. These two events – an encounter with the other and a return to the same – allow for the incorporation of the modern West and the instauration of its dialectical history. (Significantly, in Spain, 1492 also marks the banishment of the Jews and Arabs and the publication of the first modern European grammar; in other words, the expulsion of the other within and the encoding of the other without.)[23] This, too, is the period of the first museums in Europe and of 'the first works on the "life and manners" of remote peoples' – a collection of the ancients and 'savages', of the historically and spatially distant.[24] This collection only expands, as the West develops with capitalism and colonialism into a world system. By the eighteenth century, with the Enlightenment, the West is able to reflect on itself 'as a culture *in the universal*, and thus all other cultures were entered into its museum as vestiges of its own image'.[25] [...]

There is no question that today we are beyond this border, that we live in a time of cancelled limits, destructured oppositions, 'dissipated scandals'[26] (which is not to say that they are not recoded all the time). Clearly, the modern structures in which the Western subject and socius were articulated (the nuclear family, the industrial city, the nation-state) are today remapped in the movement of capital. In this movement the opposition nature/culture has become not only theoretically suspect but practically obsolete: there are now few zones of 'savage thought' to oppose to the Western *ratio*, few primitive others not threatened by incorporation. [...]

For feminists, for 'minorities', for 'tribal' peoples, there are other ways to narrate this history of enlightenment/eradication – ways which reject the narcissistic pathos that identifies the death of the Hegelian dialectic with the end of Western history and the end of that history with the death of man, which also reject the reductive reading that the other can be so 'colonized' (as if it were a zone simply to occupy, as if it did not emerge imbricated in other spaces, to trouble other discourses) – or even that Western sciences of the other, psychoanalysis and ethnology, can be fixed so dogmatically. On this reading the other remains – indeed, as the very field of difference in which the subject emerges – to challenge Western pretences of sovereignty, supremacy, and self-creation.

Notes

1 See William Rubin, 'Picasso', in '*Primitivism*' *in 20th Century Art: Affinity of the Tribal and the Modern*', ed. Rubin, New York: MOMA, 1984, pp. 252-4. [...]

2 Quoted in André Malraux, *Picasso's Mask*, trans. June and Jacques Guicharnaud, New York, 1976, pp. 10-11.

3 My discussion of primitivism as a fetishistic colonial discourse is indebted to Homi K. Bhabha, 'The Other Question', *Screen*, vol. 24, no. 6, Nov./Dec. 1983, pp. 18-36.

4 Kirk Varnedoe, 'Preface', in '*Primitivism*', p. x.

5 Ibid.

6 Claude Lévi-Strauss, 'Archaism in Anthropology', in *Structural Anthropology*, vol.1, trans. Claire Jacobson, New York, 1963, p. 117.

7 See Rubin, 'Introduction', p. 74.

8 James Johnson Sweeney, *African Negro Art*, New York, 1935, p. 21.

9 René d'Harnoncourt, preface to *Arts of the South Seas*, New York: MOMA, 1946.

10 Alfred H. Barr, Jr., letter in *College Art Journal*, vol. 10, no. 1, 1950, p. 59.

11 Rubin, 'Introduction', p.47.

12 Ibid, p. 55.

13 See Lévi-Strauss, 'Race and History', in *Structural Anthropology*, vol. 2., trans. Monique Layton, Chicago, 1976, p. 329.

14 Rubin, 'Picasso', p. 265.

15 p. 309. A residual role but perhaps a real 'affinity': for it could be argued that cubism, like some tribal art, is a process of 'split representation'. See Lévi-Strauss, 'Split Representation in the Art of Asia and America', in *Structural Anthropology*, vol 1, pp. 245-58.

16 Michel Foucault, *The Archaeology of Knowledge*, New York, 1972, p. 12.

17 See Varnedoe, 'Gauguin', pp. 201-3, and 'Contemporary Exploration', pp. 652-683.

18 Ibid., p. 202.

19 Ibid.

20 Max Horkheimer and Theodor W. Adorno, *Dialectic of Enlightenment*, trans. John Cumming, New York, 1972.

21 Varnedoe, 'Gauguin', p. 203.

22 See, for example, Varnedoe, 'Contemporary Exploration', pp. 665, 697.

23 See Tzvetan Todorov, *The Conquest of America*, trans. Richard Howard, New York, 1984, p. 123. Todorov argues that the conquest of America was from one perspective a 'linguistic' one.

24 Todorov, p.109.

25 Jean Baudrillard, *The Mirror of Production*, trans. Mark Poster, St. Louis, pp. 88-9.

26 The phrase is Robert Smithson's; see *The Writings of Robert Smithson*, ed. Nancy Holt, New York, 1979, p. 216.

Source: Rosalind E. Krauss, 'In the Name of
Picasso', *October,* 16, Spring, 1981, pp. 5-22.
This text has been edited and footnotes renum-
bered accordingly. Three plates have been
omitted.

[...] At a lecture this Fall at the Baltimore Museum of Art, William Rubin, one of the leading Picasso scholars, showed Picasso's *Seated Bather,* 1930, and *Bather with Beach Ball,* 1932 [Plates 30 and 31].[1] With these two works, he said, we find ourselves looking at two different universes -and by this he meant different formal as well as symbolic worlds. This is hard to understand; as difficult as if someone pointed first to a Hals portrait of a Dutch militia officer and then to his rendering of the *Malle Babbe* and maintained that they were products of different styles. But Rubin was insisting on this difference, a difference become incontrovertible by the very fact that behind each picture there lay a real-world model, each model with a different name: Olga Picasso; Marie-Thérèse Walter.

We are by now familiar with the sordid conditions of Picasso's marriage in the late 1920s, as we are with his passion for the somnolent blond he met when she was seventeen and who was to reign, a sleepy Venus, over a half-dozen years of his art. But in Rubin's suggestion that Olga and Marie-Thérèse provide not merely antithetical moods and subjects for the pictorial contemplation of the same artist, but that they actually function as determinants in a change in style, we run full tilt into the Autobiographical Picasso. And in this instance Rubin himself was the first to invoke it. The changes in Picasso's art, he went on to say, are a direct function of the turns and twists of the master's private life. With the exception of his cubism, Picasso's style is inextricable from his biography.

With the Museum of Modern Art's huge Picasso retrospective [1980] has come a flood of critical and scholarly essays on Picasso, almost all of them dedicated to 'Art as Autobiography'. That latter phrase is the title of a just-published book on Picasso by an author who sees everything in his work as a pictorial response to some specific stimulus in his personal life, including the *Demoiselles d'Avignon,* which she claims was made in an effort to exorcize 'his private female demons'.[2] The same author, who proudly pounces on a mish-mash of latter-day accounts to 'prove' that Picasso's turn-of-the-century decision to go to Paris to pursue his art was due to his need to 'exile himself from Spain in order to escape his tyrannical mother', provides us with a deli-cious, if unintended parody of the Autobiographical Picasso.[3]

30 Pablo Picasso, *Seated Bather*, Paris, early 1930. Oil on canvas, 163.2 × 129.5 cm. Collection, The Museum of Modern Art, New York. Mrs Simon Guggenheim Fund. © DACS, London 1993.

31 Pablo Picasso, *Bather with Beach Ball*, 1932. Oil on canvas, 146.2 × 114.6 cm. Partial gift of an anonymous donor and promised gift of Ronald S. Lauder to the Museum of Modern Art, New York. © DACS, London 1993.

But prone to parody or not, this argument is upheld by many respected scholars and is attracting many others. John Richardson, of course, took the opportunity of reviewing the Museum of Modern Art exhibition to forward the case for the Autobiographical Picasso. Agreeing with Dora Maar that Picasso's art is at any one time a function of the changes in five private forces – his mistress, his house, his poet, his set of admirers, his dog (yes, dog!) – Richardson exhorts art-historical workers to fan out among the survivors of Picasso's acquaintance, to record the last scraps of personal information still outstanding before death prevents the remaining witnesses from appearing in court.[4] Richardson's trumpet has been sounding this theme for over twenty years, so on this occasion his call was not surprising. But the Autobiographical Picasso is new to William Rubin and that this view of matters should now hold him convert is all the more impressive in that it had to overcome the resistance of decades of Rubin's training. Rubin's earlier practice of art history was rich in a host of ways of understanding art in transpersonal terms; ways that involve questions of period style, of shared formal and iconographic symbols that seem to be the function of larger units of history than the restricted profile of a merely private life. So the Rubin case is particularly instructive, all the more because in his account the personal, the private, the biographical, is given in a series of proper names: Olga, Marie-Thérèse, Dora, Françoise, Jacqueline. And an art history turned militantly away from all that is transpersonal in history - style, social and economic context, archive, structure - is interestingly and significantly symbolized by an art history as a history of the proper name. [...]

[...] Unlike allegory, in which a linked and burgeoning series of names establishes an open-ended set of analogies – Jonah / Lazarus / Christ – there is in this aesthetics of the proper name a contraction of sense to the simple task of pointing or labelling, to the act of unequivocal reference. It is as though the shifting, changing sands of visual polysemy, of multiple meanings and regroupings, have made us intolerably nervous, so that we wish to find the bedrock of sense. We wish to achieve a type of signification beyond which there can be no further reading or interpretation. Interpretation, we insist, must be made to stop somewhere. And where more absolutely and appropriately than in an act of what the police call 'positive identification'? For the individual who can be shown to be the 'key' to the image, and thus the 'meaning' of the image, has the kind of singularity one is looking for. Like his name, his meaning stops within the boundaries of identity.

The instance of 'positive identification' that led off the last dozen years' march of Picasso studies into the terrain of biography was the discovery that the major painting of the Blue Period – *La Vie*, 1904 – contained a portrait of the Spanish painter and friend of Picasso, Casagemas, who had committed suicide in 1902.[5] Until 1967, when this connection with Casagemas was made, *La Vie* had been interpreted within the general context of fin-de-siècle allegory, with works like Gauguin's *D'Où Venons Nous*? and Munch's *Dance of Life* providing the relevant comparisons.[6] But once a real person could be placed as the model for the standing male figure -moreover a person whose

life involved the lurid details of impotence and failed homicide but achieved suicide – the earlier interpretations of *La Vie* as an allegory of maturation and development could be put aside for a more local ad specific reading. Henceforth the picture could be seen as a *tableau vivant* containing the dead man torn between two women, one old and one young, the meaning of which 'is' sexual dread. And because early studies for the painting show that the male figure had originally been conceived as Picasso's self-portrait, one could now hypothesize the artist's identification with his friend and read the work as 'expressing ... that sense of himself as having been thrust by women into an untenable and ultimately tragic position. ...'[7]

The problem with this reading is not that the identification is wrong, but that its ultimate aesthetic relevance is yet to be proved or even, given current art-historical fashion, argued. And the problem of its aesthetic relevance is that this reading dissociates the work from all those other aspects, equally present, which have nothing to do with Casagemas and a sexually provoked suicide. What is most particularly left out of this account is the fact that the work is located in a highly fluctuating and ambiguous space of multiple planes of representation due to the fact that its setting is an artist's studio and its figures are related, at least on one level, to an allegory of painting.[8] Whatever its view of 'life', the work echoes such distinguished nineteenth-century forebears as Courbet and Manet in insisting that, for a painter, life and art allegorize each other, both caught up equally in the problem of representation. The name Casagemas does not extend far enough to signify either this relationship or this problem. Yet current art-historical wisdom uses 'Casagemas' to explain the picture – to provide the work's ultimate meaning or sense. When we have named Casagemas, we have (or so we think) cracked the code of the painting and it has no more secrets to withhold.

La Vie is after all a narrative painting and this close examination of its dramatis personae is an understandable (though insufficient) response to the work. The methodology of the proper name becomes more astonishing, however, when practised on the body of work inaugurated by cubism.

Two examples will serve. A recent study by Linda Nochlin takes up the question of Picasso's colour, an issue almost completely ignored by earlier scholarship.[9] Within modernist art, colour would seem to be a subject set at the furthest possible remove from a reading by proper names. This turns out not to be true, as Nochlin analyses a 1912 cubist painting that is mostly *grisaille*, broken by the intrusion of a flat plane broadly striped in red, white, and blue, and carrying the written words, '*Notre avenir est dans l'air*'. Conceived at about the same time as the famous first collage, *Still Life with Chair Caning*, the work in question echoes many other canvases from early 1912, in which the introduction of some kind of large plane which, like the chair-caning or the pamphlet '*Notre avenir...*', is a wholly different colour and texture from the monochrome faceting of analytic cubism, and inaugurates both the invention of collage and the opening of cubism to colour.

This, however, is not Nochlin's point. The actual red-white-and-blue *tricolore* pamphlet that Picasso depicted in this cubist still life had been issued

originally to promote the development of aviation for military use. Thus the pamphlet 'means' French nationalism; its colours bear the name of Picasso's adopted country. Behind the *tricolore* we read not only 'France' but the name of the artist's assumed identity; 'Picasso/Frenchman'. Colour's meaning contracts to the coding of a proper name. (Later in the same essay Nochlin reveals that behind Picasso's use of violet in his work of the early 1930s there lies yet another name, which is its meaning: once again, Marie-Thérèse.)

Thus the significance of colour reduces to a name, but then, in the following example, so does the significance of names. In his essay 'Picasso and the Typography of Cubism', Robert Rosenblum proposes to read the names printed on the labels introduced into cubist collage, and thus to identify the objects so labelled.[10] In Picasso's collages many newspapers are named: *L'Indépendant, Excelsior, Le Moniteur, L'Intransigeant, Le Quotidien du Midi, Le Figaro*; but none with such frequency as *Le Journal*. Rosenblum describes at length the way this name is fractured – most characteristically into JOU, JOUR, and URNAL – and the puns that are thereby released. But that the word-fragments perform these jokes while serving to label the object – the newspaper – with its name, is very much Rosenblum's point. For he concludes his argument by declaring the realism of Picasso's cubist collages, a realism that secures, through printed labels, the presence of the actual objects that constitute 'the new imagery of the modern world'.[11]

This assumption that the fragmented word has the ultimate function of a proper name leads Rosenblum to the following kind of discussion:

Such Cubist conundrums are quite as common in the labelling of the bottles of Picasso's compatriot, Juan Gris. On his café table tops, even humble bottles of Beaujolais can suddenly be transformed into verbal jokes. Often, the word BEAU-JOLAIS is fragmented to a simple BEAU ... in another example ... he permits only the letters EAU to show on the label (originally Beaujolais, Beaune, or Bordeaux), and thereby performs his own Cubist version of The Miracle at Cana.[12]

We are to expand the word-fragment to grasp the name (we have our choice of three reds) and thereby to secure the original object. In this certainty about word–world connection there is realism indeed.

But are the labels EAU and JOU a set of transparent signifiers, the nicknames of a group of objects (the newspaper, the wine bottle) whose real names (*Journal, Beaujolais*) form the basis for this labour of the cubist pun? Is the structure of cubist collage itself supportive of the semantic positivism that will allow it to be thus assimilated to the art history of the proper name? Or are the word-fragments that gather on the surfaces of Picasso's collages instead a function of a rather more exacting notion of reference, representation, and signification?

This is a portrait of Iris Clert if I say so. — *Robert Rauschenberg*

The most recent major addition to the scholarly inquiry on cubism is Pierre Daix's catalogue raisonné, *Picasso: 1907-1916*. Daix's suggestive text expands

the somewhat limited art-historical vocabulary for describing what transpires with the advent of collage, for Daix insists on characterizing collage-elements as signs — not simply in the loose way that had occurred earlier on in the Picasso literature — but in a way that announces its connection to structural linguistics.

Daix is careful to subdivide the sign into signifier and signified — the first being the affixed collage-bit or element of schematic drawing itself; the second being the referent of this signifier: newspaper, bottle, violin. Though this is rare in his discussion, Daix does occasionally indicate that the signified may not be an object at all but rather a free-floating property, like a texture — for example, wood, signified by a bit of wood-grained wallpaper — or a formal element such as verticality or roundness — although this element is usually shown to function as the property of an object: of the round, vertical wine bottle, for example.[13] Again and again Daix hammers away at the lesson that cubist collage exchanges the natural visual world of things for the artificial, codified language of signs.

But there is, nowhere in Daix's exposition, a rigorous presentation of the concept of the sign. Because of this, and the manner in which much of Daix's own discussion proceeds, it is extremely easy to convert the issue of the collage-sign into a question of semantics, that is, the sign's transparent connection to a given referent, thereby assimilating collage itself to a theatre of the proper name: 'EAU is really Beaujolais, and JOU is in fact Journal.'

If we are really going to turn to structural linguistics for instruction about the operation of the sign we must bear in mind the two absolute conditions posited by Saussure for the functioning of the linguistic sign. The first is the analysis of signs into a relationship between signifier and signified ($\frac{s}{S}$) in which the signifier is a *material* constituent (written trace, phonic element) and the signified, an immaterial idea or concept. This opposition between the registers of the two halves of the sign stresses that status of the sign as substitute, proxy, stand-in, for an absent referent. It insists, that is, on the literal meaning of the prefix 're' in the word *representation*, drawing attention to the way the sign works away from, or in the aftermath of, the thing to which it refers.

This grounding of the terms of representation on absence — the making of absence the very condition of the representability of the sign — alerts us to the way the notion of the sign-as-label is a perversion of the operations of the sign. For the label merely doubles an already material presence by giving it its name. But the sign, as a function of absence rather than presence, is a coupling of signifier and immaterial concept in relation to which [...] there may be no referent at all (and thus no *thing* on which to affix the label).

This structural condition of absence is essential to the operations of the sign within Picasso's collage. As just one from among the myriad possible examples, we can think of the appearance of the two *f*-shaped violin sound holes that are inscribed on the surface of work after work from 1912–14 [Plate 32]. The semantic interpretation of these *f*s is that they simply signify the presence of the musical instrument; that is, they label a given plane of the collage-assembly with the term 'violin'. But there is almost no case from among these

215

32 Pablo Picasso, *Violin*, 1912. Pasted
papers and charcoal on paper, 62 × 47 cm.
Musée National d'Art Moderne, Centre
Georges Pompidou, Paris. © DACS,
London 1993.

collages in which the two *f*s mirror each other across the plane surface. Time
and again their inscription involves a vast disparity between the two letters,
one being bigger and often thicker that the other. With this simple, but very
emphatic, size difference, Picasso composes the sign, not of violin, but of
foreshortening: of the differential size within a single surface due to its rota-
tion into depth. And because the inscription of the *f*s takes place within the
collage assembly and thus on the most rigidly flattened and frontalized of
planes, 'depth' is thus written on the very place from which it is – within the
presence of the collage – most absent. It is *this* experience of inscription that
guarantees these forms the status of signs.

What Picasso does with these *f*s to compose a sign of space as the condition
of physical rotation, he does with the application of newsprint to construct
the sign of space as penetrable or transparent. It is the perceptual disintegra-
tion of the fine-type of the printed page into a sign for the broken colour
with which painting (from Rembrandt to Seurat) represents atmosphere, that
Picasso continually exploits. In so doing, he inscribes transparency on the
very element of the collage's fabric that is most reified and opaque: its planes
of newspaper.

If one of the formal strategies that develops from collage, first into syn-
thetic and then late cubism, is the insistence of figure/ground reversal and the
continual transposition between negative and positive form, this formal
resource derives from collage's command of the structure of signification: no

positive sign without the eclipse or negation of its material referent. The extraordinary contribution of collage is that it is the first instance within the pictorial arts of anything like a systematic exploration of the conditions of representability entailed by the sign.

From this notion of absence as one of the preconditions of the sign, one can begin to see the objections to the kind of game that literalizes the labels of cubist collages, giving us the 'real' name of the wine marked by EAU or the newspaper by JOUR. Because the use of word-fragments is not the sprinkling of nicknames on the surfaces of these works, but rather the marking of the name itself with that condition of incompleteness or absence which secures for the sign its status as representation.

The second of Saussure's conditions for the operation of the sign turns not so much on absence as on difference. '*In language there are only differences*,' Saussure lectured. 'Even more important: a difference generally implies positive terms between which the difference is set up; but in language there are only differences *without positive terms*'.[14] This declaration of the diacritical nature of the sign establishes it as a term whose meaning is never an absolute, but rather a choice from a set of possibilities, with meaning determined by the very terms *not* chosen. As a very simple illustration of meaning as this function of difference (rather than 'positive identification') we might think of the traffic-light system where red means 'stop' only in relation to an alternative of green as 'go'.

In analysing the collage elements as a system of signs, we find not only the operations of absence but also the systematic play of difference. A single collage element can function simultaneously to compose the sign of atmosphere or luminosity and of closure or edge. In the 1913 *Violin and Fruit* [Plate 33], for example, a piece of newsprint, its fine type yielding the experience of tone, reads as 'transparency' or 'luminosity'. In the same work the single patch of wood-grained paper ambiguously allocated to table and or musical instrument composes the sign for open, as opposed to closed form. Yet the piece of wood-graining terminates in a complete contour that produces the closed silhouette of a neighbouring form. And the transparent colourism of the newsprint hardens into opaque line at the definitiveness of its edges. In the great, complex cubist collages, each element is fully diacritical, instantiating both line and colour, closure and openness, plane and recession. Each signifier thus yields a matched pair of formal signifieds. Thus if the elements of cubist collage do establish sets of predicates, these are not limited to the properties of objects. They extend to the differential calculus at the very heart of the formal code of painting. What is systematized in collage is not so much the forms of a set of studio paraphernalia, but the very system of form.[15]

That form cannot be separated from Picasso's meditation on the inner workings of the sign - at least as it operates within the pictorial field - is a function of the combined formal/significatory status of the most basic element of collage. For it is the affixing of the collage piece, one plane set down on another, that is the centre of collage as a signifying system. That plane, glued to its support, enters the work as the literalization of depth, actu-

33 Pablo Picasso, *The Violin (Violin and Fruit),* 1913. Pasted papers, gouache and charcoal on cardboard, 65 × 49.5 cm. Philadelphia Museum of Art, The A.E. Gallatin Collection. © DACS, London 1993.

ally resting 'in front of' or 'on top of' the field or element it now partially obscures. But this very act of literalization opens up the field of collage to the play of representation. For the supporting ground that is obscured by the affixed plane resurfaces in a miniaturized facsimile in the collage element itself. The collage element obscures the master plane only to represent that plane in the form of a depiction. If the element is the literalization of figure against field, it is so as a figure of the field it must literally occlude.

The collage element as a discrete plane is a bounded figure; but as such it is a figure of a bounded field – a figure of the very bounded field which it enters the ensemble only to obscure. The field is thus constituted inside itself as a figure of its own absence, an index of a material presence now rendered literally invisible. The collage element performs the occultation of one field in order to introject the figure of a new field, but to introject it *as* figure – a surface that is the image of eradicated surface. It is this eradication of the original surface and the reconstitution of it through the figure of its own absence that is the master term of the entire condition of collage as a system of signifiers.

The various resources for the visual illusion of spatial presence becomes the ostentatious subject of the collage-signs. But in 'writing' this presence, they guarantee its absence. Collage thus effects the representation of representation. This goes well beyond the analytic cubist dismemberment of illusion into its constituent elements. Because collage no longer retains these elements; it signifies or represents them.

What collage achieves, then, is a metalanguage of the visual. It can talk about space without employing it; it can figure the figure through the constant superimposition of grounds; it can speak in turn of light and shade through the subterfuge of a written text. This capacity of 'speaking about' depends on the ability of each collage element to function as the material signifier for a signified that is its opposite: a presence whose referent is an absent meaning, meaningful only in its absence. As a system, collage inaugurates a play of differences which is both about and sustained by an absent origin: the forced absence of the original plane by the superimposition of another plane, effacing the first in order to represent it. Collage's very fullness of form is grounded in this forced impoverishment of the ground – a ground both supplemented and supplanted.

It is often said that the genius of collage, its modernist genius, is that it heightens – not diminishes – the viewer's experience of the ground, the picture surface, the material support of the image; as never before, the ground – we are told – forces itself on our perception. But in collage, in fact, the ground is literally masked and riven. It enters our experience not as an object of perception but as an object of discourse, of *re*presentation. Within the collage system all of the other perceptual données are transmuted into the absent objects of a group of signs.

It is here that we can see the opening of the rift between collage as system and modernism proper. For collage operates in direct opposition to modernism's search for perceptual plenitude and unimpeachable self-presence. Modernism's goal is to objectify the formal constituents of a given medium, making these, beginning with the very ground that is the origin of their existence, the objects of vision. Collage problematizes that goal, by setting up discourse in place of presence, a discourse founded on a buried origin, a discourse fuelled by that absence. The nature of this discourse is that it leads ceaselessly through the maze of the polar alternatives of painting displayed as system. And this system is inaugurated through the loss of an origin that can never be objectified, but only represented.

The power of tradition can preserve no art in life that no longer is the expression of its time. One may also speak of a formal decay in art, that is, a death of the feeling for form. The significance of individual parts is no longer understood – likewise, the feeling for relationships.
– *Heinrich Wölfflin*

We are standing now on the threshold of a postmodernist art, an art of a fully problematized view of representation, in which to name (represent) an object may not necessarily be to call it forth, for there may be no (original) object. For this postmodernist notion of the originless play of the signifier we could use the term *simulacrum*.[16] But the whole structure of postmodernism has its proto-history in those investigations of the representational system of absence that we can only now recognize as the contemporaneous alternative to mod-

ernism. Picasso's collage was an extraordinary example of this proto-history, along with Klee's pedagogical art of the 1920s in which representation is deliberately characterized as absence.

At the very same moment when Picasso's collage becomes especially pertinent to the general terms and conditions of postmodernism, we are witnessing the outbreak of an aesthetics of autobiography, what I have earlier called an art history of the proper name. That this manoeuvre of finding an exact (historical) referent for every pictorial sign, thereby fixing and limiting the play of meaning, should be questionable with regard to art in general is obvious. But that it should be applied to Picasso in particular is highly objectionable, and to collage – the very system inaugurated on the indeterminacy of the referent, and on absence – is grotesque. For it is collage that raises the investigation of the impersonal workings of pictorial form, begun in analytical cubism, on to another level: the *impersonal* operations of language that are the subject of collage.

In his discussion of classic collage, Daix repeatedly stresses the de-personalization of Picasso's drawing in these works, his use of pre-existent, industrialized elements (which Diax goes so far as to call *readymade*), and his mechanization of the pictorial surfaces – in order to insist on the objective status of this art of language, this play of signs.[17] Language (in the Saussurian sense of *langue*) is what is at stake in Daix's reference to the readymade and the impersonal: that is, language as a synchronic repertory of terms into which each individual must assimilate himself, so that from the point of view of structure, a speaker does not so much speak, as he is spoken by, language. The linguistic structure of signs 'speaks' Picasso's collages and, in the 'signs' burgeoning and transmuting play, *sense* may transpire even in the absence of *reference*.

The aesthetics of the proper name involves more than a failure to come to terms with the structure of representation, although that failure at this particular juncture of history is an extremely serious one. The aesthetics of the proper name is erected specifically on the grave of form.[18]

One of the pleasures of form – held at least for a moment at some distance from reference – is its openness to multiple imbrication in the work, and thus its hospitableness to polysemy. It was the new critics – that group of determined 'formalists' – who gloried in the ambiguity and multiplicity of reference made available by the play of poetic form.

For the art historians of the proper name, form has become so devalued as a term (and suspect as an experience), that it simply cannot be a resource for meaning. Each of the studies on Picasso-via-the-proper-name begins by announcing the insufficiencies of an art history of style, of form. Because Rosenblum's essay on cubist typography was written a decade ago, it therefore opens by paying lip-service to the importance of a formal reading of cubism, modestly describing its own area of investigation as 'a secondary aspect', a matter of 'additional interpretations that would enrich, rather than deny, the formal ones'.[19] But Rosenblum's simple semantics of the proper name does not enrich the forms of cubist collage; it depletes and impover-

ishes them. By giving everything a name, it strips each sign of its special modality of meaning: its capacity to represent the conditions of representation. The deprecation of the formal, the systematic, is now much more open in what Rosenblum has to say about method. 'Certainly the formalist approach to the nineteenth century seems to me to have been exhausted a long time ago', he recently told two graduate-student interviewers. 'It's just too boring ... it's so stale that I can't mouth those words any more'.[20]

This petulant 'boredom' with form is emblematic of a dismissal that is widespread among historians as well as critics of art. With it has come a massive misreading of the processes of signification and a reduction of the visual sign to an insistent mouthing of proper names.

Notes

1 The lecture was presented on 12 October 1980, at a symposium on the Cubist legacy in twentieth-century sculpture.

2 Mary Mathews Gedo, 'Art as Exorcism: Picasso's "Demoiselles d'Avignon"', *Arts*, vol. 55, October 1980, pp. 70-81.

3 Ibid., p.72; see also *Art as Autobiography*, Chicago, 1980.

4 John Richardson, 'Your Show of Shows', *The New York Review*, 17 July 1980. Eugene Thaw uses Richardson's essay as an occasion for his own attack on art as autobiography. See 'Lust for Life', *The New York Review*, 23 October 1980.

5 Pierre Daix, 'La Période Bleue de Picasso et le suicide de Carlos Casagemas', *Gazette des Beaux-Arts*, vol. 69, April 1967, p. 245.

6 Anthony Blunt and Phoebe Pool, *Picasso, The Formative Years*, New York Graphic Society, 1962, pp. 18-21.

7 Theodore Reff, 'Themes of Love and Death in Picasso's Early Work', *in Picasso in Retrospect*, Roland Penrose, John Golding, eds., New York, 1973, p.28.

8 At the beginning of his discussion of *La Vie*, Reff has no trouble locating the work; 'the setting, an artist's studio with two of his canvases in the background' (p. 24). But after 'reading' it through the proper name of Casagemas, his account of the location changes and, curiously, 'the setting is no longer necessarily an artist's studio' (p. 28). This is a niggling detail, but I bring it to the attention of the reader who feels that there is nothing inherently objectionable to a history of proper names, since that merely adds another dimension to the interpretation of a given work. In practical fact, what we find in most cases is not addition, but restriction.

9 Linda Nochlin, 'Picasso's Colour: Schemes and Gambits', *Art in America*, vol. 68, no. 10, December 1980, pp. 105-23; 177-83.

10 Robert Rosenblum, 'Picasso and the Typography of Cubism', in *Picasso in Retrospect*, pp. 49-75.

11 Ibid., p. 75.

12 Ibid., p .56.

13 See Pierre Daix, *Picasso: The Cubist Years 1907-1916*, New York Graphic Society, 1980, p. 123.

14 Ferdinand de Saussure, *Course in General Linguistics*, trans. Wade Baskin, New York, p.120.

15 This and the next six paragraphs are adopted from my 'Re -Presenting Picasso', *Art in America*, vol. 68, no. 10, December 1980, pp. 91-6.

16 *Simulacrum* is a term used by both Jean Baudrillard and Guy de Bord.

17 Daix, *Picasso: The Cubist Years*, pp.132-7.

18 The passage from Heinrich Wölfflin, cited at the beginning of this section, which faces the possibility of the 'death of the feeling for form', is taken from Wölfflin's unpublished journals. For that passage, as for its translation, I am indebted to Joan Hart and her PhD dissertation *Heinrich Wölfflin*, University of California, Berkeley, 1981.

19 Rosenblum, p. 49.

20 In *The Rutgers Art Review*, 1, January 1980, p.73.

Benjamin H. D. Buchloh
Figures of Authority, Ciphers
of Regression: Notes on the Return
of Representation in European
Painting

Source; Benjamin H. D. Buchloh, 'Figures of
Authority, Ciphers of Regression: Notes on
the Return of Representation in European
Painting', *October,* 16, Spring 1981, pp.39-68.
This text has been edited and footnotes renum-
bered accordingly. Seven plates have been
omitted.

The crisis consists precisely in the fact that the old is dying and the new cannot be
born; in this interregnum a great variety of morbid symptoms appears.
Antonio Gramsci, Prison Notebooks

How is it that we are nearly forced to believe that the return to traditional
modes of representation in painting around 1915, two years after the
Readymade [Duchamp] and the Black Square[Malevich], was a shift of great
historical or aesthetic import? And how did this shift come to be understood
as an autonomous achievement of the masters, who were in fact the servants
of an audience craving for the restoration of the visual codes of recognizabil-
ity, for the reinstatement of figuration? If the perceptual conventions of
mimetic representation – the visual and spatial ordering systems that had
defined pictorial production since the Renaissance and had in turn been sys-
tematically broken down since the middle of the nineteenth century – were
re-established, if the credibility of iconic referentiality was re-affirmed, and if
the hierarchy of figure-ground relationships on the picture plane was again
presented as an 'ontological' condition, what other ordering systems outside
of aesthetic discourse had to have already been put in place in order to imbue
the new visual configurations with historical authenticity? In what order do
these chains of restorative phenomena really occur and how are they linked?
Is there a simple causal connection, a mechanical reaction, by which growing
political oppression necessarily and irreversibly generates traditional repre-
sentation? Does the brutal increase of restrictions in socio-economic and
political life unavoidably result in the bleak anonymity and passivity of the
compulsively mimetic modes that we witness, for example, in European
painting of the mid-1920s and early 1930s?

It would certainly appear that the attitudes of the Neue Sachlichkeit and
Pittura Metafisica cleared the way for a final takeover by such outright
authoritarian styles of representation as Fascist painting in Germany and Italy
and socialist realism in Stalinist Russia. When Georg Lukács discussed the rise
and fall of expressionism in his 'Problems of Realism', he seemed to be aware
of the relationship of these phenomena, without, however, clarifying the
actual system of interaction between protofascism and reactionary art prac-

tices: 'The realism of the Neue Sachlichkeit is so obviously apologetic and leads so clearly away from any poetic reproduction of reality that it can easily merge with the Fascist legacy.' [1] [...]

But would it not be more appropriate to conceive of these radical shifts of the period between the wars, with such decisive selections of production procedures, iconographic references, and perceptual conventions, as calculated? Should we not assume that every artist making these decisions would be aware of their ramifications and consequences, of the sides they would be taking in the process of aesthetic identification and ideological representation?

The question for us now is to what extent the rediscovery and recapitulation of these modes of figurative representation in present-day European painting reflect and dismantle the ideological impact of growing authoritarianism; or to what extent they simply indulge and reap the benefits of this increasingly apparent political practice; or worse yet, to what extent they cynically generate a cultural climate of authoritarianism to familiarize us with the political realities to come.

In order to analyse the contemporary phenomenon, it may be useful to realize that the collapse of the modernist idiom is not without precedent. The bankruptcy of capitalist economics and politics in the twentieth century has been consistently anticipated and accompanied by a certain rhythm of aesthetic manifestations. First there is the construction of artistic movements with great potential for the critical dismantling of the dominant ideology. This is then negated by those movements' own artists, who act to internalize oppression, at first in haunting visions of incapacitating and infantilizing melancholy and then, at a later stage, in the outright adulation of manifestations of reactionary power. In the present excitement over 'postmodernism' and the 'end of the avant-garde', it should not be forgotten that the collapse of the modernist paradigm is as much a cyclical phenomenon in the history of twentieth-century art as is the crisis of capitalist economics in twentieth-century political history: overproduction, managed unemployment, the need for expanding markets and profits and the resultant war-mongering as the secret promise of a final solution for late capitalism's problems. It seems necessary to insist upon seeing present developments in the larger context of these historical repetitions, in their nature as response and reaction to particular conditions that exist outside the confines of aesthetic discourse.

If the current debate does not place these phenomena in historical context, if it does not see through the eagerness with which we are assured from all sides that the avant-garde has completed its mission and has been accorded a position of comfort within a pluralism of meanings and aesthetic masquerades, then it will become complicit in the creation of a climate of desperation and passivity. The ideology of postmodernism seems to forget the subtle and manifest political oppression which is necessary to save the existing power structure. Only in such a climate are the symbolic modes of concrete anticipation transformed into allegorical modes of internalized retrospection. If one realizes that melancholy is at the origin of the allegorical mode, one

should also realize that this melancholy is enforced by prohibition and repression. What is taken as one of the key works for postmodernist aesthetics and the central reference for any contemporary theory of the return to allegory in aesthetic production and reception, Walter Benjamin's *The Origin of German Tragic Drama*, was written during the dawn of rising fascism in Germany. Its author was well aware of the work's allusion to contemporary artistic and political events, as is confirmed by Benjamin's friend Asja Lacis:

He said that he did not consider this thesis simply as an academic investigation but that it had very direct interrelationships with acute problems of contemporary literature. He insisted explicitly on the fact that in his thesis he defined the dramaturgy of the baroque as an analogy to expressionism in its quest for a formal language. Therefore I have, so he said, dealt so extensively with the artistic problems of allegory, emblems, and rituals.[2]

Or, as George Steiner describes it in his introduction to the English edition of Benjamin's study:

As during the crises of the Thirty Years' War and its aftermath, so in Weimar Germany the extremities of political tension and economic misery are reflected in art and critical discussion. Having drawn the analogy, Benjamin closes with hints towards a recursive theory of culture: eras of decline resemble each other not only in their vices but also in their strange climate of rhetorical and aesthetic vehemence. ... Thus study of the baroque is no mere antiquarian archival hobby: it mirrors, it anticipates and helps grasp the dark present.[3]

Repression and Representation

It is generally agreed that the first major breakdown of the modernist idiom in twentieth-century painting occurs at the beginning of the First World War, signalled by the end of Cubism and Futurism and the abandonment of critical ideals by the very artists who had initiated those movements. Facing the deadlock of their own academicization and the actual exhaustion of the historical significance of their work, Picasso, Derain, Carrà, and Severini – to name but a few of the most prominent figures – were among the first to call for a return to the traditional values of high art. Creating the myth of a new classicism to disguise their condition, they insisted upon the continuation of easel painting, a mode of production that they had shortly before pushed to its very limits, but which now proved to be a valuable commodity which was therefore to be revalidated. From this situation there originated their incapacity or stubborn refusal to face the epistemological consequences of their own work. Already by 1913 their ideas had been developed further by younger artists working in cultural contexts which offered broader historical, social, and political options to dismantle the cultural tenets of the European bourgeoisie. This is particularly the case with Duchamp in America and Malevich and the constructivists in Russia. [...]

Even in 1923 these polemics continued among various factions of the Parisian avant-garde. On the occasion of the first performance of Tristan

Tzara's *Coeur à Gaz*, at the Soireé du Coeur à Barbe, a fistfight broke out in the audience when one of the artists present jumped on to the stage and shouted, 'Picasso is dead on the field of battle.'[4] But even artists who had been allied with the cubist movement realized by the end of the second decade that it was exhausted, without, however, necessarily advocating a return to the past. Blaise Cendrars, for example, in his text 'Pourquoi le cube s'effrite?' published in 1919, announced the end of the relevance of the cubist language of form. On the other hand, in the very same year a number of ideological justifications appeared for the regression that had begun around 1914-15. Among the many documents of the new attitude of authoritarian classicism are a pamphlet by the cubist dealer Léonce Rosenberg, *Cubisme et Tradition*, published in 1920, and Maurice Raynal's 'Quelques intentions du cubisme', written in 1919 and published in 1924, which states, 'I continue to believe that knowledge of the Masters, right understanding of their works, and respect for tradition might provide strong support.'[5] If properly read, this statement, in its attempt to legitimize the academicization of an aging and ailing cubist culture, already reveals the inherent authoritarian tendency of the myth of a new classicism. Then as now, the key terms of this ideological backlash are the idealization of the perennial monuments of art history and its masters, the attempt to establish a new aesthetic orthodoxy, and the demand for respect for the cultural tradition. It is endemic to the syndrome of authoritarianism that it should appeal to and affirm the 'eternal' or ancient systems of order (the law of the tribe, the authority of history, the paternal principle of the master, etc.). This unfathomable past history then serves as a screen upon which the configurations of a failed historical presence can be projected. In 1915, when Picasso signals his return to a representational language by portraying the cubist poet Max Jacob, recently converted to Catholicism, in the guise of a Breton peasant, drawn in the manner of Ingres, we get a first impression of the degree of eclecticism that is necessary to create the stylistic and historical pose of classical simplicity and equilibrium, with its claim to provide access to the origins and essentials of universal human experience. Subsequently this historicist eclecticism becomes an artistic principle, and then, as in Jean Cocteau's 'Rappel à l'Ordre' of 1926, it is declared the new avant-garde programme.

In Picasso's work the number and heterogeneity of stylistic modes quoted and appropriated from the fund of art history increases in 1917: not only Ingres's classical portraits but, as a result of Picasso's journey to Italy in the company of Cocteau, the iconography of the Italian *commedia dell'arte* and the frescoes of Herculaneum (not to mention the sculpture of the Parthenon frieze and the white figure vases at the Louvre, the peasant drawings of Millet, the late nudes of Renoir, the pointillism of Seurat, as Blunt, Green and other Picasso scholars have pointed out). And of course, there is the self-quotation of synthetic cubist elements, which lend themselves so easily to the high sensuousness of Picasso's decorative style of the early twenties.

Again it is Maurice Raynal who naïvely provides the clue to an analysis of these works when he describes Picasso's 1921 *Three Musicians* [Plate 34] as

34 Pablo Picasso, *Three Musicians*, Fontainebleau, Summer 1921. Oil on canvas, 200.7 × 222.9 cm. Collection, The Museum of Modern Art, New York. Mrs Simon Guggenheim Fund. © DACS, London 1993.

'rather like magnificent shop windows of cubist inventions and discoveries'.[6] The free-floating availability of these cubist elements and their interchangeability indicate how the new language of painting – now wrenched from its original symbolic function – has become reified as 'style' and thus no longer fulfils any purpose but to refer to itself as an aesthetic commodity within a dysfunctional discourse. It therefore enters those categories of artistic production that by their very nature either work against the impulse to dissolve reification or are oblivious to that impulse: the categories of decoration, fashion, and objets d'art.

This transformation of art from the practice of the material and dialectical transgression of ideology to the static affirmation of the conditions of reification and their psychosexual origins in repression have been described as the source of a shift towards the allegorical mode by Leo Bersani: 'It is the extension of the concrete into memory and fantasy. But with the negation of desire, we have an immobile and immobilizing type of abstraction. Instead of imitating a process of endless substitutions (desire's ceaseless "travelling" among different images), abstraction is now a transcendence of the desiring process itself. And we move toward an art of allegory.'[7]

227

35 Gino Severini, *Spherical Expansion of Light (Centrifugal)*, 1914. Oil on canvas, 62 × 50 cm. Collection Dr Riccardo Jucker, Milan. © ADAGP, Paris and DACS, London 1993.

36 Carlo Carrà, *Patriotic Celebration* also known as *Words in Freedom: Interventionist Manifesto*, 1914. Collage on card, 38 × 30 cm. Mattioli Collection, Milan. Photo: Scala. © DACS, London 1993.

37 Gino Severini, *Maternity*, 1916. Oil on canvas, 92 × 65 cm. Museo dell' Academia Etrusca Cortone. Photo: Scala. © ADAGP, Paris and DACS, London 1993.

This becomes even more evident in the iconography of Pittura Metafisica, which de Chirico and the former futurist Carrà initiated around 1913. The conversion of the futurists, parallel to that of the cubists, involved not only a renewed veneration of the cultural tradition of the past – as opposed to their original fervent antipathy to the past – but also a new iconography of haunting, pointlessly assembled quotidian objects painted with meticulous devotion to representational conventions. De Chirico describes his paintings as stages decorated for imminent but unknown and threatening acts, and insists on the demands that are inherent in the objects of representation: 'The metaphysical work of art seems to be joyous. Yet one has the Impression that something is going to happen in this joyous world.'[8] De Chirico speaks of the tragedy of joy, which is nothing other than the calm before the storm, and the canvas now becomes the stage upon which the future disaster can be enacted. As the Italian historian Umberto Silva pointed out, 'De Chirico is the personification of Croce's Italian disease: not quite fascism yet, but the fear of its dawn'.[9]

As was the case in Picasso's conversion, the futurists now fully repudiated their earlier non-representational modes and procedures of fragmentation and pictorial molecularization [Plates 35 and 36]. They further rejected the collage techniques by which they had forced the simultaneous presence of heterogeneous materials and procedures within the painted surface, and

38 Carlo Carrà, *Daughters of Lot*, 1919. Oil on canvas, 110 × 80 cm. Museum Ludwig, Cologne. Photo: Rheinisches Bildarchiv. © DACS, London 1993.

through which they had underlined the interaction of aesthetic phenomena with their social and political context. It is surely no accident that one of Severini's first paintings to manifest his return to history is a work called *Maternity* [Plate 37], which represents a mother suckling an infant in the traditional pose of the Madonna. Even more conspicuous perhaps is the case of Carrà [Plate 36], who had been one of the most important futurists due to his development of non-mimetic pictorial signs, his systematic transgression of verbal and visual codes through the insertion of verbal fragments within painting, and his mechanization of pictorial production processes and their juxtaposition with pictorialized remnants of mechanical production processes. Carrà turned at that time to representational depictions of biblical scenes in the manner of Tuscan painting [Plate 38].

Art, Past and Master

To the very same extent that the rediscovery of history serves the authoritarian purpose of justifying the failure of modernism, the atavistic notion of the master artist is re-introduced to continue a culture oriented to an esoteric élite, thus guaranteeing that élite's right to continued cultural and political leadership. The language of the artists themselves (or rather these particular

artists, for there is an opposite definition of artistic production and culture simultaneously developing in the Soviet Union) blatantly reveals the intricate connection between aesthetic mastery and authoritarian domination. Three examples from three different decades may serve to illustrate this aesthetic stance:

Hysteria and dilettantism are damned to the burial urns. I believe that everybody is fed up now with dilettantism: whether it be in politics, literature, or painting. – Giorgio de Chirico, 1919.[10]

Socialism has only been invented for the mediocre and the weak. Can you imagine socialism or communism in Love or in Art? One would burst into laughter – if one were not threatened by the consequences. – Francis Picabia, 1927.[11]

And finally, Picasso's notorious statement from 1935:

There ought to be an absolute dictatorship ... a dictatorship of painters ... a dictatorship of one painter ... to suppress all those who have betrayed us, to suppress the cheaters, to suppress the tricks, to suppress mannerisms, to suppress charms, to suppress history, to suppress a heap of other things.[12]

Like senile old rulers who refuse to step down, the stubbornness and spite of the old painters increase in direct proportion to the innate sense of the invalidity of their claims to save a cultural practice that had lost its viability. When, in the early twenties, the former German Dadaist Christian Schad [Plates 39 and 40] attempts a definition of the Neue Sachlichkeit by portraying members

39 Christian Schad, *Portrait of a Woman*, 1920. Oil on wood with collage, 60 × 30 x 10.5 cm. Private Collection. © G. A. Richter, Rottach-Egern, Germany.

40 Christian Schad, *Self-Portrait with Model,*
1927. Oil on panel, 76 × 71.5 cm. Private
Collection. © G. A. Richter, Rottach-
Egern, Germany.

of the Weimar hautemonde and demimonde in the manner of Renaissance
portraits; when, in 1933, Kasimir Malevich portrays himself and his wife in
Renaissance costumes; then obviously the same mechanism of authoritarian
alienation is at work [Plates 41 and 42]. In a text from 1926 Schad delivers a com-
plete account of the syndrome's most conspicuous features:

Oh, it is so easy to turn one's back on Raphael. Because it is so difficult to be a good
painter. And only a good painter is able to paint well. Nobody will ever be a good
painter if he is only capable of painting well. One has be born a good painter. ... Italy
opened my eyes about my artistic volition and capacity. ... In Italy the art is ancient
and ancient art is often newer than the new art.[13]

The idealization of the painter's craft, the hypostasis of a past culture that
serves as a fictitious realm of successful solutions and achievements that have
become unattainable in the present, the glorification of the Other culture –
in this case Italy – all of these features – currently discussed and put into prac-
tice once again – recur through the first three decades of twentieth-century
modernism. They seek to halt that modernism and to deny its historical
necessity as well as to deny the dynamic flux of social life and history through
an extreme form of authoritarian alienation from these processes. It is impor-
tant to see how these symptoms are rationalized by the artists at the time of
their appearance, how they are later legitimized by art historians, and how
they are finally integrated into an ideology of culture. [...]
 [...] Style, the very gem of reified art-historical thinking, the fiction that
there could be a pictorial mode or a discursive practice that might function

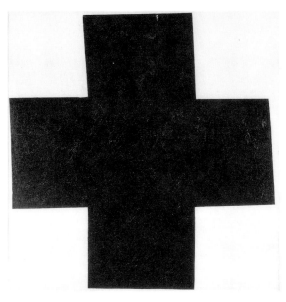

41 Kasimir Malevich, *The Black Cross*, 1915. Oil on canvas,
80 × 80 cm. Musée National d'art Moderne,
Centre Georges Pompidou, Paris.

42 Kasimir Malevich, *Self-Portrait*, 1933. Oil on canvas,
73 × 66 cm. Collection State Russian Museum, St. Petersburg.

autonomously – traditionally rejected by artists – is now applied by the artists to imbue these exhausted modes with historical meaning. 'All the wasms have become isms', is a vulgar contemporary variation on the theme of historicism put forward by the self-styled spokesman of postmodernist architecture, Charles Jencks.

Style then becomes the ideological equivalent of the commodity: its universal exchangeability, its free-floating availability indicating a historical moment of closure and stasis. When the only option left to aesthetic discourse is the maintenance of its own distribution system and the circulation of its commodity forms, it is not surprising that all 'audacities have become convention' and that paintings start looking like shop windows decorated with fragments and quotations of history.

None of the manifold features of this eclecticism should be seen as random; they confirm one another in an intricate network of historical meaning, which may, however, be read differently from the intentions of the authors or the interests of their audience and the art historians who constitute their cultural reception. This transformation of the subversive function of aesthetic production to plain affirmation necessarily manifests itself in each detail of production. The discovery of 'history' as a treasure trove into which one might dip for the appropriation of abandoned elements of style is but one obvious step. The secret attraction of the iconography of Italian theatre for Picasso and others at that time becomes more comprehensible in such a perspective. The Harlequins, Pierrots, Bajazzos, and Pulcinelles invading the work of Picasso, Beckmann, Severini, Derain, and others in the early twenties (and, in the mid-thirties, even the work of the former constructivist/productivist Rodchenko in Russia) can be identified as ciphers of an enforced regression. They serve as emblems for the melancholic infantilism of the avant-garde artist who has come to realize his historical failure. The clown functions as a social archetype of the artist as an essentially powerless, docile, and entertaining figure performing his acts of subversion and mockery from an undialectical fixation on utopian thought.

This carnival of eclecticism, this theatrical spectacle, this window dressing of self-quotation becomes transparent as a masquerade of alienation from history, a return of the repressed in cultural costume. It is essential to the functioning of historicism and its static view of history that it assemble the various fragments of historical recollection and incantation according to the degree of projection and identification that these images of the past will provide for the needs of the present. Quite unlike the modernist collage, in which various fragments and materials of experience are laid bare, revealed as fissures, voids, unresolvable contradictions,irreconcilable particularizations, pure heterogeneity, the historicist image pursues the opposite aim: that of synthesis, of the illusory creation of a unity and totality which *conceals* its historical determination and conditioned particularity.[14] This appearance of a unified pictorial representation, homogeneous in mode, material, and style, is treacherous, supplying as it does aesthetic pleasure as false consciousness, or vice versa. If the modernist work provides the viewer with perceptual clues to all its

233

material, procedural, formal, and ideological qualities as part of its modernist programme, which therefore gives the viewer an experience of increased *presence* and autonomy of the *self*, then the historicist work pretends to a successful resolution of the modernist dilemma of aesthetic self-negation, particularization, and restriction to detail, though *absence*, leading to the seductive domination of the viewer by the Other, as Julia Kristeva has described the experience of alienation and perversion that ideology imposes on the subject.

The Returns of the New

[...] Perceptual and cognitive models and their modes of artistic production function in a manner similar to the libidinal apparatus that generates, employs, and receives them. Historically, they lead a life independent of their original contexts and develop specific dynamics: they can be easily reinvested with different meanings and adapted to ideological purposes. Once exhausted and made obsolete by subsequent models, these production modes can generate the same nostalgia as does iconic representation for an obsolete code. Emptied of their historical function and meaning, they do not disappear but rather drift in history as empty vessels waiting to be filled with reactionary interests in need of cultural legitimation. Like other objects of cultural history, aesthetic production modes can be wrenched from their contexts and functions, to be used to display the wealth and power of the social group that has appropriated them.

To invest these obsolete modes with meaning and historical impact requires, however, that they be presented as *radical* and *new*. The secret awareness of their obsolescence is belied by the obsession with which these regressive phenomena are announced as innovation. 'The New Spirit of Painting', 'The New Fauves', 'Naïve Nouveau', 'Il Nuove Nuove', 'The Italian New Wave' are some of the labels attached to recent exhibitions of retrograde contemporary art (as though the prefix *neo* did not indicate the restoration of pre-existing forms). It is significant in this regard that the German neo-expressionists who have recently received such wide recognition in Europe (presumably to be followed by a similar acclaim in North America) have been operating on the fringes of the German art world for almost twenty years. Their 'newness' consists precisely in their current historical availability, not in any actual innovation of artistic practice. [...]

But the intentions of the artists and their apologists remain to be understood, because contrary to their claim to psychic universality they in fact 'express' only the needs of a very circumscribed social group. If 'expressivity' and 'sensuousness' have again become criteria of aesthetic evaluation, if we are once again confronted with the depictions of the sublime and the grotesque – complementary experiential states of modernism's high culture products – then that notion of sublimation which defines the individual's work as determined by alienation, deprivation, and loss is reaffirmed. This process is simply described by Lillian Robinson and Lise Vogel:

Suffering is portrayed as a personal struggle, experienced by the individual in isolation. Alienation becomes a heroic disease for which there is no social remedy. Irony masks resignation to a situation one cannot alter or control. The human situation is seen as static, with certain external forms varying but the eternal anguish remaining. Every political system is perceived to set some small group into power, so that changing the group will not affect our 'real' (that is private) lives. ... Thus simply expressed, the elements of bourgeois ideology have a clear role in maintaining the status quo. Arising out of a system that functions through corporate competition for profits, the ideas of the bourgeoisie imply the ultimate powerlessness of the individual, the futility of public action and the necessity of despair.[15]

Modernist high culture canonized aesthetic constructs with the appellation 'sublime' when the artists in question had proven their capacity to maintain utopian thought in spite of the conditions of reification, and when, instead of actively attempting to change those conditions, they simply shifted subversive intentions into the aesthetic domain. The attitude of individual powerlessness and despair is already reaffirmed in the resignation implicit in a return to the traditional tools of the craft of painting and in the cynical acceptance of its historical limitations and its materially, perceptually, and cognitively primitivist forms of signification.

Such paintings, experienced by a certain audience as sensuous, expressive, and energetic, perform and glorify the ritual of instant excitation and perpetually postponed gratification that is the bourgeois mode of experience. This bourgeois model of sublimation – which has, of course, been countered by an avant-garde tradition of negation, a radical denial of that model's perpetrations of the extreme division of labour and specialization of sexual role behaviour – finds its appropriate manifestation in the repeated revitalization of obsolete representational and expressive pictorial practices. It is not accidental that Balthus – champion of the bourgeois taste for high titillation with his scopophilic pictures of sleeping or otherwise unaware adolescent female nudes – has recently received renewed acclaim and is regarded as one of the patriarchal figures of the 'new' figuration. Nor is it accidental that not *one* of the German neo-expressionists or the Italian Arte Ciphra painters is female. At a time when cultural production in every field is becoming increasingly aware of, if not actively countering, the oppression of traditional role distinctions based on the construction of sexual difference, contemporary art (or at least that segment of it that is currently receiving prominent museum and market exposure) returns to concepts of psychosexual organization that date from the origins of bourgeois character formation. The bourgeois concept of the avant-garde as the domain of heroic male sublimation functions as the ideological complement and cultural legitimation of social repression. [...]

The abandonment of painting as sexual metaphor that occurred around 1915 implied not only formal and aesthetic changes but also a critique of traditional models of sublimation. This is most evident in Duchamp's interest in androgyny and in the Constructivists' wish to abolish the production mode of the individual master in favour of one oriented to collective and utilitarian practice. In contradistinction, those painting practices which operate under

235

the naïve assumption that gestural delineation, high-contrast colour, and heavy impasto are immediate (unmediated, noncoded) representations of the artist's desire propagate the traditional role model; and they do so far more effectively than the painting practices which systematically investigate their own procedures. The former's attraction and success, its role and impact with regard to notions of high culture and the hierarchy of the visual arts, are governed by its complicity with these models of psychosexual organization. Carol Duncan has described how psychosexual and ideological concepts interrelate, how they are concealed and mediated in early twentieth-century Expressionist painting:

> According to their paintings, the liberation of the artist means the domination of others; his freedom requires their unfreedom. Far from contesting the established social order, the male-female relationship that these paintings imply – the drastic reduction of women to objects of specialized male interest – embodies on a sexual level the basic class relationship of capitalist society. In fact such images are splendid metaphors for what the wealthy collectors who eventually acquired them did to those beneath them in the social as well as the sexual hierarchy. However, if the artist is willing to regard women as merely a means to his own ends, if he exploits them to achieve his boast of virility, he, in turn, must merchandize and sell himself – an illusion of himself and his intimate life – on the open, competitive avant-garde market. He must promote (or get dealers and critic friends to promote) the value of his special credo, the authenticity of his special vision, and – most importantly – the genuineness of his antibourgeois antagonism. Ultimately, he must be dependent on and serve the pleasure of this very bourgeois world or enlightened segments of it that his art and life seem to contest.[16]

Inasmuch as this sexual and artistic role is itself reified, *peinture* – the fetishized mode of artistic production – can assume the function of an aesthetic equivalent and provide a corresponding cultural identification for the viewer. Not surprisingly, then, both German neo-expressionists and Italian Arte Ciphra painters draw heavily upon the stock of painterly styles that predate the two major shifts in twentieth-century art history: fauvism, expressionism, and Pittura Metafisica before Duchamp and constructivism; surrealist automatism and abstract expressionism before Rauschenberg and Manzoni – the two essential instances in modern art when the production process of painting was radically questioned for its claim to organic unity, aura, and presence, and replaced by heterogeneity, mechanical procedures, and seriality.

The contemporary regressions of 'postmodernist' painting and architecture are similar in their iconic eclecticism to the neoclassicism of Picasso, Carrà, and others. A variety of production procedures and aesthetic categories, as well as the perceptual conventions that generated them are now wrested from their original historical contexts and reassembled into a spectacle of availability. They postulate an experience of history as private property; their function is that of *decorum*. The gaudy frivolity with which these works underscore their awareness of the ephemeral function they perform cannot conceal the material and ideological interests they serve; nor can their aggres-

sivity and bravura disguise the exhaustion of the cultural practices they try to maintain.

The works of the contemporary Italians explicitly revive, through quotation, historical production processes, iconographic references, and aesthetic categories. Their techniques range from fresco painting (Clemente) to casting sculpture in bronze (Chia), from highly stylized primitivist drawing to gestural abstraction. Iconographic references range from representations of saints (Salvo) to modish quotations from Russian constructivism (Chia). With equal versatility they orchestrate a programme of dysfunctional plastic categories, often integrated into a scenario of aesthetic surplus: free-standing figurative sculpture combined with an installation of aquatint etchings, architectural murals with small-scale easel paintings, relief constructions with iconic objects.

The German neo-expressionists are equally protean in their unearthing of atavistic production modes, including even primitivist hewn wood polychrome sculpture, paraphrasing the expressionist paraphrase of 'primitive' art (Immendorff). The rediscovery of ancient teutonic graphic techniques such as woodcuts and linocuts flourishes (Baselitz, Kiefer), as does their iconography: the nude, the still life, the landscape, and what these artists conceive of as allegory.

Concomitant with the fetishization of painting in the cult of *peinture* is a fetishization of the perceptual experience of the work as *auratic*. The contrivance of aura is crucial for these works in order that they fulfil their function as the luxury products of a fictitious high culture. In the tangibility of the auratic, figured through crafted surface textures, aura and commodity coalesce. Only such synthetic uniqueness can satisfy the contempt that bourgeois character holds for the 'vulgarities' of social existence; and only this 'aura' can generate 'aesthetic pleasure' in the narcissistic character disorder that results from this contempt. Meyer Schapiro saw this symbiotic relationship between certain artists and their patrons in 1935: 'The artist's frequently asserted antagonism to organized society does not bring him into conflict with his patrons, since they share his contempt for the public and are indifferent to practical social life.'[17]

The aesthetic attraction of these eclectic painting practices originates in a nostalgia for the moment in the past when the painting modes to which they refer had historical authenticity. But the spectre of derivativeness hovers over every contemporary attempt to resurrect figuration, representation, and traditional modes of production. This is not so much because they actually derive from particular precedents, but because their attempt to re-establish forlorn aesthetic positions immediately situates them in historical secondariness. That is the price of instant acclaim achieved by affirming the status quo under the guise of innovation. The primary function of such cultural re-presentations is the confirmation of the hieratics of ideological domination. [...]

Notes

1 Lukács, *Probleme des Realismus*, vol.1, *Gesammelte Werke*, vol.4, Berlin, 1971, p. 147.

237

2 Asja Lacis, *Revolutionär im Beruf*, ed. Hildegard Brenner, Munich, 1971, p. 44.

3 George Steiner, 'Introduction', in Walter Benjamin, *The Origin of German Tragic Drama*, London, 1977, p. 24.

4 See William Rubin, *Picasso*, New York: Museum of Modern Art, 1980, p. 224. The awareness of Picasso's decline eventually developed even among art historians who had been previously committed to his work: 'Picasso belongs to the past. ... His downfall is one of the most upsetting problems of our era' (German Bazin, quoted in Rubin, p. 277).

5 Maurice Raynal, 'Quelques intentions du cubisme', *Bulletin de l'effort moderne*, no. 4, 1924, p. 4.

6 Ibid.

7 Leo Bersani, *Baudelaire and Freud*, Berkeley, 1977, p. 98.

8 Giorgio de Chirico, 'Uber die metaphysische Kunst', in *Wir Metaphysiker*, Berlin, n.d., p. 45.

9 Umberto Silva, *Kunst und Ideologie des Faschismus*, Frankfurt, 1975, p. 18.

10 Giorgio de Chirico, *Valori Plastici*, nos. 3-4, Rome, 1919. [...] When the French art historian Jean Clair tries to understand these phenomena outside of their historical and political context, his terminology, which is supposed to explain these contradictions and save them for a new reactionary anti-modernist art-history writing, has to employ the same clichés of authoritarianism, the fatherland, and the paternal heritage: '[These painters] come to collect their paternal heritage, they do not even dream of rejecting it. ... Neoclassicism is lived as a meditation on the exile, far from the lost fatherland which is also that of painting, the lost fatherland of paintings' (Jean Clair, 'Metafisica et Unheimlichkeit', in *Les Realismes 1919-1939*, Paris: Musée National d'Art Moderne, 1981, p. 32).

11 'Francis Picabia contre Dada ou le Retour à la Raison', in *Comoedia*, 14 March 1927, p. 1. [...]

12 Pablo Picasso, in conversation with Christian Zervos, in *Cahiers d'Art*, vol.10, no. 1, 1935, p. 173.

13 Christian Schad, statement in exhibition catalogue, Galerie Würthle, Vienna, 1927. See also a nearly identical statement by the former Expressionist Otto Dix: 'The new element of painting for me resides in the intensification of forms of expression which *in nuce* exist already as given in the work of *old masters*' (in *Das Objekt ist das Primäre*, Berlin, 1927). Compare this with the statement by George Grosz, a peer of Schad and Dix: 'The return to French classicist painting, to Poussin, Ingres, and Corot, is an insidious fashion of *Biedermeier*. It seems that the political reaction is therefore followed by an intellectual reaction' (in *Das Kunstblatt*, 1922, as a reply to Paul Westheim's inquiry 'Towards a New Naturalism?').

14 These 'concealed collages' in paintings represent a false unification. Fredric Jameson describes this analogous attempt at unification in literature: '... the mirage of the continuity of personal identity, the organizing unity of the psyche or the personality, the concept of society itself, and not least, the notion of the organic unity of the work of art' (*Fables of Aggression*, Berkeley, 1980, p.8). [...]

15 Lillian Robinson and Lise Vogel, 'Modernism and History', *New Literary History*, vol.3, no. 1, p. 196.

16 Carol Duncan, 'Virility and Domination in Early Twentieth Century Painting', *Artforum*, vol. 12, no. 9, June 1974, p. 38.

17 Meyer Schapiro, quoted in Maz Koxloff, 'The Authoritarian Personality in Modern Art', *Artforum*, vol. 12, no. 8, May 1971.

23

Serge Guilbaut
The New Adventures of the
Avant-Garde in America:
Greenberg, Pollock, or from
Trotskyism to the New Liberalism
of the 'Vital Center'
Translated by Thomas Repensek

Source: Serge Guilbaut, 'The New Adventures
of the Avant-Garde in America: Greenberg,
Pollock, or from Trotskyism to the New
Liberalism of the "Vital Center" ', *October,* 15,
Winter 1980, pp.61-78. This text has been
edited and footnotes renumbered accordingly.

We now know that the traditional make-up of the avant-garde was revitalized in the United States after the Second World War. In the unprecedented economic boom of the war years, the same strategies that had become familiar to a jaded Parisian bourgeoisie were skilfully deployed, confronted as they were with a new bourgeois public recently instructed in the principles of modern art.

Between 1939 and 1948 Clement Greenberg developed a formalist theory of modern art which he would juxtapose with the notion of the avant-garde, in order to create a structure which, like that of Baudelaire or Apollinaire, would play an aggressive, dominant role on the international scene. [...]

When we speak about Greenbergian formalism, we are speaking about a theory that was somewhat flexible as it began clearly to define its position within the new social and aesthetic order that was taking shape during and after the war; only later would it solidify into dogma. We are also speaking about its relationship to the powerful Marxist movement of the 1930s, to the crisis of Marxism, and finally to the complete disintegration of Marxism in the 1940s – a close relationship clearly visible from the writings and ideological positions of Greenberg and the abstract expressionists during the movement's development. Greenbergian formalism was born from those Stalinist-Trotskyite ideological battles, the disillusionment of the American Left, and the de-Marxification of the New York intelligentsia. [...]

De-Marxification really began in 1937 when a large number of intellectuals, confronted with the mediocrity of the political and aesthetic options offered by the Popular Front, became Trotskyites. Greenberg, allied for a time with Dwight MacDonald and *Partisan Review* in its Trotskyite period (1937-9), located the origin of the American avant-garde venture in a Trotskyite context: 'Some day it will have to be told how anti-Stalinism which started out more or less as Trotskyism turned into art for art's sake, and thereby cleared the way heroically for what was to come.'[1] When the importance of the Popular Front, its voraciousness and success are taken into account, it is hardly surprising that Trotskyism attracted a certain number of intellectuals. The American Communist party's alliance with liberalism disillusioned those who sought a radical change of the political system that had

been responsible for the Depression. This alliance prepared the stage for revolution. [...]

It was the art historian Meyer Schapiro who initiated the shift. In 1937, abandoning the rhetoric of the Popular Front as well as the revolutionary language used in his article 'Social Bases of Art', in which he emphasized the importance of the alliance between the artist and the proletariat,[2] he crossed over to the Trotskyite opposition. He published in *Marxist Quarterly* his celebrated article 'Nature of Abstract Art',[3] important not only for its intelligent refutation of Alfred Barr's formalist essay 'Cubism and Abstract Art',[4] but also for the displacement of the ideology of his earlier writing, a displacement that would subsequently enable the Left to accept artistic experimentation, which the Communist Popular Front vigorously opposed.

If in 1936, in 'Social Bases of Art', Schapiro guaranteed the artist's place in the revolutionary process through his alliance with the proletariat, in 1937, in 'Nature of Abstract Art', he became pessimistic, cutting the artist off from any revolutionary hope whatsoever. For Schapiro, even abstract art, which Alfred Barr and others persistently segregated from social reality in a closed, independent system, had its roots in its own conditions of production. The abstract artist, he claimed, believing in the illusion of liberty, was unable to understand the complexity and precariousness of his own position, nor could he grasp the implications of what he was doing. By attacking abstract art in this way, by destroying the illusory notion of the artist's independence, and by insisting on the relationships that link abstract art with the society that produces it, Schapiro implied that abstraction had a larger signification than that attributed to it by the formalists.

Schapiro's was a two-edged sword: while it destroyed Alfred Barr's illusion of independence, it also shattered the Communist critique of abstract art as an ivory tower isolated from society. The notion of the non-independence of abstract art totally disarmed both camps. Leftist painters who rejected 'pure art' but who were also disheartened by the Communist aesthetic, saw the 'negative' ideological formulation provided by abstract art as a positive force, a way out. It was easy for the Communists to reject art that was cut off from reality, isolated in its ivory tower. But if, as Schapiro claimed, abstract art was part of the social fabric, if it reacted to conflicts and contradictions, then it was theoretically possible to use an abstract language to express a critical social consciousness. In this way, the use of abstraction as critical language answered a pressing need articulated by *Partisan Review* and *Marxist Quarterly*: the independence of the artist vis-à-vis political parties and totalitarian ideologies. An opening had been made that would develop (in 1938 with Breton-Trotsky, in 1939 with Greenberg, in 1944 with Motherwell)[5] into the concept of a critical, avant-garde abstract art. The 'Nature of Abstract Art' relaxed the rigid opposition of idealist formalism and social realism, allowing for the re-evaluation of abstraction. For American painters tired of their role as propagandizing illustrators, this article was a deliverance, and it conferred unassailable prestige on the author in anti-Stalinist artistic circles. Schapiro remained in the minority, however, in spite of his alignment with J. T.

Farrell, who also attacked the vulgar Marxism and the aesthetic of the Popular Front in his 'Note on Literary Criticism'.[6]

In December 1937, *Partisan Review* published a letter from Trotsky in which he analysed the catastrophic position of the American artist who, he claimed, could better himself, caught as he was in the bourgeois stranglehold of mediocrity, only through a thorough political analysis of society. [...]

Trotsky and Breton's analysis, like Greenberg's, blamed cultural crisis on the decadence of the aristocracy and the bourgeoisie, and placed its solution in the hands of the independent artist; yet they maintained a revolutionary optimism that Greenberg lacked. For Trotsky, the artist should be free of partisanship but not politics. Greenberg's solution, however, abandoned this critical position, as well as what Trotsky called eclectic action, in favour of a unique solution: the modernist avant-garde.[7] In fact, in making the transition from the political to the artistic avant-garde, Greenberg believed that only the latter could preserve the quality of culture against the overwhelming influence of kitsch by enabling culture to continue to progress. Greenberg did not conceive of this cultural crisis as a conclusion, as had been the case during the preceding decade, that is, as the death of a bourgeois culture being replaced by a proletarian one, but as the beginning of a new era contingent on the death of a proletarian culture destroyed in its infancy by the Communist alliance with the Popular Front, which *Partisan Review* had documented. As this crisis swiftly took on larger proportions, absorbing the ideals of the modern artist, the formation of an avant-garde seemed to be the only solution, the only thing able to prevent complete disintegration. Yet it ignored the revolutionary aspirations that had burned so brightly only a few years before. After the moral failure of the Communist Party and the incompetence of the Trotskyites, many artists recognized the need for a frankly realistic, non-revolutionary solution. Appealing to a concept of the avant-garde, with which Greenberg was certainly familiar, allowed for a defence of 'quality', throwing back into gear the progressive process brought to a standstill in academic immobility – even if it meant abandoning the political struggle in order to create a conservative force to rescue a foundering bourgeois culture.

Greenberg believed that the most serious threat to culture came from academic immobility, the Alexandrianism characteristic of kitsch. During that period the power structure was able to use kitsch easily for propaganda purposes. According to Greenberg, modern avant-garde art was less susceptible to absorption, not, as Trotsky believed, because it was too critical, but on the contrary because it was 'innocent', therefore less likely to allow a propagandistic message to be implanted in its folds. Continuing Trotsky's defence of a critical art 'remaining faithful to itself', Greenberg insisted on the critical endeavour of the avant-garde, but a critique that was directed inward, to the work itself, its medium, as the determining condition of quality. Against the menacing background of the Second World War, it seemed unrealistic to Greenberg to attempt to act simultaneously on both a political and cultural front. Protecting Western culture meant saving the furniture.

'Avant-Garde and Kitsch' was thus an important step in the process of de-Marxification of the American intelligentsia that had begun around 1936. The article appeared in the nick of time to rescue the intellectual wandering in the dark. After passing through a Trotskyite period of its own, *Partisan Review* emphasized the importance of the intellectual at the expense of the working class. It became preoccupied with the formation of an international intellectual élite to the extent that it sometimes became oblivious to the politics itself. [...]

Greenberg's article should be understood in this context. The delicate balance between art and politics which Trotsky, Breton, and Schapiro tried to preserve in their writings, is absent in Greenberg. Although preserving certain analytical procedures and a Marxist vocabulary, Greenberg established a theoretical basis for an élitist modernism, which certain artists had been thinking about since 1936, especially those associated with the American Abstract Artists group, who were also interested in Trotskyism and European culture.[8]

'Avant Garde and Kitsch' formalized, defined, and rationalized an intellectual position that was adopted by many artists who failed fully to understand it. Extremely disappointing as it was to anyone seeking a revolutionary solution to the crisis, the article gave renewed hope to artists. By using kitsch as a target, as a symbol of the totalitarian authority to which it was allied and by which it was exploited, Greenberg made it possible for the artist to act. By opposing mass culture on an artistic level, the artist was able to have the illusion of battling the degraded structures of power with élitist weapons. Greenberg's position was rooted in Trotskyism, but it resulted in a total withdrawal from the political strategies adopted during the Depression: he appealed to socialism to rescue a dying culture by continuing tradition. 'Today we no longer look towards socialism for a new culture – as inevitably as one will appear, once we do have socialism. Today we look to socialism *simply* for the preservation of whatever living culture we have right now.'[9] The transformation functioned perfectly, and for many years Greenberg's article was used to mark the beginning of the American pictorial renaissance, restored to a pre-eminent position. The old formula for the avant-garde, as was expected, was a complete success.

The appearance of 'Avant-Garde and Kitsch' coincided with two events that threw into question the integrity of the Soviet Union – the German-Soviet alliance and the invasion of Finland by the Soviet Union – and which produced a radical shift in alliances among Greenberg's literary friends and the contributors to *Partisan Review*. After the pact, many intellectuals attempted to return to politics. But the optimism which some maintained even after the alliance was announced evaporated with the Soviet invasion of Finland. Meyer Schapiro could not have chosen a better time to interrupt the self-satisfied purrings of the Communist-dominated American Artists' Congress and create a split in the movement. He and some thirty artist colleagues, in the minority because of their attempt to censure the Soviet Union, realized the importance of distancing themselves from an organiza-

tion so closely linked not only to Stalinism, but also the social aesthetic of the Popular Front.

And so the Federation of American Painters and Sculptors was born, a non-political association that would play an important part in the creation of the avant-garde after the war, and from which would come many of the first-generation painters of abstract expressionism (Gottlieb, Rothko, Poussette-Dart). After the disillusion of 1939 and in spite of a slight rise in the fortunes of the Popular Front after Germany attacked Russia in June 1941, the relationship of the artist to the masses was no longer the central concern of major painters and intellectuals, as it had been during the 1930s. With the disappearance of the structures of political action and the dismantling of the Works Progress Administration programmes, there was a shift in interest away from society back to the individual. As the private sector re-emerged from the long years of the Depression, the artist was faced with the unhappy task of finding a public and convincing them of the value of his work. After 1940 artists employed an individual idiom whose roots were nevertheless thoroughly embedded in social appearance. The relationship of the artist to the public was still central, but the object had changed. Whereas the artist had previously addressed himself to the masses through social programmes like the WPA, with the re-opening of the private sector he addressed an élite through the 'universal'. By rediscovering alienation, the artist began to see an end to his anonymity, as Ad Reinhardt explained, 'Toward the late 1930s a real fear of anonymity developed and most painters were reluctant to join a group for fear of being labelled or submerged.'[10] [...]

Nineteen forty-three was a particularly crucial year, for quietly, without shock, the United States passed from complete isolationism to the most utopian internationalism of that year's best-seller, *One World* by Wendell Wilkie.[11] Prospects for the internationalization of American culture generated a sense of optimism that silenced the anti-capitalist criticism of some of its foremost artists. In fact, artists who, in the best tradition of the avant-garde, organized an exhibition of rejected work in January 1943, clearly expressed this new point of view. In his catalogue introduction Barnett Newman revealed a new notion of the modern American artist:[12]

We have come together as American modern artists because we feel the need to present to the public a body of art that will adequately reflect the new America that is taking place today and the kind of America that will, it is hoped, become the cultural "center" of the world. This exhibition is a first step to free the artist from the stifling control of an outmoded politics. For art in America is still the plaything of politicians. Isolationist art still dominates the American scene. Regionalism still holds the reins of America's artistic future. It is high time we cleared the cultural atmosphere of America. We artists, therefore, conscious of the dangers that beset our country and our art can no longer remain silent.[13]

This rejection of politics, which had been re-assimilated by the propagandistic art of the 1930s, was, according to Newman, necessary to the realization of international modernism. His manifest interest in internationalism thus aligned him – in spite of the illusory antagonism he maintained in order

243

to preserve the adversary image of the avant-garde – with the majority of the public and of political institutions.

The United States emerged from the war a victorious, powerful, and confident country. The American public's infatuation with art steadily increased under the influence of the media. Artists strengthened by contact with European colleagues, yet relieved by their departures, possessed new confidence, and art historians and museums were ready to devote themselves to a new national art. All that was needed was a network of galleries to promote and profit from this new awareness. By 1943 the movement had begun; in March of that year the Mortimer Brandt Gallery, which dealt in old masters, opened a wing for experimental art, headed by Betty Parsons, to satisfy the market's demand for modernity.[14] In April 1945, Sam Kootz opened his gallery. And in February 1946, Charles Egan, who had been at Ferargil, opened a gallery of modern art, followed in September by Parsons, who opened her own gallery with the artists Peggy Guggenheim left behind when she returned to Europe (Rothko, Hofmann, Pollock, Reinhardt, Stamos, Still, Newman). Everything was prepared to enter the postwar years confidently.

The optimism of the art world contrasted sharply with the difficulties of the Left in identifying itself in the nation that emerged from the war. In fact, as the newly powerful middleclass worked to safeguard the privileges it had won during the economic boom, expectations of revolution, even dissidence, began to fade among the Communist Party Left. And the disillusions of the postwar period (the international conferences, the Truman administration, the Iron Curtain) did nothing to ease their anxiety. What began as a de-Marxification of the extreme Left during the war, turned into a total de-politicization when the alternatives became clear: Truman's America or the Soviet Union. Dwight MacDonald accurately summarized the desperate position of the radical Left: 'In terms of "practical" political politics we are living in an age which consistently presents us with impossible alternatives. ... It is no longer possible for the individual to relate himself to world politics. ... Now the clearer one's insight, the more numbed one becomes'.[15]

Rejected by traditional political structures, the radical intellectual after 1939 drifted from the usual channels of political discourse into isolation, and, utterly powerless, surrendered, refused to speak. Between 1946 and 1948, while political discussion grew heated in the debate over the Marshall Plan, the Soviet threat, and the presidential election in which Henry Wallace and the Communists again played an important part, a humanist abstract art began to appear that imitated the art of Paris and soon began to appear in all the galleries. Greenberg considered this new academicism[16] a serious threat, saying in 1945:

We are in danger of having a new kind of official art foisted on us – official 'modern' art. It is being done by well intentioned people like the Pepsi-cola company who fail to realize that to be for something uncritically does more harm in the end than being against it. For while official art, when it was thoroughly academic, furnished at least a sort of challenge, official 'modern' art of this type will confuse, discourage and dissuade the true creator.[17]

During that period of anxious renewal, art and American society needed an infusion of new life, not the static pessimism of academicism. Toward that end Greenberg began to formulate in his weekly articles for the *Nation* [through the late 1940s] a critical system based on characteristics which he defined as typically American, and which were supposed to differentiate American from French art. This system was to revive modern American art, infuse it with a new life by identifying an essential formalism that could not be applied to the pale imitations of the School of Paris turned out by the American Abstract Artists. Greenberg's first attempt at differentiation occurred in an article about Pollock and Dubuffet. [...]

Greenberg emphasized the greater vitality, virility, and brutality of the American artist. He was developing an ideology that would transform the provincialism of American art into internationalism by replacing the Parisian standards that had until then defined the notion of quality in art (grace, craft, finish) with American ones (violence, spontaneity, incompleteness).[18] Brutality and vulgarity were signs of the direct, uncorrupted communication that contemporary life demanded. American art became the trustee of this new age.

On 8 March 1947, Greenberg stated that new American painting ought to be modern, urbane, casual, and detached, in order to achieve control and composure. It should not allow itself to become enmeshed in the absurdity of daily political and social events. That was the fault of American art, he said, for it had never been able to restrain itself from articulating some sort of message, describing, speaking, telling a story:

In the face of current events painting feels, apparently, that it must be epic poetry, it must be theatre, it must be an atomic bomb, it must be the rights of man. But the greatest painter of our time, Matisse, pre-eminently demonstrated the sincerity and penetration that go with the kind of greatness particular to twentieth century painting by saying that he wanted his art to be an armchair for the tired businessman.[19]

For Greenberg, painting could be important only if it made up its mind to return to its ivory tower, which the previous decade had so avidly attempted to destroy. This position of detachment followed naturally from his earlier critical works (1939), and from many artists' fears of participating in the virulent political propaganda of the early years of the Cold War. It was this integration that Greenberg attempted to circumvent through a re-interpretation of modernist detachment – a difficult undertaking for artists rooted in the tradition of the 1930s who had so ruthlessly been made a part of the social fabric. The central concern of avant-garde artists like Rothko and Still was to save their pictorial message from distortion: 'The familiar identity of things had to be pulverized in order to destroy the finite associations with which our society increasingly enshrouds every aspect of our environment.'[20]

Rothko tried to purge his art of any sign that could convey a precise image, for fear of being assimilated by society. Still went so far as to refuse at various times to exhibit his paintings publicly because he was afraid critics

would deform or obliterate the content embedded in his abstract forms. In a particularly violent letter to Betty Parsons in 1948, he said:

Please – and this is important, show them [my paintings] only to those who may have some insight into the values involved and allow no one to write about them. NO ONE. My contempt for the intelligence of the scribblers I have read is so complete that I cannot tolerate their imbecilities, particularly when they attempt to deal with my canvases. Men like Soby, Greenberg, Barr, etc. ... are to be categorically rejected. And I no longer want them shown to the public at large, either singly or in group.[21]

The work of many avant-garde artists, in particular Pollock, de Kooning, Rothko, and Still, seemed to become a kind of un-writing, an art of effacement, of erasure, a discourse which in its articulation tried to negate itself, to be re-absorbed. There was a morbid fear of the expressive image that threatened to regiment, to petrify painting once again. Confronted with the atomic terror in 1946, Dwight MacDonald analysed in the same way the impossibility of expression that characterizes the modern age, thus imputing meaning to the avant-garde's silence. 'Naturalism is no longer adequate', he wrote, 'either esthetically or morally, to cope with the modern horror.'[22]

Descriptions of nuclear destruction had become an obscenity, for to describe it was to accept it, to make a show of it, to represent it. The modern artist therefore had to avoid two dangers: assimilation of the message by political propaganda, and the terrible representation of a world that was beyond reach, unrepresentable. Abstraction, individualism, and originality seemed to be the best weapons against society's voracious assimilative appetite.

In March 1948, when none of the work being shown in New York reflected in any way Greenberg's position, he announced in his article 'The Decline of Cubism', published in *Partisan Review*, that American art had definitively broken with Paris and that it had finally become essential to the vitality of Western culture. This declaration of faith assumed the decline of Parisian cubism, he said, because the forces that had given it birth had emigrated to the United States.

The fact that Greenberg launched his attack when he did was not unrelated to certain political events and to the pre-war atmosphere that had existed in New York since January of that year.[23] The threat of a Third World War was openly discussed in the press; and the importance accorded by the government to the passage of the European Recovery Plan reinforced the idea that Europe – France and Italy – was about to topple into the Soviet camp. What would become of Western civilization? Under these circumstances, Greenberg's article seemed to rescue the cultural future of the West:[24]

If artists as great as Picasso, Braque and Léger have declined so grievously, it can only be because the general social premises that used to guarantee their functioning have disappeared in Europe. And when one sees, on the other hand, how much the level of American art has risen in the last five years, with the emergence of new talents so full of energy and content as Arshile Gorky, Jackson Pollock, David Smith – then the conclusion forces itself, much to our own surprise, that the main premises of Western

art have at least migrated to the United States, along with the center of gravity of industrial production and political power.[25]

New York's independence from an enfeebled, faction-ridden Paris, threatened by communism from within and without, was in Greenberg's eyes necessary if modern culture was to survive. Softened by many struggles and too much success, the Parisian avant-garde survived only with difficulty. Only the virility of an art like Pollock's, its brutality, ruggedness, and individualism, could revitalize modern culture, traditionally represented by Paris, and effeminized by too much praise. By dealing only with abstract-expressionist art, Greenberg's formal analysis offered a theory of art that finally brought 'international' over to the American side.

For the first time an important critic had been aggressive, confident, and devoted enough to American art to openly defy the supremacy of Parisian art and to replace it on an international scale with the art of Pollock and the New York School. Greenberg dispensed with the Parisian avant-garde and placed New York at the centre of world culture. From then on the United States held all the winning cards in its struggle with communism: the atomic bomb, a powerful economy, a strong army, and now artistic supremacy – the cultural superiority that had been missing.

After 1949 and Truman's victory, the proclamation of the Fair Deal, and the publication of Schlesinger's *Vital Center*, traditional liberal democratic pluralism was a thing of the past. Henry Wallace disappeared from the political scene, the Communist Party lost its momentum and even at times ventured outside the law. Victorious liberalism, ideologically refashioned by Schlesinger, barricaded itself behind an elementary anti-communism, centred on the notion of freedom. Aesthetic pluralism was also rejected in favour of a unique, powerful, abstract, purely American modern art, as demonstrated by Sam Kootz's refusal to show the French-influenced modern painters Brown and Holty.[26] Individualism would become the basis for all American art that wanted to represent the new era – confident and uneasy at the same time. Artistic freedom and experimentation became central to Abstract-Expressionist art.[27]

In May 1948, René d'Harnoncourt presented a paper before the annual meeting of the American Federation of Art in which he explored the notion of individuality, explaining why – his words were carefully chosen for May 1948 – no collective art could come to terms with the age. Freedom of individual expression, independent of any other consideration, was the basis of our culture and deserved protection and even encouragement when confronted with cultures that were collectivist and authoritarian.

The art of the twentieth century has no collective style, not because it has divorced itself from contemporary society but because it is part of it. And here we are with our hard-earned new freedom. Walls are crumbling all around us and we are terrified by the endless vistas and the responsibility of an infinite choice. It is this terror of the new freedom which removed the familiar signposts from the roads that makes many of us wish to turn the clock back and recover the security of yesterday's dogma. The total-

247

itarian state established in the image of the past is one reflection of this terror of the new freedom.[28]

The solution to the problems created by such alienation was, according to d'Harnoncourt, an abstract accord between society and the individual:

> It can be solved only by an order which reconciles the freedom of the individual with the welfare of society and replaces yesterday's image of one unified civilization by a pattern in which many elements, while retaining their own individual qualities, join to form a new entity. The perfecting of this new order would unquestionably tax our abilities to the very limit, but would give us a society enriched beyond belief by the full development of the individual for the sake of the whole. I believe a good name for such a society is democracy, and I also believe that modern art in its infinite variety and ceaseless exploration is its foremost symbol.[29]

In this text we have, perhaps for the first time, the ideology of the avant-garde aligned with postwar liberalism – the reconciliation of the ideology forged by Rothko and Newman, Greenberg and Rosenberg (individuality, risk, the new frontier) with the liberal ideology as Schlesinger defined it in *Vital Center*: a new radicalism. [...]

The new liberalism was identified with the avant-garde not only because that kind of painting was identifiable in modern internationalist terms (also perceived as uniquely American), but also because the values represented in the pictorial work were especially cherished during the Cold War (the notion of individualism and risk essential to the artist to achieve complete freedom of expression). The element of risk that was central to the ideology of the avant-garde, was also central to the ideology of *Vital Center*.[30] Risk, as defined by the avant-garde and formulated in their work as a necessary condition for freedom of expression, was what distinguished a free society from a totalitarian one, according to Schlesinger: 'The eternal awareness of choice can drive the weak to the point where the simplest decision becomes a nightmare. Most men prefer to flee choice, to flee anxiety, to flee freedom.'[31] In the modern world, which brutally stifles the individual, the artist becomes a rampart, an example of will against the uniformity of totalitarian society. In this way the individualism of abstract expressionism allowed the avant-garde to define and occupy a unique position on the artistic front. The avant-garde appropriated a coherent, definable, consumable image that reflected rather accurately the objectives and aspirations of a newly powerful, liberal, internationalist America. The juxtaposition of political and artistic images was possible because both groups consciously or unconsciously repressed aspects of their ideology in order to ally themselves with the ideology of the other. Contradictions were passed over in silence.

It was ironic but not contradictory that in a society as fixed in a right-of-centre position as the United States, and where intellectual repression was strongly felt,[32] abstract expressionism was for many people an expression of freedom: freedom to create controversial works, freedom symbolized by action and gesture, by the expression of the artist apparently free from all restraints. It was an essential existential liberty that was defended by the

moderns (Barr, Soby, Greenberg, Rosenberg) against the attacks of the humanist liberals (Devree, Jewell) and the conservatives (Dondero, Taylor), serving to present the internal struggle to those outside as proof of the inherent liberty of the American system, as opposed to the restrictions imposed on the artist by the Soviet system. Freedom was the symbol most enthusiastically promoted by the new liberalism during the Cold War.[33]

Expressionism became the expression of the difference between a free society and totalitarianism; it represented an essential aspect of liberal society: its aggressiveness and ability to generate controversy that in the final analysis posed no threat. Once again Schlesinger leads us through the labyrinth of liberal ideology: 'It is threatening to turn us all into frightened conformists; and conformity can lead only to stagnation. We need courageous men to help us recapture a sense of the indispensability of dissent, and we need dissent if we are to make up our minds equably and intelligently.'[34]

While Pollock's drip paintings offended both the Left and the Right as well as the middle class, they revitalized and strengthened the new liberalism. Pollock became its hero and around him a sort of school developed, for which he became the catalyst, the one who, as de Kooning put it, broke the ice. He became its symbol. But his success and the success of the other abstract-expressionist artists was also the bitter defeat of being powerless to prevent their art from being assimilated into the political struggle.

The trap that the modern American artist wanted to avoid, as we have seen, was the image, the 'statement'. Distrusting the traditional idiom, he wanted to warp the trace of what he wanted to express, consciously attempt to erase, to void the readable, to censure himself. In a certain way he wanted to write about the impossibility of description. In doing this, he rejected two things, the aesthetic of the Popular Front and the traditional American aesthetic, which reflected the political isolationism of an earlier era. The access to modernism that Greenberg had theoretically achieved elevated the art of the avant-garde to a position of international importance, but in so doing integrated it into the imperialist machine of the Museum of Modern Art.[35]

So it was that the progressively disillusioned avant-garde, although theoretically in opposition to the Truman administration, aligned itself, often unconsciously, with the majority, which after 1948 moved dangerously toward the right. Greenberg followed this development with the painters, and was its catalyst. By analysing the political aspect of American art, he defined the ideological, formal vantage point from which the avant-garde would have to assert itself if it intended to survive the ascendency of the new American middle class. To do so it was forced to suppress what many first-generation artists had defended against the sterility of American abstract art: emotional content, social commentary, the discourse that avant-garde artists intended in their work, and which Meyer Schapiro had articulated.

Ironically, it was that constant rebellion against political exploitation and the stubborn determination to save Western culture by Americanizing it that led the avant-garde, after killing the father (Paris), to topple into the once disgraced arms of the mother country.

Notes

1 Clement Greenberg, 'The Late 30s in New York', *Art and Culture*, Boston, 1961, p. 230.

2 Meyer Schapiro, 'Social Bases of Art', *First American Artists' Congress*, New York, 1936, pp. 31-7.

3 Meyer Schapiro, 'Nature of Abstract Art', *Marxist Quarterly*, January/February 1937, pp. 77-98; comment by Delmore Schwartz in *Marxist Quarterly*, April/June 1937, pp. 305-10, and Schapiro's reply, pp. 310-14.

4 Alfred Barr, *Cubism and Abstract Art*, New York, 1936.

5 Leon Trotsky, 'Art and Politics', *Partisan Review*, August/September, 1938, p. 310; Diego Rivera and André Breton, 'Manifesto: Towards a Free Revolutionary Art', *Partisan Review*, Fall 1938, pp. 49-53; Robert Motherwell, 'The Modern Painter's World', *Dyn*, November 1944, pp. 9-14.

6 J. T. Farrell, *A Note on Literary Criticism*, New York, 1936.

7 Trotsky agreed with Breton that any artistic school was valid (his 'eclecticism') that recognized a revolutionary imperative; see Trotsky's letter to Breton, 21 October, 1938, quoted in Arturo Schwartz, *Breton/Trotsky*, Paris, 1977, p. 129.

8 Many members of American Abstract Artists were sympathetic to Trotskyism but looked to Paris for an aesthetic standard; Rosalind Bengelsdorf interviewed by the author, 12 February 1978, New York.

9 Greenberg, 'Avant-Garde and Kitsch', *Partisan Review*, Fall 1939, p. 49.

10 Ad Reinhardt, interviewed by F. Celentano, 2 September 1955, for *The Origins and Development of Abstract Expressionism in the U.S.*, unpublished thesis, New York, 1957, p. xi.

11 Nineteen forty-three was the year of internationalism in the United States. Although occurring slowly, the change was a radical one. The entire political spectrum supported United States involvement in world affairs. Henry Luce, speaking for the right, published his celebrated article 'The American Century' in *Life* magazine in 1941, in which he called on the American people vigorously to seize world leadership. The century to come, he said, could be the American century as the nineteenth had been that of England and France. Conservatives approved this new direction in the MacKinac resolution. See Wendell Wilkie's best-seller, *One World*, New York, 1943.

12 Catalogue introduction to the First Exhibition of Modern American Artists at Riverside Museum, January 1943. This exhibition was intended as an alternative to the gigantic one organized by the Communist-dominated Artists for Victory. Newman's appeal for an apolitical art was in fact a political act since it attacked the involvement of the Communist artist in the war effort. Newman was joined by M. Avery, B. Brown, G. Constant, A. Gottlieb, B. Green, G. Green, J. Graham, L. Krasner, B. Margo, M. Rothko, and others.

13 Ibid.

14 Betty Parsons, interviewed by the author, New York, 16 February 1978.

15 Dwight MacDonald, 'Truman's Doctrine, Abroad and at Home', May 1947, published in *Memoirs of a Revolutionist,* New York, 1963, p. 191.

16 The abstract art fashionable at the time (R. Gwathmey, P. Burlin, J. de Martini) borrowed classical themes and modernized or 'Picassoized' them.

17 Greenberg, *Nation*, April 1947.

18 For an analysis of the ideology of this position see S. Guilbaut, 'Création et développement d'une Avant-Garde: New York 1946-1951', *Histoire et critique des arts*, 'Les Avant-Gardes', July 1978, pp. 29-48.

19 Greenberg, 'Art', *Nation*, 8 March, 1947, p. 284.

20 M. Rothko, *Possibilities*, no. 1, Winter 1947-8, p. 84

21 Clifford Still, letter to Betty Parsons, 20 March 1948, Archives of American Art, Betty Parsons papers, N 68-72.

22 Dwight MacDonald, October 1946, published in *Memoirs*, 'Looking at the War', p. 180.

23 His article had an explosive effect since it was the first time an American art critic had given pride of place to American art. There were some who were shocked and angered by it. See G. L. K. Morris, [...] 'Morris on Critics and Greenberg: A Communication', *Partisan Review*, pp. 681-4; Greenberg's reply, pp. 686-7.

24 For a more detailed analysis of how events in Europe were understood by the American public, see Richard M. Freeland, *The Truman Doctrine and the Origins of McCarthyism*, New York, 1974, pp. 293-306.

25 Greenberg, 'The Decline of Cubism', *Partisan Review*, March 1948, p. 369.

26 When Kootz reopened his gallery in 1949 with a show entitled 'The Intrasubjectives', Brown and Holty were no longer with him. The artists shown included Baziotes, de Kooning, Gorky, Gottlieb, Graves, Hofmann, Motherwell, Pollock, Reinhardt, Rothko, Tobey, and Tomlin. It was clear what had happened: artists who worked in the tradition of the School of Paris were no longer welcome. In 1950 and 1951, Kootz disposed of Holty and Brown's work, making a killing by selling the paintings at discount prices in the Bargain Basement of Gimbels department store chain. It was the end of a certain way of thinking about painting. The avant-garde jettisoned its past once and for all.

27 The ideology of individualism would be codified in 1952 by Harold Rosenberg in his well-known article 'The American Action Painters', *Art News*, December 1952.

28 René d'Harnoncourt, 'Challenge and Promise: Modern Art and Society', *Art News*, November 1948, p. 252.

29 Ibid.

30 See discussion in 'Artist's Session at Studio 35' in *Modern Artists in America*, ed. Motherwell, Reinhardt, Wittenborn, Schultz, New York, 1951, pp. 9-23.

31 Arthur Schlesinger, *The Vital Center, Our Purposes and Perils on the Tightrope of American Liberalism*, Cambridge, 1949, p. 52.

32 We should recall that at that time the power of the various anti-communist committees was on the rise (HUAC, the Attorney General's list) and that attempts were made to bar persons with Marxist leanings from university positions. Sidney Hook, himself a former Marxist, was one of the most vocal critics; see 'Communism and the Intellectuals', *The American Mercury*, vol. 68, no. 302, February 1949, pp. 133-44.

33 See Max Kozloff, 'American Painting during the Cold War', *Artforum*, May 1973, pp. 42-54.

34 Schlesinger, *Vital Center*, p. 208.

35 See Eva Cockcroft, 'Abstract Expressionism: Weapon of the Cold War', *Artforum*, 12, June 1974, pp. 39-41 [Text 10].

251

24

Barbara M. Reise
Greenberg and The Group:
A Retrospective View

Source: Barbara M. Reise,'Greenberg and The
Group: A Retrospective View', *Studio
International*, vol. 175, no. 901, May 1968,
pp. 254-57 (Part 1) and vol. 175, no. 902,
June 1968, pp. 314-16 (Part2).

Mr Clement Greenberg has been a controversial figure most of his life, a Guru to some and a Satan to others. His art criticism – especially on American painting and sculpture after The Second World War – has been so intelligent, perceptive, biased, and influential that everyone concerned with contemporary art seems to take some sort of stand in relation to it. In Britain his collected essays in *Art and Culture*[1] and articles on 'After Abstract Expressionism' and 'Post Painterly Abstraction'[2] have been read avidly (or suspiciously) by those wanting to know What's Been Happening in American Art; and the admiration and scathing disgust recently expressed respectively by Edward Lucie-Smith and Patrick Heron in *Studio International*[3] are examples of reactions to Greenberg which have developed into a family squabble in America. There, disagreements with Greenberg's criticism by other critics like Harold Rosenberg, Robert Goldwater, and Max Kozloff[4] have been paralleled by attacks from artists like Dan Flavin, Robert Smithson, Robert Irwin, and Allan Kaprow; rightfully the focus of these attacks is on the uncritical and dogmatic propagation of Greenberg's ideas – especially on the part of those critics who are his closest followers: Sidney Tillim, Jane Harrison Cone, Rosalind Krauss, and above all Michael Fried. Who is this man, why has he become so important, how true are his pronouncements: these are questions which require a retrospective view of Greenberg, his style of criticism, and his influence in the American art world.

From Greenberg's first art criticism for *The Nation* in 1943, his writings have been prose essays deeply committed to the formal and historical significance of the art he discussed. His previous experience as editor of *Partisan Review*, involvements with Marxist thought, and acquaintance with students of Hans Hofmann prepared him to be a champion of American avant-garde painting in journalism which would reach a broad public.[6] His involvement with Marxism gave him a historical sense which committed him to the avant-garde, converted him to 'abstract' art as a revolution against the established American taste for nationalistic narrative paintings, and gave him an evolutionary concept of history allowing him to see the 1940s immigration of European artists as historically establishing New York as the artistic centre of the future. The teachings of Hofmann on the pure plastic

mechanics of painting gave him the tools for formal analysis of colour, line, planes, and their 'push and pull' of space in the art of Matisse and Kandinsky, and especially in Cubism – and a vision of artistic form as embodying its own relevance.[7] And Hofmann students like Lee Krasner opened the way to Greenberg's acquaintances with young American artists like Pollock and De Kooning after their joint inclusion in the McMillen Gallery's 1942 exhibition of 'French and American Painters'.

This important exhibition was organized by John Graham, a painter and theorist who was friends with David Smith, Arshile Gorky, William De Kooning, and Stuart Davis in the 1930s. It brought together Graham's friends and presented Jackson Pollock's work to the public for the first time, with De Kooning's and Krasner's in juxtaposition with paintings by acknowledged French masters like Braque and Picasso. As such, it provided Greenberg with the 'discovery' of Pollock,[8] acquaintance with artists whose work was to receive attention in his writings, and a corroborative reference for his championing of young American artists against the dominance of the 'School of Paris' in the eyes of the artists and taste of the art world.[9]

But however indebted was Greenberg to Hofmann's formal vision and to Graham's artistic discoveries, it was Greenberg alone whose journalism championed Pollock, Gorky, De Kooning, Smith and Robert Motherwell to the public at large in the 1940s. Their work dominated his writings at that time and he seemed only peripherally aware of concurrent activity of other young artists like Rothko, Still, Newman, Baziotes and Gottlieb who were more closely involved with the French Surrealists than with the Graham-Hofmann circle.[10]

When the work of the artists known as the 'first generation' Abstract Expressionists began to receive international acclaim in the 1950s, the quality and courage of Greenberg's insight was recognized as well. He was asked to organize or write prefaces to exhibitions of the artists' work for academic and commercial galleries, both in America and abroad. He organized major exhibitions of paintings by Pollock,[11] Gottlieb,[12] and Newman;[13] he contributed introductory essays to the Hans Hofmann exhibition at the Kootz Gallery in 1958, and to Betty Parsons's 1955-6 group show of 'Ten Years' work by the Abstract Expressionists associated with her gallery. His role easily shifted from the alienated critic writing art columns for intellectual magazines to an Impresario in the New York art world judged by his commitment to a specific type of art and respected for its ultimate (commercial and influential) success. As such he took on the character of a Prophet in the New York art world. Artists like Anthony Caro, Morris Louis, and Kenneth Noland sought his criticism and advice,[14] and gallery directors sought his predictions; when Greenberg selected the 'Emerging Talent' exhibition at Samuel Kootz Gallery in 1954, Louis and Noland were included.[15]

By the mid-1950s Greenberg's critical style was clearly different from that of Harold Rosenberg, his chief rival as an interpreter of Abstract Expressionism. Rosenberg had become involved with the Abstract Expressionist painters in the later 1940s, as a poet through the Surrealist circle, and in terms

253

more of artistic collaboration behind the scenes than of public discussions of exhibited works; he wrote introductions to some early important group exhibitions organized by Samuel Kootz[16] and contributed to 'little magazines' with which the painters were involved.[17] As a practising poet writing to a private and sympathetic audience, his style was metaphoric rather than didactic, and he was naturally concerned more with the character and context of the creative act than its resulting pictorial form. Writing of a shared experience, Rosenberg was little help to more prosaic souls outside that experience; he was no help to critics wanting to evaluate the paintings as objects in galleries;[18] and it is hardly surprising that his important essay on 'The American Action Painters'[19] has been universally misunderstood and reduced to a label for thrown paint.

The fact that his rival's 1952 label of 'Action Painting' caught on quickly and misleadingly infuriated Greenberg, and the two men began quarrelling.[20] The ensuing argument encouraged both to refine their stands in mutual opposition, and each became more fixed in his own approach. But Greenberg's didactic prose, references to the history of modern art, and analyses of formal properties of exhibited art made his ideas more accessible to critics and the countless art-history and painting students who discovered Abstract Expressionism in the late 1950s. With the 1961 publication of his collected and smoothly rewritten essays and his continued interest in the latest things shown in galleries, Greenberg's stature to the newly-arrived was truly monumental.

During the 1960s, the tone of Greenberg's criticism changed. In the 1940s, and to a lesser degree in the 1950s, it had been obviously passionate, avowedly personal, conveying a real Impression of direct confrontation with his artistic enthusiasms. In the 1960s it has become more didactic, concerned with philosophy and history, removed from concrete aesthetic encounters, and seemingly sure of its own objectivity. His early penchants for discussing art in terms of form rather than content, Cubist and late Cubist form, purist media categories, and an evolving linear progression abstracted from artists' lives and historic events were noted by some critics after reading his book.[21] In the 1960s , these penchants rigidified into dogma: allowing only art which conformed to Greenberg's philosophy of art history to be considered as 'authentic', 'serious', 'high' art in his discussions.

This increasingly defensive and academic stance against the subjective nature of aesthetic judgements, recently defended by Greenberg in the face of rising criticism,[22] was begun under the influence of two historical phenomena around 1962: the threat to his taste and critical assumptions in the success of Pop art in the New York art world; and the enthusiastic respect for his approach and experience from the American art-historical academic establishment. For it was between 1961 and 1963 that Greenberg's involvement began with three Harvard postgraduate students of art history: Michael Fried, Rosalind Krauss, and Jane Harrison Cone. Their academic training in formal analysis of a quasi-dialectical evolution of styles complemented Greenberg's approach; and their espousal of Greenberg as Guru provided an

implicit corroboration of his methodology by gilt-edged academic creden-tials.[23] Greenberg's own experience in leading a seminar on criticism at Princeton in 1958 could only have accentuated his receptivity to the acade-mic framework in which he was moving, encouraging his efforts to find meaningful *principles* of history and form which would bring order and 'objectivity' to his subjective rejection of Johns, Rauschenberg, Happenings, and Pop artists as creators of serious Art.[24]

Greenberg's failure to predict and inability to discuss – or even 'see' – this type of art seriously threatened his established position as Prophet of Future Trends. Museums and galleries which had been sufficiently 'avant-garde' to embrace Abstract Expressionism rapidly supported this 'new movement' in the early 1960s; critics of indisputable intelligence and art-historical training like Leo Steinberg, Henry Geldzahler, and Robert Rosenblum discussed it seriously. But Greenberg was naturally alienated by its use of representation, conceptual wit, and sources from 'low', commercial, popular imagery. He described Jasper Johns's paintings in terms of 'homeless representation' which was part of the 'degenerate mannerisms' of art 'After Abstract Expression-ism'.[25] He collectively labelled Pop art a 'fashion' and a 'school' which in general 'amounts to a new episode in the history of taste, not to an authenti-cally new episode in the evolution of contemporary art'.[26]

255

Greenberg's own version of 'a new episode in that evolution' of (authen-tic) art was 'Post Painterly Abstraction'.[27] He characterized this type of paint-ing formally as emphasizing 'physical openness' and 'linear clarity' of design, and high-keyed, even-valued colour. This rather superficial description[28] easily suited the recent work of Greenberg's 1953-4 authentic discoveries, Morris Louis and Kenneth Noland; to no one's surprise, their paintings figured prominently in the exhibition.[29] In support of his presentation of this type of painting as the (only) authentic contemporary art, Greenberg turned to the philosophy of art history of Heinrich Wölfflin which abstracted 'painterly' (*malerisch*) and 'linear' form from Baroque and Renaissance art and pronounced their inevitable dialectic evolution throughout art history.[30] In contrast to the 'painterly abstraction' Greenberg perceived in Abstract Expressionism, this 'post-painterly abstraction' fell neatly into Wölfflin's alternative category, while continuing 'a tendency' begun 'inside Painterly Abstraction itself, in the work of artists like Still, Newman, Rothko, Motherwell, Gottlieb, Mathieu, the 1950-4 Kline, and even Pollock'.

If Greenberg seems incredibly naïve in presenting this philosophy of form-history as proof of the artistic value of paintings in the 'Post Painterly Abstraction' exhibition, it is partly because he assumed that its truth had been argued convincingly in his essay on 'After Abstract Expressionism' two years before.[31] There he had argued that Abstract Expressionism was essentially a formal revolution, 'a painterly reaction against the tightness of Synthetic Cubism, combined with what remained an essentially Cubist feeling for design', which fitted – and corroborated – Wölfflin's theory.[32] Correspond-ing to current Harvard art-historical modifications of Wölfflin's approach, Greenberg found an intermediary style whose roots were in the latest formal

revolution:[33] 'Still, Newman, and Rothko turn away from the painterliness of Abstract Expressionism as though to save the objects of painterliness – colour and openness – from painterliness itself.' For Greenberg, these men's paintings 'point to ... the only way to high pictorial art in the near future', 'confirm(s) painters like Louis and Noland, because, paradoxically enough, they have not been influenced by Newman' or Rothko, and render painters following these three 'as safe in their taste as they would be following De Kooning or Gorky or Kline'.

The irony of hearing a pronouncement on 'safe' taste by a man once renowned for the courage of his conviction that Pollock was a 'Master' is somewhat lessened by the realization that this taste was 'safe' to Greenberg because it was 'objective' as part of the inevitable evolution of the history of art. The point that is too often missed by Greenberg's readers, however, is that this art history is *Greenberg's* version; like any avowedly subjective art criticism it can be analysed and evaluated in terms of its form, content, and probity.

The philosophical form of Greenberg's historiography is quasi-dialectic progress in linear evolution; it is influenced by Marx, later dominated by Wölfflin, and thus tied to pre-Darwinian thought and to Hegel. His vision is limited to the optical form and mechanics of artistic material, untouched by emotional or conceptual associations; to style abstracted into formal movements; to movements limited by national boundaries and temporal epochs: a vision which corresponds artistically to the Impressionists and critically to Bernard Berenson and Heinrich Wölfflin. Thus his historiographical vision plants Greenberg's art-historical form firmly in the nineteenth century. Since the content of his art history is twentieth century art, some interesting disparities between form and content occur; and in his later writings it is apparent that Greenberg's art history warps contemporary art to the shape of its own inflexible form.

The scope of Modern art is reduced in Greenberg's later writings to a narrow line between Impressionism, (Analytical) Cubism, late (Synthetic) Cubism, Abstract Expressionism, and Post-Painterly Abstraction.[34] Reading only Greenberg, one would never know of the existence of (using similar style labels) Symbolism, Futurism, Expressionism, Dada and Surrealism, Pop Art and mixed-media Happenings. This warping of the total picture necessitates a biased view on the art which *is* discussed. In his single essay on 'After Abstract Expressionism' there are three excellent examples of distorted history: his absurd assertion that Noland and Louis were not influenced by Newman's and Rothko's paintings;[35] his misleading implication that Newman, Rothko, and Still developed their colour-field paintings *after* participating in the 'painterliness' of Abstract Expressionism;[36] and his demeaning presentation of Abstract Expressionism as only a formal, still Cubist, statement.[37]

This Greenbergian distortion of art and history ensures the subjectivity of his evaluations of art, no matter how 'objective' he believes his arguments to be. It is no more an objective compliment to be included in his history of

Modern Masters than exclusion is an objective damnation to the realm of Kitsch. It is *despite* their relevance to Greenberg's philosophizing that the work of Newman, Rothko, Noland, Louis, Smith and Caro has artistic merit.

The sad thing is that this fact has not been apparent to Greenberg's followers, some of whose writings show blind adherence to his philosophy as if it were a true criterion for qualitative evaluation. In the writings of his Harvard-student disciples, Rosalind Krauss, Jane Harrison Cone, and Michael Fried, the constant quoting of Greenberg's statements and respectful footnoting to each others' ideas leads one to believe that they are unaware that any alternative view of art exists. Their sense of history is equally linear, their penchant for cubby-holing art into purist media and style label is more pronounced, and choices of whom to write about are almost hypnotically repetitive of Greenberg's 1960s enthusiasms.[38] The qualitative excellence of being in the forefront of Greenberg's progressive Modernism is so pervasive an assumption among them that they plot artists' positions like sportscasters describing a horse-race. Michael Fried praises Ron Davis's works because they 'place him, along with Stella and Bannard, at the forefront of his generation',[39] Rosalind Krauss deprecates De Kooning's recent paintings because they seem to her 'like nervous attempts to somehow re-enter the dialogue of advanced painting' while missing the (to her) major point 'that other artists have entirely reformulated the question of measurement'.[40]

257

Mrs Krauss's essay on De Kooning shares honours with Sidney Tillim's recent essay on Lichtenstein[41] as an example of uncritical acceptance of Greenberg's approach, producing insensitive criticism of artists too big for the philosophy. Lichtenstein's change of pictorial reference from popular comic and advertising imagery of the 1940s to popular architectural design of the 1930s is interpreted by Tillim as a fashionable nostalgia inferior to *Bonnie and Clyde*, a use of late Cubism inferior to that of David Smith, and a feeling for 1930s design less assimilated than Frank Stella's; he also interprets it as going 'abstract' and respectfully reports Greenberg as saying 'that Lichtenstein has proved that abstraction painting is fashionable again', and forecasts (hopefully) 'the end of Pop art as we know it'.

Krauss and Tillim toll the death knell on artistic styles on the 'objective' basis that the art changed from their own labelled concept of it. Their concern with the death of Art by art shows an antagonism naturally arising from the conflict between their concept and the lively irreverence of art to it, an antagonism which reaches a passionate peak in the writings of Greenberg's most committed follower, Michael Fried.

'Art and Objecthood'[42] is Fried's garrulous attack on the work of Robert Morris, Don Judd, and Tony Smith as presenting objects in a basically theatrical dialogue with the viewer; his analysis of the work of these 'Minimalists' is taken from Greenberg with changed labels,[43] but his rather war-hawkish assertions that 'theatre and theatricality are at war today, not simply with modernist painting ... but with art as such', and that 'Art degenerates as it approaches the conditions of theatre'[44] are probably original.

Fried's Greenbergian and rigid understanding of art only in purist media cat-
egories, and his inability to apprehend 'content' outside the material form of
painting and sculpture, result in his crude categorization of all media-mix-
tures and 'content' of general human sensibility into 'theatre': a category
which he rightly sees as dangerous to his own too narrow concept of uncor-
rupted art.

The obvious dangers of swallowing Greenberg's philosophy without crit-
icism of it have done much to render irrelevant the determination of these
Greenberg followers to write significantly, originally, and influentially: a sad
waste of concentrated intelligence, energy, and frequently excellent insights.
For Krauss and Fried give an abundance of these, and Greenberg's pro-
nouncements constantly embody insights which, if thought about critically,
can provide a structure against which to build one's own artistic vision.

This is the way two other critics have reacted: both Barbara Rose and
William Rubin have been influenced by Greenberg's criticism, both
approach art in terms of history, visual form, and style-epochs, but neither
limits him/herself to Greenberg's vision of modern art. Rubin's essays on
'Jackson Pollock and the Modern Tradition'[45] present Pollock's style in rela-
tion to Cubism, but in a more complicated and sensitive way and in a paral-
lel with its relation to Impressionism and Surrealism. Miss Rose's account of
American Art since 1900[46] departs from the Greenberg vision in considering
Surrealism, mixed-media activity by Johns, Rauschenberg, and John Cage,
and Pop art as serious aspects of American art; although she propagates some
Greenberg fallacies in that book,[47] she has since taken a more critical stand
against 'formalist criticism'.[48] Recently she attacked Greenberg, Rosenberg,
and Fried for their Marxist vested interest in a linear evolutionary concept of
history and in a formally 'purist' art, and for their partisan dogmas;[49] at the
same time she made the positive suggestions that newcomers to criticism
look to other models and consider art in terms of its 'horizontal' rather than
'vertical' historic relationships.[50]

I would second these suggestions with an additional one: that critics try to
abstract themselves from the hustle of contemporary history to spend more
time thinking and feeling about *what* a particular artistic experience is all
about before they begin relating it to anything. More open feeling about and
listening to art and artists could sharpen every critic's ear when he hears his
own voice in the noisy world. And we are all critics.

Notes

1 Boston, 1961.

2 *Art International*, issues of 25 October 1962 and Summer 1964, respectively.

3 Cf. Edward Lucie-Smith's introductory comments to 'An Interview with Clement
Greenberg' and Patrick Heron's 'A kind of Cultural Imperialism?' in the issues of January and
February 1968 respectively.

4 Cf. Robert Goldwater, 'Art and Criticism', *Partisan Review*, vol. 28, nos. 5-6, 1961; George
Dennison, 'The Craft-history of Modern Art', *Arts Yearbook*, no. 7, 1964; Max Kozloff, letters
to the Editor of *Art International* June 1963 and *Artforum* November 1967, and 'Problems in
Criticism III: Venetian Art and Florentine Criticism', *Artforum*, December 1967. For
Rosenberg's criticisms of Greenberg and his followers, see below, note 20.

5 Cf. Letters to the Editor of *Artforum* from Robert Smithson (issue of October 1967), Robert Irwin (February 1968), and Allan Kaprow (September 1967). Kaprow and Smithson criticize Greenberg's approach in his disciple Michael Fried; Dan Flavin criticizes Greenberg – and everyone else – in his enjoyably garrulous 'Some Other Comments', *Artforum*, December 1967.

6 Greenberg was editor of *Partisan Review* from 1941-3, and re-entered the New York art world through his friendships with Hofmann students like Lee Krasner (cf. his 'The Late Thirties in New York', *Art and Culture*, pp. 230-3). His association with *Partisan Review* automatically involved him with Marxism, for the magazine was founded by the Communist Party specifically to counteract 'Bohemianism in Literature' (cf. Harold Rosenberg, *The Tradition of the New*, London, 1962, pp. 250-1). Greenberg's Marxism influenced his commitment to journalism as modern communication with the mass public; years later, sure that academic art history and belles-lettres criticism were hopelessly retardataire, he asserted that 'It belongs to journalism … that each new phase of Modernist art should be hailed as a start of a whole new epoch in art, marking a decisive break with the past' ('Modernist Painting', *Arts Yearbook* no. 4, 1961 [see Text 28]).

7 Greenberg's debt to the teachings of Hofmann is profound. He notes that Hofmann's 1938-9 public lectures 'were crucial' to him when he was 'just beginning to see abstract art' ('The Late Thirties in New York', *Art and Culture*, p. 232). See also his essay on Hofmann as 'The Most Important Teacher of Our Time', *The Nation*, April 1945. Hofmann's teachings are presented in his *Search for the Real and Other Essays*, Andover (Mass.), Addison Gallery of American Art, 1949.

8 Greenberg's fame as Pollock's 'discoverer' is justified in terms of journalistic championing, but not in terms of living history. Pollock was 'discovered' by John Graham in this show: a point which De Kooning recently took the trouble to emphasize. In an interview with James T. Valliere, ('De Kooning on Pollock', *Partisan Review*, Fall 1967) De Kooning discussed this exhibition and said: 'Graham was very important and he discovered Pollock. I make that very clear. It wasn't anybody else, you know.' And when Valliere asked in surprise, 'You think Graham discovered Pollock?', De Kooning replied: 'Of course he did. Who the hell picked him out? The other critics came later – much later.' De Kooning also noted that it was through this exhibition that he and Pollock and Krasner became acquainted; Greenberg probably met them at the same time, through Lee Krasner.

9 It is enlightening to compare Greenberg's contribution with those of other critics and museum directors in a 'Symposium: The State of American Art', *Magazine of Art*, March 1949. Almost all the contributors except Greenberg were suspicious of the quality of American art within an international context, and believed, like Daniel Catton Rich, that 'the leaders of modern painting and sculpture will be found in Europe or Mexico rather than in the United States'. Greenberg, however, asserted that young artists like Pollock, De Kooning and Motherwell were doing things qualitatively matching anything elsewhere and that 'they are actually ahead of the French artists who are their contemporaries in age'. It was not a large step from this sort of defensive enthusiasm to real chauvinism.

10 Greenberg did not like the Surrealists, who were French, differently-styled Marxist, Freudian-oriented, and concerned with 'content'; his aversion was so strong that he seldom mentioned their presence in New York in his accounts of immigrant artists. As Max Kozloff has noted, he refused to use the term 'drips' when discussing Pollock's first exhibited dripped paintings in 1949 and ignored the relevance of 'automatism' to them (cf. Max Kozloff, 'The Critical Reception of Abstract Expressionism', *Arts*, December 1965).

11 At Bennington College, Bennington, Vermont, 1952.

12 At Bennington and Williams Colleges in 1954; in 1959 work by Gottlieb and the 'New York School' for the Galerie Rive Droite in Paris, the ICA in London, French & Co. and the Jewish Museum in New York.

13 He wrote the preface to Newman's 'First Retrospective' at Bennington College in 1958; that preface was reprinted for French & Co. in 1959.

14 Michael Fried states that Louis and Noland went to Greenberg in 1953 ('The Achievement of Morris Louis', *Artforum*, February 1967).

15 Cf. James Fitzsimmons, 'Critic Picks Some Promising Painters', *Art Digest*, 15 January 1954, pp. 10-11.

16 Rosenberg wrote an introduction to 'Six American Artists' exhibited at Galerie Maeght,

259

Paris, 1947; the exhibition included work by Baziotes, Gottlieb and Motherwell, and the essay was partially reprinted in *Possibilities*, I, 1947/8. He also contributed an essay to the catalogue of the 'Intrasubjectivists' exhibition at Samuel Kootz Gallery in 1948: an important early group exhibition with works by Baziotes, De Kooning, Gorky, Gottlieb, Hofmann, Motherwell, Pollock, Reinhardt, Rothko, Tomlin, Mark Tobey and Morris Graves.

17 He was joint editor (with Robert Motherwell and John Cage) of *Possibilities*, I, 1947/8; he contributed poetry and criticism to *Tiger's Eye* (edited at one time by Barnett Newman) and to *It Is* (the journal of the Abstract Expressionists' 'Club' in the 1950s).

18 One furious critic said that a function of his writing was that 'it drives other critics nuts'. (Amy Goldin, 'Harold Rosenberg's Magic Circle', *Arts*, November 1965.)

19 *Art News*, December 1952; reprinted in *The Tradition of the New*, London, 1962.

20 At first this was kept somewhat intra-mural. Greenberg criticized the concept of 'Action Painting' in notes to his own important and re-labelled essay on the Abstract Expressionists ('American Type Painting', *Partisan Review*, vol. 22, no. 2, 1955; re-written for *Art and Culture* in 1958). His most violent attack on Rosenberg and everyone respecting him is to be found in 'How Art Writing Earns Its Bad Name', *Encounter*, December 1962. Rosenberg's response was 'Action Painting: a Decade of Distortion', *Art News*, December 1961 (reprinted in *Encounter*, May 1963, and as 'Action Painting: Crisis and Distortion' in Rosenberg's *The Anxious Object*, London, 1965). Cf. also Rosenberg's 'After Next, What?', *Art in America*, April 1964 (reprinted in *The Anxious Object*), which is a criticism of Greenberg and his followers sparked by Greenberg's 'After Abstract Expressionism', loc. cit.

21 Robert Goldwater, 'Art and Criticism', *Partisan Review*, vol. 28, nos. 5-6, 1961; George Dennison, 'The Craft-history of Modern Painting', *Arts Yearbook*, no. 7, 1964.

22 'Problems in Criticism II: Complaints of a Critic', *Artforum*, October 1967. In this essay Greenberg complains that just because he notes a tendency in art does not mean that he approves of it, and that his readers and critics must distinguish between his descriptions and aesthetic judgements. Aesthetic judgements are, he states, 'immediate, intuitive, undeliberate, and involuntary' leaving 'no room for the conscious application of standards, rules, and precepts' (p. 38). Criticism becomes 'objective' only when it 'produces consensus'; a consensus which is based on a 'qualitative principle or norm' in 'subliminal operation', and which appears in the 'verdicts of those who care most about art and pay it the most close attention' (p.38, and response to a letter from Max Kozloff, *Artforum*, November 1967). Of course this amounts to a personal abnegation of responsibility for one's own taste by relegating it to the realm of the unconscious and finding its criticism outside oneself in history. The recent domination of Greenberg's discussion of art by his concern with a philosophy of art history should be seen, I believe, as part of his effort to find that 'qualitative principle' whose operation through history would objectify his own increasingly personal and exclusive taste.

23 American art history in general is permeated by formalist analysis of art seen as style-epochs in a linear evolutionary progression: an approach dependent on that of Heinrich Wölfflin, Bernard Berenson, and Roger Fry. 'Content' is usually associated with Warburg-Panofsky interests in 'iconography', and is seen as relevant to intellectual history rather than to artistic value. Its scope is usually a Western European 'From the Pyramids to Picasso', passing 1900 with luck, and superficial historical analyses of Museum of Modern Art catalogues and writings by men like Greenberg. Harvard's Department of Art History provides few alternatives to this approach, which its graduates largely propagate. Dominated by the Wölfflin-Berenson approach of Sydney Freedberg to the rise and fall of Renaissance pictorial style, it offers little in modern art with a notable paucity of imagination and attention to the twentieth century. Art history students at New York and Columbia Universities interested in contemporary art can study with Meyer Schapiro, Robert Goldwater, and Robert Rosenblum; but Krauss, Cone and Fried were almost driven as well as attracted to the teachings of Greenberg.

24 For an excellent discussion of this phenomenon, particularly of the impact of Sidney Janis's 1962 exhibition of Pop art as 'The New Realism' from another suspicious critic, see Harold Rosenberg, 'The Game of Illusion, Pop and Gag', *The Anxious Object*, London, 1962, pp. 63-4.

25 'After Abstract Expressionism', *Art International*, 25 October 1962. 'Homeless representation, was the term used to describe the representational elements in Pollock's paintings of the 1950s and De Kooning's 'Women' series of the same period – representation which Greenberg obviously thought had 'no place' in that art (or any art?); it was paralleled as a 'degenerative

mannerism' by another 'witty' label: the 'furtive bas-reliefs' of Dubuffet.

26 'Post Painterly Abstraction', *Art International*, summer 1964. Greenberg does not define what he means by Pop art in this essay, either in terms of stylistic characteristics or of artists. He does not say that it is 'bad' art, but rather implies that it is not art at all: only a 'diverting' fashion, not 'really fresh. Nor does it challenge taste on more than a superficial level.' (As if it had not challenged *his*.)

27 The title of an exhibition he organized for the Los Angeles County Museum of Art, presented in 1964. Greenberg's catalogue introduction is reprinted under the same title in *Art International*, summer 1964.

28 One learns much more from Barbara Rose's earlier essay on 'The Primacy of Colour' (*Art International*, May 1964) and Max Kozloff's discussion of colour in 'Problems in Criticism III: Venetian Art and Florentine Criticism' (*Artforum*, December 1967).

29 In 1960 Greenberg pronounced these painters the only two 'candidates for serious status' among the younger American painters ('Louis and Noland', *Art International*, vol. 4, no. 5, 1960). It is not irrelevant that among Greenberg's 1954 'Emerging Talent' discoveries, these two are the only painters widely known today and continuing (unlike Philip Pearlstein) to work in an 'abstract' manner.

30 Cf. Heinrich Wölfflin, *Principles of Art History*, London, 1952. The work has long been available in America, and is often used as an introductory text for undergraduate survey courses in the history of art.

31 *Art International*, 25 October 1962.

32 Unlike most American undergraduates, Greenberg not only accepted Wölfflin's classifications as useful tools for visual analysis, but he also swallowed Wölfflin's theory of the absolute inevitability of a linear dialectic of these formal categories in the history of art. As a result, Abstract Expressionism is neatly reduced in Greenberg's essay to merely 'another instance of that cyclical alternation of painterly and non-painterly which has marked the evolution of Western art ... since the sixteenth century'.

33 The discovery of Mannerism as a style-epoch between Renaissance and Baroque has required modification of acceptance of Wölfflin's historical theory. One of Sydney Freedberg's contributions to the philosophy about Renaissance style is his description of it as carrying the seeds of Mannerism within its own formal evolution; he also finds seeds of Baroque form within Mannerism – and thus a *continuation* between Renaissance and Baroque style. If Greenberg showed enthusiasm for Wölfflin to his young Harvard friends, they would have argued for this sort of modification, which is presented to Harvard undergraduates by postgraduate teaching assistants.

34 Paralleled in sculpture by a line between collage, metal construction, David Smith, and Anthony Caro.

35 Were Louis and Noland so provincial in 1959 that, alone among artists along the Eastern seaboard, they did *not* go to New York to see 'The New American Painting' exhibition on its triumphal return from Europe? If not, they would have seen excellent work by Newman, Rothko, and Still, and could have read statements by the artists in the accompanying catalogue (*The New American Painting*, New York, Museum of Modern Art, 1959). And was Greenberg's influence on Louis and Noland so slight at this time that they ignored the exhibition of Newman's work which he organized for French & Co. in the same year? It's doubtful. And if following Newman, Rothko, and Still is such 'safe' taste in 1962, why deny Noland and Louis an early exercise of it? I suspect that it is to support, again by implication, Greenberg's notion of the historic art-spirit evolving independently of artists and their real contact with art.

36 Newman, Still and Rothko developed their characteristic styles in the late 1940s concurrently and in close association with Pollock, De Kooning, Motherwell, Gottlieb, Tomlin, and (later) Kline; they did not previously paint in interlaced drips or body-gestured slashings characteristic of the morphological form of the others' paintings. Also, they exhibited at the same galleries, contributed to the same 'little magazines', participated in the teaching and Friday lectures at the 'Subject of the Artist' school founded by Motherwell, Rothko, Baziotes and David Hare, collaborated on the 1951 letter of 'The Irascible 18' protesting at the policies of the Metropolitan Museum, and thus must be considered as much a part of the *group* as the artists known as 'Abstract Expressionists' as Pollock, De Kooning, Baziotes, Motherwell, Gottlieb, Kline or Tomlin.

But Greenberg did not seem to know their work well in the late 1940s; he only 'discovered'

Barnett Newman in print two years after Newman's first one-man show at Betty Parsons's in 1950 (cf. his 'Feeling is all', *Partisan Review*, January–February 1952). His distinction of the style of Rothko, Newman and Still from that of the 'painterly abstraction' of Abstract Expressionism shows how tied is his style-label to his 1940s enthusiasms unmodified by later self-criticism, how dependent is his sense of style-history on the chronology of his own confrontations with publicly exhibited art, and how unrelated are his style-epoch labels to the real living history of art and artists.

37 After 1949 the paintings of the group known as the 'Abstract Expressionists' (as discussed above, note 36) have *essentially* nothing to do with Cubist compositional space fragmented by multiple planes related to the picture surface and to represented objects: rather they are unified fields of space and colour in which no 'planes can be measured by geometric or representational standards, fields whose space is *established* by the paintings as wholes rather than confined or manipulated within the canvas frame (its shape or planar surface).

This new form was developed by the Abstract Expressionists as direct, single, large, unequivocal expressions of terror, tragedy, and ultimate harmony in confrontations with Man and His actions, particularly with their own inner selves and their activity as artists. Concern with this sort of content is constantly expressed in the artists' statements, and it is related to their interest in the art, ritual, myth, and character of primitive and pre-classical mankind. It was the Surrealists who were examples to the Abstract Expressionists in these interests in myth, ritual, primitive art, and painting directly expressive of one's inner, subconscious self. The idea behind their technique of 'automatism' was important, in controlled forms, to all the Abstract Expressionists. Barnett Newman's drawn 'liners' are as much a personal, gestural expression of his own interior self (a self more structured, intellectual, and philosophical than Pollock's) as Pollock's dripped lines are of his more physiologically turbulent mysticism. This sort of insight requires an openness to content, Surrealism, and the uniqueness of the paintings, painters, and their interrelationships; superficially morphological descriptions of the group style in relation to Cubism at best lead away from the powerful, personal statements of Abstract Expressionist paintings.

38 The almost incestuous territorializing of David Smith is a case in point: Fried has written about him, of course; Jane Harrison Cone organized an exhibition of his work at Harvard's Fogg Museum in 1966; and Smith is now the subject of Rosalind Krauss's Harvard Ph.D. thesis. Louis, Noland, Olitski, Stella, and Caro have also received repeated notice from them.

39 'Ronald Davis', *Artforum*, April 1967.

40 Mrs Krauss assumes that one lecture by De Kooning on 'measurement' in the early 1950s, plus his formal relationship with Braque's and Picasso's Cubism ('a relationship Clement Greenberg was the first to point to ... as immediate and irrefutable', she says), is enough to have 'guaranteed that measurement would preoccupy his painting as it did theirs'. She proceeds to analyse De Kooning's development in terms of Braque's concept of measurement, blithely ignoring De Kooning's more immediate interest in Gorky's Miró–Kandinsky-like paintings and the alternative side of De Kooning's interest in 'measurement' as part of his search for order: his concern with the 'melodrama of vulgarity' in which he felt himself so 'wrapped' that 'Art never seems to make me feel peaceful or pure'. (Cf. his statement on this in the 1951 Symposium on 'What Abstract Art Means to Me' at the Museum of Modern Art in New York, printed in their *Bulletin*, vol. 18, spring 1951, and in *The New American Painting*, 1959.)

Unlike Greenberg and Krauss, De Kooning has not replaced the struggle within himself by an easy rigid 'order'. His recent paintings show this; and if Krauss' ideas of 'measurement' are not there, passion still is: and *that* is what should be discussed critically.

41 'Lichtenstein's Sculpture', *Artforum*, January 1968. This essay is really a criticism of Lichtenstein's autumn 1967 exhibition of 'Modern Art' at the Leo Castelli Gallery in New York.

42 *Artforum*, summer 1967. It was this essay which drew witty criticism from Allan Kaprow and Robert Smithson (cited in note 1, May issue).

43 Fried notes that 'minimalist' is Greenberg's term and he himself prefers 'literalist'. After isolating this type of art from 'modernist' painting and sculpture (for which his examples are, naturally, Noland, Stella, Olitski, Smith and Caro), Fried describes its salient features according to Greenberg as presenting or embodying the condition of 'non-art' (a condition re-labelled by Fried as 'objecthood') in a 'presence' which 'Greenberg was the first to analyse, is basically a

theatrical effect or quality – a kind of *stage presence*'.

44 Fried's announcement of theatre's 'war' with 'modernist painting' and 'art as such' extends to a war 'with modernist sensibility as such'. This claim, which he admits is impossible 'to prove or substantiate' has a subjectivity which is only superficially masked by his pseudo-scientific presentation of three subsidiary 'propositions or theses'. One of these is quoted above; the others are: 'The success, even the survival, of the arts has come to depend on their ability to defeat theatre,' and 'The concepts of quality and value – and to the extent that these are central to art, the concept of art itself – are meaningful, or wholly meaningful, only within the individual arts.'
Much of the peculiar originality of Fried's unbelievable claims is probably influenced by Stanley Cavell, a young philosophy teacher at Harvard whose ideas on aesthetics have impressed Fried very much, and to whose writings on 'Music Discomposed' and 'Must We Mean What We Say?' Fried respectfully footnotes in this essay. That the influence parallel to Greenberg's on Fried is *philosophical* does little to improve Fried's critical perspective on Greenberg's approach or his own emotional openness in direct confrontations with artistic experiences transcending traditional aesthetic categories.

45 *Artforum*, February, April and March 1967: excerpts from a book soon to be published by Harry Abrams in New York.

46 London, 1967.

47 She speaks of styles as living realities in a history abstracted from artists' lives: thus, 'Abstract Expressionism was born of two (historic) catastrophes' (p. 155); and 'the current of geometric abstraction' is described as a 'movement, which had been active in the thirties, was to run submerged in the forties and fifties, and become central once again in the sixties' (p. 158).
 More dangerous is her propagation of the Greenberg-slanted view that the 'colour-field' Abstract Expressionism of Rothko, Newman, and Still developed *later* than the 'gestural abstraction' of Pollock and De Kooning. She does this through the structure and language of her presentation of historic facts. Pollock and De Kooning are discussed in her chapters on the thirties, forties, *and* fifties, whereas the chronologically parallel presence and development of Newman, Rothko, and Still is mentioned only in her chapter on the 1950s; when she back-tracks (a bit awkwardly) to discuss their parallel development in the late 1940s, her verb tenses subtly reinforce this misleading chronology: '... while De Kooning and Pollock *explored* the possibilities of gestural abstraction, Clyfford Still, Barnett Newman, and Mark Rothko *were working toward* a more static, reductive abstraction ...' (p. 192 – italics mine).
It is not irrelevant that acknowledgements of her 'special debt' include one to Greenberg's criticism.

48 'The Value of Didactic Art', *Artforum*, April 1967.

49 'Problems in Criticism IV: Art and Politics', *Artforum*, February 1968. She sees the intense, dogmatic bent of their writing as resulting from the re-channelling of their political frustrations into art-criticism, where they are (ostensibly) more safe.

50 She suggests people like Leo Steinberg, William Rubin, and Robert Rosenblum, who have no political reasons for avoiding questions of 'content'. These people are art historians with academic bases, much like herself, and quite different from some other less academic and excellent critics unafraid of 'content', like Nicolas Calas and Max Kozloff.

263

Anna C. Chave
Minimalism and the Rhetoric
of Power

Source: Anna C. Chave, 'Minimalism and the Rhetoric of Power', *Arts Magazine*, vol. 64, no. 5, January 1990, pp. 44-63. This text has been edited and footnotes renumbered accordingly. Twelve plates have been omitted.

[...] What concerns me about Minimalist art is what Teresa de Lauretis describes as 'the relations of power involved in enunciation and reception', relations 'which sustain the hierarchies of communication; ... the ideological construction of authorship and mastery; or more plainly, who speaks to whom, why and for whom.'[1] I want, further, to historicize those relations – to examine the rhetoric inscribed in Minimalism, and the discursive context of the movement, in relation to the socio-political climate of the time during which it emerged. Richard Serra remembers that in the 1960s, 'It was your job as an artist to redefine society by the values you were introducing, rather than the other way around.'[2] But did Minimalist art in any way propose, or effect, a revaluation of values? And how are we to understand its cool displays of power in relation to a society that was experiencing a violent ambivalence toward authority, a society where many were looking for the means of transforming power relations?

By manufacturing objects with common industrial and commercial materials in a restricted vocabulary of geometric shapes, Judd [Plate 43] and the other Minimalist artists availed themselves of the cultural authority of the markers of industry and technology. Though the specific qualities of their objects vary – from the corporate furniture-like elegance of Judd's polished floor box, to the harsh, steel mesh of Robert Morris's cage-like construction of 1967, to the industrial banality of Carl Andre's *Zinc-Zinc Plain* of 1969 [Plate 44] – the authority implicit in the identity of the materials and shapes the artists used, as well as in the scale and often the weight of their objects, has been crucial to Minimalism's associative values from the outset.[3] In one of the first Minimalist group shows, *Shape and Structure*, at Tibor de Nagy in 1965, Andre submitted a timber piece so massive it almost caused the gallery's floor to collapse and had to be removed. The unapologetic artist described his ambitions for that work in forceful and nakedly territorial terms: 'I wanted very much to seize and hold the space of that gallery – not simply fill it, but seize and hold that space.'[4] More recently, Richard Serra's mammoth, curving, steel walls have required even the floors of the Castelli Gallery's industrial loft space to be shored up – which did not prevent harrowing damage to both life and property.[5]

43 Don Judd, *Untitled*, 1968. Brass, 55.9 × 122 × 91.4 cm. Collection, The Museum of Modern Art, New York. Gift of Philip Johnson 687.80. © 1992 Don Judd/ARS, New York.

44 Carl Andre, *Zinc-Zinc Plain*, 1969. 182.9 × 182.9 cm (36 zinc plates 30.48 × 30.48 cm). Photograph by courtesy of Paula Cooper Gallery, New York. © Carl Andre/DACS, London/ VAGA, New York 1993.

The Minimalists' domineering, sometimes brutal rhetoric was breached in this country in the 1960s, a decade of brutal displays of power by both the American military in Vietnam, and the police at home in the streets and on university campuses across the country. Corporate power burgeoned in the U.S. in the 1960s too, with the rise of the 'multinationals', due in part to the flourishing of the military-industrial complex. The exceptionally visible violence of the state's military and disciplinary establishments in this period met with a concerted response, of course. Vested power became embattled on every front with the eruption of the civil rights alongside the feminist and gay rights movements. In keeping with the time-honoured alignments of the avant-garde, the Minimalists were self-identified, but not especially clear-thinking, leftists. 'My art will reflect not necessarily conscious politics but the unanalysed politics of my life. Matter as matter rather than matter as symbol is a conscious political position, I think, essentially Marxist,' said Andre, contradictorily, in 1970.[6] [...]

Now, as in the 1960s, the dominant accounts of Minimalism do not portray it as an instrument of social change but, on the contrary, as art that somehow generated and occupied a special sphere, aloof from politics and commerce and above personal feeling. The language typically used to describe Minimalism employs a rhetoric of purity, primacy, and immediacy in focusing on the artists' means and on the objects' relations to the constitutive terms of their media. 'The demand has been for an honest, direct, unadulterated experience in art ... minus symbolism, minus messages and minus personal exhibitionism,' wrote Eugene Goossen in 1966;[7] with Minimalism, 'the very means of art have been isolated and exposed,' he stated two years later.[8] In the standard narratives, Minimalism forms the terse, but veracious last word in a narrowly framed argument about what modern art is or should be. As it happens, the person most responsible for framing that argument, Clement Greenberg, finally disliked seeing his logic carried to its extremes: 'Minimal works are readable as art, as almost anything is today,' he complained in 1967, 'including a door, a table, or a blank sheet of paper ... it would seem that a kind of art nearer the condition of non-art could not be envisaged or ideated at this moment. That, precisely, is the trouble. Minimal Art remains too much a feat of ideation, and not enough anything else.'[9] But it was an account of the history of modern art that Greenberg had inscribed as the true history that enabled these objects, which verged on being non-art, to be lionized instead as art of the first importance. Andre's metal plates and Morris's cage could only be regarded as works of art in the context of a discourse in which they stood as compelling proof of the unfolding of a certain historical inevitability. Lay spectators only recognize such objects as works of art (when or if they do so) because they are located in the legitimating contexts of the gallery and museum, installed by curators and dealers in thrall (as the artists themselves were) to a particular account of history.

Most of the artists and critics concerned would have agreed with Goossen that with Minimalism, 'the spectator is not given symbols, but facts';[10] that it offers no quarter to 'the romantic mentality, which fails to appreciate experience for its own intrinsic value and is forever trying to elevate it by complications and associations'.[11] The present account is concerned precisely with how such patently non-narrative art is 'complicated' by 'associa-

45 Robert Morris, *Untitled (Cock/Cunt)*, 1963. Painted wood, Leo Castelli Gallery. ©1992 Robert Morris/ARS, New York.

46 Dan Flavin, *The Diagonal of May 25, 1963 (to Robert Rosenblum)*, 1963. Cool-white fluorescent light, 243.8 × 9.52 cm. Leo Castelli Gallery. ©1992 Dan Flavin/ARS, New York.

tions', however, and is bent on describing those associations. Morris's *Cock / Cunt* sculpture of 1963 [Plate 45], with its schematic image of sexual difference and coitus, demonstrates plainly that highly simplified abstract configurations may indeed be coded. A more characteristic example, however – one that is not literally, but metaphorically, 'inscribed' – is Dan Flavin's seminal and canonical work (I choose my adjectives advisedly), *The Diagonal of May 25, 1963 (to Robert Rosenblum)* [Plate 46], his first work done entirely in fluorescent light. The type of power involved here is, in the first place, actual electrical power (with the requisite cords and connections hidden so that the power's contingency remains inapparent), but the rigid glass tube is also plainly phallic. This is, literally, a hot rod, and Flavin coyly referred to the specific angle he poised the fixture at as 'the diagonal of personal ecstasy,'[12] alluding to the characteristic angle of an erect penis on a standing man. [...]

In Flavin's mind, his *Diagonal* was less a reaffirmation of the possibility for spiritual experience in contemporary society, than 'a modern technological fetish'[13] – a fetish being, in Freudian terms, a talisman against castration and impotence, a symbolic surrogate for the female body's absent penis. From this perspective, Flavin's dependence on technological artifacts for his work may evince the sense of impotence visited on the once sovereign, universal (read: male) subject by the ascendancy of technology. 'Disenfranchised by an independently evolving technology, the subject raises its disenfranchisement to the level of consciousness, one might almost say to the level of a programme for artistic production', as Theodor Adorno observed.[14] Flavin's *Diagonal* not only looks technological and commercial – like Minimalism generally – it *is* an industrial product and, as such, it speaks of the extensive power exercised by the commodity in a society where virtually everything is for sale – where New York Telephone can advertise 'love', 'friendship', and 'comfort' for 'as little as ten cents a call', for instance. Further, in its identity as object or commodity, Flavin's work may arouse our ambivalence toward

those ever-proliferating commodities around us for which we have a hunger that is bound to be insatiable, as they will never fully gratify us.

Standard products, or commercially available materials, can also be seen to bear secondary meanings in Andre's famous *Lever* of 1966, done for the important *Primary Structures* show at the Jewish Museum in 1966. 'Artworks at their best spring from physical, erotic propositions', Andre stated. And with its 137 fire bricks set side by side in a row 34½ feet long, *Lever* manifests his determination to put 'Brancusi's *Endless Column* on the ground instead of in the sky. Most sculpture is priapic with the male organ in the air. In my work, Priapus is down on the floor. The engaged position is to run along the earth.'[15] In terms of the artist's view of it, then, *Lever* is closer to Morris's *Cock/Cunt* than to Flavin's *Diagonal*, as it offers a schematic image of coitus with the floor serving as the (unarticulated) female element. Significantly too, of course, a 'lever' is a long, rigid tool used to pry or lift, while *lever* means to rise, raise, or lift in French. [...]

Like much of Morris's and Judd's work of the early and mid-1960s, Kenneth Noland's pictures often involved simple, repeated, geometric forms, his favoured schemas being those military emblems, the chevron and the target, realized on an outsized scale, often with bold, bright colours [Plate 29]. But Noland's reliance on comparatively weak and natural materials (cloth and wood), not to mention his art's accustomed placement on the peripheries of space, made some problems for him within the Minimalist ambit. 'Noland is obviously one of the best painters anywhere', wrote Judd in 1963 in his guise as critic and monitor of the Minimalist ethos, but his

paintings are somewhat less strong than the several kinds of three-dimensional work. Painting has to be as powerful as any kind of art; it can't claim a special identity, an existence for its own sake as a medium. If it does it will end up like lithography and etching. Painting now is not quite sufficient, although only in terms of plain power. It lacks the specificity and power of actual materials, actual colour and actual space.[16]

Judd continued to insist on the paramount importance of the 'plain power' of art in 'Specific Objects', the essay he published in 1965 that is often taken as a kind of keynote essay for the Minimalist movement.[17] Minimalism began to coalesce as a vision in 1964 and 1965 when the first group shows bringing together the artists now regarded as the Minimalists took place.[18] Historically, 1965 is also the year the first regular American combat troops entered Vietnam; the year the United States started massive bombings of North Vietnam; the year Watts exploded in riots; and the year Malcolm X was assassinated. De Maria's *Death Wall* of 1965, a small stainless-steel plinth marked by a notch-like opening with the word DEATH engraved over it, makes an exceedingly discreet, but evidently directed nod toward the violence of the time. Here, however, as with Minimalism generally, the art's political moment remains implicit largely in its acts of negation; it negated, that is, almost everything the public associated with or expected from works of art, including a sense of moral or spiritual uplift. Some female critics, especially, pointed (though not in a censorious way) to the violence implicit in the

47 Don Judd, *Untitled*, 1966. Painted cold-rolled steel, ten rectangles. Overall 121.92 × 304.8 × 304.8 cm. Each rectangle 15.51 × 304.8 × 121.92 cm. Collection of Whitney Museum of American Art, New York, Gift of Howard and Jean Lipman. ©1992 Don Judd/ARS, New York.

Minimalists' categorical refusal of the humanist mission of art: 'a negative art of denial and renunciation' and a 'rejective art', Barbara Rose and Lucy Lippard, respectively, dubbed it in 1965, while Annette Michelson suggested in 1967 that negation was the 'notion, philosophical in character, ... animating [this] contemporary aesthetic'.[19]

The Minimalists effectually perpetrated violence through their work – violence against the conventions of art and against the viewer – rather than using their visual language to articulate a more pointed critique of particular kinds or instances of violence. Judd insisted in 1970 that his work had not had

anything to do with the society, the institutions and grand theories. It was one person's work and interests; its main political conclusion, negative but basic, was that it, myself, anyone shouldn't serve any of these things ... Art may change things a little, but not much; I suspect one reason for the popularity of American art is that the museums and collectors didn't understand it enough to realize that it was against much in the society.[20]

But Judd's work was not, as he would have it, aloof from society. And given the geometric uniformity of his production, its slick surfaces, its commercial fabrication (often in multiples), and its stable, classic design, those prosperous collectors and institutions who were drawn to it could hardly be called obtuse if they perceived it not as 'against much in the society', but as continuous with their own ideals [Plate 47]. Judd's work can easily be seen as reproducing some of the values most indelibly associated with the modern technocracy, in other words, even as it negated many of the qualities the public most fondly associated with the fine arts.

Though some of the Minimalists were alluding, by 1970, to a political moment implicit in their work, it was not at all plain from the way they rep-

resented their enterprise in the 1960s that they initially conceived it as a form of political resistance in keeping with the avant-garde mandate for oppositional artistic practices. Some critics now point to the Minimalists' interest in Russian Constructivism as a sign of their simmering political consciousness, but that interest revealed itself sporadically and not in politicized terms. In 1966, on the other hand, Brian O'Doherty was congratulating the Minimalists for confronting 'what has become the illusion of avant-gardism', and developing 'a sort of intellectual connoisseurship of non-commitment'. This artist-critic went on to claim that the 'anti-avant-garde' object makers were successfully establishing a new academy. Comparing the ambit of contemporary art to that of show jumping, he continued: the latest work 'sits blandly within the gates, announcing that it is not ahead of its time (therefore arousing no shock) and that the future is simply *now* ... This is going to be a tough academy to displace.'[21] [...]

Whereas Pop Art initially caused a collective shudder of distaste within the intelligentsia while being rapidly embraced by the public at large, Minimalism (in the same period) generally garnered toleration, at the least, from the cognoscenti, and either deep scepticism or unmitigated loathing from the public at large. That very loathing could be construed as a sign of this art at work, however, for what disturbs viewers most about Minimalist art may be what disturbs them about their own lives and times, as the face it projects is the society's blankest, steeliest face; the impersonal face of technology, industry, and commerce; the unyielding face of the father: a face that is usually far more attractively masked.

In 'Specific Objects', Judd adduced what he plainly regarded as a positive vision: that the art of the future 'could be mass-produced, and possibilities otherwise unavailable, such as stamping, could be used. Dan Flavin, who uses fluorescent lights, has appropriated the results of industrial production.'[22] In the final event, however, neither Flavin nor Judd would sacrifice the cachet or the profits that mass-producing their work would likely have entailed. Artists like Flavin and Andre, who worked with commonly available products, took care to work in editions, limiting quantities so as to assure market value and, in Flavin's case, issuing certificates of authenticity upon the sale of their work. If Flavin appropriated commercial lighting fixtures and Andre used common building materials, it was not, in the end, with a view to standing the economy, or the valuations of the market, on its ear. Collectors were compelled to spend thousands of dollars to have 120 sand-lime bricks purchased by Andre – to make *Equivalent VII*, for instance – rather than tens of dollars to buy the bricks for themselves. Though the artists depersonalized their modes of production to the furthest extent, they would not surrender the financial and other prerogatives of authorship, including those of establishing authenticity.

The rhetoric Judd mustered in 'Specific Objects' to promote the new (non-)art pointed to its attainment of 'plain power' through the deployment of 'strong' and 'aggressive' materials. At a time when the call was going out for a reformulation of the configurations of power, however, Judd's use of

48 Albert Speer, Arcade of Nuremberg Parade Ground. *Die Deutsche Baukunst* 1943.

the term bore no inkling of its incipient volatility. For works of art to be powerful and aggressive was, from the Minimalists' standpoint, an unproblematic good, almost as it was once self-evident that art should be 'beautiful'. For an artist, 'power isn't the only consideration,' Judd grudgingly allowed, 'though the difference between it and expression can't be too great either.'[23] This equating of expression with power, rather than with feeling or communication, may or may not strike a reader as strange. Some kinds of art are routinely described as powerfully (read: intensely) expressive or emotional, but Judd's work is not of that sort: if his objects were persons (and I mean this strictly in a fanciful way) they would more likely be described as the proverbial 'strong, silent type'. In art-historical parlance, however, it has long been common approbatory language, even the highest level of praise, to describe works of art in terms of the exercise of power: as strong, forceful, authoritative, compelling, challenging, or commanding; and the masculinist note becomes even more explicit with the use of terms like masterful, heroic, penetrating, and rigorous [Plate 48]. That what is rigorous and strong is valued while what is soft or flexible is comic or pathetic emerges again and again in the Minimalists' discourse, as it does in the everyday language of scholars. (Terms that might, but do not as readily, serve as high praise for art include, for instance: pregnant, nourishing, pleasurable.) The language used to esteem a work of art has come to coincide with the language used to describe a

human figure of authority, in other words, whether or not the speaker holds that figure in esteem. As the male body is understood to be the strong body – with strength being measured not by tests of endurance, but by criteria of force, where it specially excels – so the dominant culture prizes strength and power to the extent that they have become the definitive or constitutive descriptive terms of value in every sphere: we are preoccupied not only with physical strength and military strength but with fiscal, cultural, emotional, and intellectual strength, as if actual force were the best index or barometer of success in any of those spheres.

Foucault has written at length about the power/knowledge paradigms that underwrite the master discourses, the 'True Discourses' of the successive regimes of modern history, and has pointed also to the 'will to power/knowledge' through which 'man' has historically been shaped and transformed. In Foucault's scheme, however (as de Lauretis has incisively observed), 'nothing exceeds the totalizing power of discourse, [and] nothing escapes from the discourse of power.'[24] Foucault admits no possibility of a radical dismantling of systems of power and undertakes no theorizing or imagining of a society or world without domination. Balbus points perceptively to 'the blindness of a man [Foucault] who so takes for granted the persistence of patriarchy that he is unable even to see it. His gender-neutral assumption of a will to power (over others) that informs True Discourses and the technologies with which they are allied, transforms what has in fact been a disproportionately *male* into a generically human orientation, and obliterates in the process the distinctively female power' – my own word would have been capacity – 'of nurturance in the context of which masculine power is formed and against which it reacts.'[25] A persuasive case can be made, after all, that the patriarchal overvaluation of power and control – at the expense of mutuality, toleration, or nurturance – can be held to account for almost all that is politically reprehensible and morally lamentable in the world. The case can be made as well that what is most badly needed are, at least for a start, visions of something different, something else.

The Minimalists' valorization of power can readily be seen as a reinscribing of the True Discourses, the power discourses, found in art history as in the society at large. Received art-historical wisdom about what makes works of art 'powerful' is a quality of unity, with effects of dissonance or difference successfully effaced or overmastered such that an object's or image's composite parts are manoeuvred into a singular, coherent totality. Unity is associated with identity and a successful work of art is understood to require a whole identity no less than an integrated person does. Crudely speaking, the task that an artist is conventionally said to have undertaken is one of balancing the multifarious elements of a composition until they are harmonized and unified. The canny Minimalists started at the usual end of that task, however, by using configurations that were unified or balanced to begin with, such as squares and cubes, rather than engaging in the process of composing part by part. Thinking about what the society values most in art, Judd observed that, finally, no matter what you look at, 'The thing as a whole, its quality as a

whole, is what is interesting. The main things are alone and are more intense, clear and powerful. They are not diluted by ... variations of a form, mild contrasts and connecting parts and areas.'[26] In the best of the new art, Judd concluded (using Stella as his example), 'The shapes, the unity, projection, order and colour are specific, aggressive and powerful.'[27] [...]

Like Judd's boxes, Morris's cage-like construction of 1967 does not intrude aggressively on the viewers' space due to its moderate scale and its transparency. Unlike Judd's boxes, however, Morris's construction, with its steel materials reminiscent of chain-link fencing, evokes not corporate but carceral images, of discipline and punishment, that intrude aggressively on the viewers' sensibilities.[28] A fenced-in quadrangle surrounded by a fenced-in corridor evokes an animal pen and run, both without exits. Made during a year of African American uprisings in Detroit and elsewhere, and the year of the siege of the Pentagon – a time when masses of ordinarily law-abiding citizens became subject to an exceptionally pervasive and overt meting out of discipline and punishment – Morris's sculpture succinctly images containment or repression. If it does not refer in any more pointed or pointedly critical way to the events of the day, by representing power in such an abrasive, terse, and unapologetic way, the work none the less has a chilling effect: this is authority represented as authority does not usually like to represent itself; authority as authoritarian.

To judge by Morris's writings, his success at realizing such authoritative and oppressive images owed more to his infatuation with power than to his interest in finding strategies to counter the abuses of power rife and visible at the time. In terms fitting a military strategist, Morris wrote in his 'Notes on Sculpture' of seeking 'unitary' or 'strong gestalt[s]' that would 'fail to present lines of fracture' and that would offer 'the maximum resistance to being confronted as objects with separate parts'.[29] Separate parts could become entangled in internal relationships that would render the objects vulnerable; because they lead to weak gestalts, 'intimacy producing relations have been gotten rid of in the new sculpture.' An elimination of detail is required in the new sculpture, further, because detail would 'pull it toward intimacy'; and the large scale of the work is important as 'one of the necessary conditions of avoiding intimacy'. There is plainly a psycho-sexual dimension to Morris's trenchant objections to relationships and intimacy, to his insistence on distancing the viewer, as well as to his fixation on keeping his objects discrete and intact.[30] In his pathbreaking study of male fantasies, for that (last) matter, Klaus Theweleit has described how the population of 'soldier males' whose writings he analysed

freeze up, become icicles in the fact [*sic*] of erotic femininity. We saw that it isn't enough simply to view this as a defence against the threat of castration; by reacting in that way, in fact, the man holds himself together as an entity, a body with fixed boundaries. Contact with erotic women would make him cease to exist in that form. Now, when we ask how that man keeps the threat of the Red flood of revolution away from his body, we find the same movement of stiffening, of closing himself off to form a 'discrete entity'.[31]

Morris declared in 1966 that 'The better new work takes relationships out of the work and makes them a function of space, light and the viewer's field of vision.'[32] He referred not to a relationship between viewer and work, that is, but only to a relation between the work and the viewers' 'field of vision' – as if the viewers' sight were separable from their minds, bodies, or feelings. The relation between art and spectator that interested Morris became clearer over the course of the 1960s and early 19'70s as he made manifest an attitude toward the (embodied) viewer that was ambivalent at best, belligerent and malevolent at worst. The public, at times, returned the artist's animosity: his exhibition at the Tate Gallery in London in 1971 had to be closed after five days, allegedly to protect the public, but also to protect the work which the public was battering. Some of that work invited viewer participation – in simple tests of agility, for instance – but with work that engages the public, as the artist discovered, 'sometimes it's horrible. Sometimes you just can't get people to do what you want.' The following year Morris retaliated, as it were, against a different audience with a work called *Hearing*, a gallery installation that consisted of a copper chair, a zinc table, and a lead bed (still executed in a Minimalist idiom). The chair contained water heated almost to the boiling point, and the bed and table were connected with thirty-six volts of electricity, while loudspeakers broadcast a (mock) interrogation lasting for three-and-a-half hours.[33] Later still, to tout another show of his work at the Castelli Gallery, Morris exposed his bare-chested body clad in sadomasochistic paraphernalia [Plate 49], thereby equating the force of art with corporeal force, where what prevails or dominates is generally the greatest violence.[34] [...]

The paradigmatic relation between work and spectator in Serra's art is that between bully and victim, as his work tends to treat the viewer's welfare with contempt. This work not only looks dangerous, it *is* dangerous: the 'prop' pieces in museums are often roped off or alarmed and sometimes, especially in the process of installation and deinstallation, they fall and injure or even (on one occasion) kill. Serra has long toyed with the brink between what is simply risky and what is outright lethal, as in his *Skullcracker Series: Stacked Steel Slabs* of 1969, which consisted of perilously imbalanced, 20-to-40-foot tall stacks of dense metal plates. Rosalind Krauss insists that 'It matters very little that the scale of this work ... is vastly over life size', but Serra's ambitious expansion of the once-moderate scale of the Minimalist object was, together with his fascination with balance and imbalance, central to his work's concern with jeopardy, and crucial to its menacing effect.[35] Judging by his own account, what impelled Serra to make even bigger works in ever more public spaces was never an interest in the problems of making art for audiences not fluent, let alone conversant, in the difficult languages of modernist art, but rather a consuming personal ambition, a will to power. 'If you are conceiving a piece for a public place,' he conceded (while avoiding the first-person pronoun), '... one has to consider the traffic flow, but not necessarily worry about the indigenous community, and get caught up in the politics of the site.'[36] Serra's assurance that he could remain aloof from politics proved

49 Robert Morris, Poster for Castelli/Sonnabend Gallery exhibition, April 6-27, 1974. Offset on paper, courtesy of Sonnabend Gallery. ©1992 Robert Morris/ARS, New York.

fallacious, of course, as the public returned his cool feelings, most notably in the case of the *Tilted Arc* of 1981 [Plate 50].

It has been argued about the *Arc* that its oppressiveness could serve in a politically productive way to alert the public to its sense of oppression. Though an argument can be made for Serra similar to the ones I have made here for Judd, Morris and Stella – that the work succeeds insofar as it visualizes, in a suitably chilling way, a nakedly dehumanized and alienating expression of power – it is more often the case with Serra (as sometimes also with Morris) that his work doesn't simply exemplify aggression or domination, but acts it out. In its site on Federal Plaza in lower Manhattan, Serra's mammoth, perilously tilted steel arc formed a divisive barrier too tall (12 feet) to see over, and a protracted trip (120 feet) to walk around. In the severity of its material, the austerity of its form, and in its gargantuan size, it served almost as a grotesque amplification of Minimalism's power rhetoric. Something about the public reaction to that rhetoric can be deduced from the graffiti and the urine that liberally covered the work almost from the first, as well as from the petitions demanding its removal (a demand met [in 1989]).

A predictable defence of Serra's work was mounted by critics, curators, dealers, collectors, and some fellow artists. At the General Services Administration hearings over the petitions to have the work removed, the dealer Holly Solomon made what she evidently regarded as an inarguable case in its favour: 'I can only tell you, gentlemen, that this is business, and to take down the piece is bad business ... the bottom line is that this has financial value, and you really have to understand that you have a responsibility to the financial community. You cannot destroy property.' But the principal arguments

276

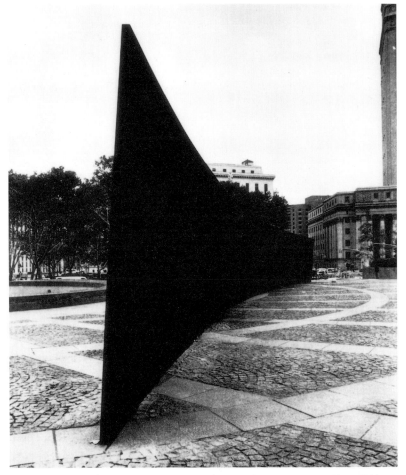

50 Richard Serra, *Tilted Arc*, 1981. Cor-ten steel, 365.76 × 3657.6 × 76.2 cm. Photo: Dith Prahn, Susan Swidler and Anne Chauvet by courtesy of the Pace Gallery. Installed Federal Plaza, New York, destroyed by U.S. government 15 March 1989.

mustered on Serra's behalf were old ones concerning the nature and function of the avant-garde. Thus, the Museum of Modern Art's chief curator of painting and sculpture, William Rubin, taught a hoary art-history lesson. 'About one hundred years ago the Impressionists and post-Impressionists ... artists whose works are today prized universally, were being reviled as ridiculous by the public and the established press. At about the same time, the Eiffel Tower was constructed, only to be greeted by much the same ridicule ... Truly challenging works of art require a period of time before their artistic language can be understood by the broader public.'[37]

What Rubin and Serra's other supporters declined to ask is whether the sculptor really is, in the most meaningful sense of the term, an avant-garde artist. Being avant-garde implies being ahead of, outside, or against the

dominant culture; proffering a vision that implicitly stands (at least when it is conceived) as a critique of entrenched forms and structures. 'Avant-garde research is functionally ... or ontologically ... located outside the system,' as Lyotard put it, 'and by definition, its function is to deconstruct everything that belongs to order, to show that all this "order" conceals something else, that it represses.'[38] But Serra's work is securely embedded within the system: when the brouhaha over the *Arc* was at its height, he was enjoying a retro-spective at the Museum of Modern Art (in the catalogue of which, by a special exception, he was allowed to have a critic of his own choosing, Douglas Crimp, make a case for him).[39] The panel of luminaries who were empowered to award Serra the commission in the first place plainly found his vision congenial to their own. And his defence of the work rested precisely on this basis, that far from being an outsider, he was an eminent member of the establishment who, through some horrifying twist of fate, had become subject to harassment by the unwashed and uncouth who do not even rec-ognize, let alone respect, authority when they see it.

277

Because his work was commissioned according to the regulations of a gov-ernment agency, Serra reasoned that 'The selection of this sculpture was, therefore, made by, and on behalf of the public.' Stella expanded on this theme in his own remarks at the hearing: 'The government and the artist have acted as the body of society attempting to meet civilized, one might almost say civilizing goals ... To destroy the work of art and simultaneously incur greater public expense in that effort would disturb the status quo for no gain ... Finally, no public dispute should force the gratuitous destruction of any benign, civilizing effort.'[40] These arguments locate Serra not with the vanguard but with the standing army or 'status quo', and as such represent a more acute view than Rubin's, though the rhetoric they depend on is no less hackneyed. More thoughtful, sensible, and eloquent testimony at the hearing came instead from some of the uncouth:

My name is Danny Katz and I work in this building as a clerk. My friend Vito told me this morning that I am a philistine. Despite that I am getting up to speak ... I don't think this issue should be elevated into a dispute between the forces of ignorance and art, or art versus government. I really blame government less because it has long ago outgrown its human dimension. But from the artists I expected a lot more. I didn't expect to hear them rely on the tired and dangerous reasoning that the government has made a deal, so let the rabble live with the steel because it's a deal. That kind of mentality leads to wars. We had a deal with Vietnam. I didn't expect to hear the arro-gant position that art justifies interference with the simple joys of human activity in a plaza. It's not a great plaza by international standards, but it is a small refuge and place of revival for people who ride to work in steel containers, work in sealed rooms and breathe recirculated air all day. Is the purpose of art in public places to seal off a route of escape, to stress the absence of joy and hope? I can't believe this was the artistic intention, yet to my sadness this for me has become the dominant effect of the work, and it's all the fault of its position and location. I can accept anything in art, but I can't accept physical assault and complete destruction of pathetic human activity. No work of art created with a contempt for ordinary humanity and without respect for the common element of human experience can be great. It will always lack a dimension.[41]

The terms Katz associated with Serra's project include arrogance and contempt, assault and destruction; he saw the Minimalist idiom, in other words, as continuous with the master discourse of our imperious and violent technocracy. [...]

It proves less of a strain to perceive Minimalist art as 'against much in the society' (as the artists themselves would generally have it), then, when we compare it with art that harbours no such ambitions. But can Minimalism readily be seen as having that oppositional moment we demand of vanguard or modernist art? The most defensible answer to this question is surely 'no', but a contrary answer can still be contrived given the, at times, disquieting effect of the most uningratiating Minimalist production – that bothersomeness that impels some viewers even to kick it. To construct the inobvious answer takes a recourse to the modernist theory of Adorno, however. 'One cannot say in general whether somebody who excises all expression is a mouthpiece of reification. He may also be a spokesman for a genuine non-linguistic, expressionless expression and denounce reification. Authentic art is familiar with expressionless expression, a kind of crying without tears,' wrote Adorno.[42] If no general judgement of this kind can be made, I have proposed here that some local or specific judgements might be; that in some of the Minimalists' most contained and expressionless works we might infer a denunciatory statement made in, and not against, the viewer's best interests. Adorno suggested that 'The greatness of works of art lies solely in their power to let those things be heard which ideology conceals.'[43] Whether by the artists' conscious design or not, the best of Minimalist art does that well enough through its lapidary reformulations of some especially telling phrases of the master discourse. Adorno championed modernist art not only for its negative capability, however, but also for its utopian moment, its vision of something other or better than the present regime. Here we encounter Minimalism's departure: its refusal to picture something else; a refusal which finally returns the viewer – at best a more disillusioned viewer – to more of the same.

Notes

1 Teresa de Lauretis, *Alice Doesn't: Feminism, Semiotics, Cinema,* Bloomington, 1984, p. 179.
2 Harriet Senie, 'The Right Stuff', *Art News,* March 1984, p. 55.
3 Hal Foster alone has ventured in print (however tentatively): 'Is it too much to suggest that "art for art's sake" returns here in its authoritative (authoritarian?) guise, a guise which reveals that, far from separate from power and religion (as Enlightenment philosophy would have it) bourgeois art is a displaced will to power ... and ultimately *is* a religion?' 'The Crux of Minimalism', in Howard Singerman, ed., *Individuals: A Selected History of Contemporary Art 1945-1986,* New York: Abbeville Press, for the Museum of Contemporary Art, Los Angeles, c. 1986, p. 174.
4 Phyllis Tuchman, 'An Interview with Carl Andre', *Artforum,* June 1970, p. 61. Insofar as space or voids are conventionally coded as feminine, a symbolic form of sexual domination is at issue here too.
5 See Don Terry, 'A 16-Ton Sculpture Falls, Injuring Two', *New York Times,* 27 October 1988, B6; and Ruth Landa, 'Sculpture Crushes Two: Worker Loses Leg as 16-Ton Piece Falls', [New York] *Daily News,* 27 October 1988, 1, 3. [...]

6 'Carl Andre: Artworker', interview with Jeanne Siegel, *Studio International*, vol.180, no. 927, November 1970 p. 178. Andre, and, to a lesser extent, Morris, were active in the Art Workers Coalition, an anarchic body formed in 1969 whose principal achievement was helping to organize the New York Art Strike against War, Racism and Repression, which closed numerous galleries and museums on 22 May 1970 (a sit-in on the steps of the Metropolitan Museum, which did not close, drew about five hundred participants). The A.W.C. drew a distinction between the politicizing of artists, which it urged, and the politicizing of art, which it did not.

It bears noting that the prime motivator of political action in the student population, the draft, did not threaten any of the men discussed here, as most of them had spent years in the military – in some cases by choice – prior to pursuing careers as artists. Kenneth Noland, born in 1924, served from 1942 to 1946 as a glider pilot and cryptographer in the air force, mainly in the United States but also in Egypt and Turkey; he subsequently studied art at Black Mountain College and in Paris. Judd, born in 1928, served in the army in Korea in an engineer's unit, 1945-7 (before the outbreak of war there); subsequently he studied at the Art Students League and at Columbia University, from which he graduated in 1953 with a B.S. in Philosophy and where he pursued graduate studies in Art History, from 1958 to 1960. Sol LeWitt, born in 1928, earned a B.E.A. from Syracuse University in 1949 and then served in the U.S. Army in Japan and Korea, in 1951-2. Morris, born in 1931, served time in Korea as an engineer toward the end of the Korean war; he attended numerous universities and art schools, including the California School of Fine Arts and Reed College, and did graduate work at Hunter College in New York in Art History. Dan Flavin, born in 1933, found himself, in 1955, by his own account, 'loitering in Korea with an army of occupation as an Air Weather Service Observer'; he subsequently attended Columbia University. Andre, born 1935, studied at Phillips Andover Academy, 1951-3, and served in the army in North Carolina in 1955-6. Walter De Maria, born in 1935, earned a B.A. in History and an M.A. in Sculpture at the University of California at Berkeley, and was not in the military. Frank Stella, born in 1936, expected to be drafted on graduating from Princeton, but was exempted because of a childhood injury to his hand. Serra, born in 1939, also did not see military service.

7 Eugene Goossen, 'Distillation', 1966 (a text accompanying an exhibition held at the Tibor de Nagy and Stable galleries in September 1966), reprinted in *Minimal Art: A Critical Anthology*, ed. Gregory Battcock, New York, 1968, p. 169.

8 Eugene Goossen, *The Art of the Real: U.S.A. 1948-1969* New York: Museum of Modern Art, 1968, p. 11; this show represented the debut of Minimalism at the Museum of Modern Art, though it did not feature Minimalism exclusively.

9 Clement Greenberg, 'Recentness of Sculpture', 1967, reprinted in *Minimal Art*, ed. Battcock, p. 183. In 'The Crux', Foster discusses Minimalism aptly as representing at once an ultimate realization of, and a break with, the Greenbergian Modernist model.

10 Goossen, *Art of the Real*, p. 11.

11 Eugene Goossen, 'Eight Young Artists', 1964 (an essay accompanying an exhibition of the Hudson River Museum in Yonkers, N.Y. in October 1964), reprinted in *Minimal Art*, ed. Battcock, p. 167.

12 Such was the title given to the drawing for the work in Brydon Smith, *Dan Flavin: Fluorescent Light*, Ottawa: National Gallery of Canada, 1969, p. 166; and Flavin reiterated the phrase when showing a slide of the work at a lecture at Harvard University in 1986.

13 Flavin, ' ... "in daylight or cool white": An Autobiographical Sketch', *Artforum*, December 1965, p. 24.

14 Theodor W. Adorno, *Aesthetic Theory*, trans. C. Lenhardt, ed. Gretel Adorno and Rolf Tiedemann, London, 1984, p. 35.

15 Siegel, 'Andre: Artworker', p. 178; and David Bourdon, *Carl Andre: Sculpture 1959-1977*, New York: Jaap Reitman, 1978, p. 27. A key work Andre conceived in 1960, but could not afford to execute until 1966, was *Herm*, consisting of a single rectangular timber standing on end. The title refers to ancient Greek road markers, simple, rectangular, stone pillars often marked by an erect penis and surmounted by a bust of Hermes. In 1963, Andre made a wooden sculpture called *Cock* in evident homage to Brancusi (though 'cock') does not have the explicit slang connotation in French that it has in English).

16 Reprinted in *Judd: Complete Writings 1959-1975*, Halifax, 1975, p. 93.

17 While its rhetoric most plainly described Judd's own vision, this essay did not deal exclu-

279

sively with the Minimalists, but included others such as Rauschenberg, Lucas Samaras, and Claes Oldenburg, who were using non-fine-arts materials or objects in their work.

18 Samuel Wagstaff, Jr.'s *Black, White and Grey*, an exhibition at the Wadsworth Atheneum in Hartford in January-February 1964, included Morris, Tony Smith, Flavin, Agnes Martin and Anne Truitt, for example, among other artists who would not become associated with Minimalism. Flavin organized an exhibition at the Kaymar Gallery in New York in March 1964 that included himself, Judd, LeWitt, Stella, Bannard, Robert Ryman, and Jo Baer, among others. Goossen organized *Eight Young Artists* at the Hudson River Museum in October 1964, including Andre and Bannard. The *Shape and Structure* show at Tibor de Nagy in 1965 included Judd, Morris and Andre, among others. Michael Fried's *Three American Painters*, with Stella, Noland, and Olitski, took place at the Fogg Art Museum at Harvard in 1965. And Kynaston McShine *Primary Structures* exhibition occurred at the Jewish Museum in 1966.

19 Rose, 'ABC Art', reprinted in *Minimal Art,* ed. Battcock, p. 296; Lucy R. Lippard, 'New York Letter: Rejective Art', 1965, reprinted in Lippard, *Changing: Essays in Art Criticism*, New York, 1971, pp. 141-53; Annette Michelson, '10 x 10 ...', *Artforum*, Jan. 1967, pp. 30-1.

20 'The Artist and Politics: A Symposium', *Artforum,* Sept. 1970, p. 37.

21 O'Doherty, 'Minus Plato', reprinted in *Minimal Art*, ed. Battcock, pp. 252, 254.

22 Judd, 'Specific Objects', *Arts Yearbook*, 8, 1965, reprinted in *Judd: Complete Writings*, p. 187.

23 Judd, 'Specific Objects', p. 181.

24 de Lauretis, *Alice Doesn't*, p. 87.

25 Isaac Balbus, 'Disciplining Women: Michel Foucault and the Power of Feminist Discourse', in *Feminism as Critique*, ed. Seyla Benhabib and Drucilla Cornell, Minneapolis, 1987, p. 120.

26 Judd, 'Specific Objects', p. 187.

27 Judd, 'Specific Objects', p. 184.

28 In 1978, Morris would do a series of ink on paper drawings, called 'In the Realm of the Carceral'; see Stephen F. Eisenman, 'The Space of the Self: Robert Morris "In the Realm of the Carceral"', *Arts*, September 1980, pp. 104-9.

29 Morris, 'Notes on Sculpture: Part One', reprinted in *Minimal Art,* ed. Battcock, pp. 226, 228.

30 Morris, 'Notes on Sculpture: Part Two', reprinted in *Minimal Art*, ed. Battcock, pp. 232-3. Naomi Schor suggests that details have historically been coded feminine and viewed accordingly with suspicion, if not contempt: *Reading in Detail: Aesthetics and the Feminine*, New York, 1987. The psycho-sexual aspect to Morris's project became clearer in a performance piece of 1964 called 'Site' in which the artist moved standard 4 x 8 feet construction materials (painted plywood panels?) around a stage while maintaining a studied indifference to the nude body of a woman (Carolee Schneeman) posed as the courtesan Olympia. When a critic suggested that the work 'implied that as the nude woman was to Manet, so the grey construction material was to him', the artist replied with a story about a woman being sexually aggressive toward him and so, as it seems, threatening the integrity of his work process: 'Morris's comment was that he had been approached several times by a dancer who wanted to work with him, unbuttoning her blouse as she spoke. His solution was *Site*", William S. Wilson, 'Hard Questions and Soft Answers', *Art News*, November 1969, p. 26.

31 Klaus Theweleit, *Male Fantasies, vol. 1: Women, Floods, Bodies, History*, Minneapolis, 1987, p. 224. The specific population Theweleit studied is the German Freikorps, 'the volunteer armies that fought, and to a large extent, triumphed over, the revolutionary German working class in the years immediately after World War I', p. ix.

32 Morris, 'Notes: Part Two', p. 232.

33 Jonathan Fineberg, 'Robert Morris Looking Back: An Interview', *Arts*, September 1975, pp. 111-13.

34 Morris's violence emerged most explicity in some of the non-Minimalist work that forms the greater part of his production: he described a 'process piece' he conceived in the 1960s as follows, for example: 'I had them shoot a shotgun blast into the wall [of the gallery], and the pattern of the shot was photographed. That was a travelling show. At the next place the photograph was put up and the gun fired, and the result was photographed and enlarged. Each museum got a photograph of the shot photograph,and they shot that one so that you got a series of photographs of photographs that had been shot. Each photograph had to be bigger. I

wanted it to get bigger and bigger', Goossen, 'The Artist Speaks', p .105.

35 Rosalind Krauss, *Richard Serra: Sculpture*, ed. Laura Rosenstock, New York: Museum of Modern Art, 1986, p. 24.

36 Interview with Liza Baer, 30 March 1976, in 'Richard Serra with Clara Weyergraf, *Richard Serra: Interviews, Etc. 1970-1980*, Yonkers N.Y.: Hudson River Museum, 1980, p. 73.

37 Transcript: The Storm in the Plaza', excerpts from the General Services Administration hearing on the *Tilted Arc, Harper's*, July 1985, pp. 30, 32.

38 Jean-François Lyotard, 'On Theory: An Interview', in *Driftworks*, ed. Roger McKeon, New York, 1984, p. 29.

39 William Rubin: 'Preface', to Krauss, *Serra*, pp. 9-10. Serra announced sententiously at the hearing that the *Tilted Arc* would, *de facto*, be destroyed if it were moved as he does not make portable sculpture; but he had erected similar pieces on public sites on a temporary basis and he had no plans to dispose of the numerous works in his exhibition at the Museum of Modern Art once it was over.

40 'Transcript', pp. 28, 32.

41 'Transcript,' p. 33. Katz went on to give Serra and the work the benefit of the doubt: 'I don't believe the contempt is in the work. The work is strong enough to stand alone in a better place. I would suggest to Mr. Serra that he take advantage of this opportunity to walk away from this fiasco and demand that the work be moved to a place where it will better reveal its beauty.'

42 Adorno, *Aesthetic Theory*, p. 171.

43 Adorno, 'Lyric Poetry and Society', *Telos*, 20, Summer 1974, p. 58.

281

26 | **Alan Wallach**
The Museum of Modern Art:
The Past's Future

Source: Alan Wallach, 'MOMA: The Past's Future', based on a paper presented at the Association of Art Historians' Annual Conference, London, April 1991. Footnotes have been edited and renumbered accordingly.

Introduction

Between 1980 and 1984 the Museum of Modern Art carried out a far-reaching renovation and expansion. Following a design developed by Cesar Pelli, then dean of the Yale School of Architecture, MOMA doubled its exhibition space, added a glassed-in atrium or 'garden hall', upgraded its dining facilities, built a new theatre-lecture hall, and vastly expanded its bookstore. To help finance the undertaking, the Museum, in an unprecedented move, sold air rights to a developer who erected a 52-storey residential condominium tower (also designed by Pelli) over the Museum's new west wing.[1] [Plate 51]. Initially critics feared the condominium tower would mar MOMA's appearance; however, when the Museum reopened they were nearly unanimous in their praise of Pelli's design. The *New York Times*, in an editorial called 'Marvelous MOMA', pronounced 'the surgery ... a success. A lot has been gained but the miracle is that nothing has been lost.'[2] Robert Hughes, in an article in *Time Magazine* entitled 'Revelation on 53rd Street', observed that 'perhaps there are no second acts in American lives. But there are in American museums, and this one promises to be a triumphant success.'[3] Even Hilton Kramer, editor of the neo-conservative *New Criterion* and frequently a harsh critic of the Museum, concluded that despite the Museum's looming condominium tower, its mass audience more or less indifferent (according to Kramer) to art, the 'irksome sense of bustle and commotion' that made the garden hall a 'ghastly experience' – despite all this, the renovation had resulted in the best of all possible new MOMAs.[4] Critical comment thus added up to a collective sigh of relieve that 'surgery' on MOMA (!) had not been too radical after all. Instead of lamenting the lack of a fresh start or new direction, it tended to laud MOMA's deepening attachment to tradition. Kramer, for example, noted in the course of a sometimes shrewd analysis that 'the museum's primary function [now is] to exhibit as extensively as possible and as intelligently as possible the masterworks from its own permanent collection',[5] and he quoted with evident satisfaction the words of Alfred Barr, inscribed on a plaque newly installed at the entrance to the permanent collection of painting and sculpture, concerning the Museum's obligation to

51 Photograph of the Museum
of Modern Art Façade, May 1984.
Showing, left to right: Museum Tower,
1984, designed by Cesar Pelli
& Associates; The Museum of Modern
Art Building, 1939, designed by Philip
L. Goodwin and Edward D. Stone;
East Wing, 1964, designed by Philip
Johnson. Photograph by Adam Bartos,
courtesy The Museum of Modern
Art, New York.

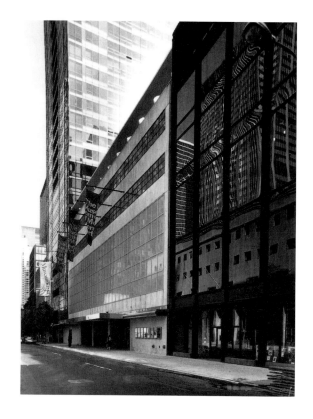

engage in 'the conscientious, continuous and resolute distinction of quality
from mediocrity'.

Jo-Anne Berelowitz has observed that the term 'museum', as an encom-
passing signifier, 'must be granted the flexibility of a cloth that can be gath-
ered here, stretched there to accommodate a form whose mutations are
linked to the changing character of capital, the state and public culture'.[6] The
Pelli renovation was frequently explained in terms of the Museum's need for
additional space, more efficient access, etc. Yet the renovation was also a
'mutation' in the sense Berelowitz uses the word, enacted upon the fabric of
an institution that was, and in many respects remains, the most influential of
its type. Later in this paper I shall argue that despite the opinions of the jour-
nalist-critics, their enthusiasm for *plus ça change*, the Pelli renovation marked
a new stage in the Museum's history. To arrive at that argument I shall treat
two fundamental aspects of what might be called 'museum perception': the
first, the temporal relation between viewer and object in the sense of the
viewer's perception of the time of the object, i.e., where the object stands in
relation to the viewer's present; and, second, the related issue of MOMA's
representation of itself, in particular the way the Museum building has
evolved or 'mutated' as a signifier of the modern.

Utopia

MOMA's history can be divided into three periods. The first, beginning with the Museum's opening in 1929 and petering out in the late 1950s, might be called its Utopian moment. During this period MOMA constituted its history of modernism. Drawing upon then current aesthetic discourses, it subjected a heterogeneous set of materials (paintings by El Lissitzky and Matisse, films by Dziga Vertov and the Marx Brothers, etc.) to the systematizing and taxonomical procedures that characterize the museum as a cultural institution. This involved the division and classification of materials according to media (painting, sculpture, photography, film, etc.) and their further classification by styles through the application of aesthetic criteria. At the beginning these criteria were not altogether fixed. A study of MOMA during the 1930s would reveal a process of experimentation, of trial and error out of which there emerged a complex modernist aesthetic construct based on Bauhaus architecture and design, Fauvism (with the emphasis on Matisse), Cubism (Picasso and Braque), and Surrealism. In the process MOMA produced a history of modernism that justified this aesthetic, made it seem historically inevitable [Plate 9].

Writing on the cultural logic of late capitalism, Fredric Jameson has argued that an artist's resistance to one manifestation of capital can lead to an art of compensation.[7] Through a Utopian gesture, the artist, in Jameson's words, 'ends up producing a whole new Utopian realm of the senses'.[8] Yet this Utopian move, while it represents an imaginative escape from the oppressive conditions of the present, is also unavoidably grounded in those same conditions. What appears as an escape from a particular stage of capital often anticipates a later, more advanced stage. This Utopian reflex may also apply to aesthetic constructs. It takes no special insight to see the MOMA of the 1930s projecting a (modernist) resolution to the contradictions of its particular historical moment, and this resolution being cast precisely in terms of capitalism's next stage of development – the unprecedented corporate expansion and modernization, through the application of advanced technology, of post-Second World War America. Of course MOMA was far from alone in its anticipations of corporate modernization. The New York World's Fair of 1939, for example, represents a popular version of a similar Utopian projection.

Probably the most revealing feature of MOMA's Utopianism was the new museum building itself [Plate 52]. Designed by Philip Goodwin in collaboration with Edward Durrell Stone and opened in the spring of 1939, the building functioned, first of all, as a unifying element, one that diminished or obscured the heterogeneity of the collections and the diversity of experiences on offer. The building also proved to be MOMA's most representative artifact, not something it had collected but something it had deliberately created, the most potent signifier of its Utopian aspirations. The building, with its clear, simple lines and polished surfaces (the façade's Thermolux windows contributed a great deal to its industrial or machine-made look) directly con-

52 Façade of the Museum of
Modern Art, 1939. Showing the sign
of *Art in Our Time*, May–September
1939. Photograph by Wurts Brothers,
courtesy of The Museum of Modern
Art, New York.

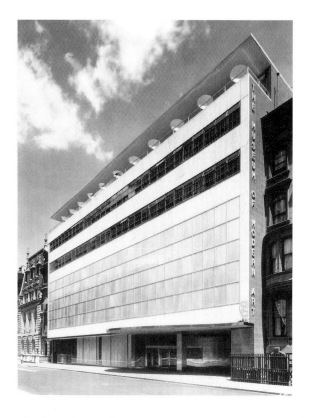

trasted with adjacent brownstones and other nineteenth-century structures
on West 53rd Street.[9] This type of contrast was crucial to MOMA's develop-
ing aesthetic. The building set up an opposition between a present still
haunted by a backward, Victorian past and a future of clarity, rationality,
efficiency, and functionality: an opposition that was obvious even to the most
untutored observer, as I can vouch from my own experience. When I was
four my father took me to the Museum for the first time and later the same
day we marched in the 1947 May Day Parade, which, as I recall, had as its
slogan 'Two, Four, Six, Eight, Henry Wallace '48.' MOMA became inextri-
cably bound up in my mind with other emblems of modernity I was aware
of at the time: warplanes at Floyd Bennet Field; the Empire State Building;
the streamlined IND subway train that brought us to Manhattan that day, so
different from the World War I vintage trains we usually rode. I was thus
made aware of a contract between my Brooklyn neighbourhood of shabby
brownstones and rundown tenements rapidly becoming slums, the 'fallen
city fabric'[10] of the present, and these glimpses of a promised future, which I
then indiscriminately associated with 'progressive' politics and the 1947 May
Day parade – a last gasp, as it turned out, of the Popular Front of the 1930s.

The crucial point is this: the Goodwin–Stone building represented a deci-
sive break with conventional museum design.[11] It therefore implied a massive
restructuring of the viewing subject. If the building's façade proclaimed a

repudiation of the past and an exaltation of a technological future, the interior demonstrated the means by which such a future might be achieved. The Museum interior was turned into antiseptic, laboratory-like spaces – enclosed, isolated, artificially illuminated and apparently neutral environments in which viewers could study works of art displayed as so many isolated specimens. Much has been made of the 'intimacy' of these gallery spaces.[12] Yet this 'intimacy' also produced its own sense of distance. The museum space – the white cube which MOMA became famous for pioneering – contributed to a new aesthetic of reification, an aesthetic that redefined both the work of art, and the viewer who was prompted to gaze upon the work with something approaching scientific detachment. In this technologized space, the work acquired its Utopian aura.

286

Nostalgia

The 1950s, the beginning of the second phase of MOMA's history, was the Museum's moment of vindication. Bauhaus-style architecture, which the Museum assiduously promoted, became a ubiquitous signifier of corporate modernity. The decade also witnessed the international 'triumph of American painting', a 'triumph' which MOMA did much to engineer. In a sense, it was possible to say that the future MOMA projected during the 1930s and 1940s had come to pass – a future, as it turned out, that coincided with unprecedented economic expansion and the beginning of the 'American century'. Yet this future proved to be no Utopia. Bauhaus modernism became Bauhaus monotony, standing for an impersonal corporate rationalism and the commodification of architectural form. The 'new American painting', as it was frequently called, was transformed almost overnight into a modernist academy. We might at this point begin to conceive of MOMA as an undertaking of a powerful corporate élite – an élite that, as part of its claims to dominance, successfully projected its own aesthetic regime of modernity. Yet what is perhaps most remarkable about this history is the failure of vision that quickly followed. There were no convincing post-war Utopias. The 1950s marked MOMA's highpoint as an institution and the beginning of its transformation. For at this point, in accord with the cultural logic I have been tracing, MOMA began to look increasingly to itself and its past. Utopian projection was replaced by nostalgia for an outmoded Utopia – or rather, for the time when belief in a Utopian future was still credible. This longing for the past's Utopia came to dominate MOMA's practice as an institution. For a while the Museum attempted to maintain its influence on contemporary art – the Op Art Exhibition of 1967 was, arguably, a last pathetic gesture in that direction. Yet without a credible historical-aesthetic construct extending from past to future, MOMA's influence was bound to dwindle. Today MOMA has little direct impact on artistic practice.[13] Instead, the Museum's activities are generally split between reporting recent artworld developments and maintaining its permanent collection,

with the latter involving, among other things, blockbuster exhibitions (Picasso, Primitivism, Cubism, 'Matisse in Morocco', 'High and Low') focused on one or other aspect of the canonical history of modernism that the Museum promulgated more than half a century ago.

The history of the permanent collection underscores the retrospective mood that during the 1950s began to take hold. MOMA's founders initially conceived of the Museum as a Kunsthalle, an institution primarily devoted to special exhibitions. Although the Museum began to build a collection during its early years, its collecting policy was deliberately limited. In effect, the Museum attempted to overcome the contradiction inherent in the idea of a museum of modern art by deaccessioning or selling to other museums works in its collection that were more than fifty years old. Indeed, as late as 1947 MOMA sold twenty-six paintings to the Metropolitan Museum, works that, in Alfred Barr's words, 'the two museums agree[d had] passed from the category modern to that of "classic"'. Among these 'classics' were Cézanne's *Man in a Blue Cap* and Picasso's *Woman in White*.[14] Symptomatically, in the 1950s MOMA abandoned its original policy and focused more of its efforts on building and exhibiting a permanent collection. In 1953 it did away with the fifty-year rule; three years later it officially declared its intention of exhibiting a 'permanent collection of masterworks'. This decision led directly to the expansion of the Goodwin-Stone building which was carried out between 1962 and 1964 under the direction of architect-trustee Philip Johnson [see Plate 51]. The Johnson expansion in effect enshrined the permanent collection. During the 1950s, MOMA had at most devoted 11,000 square feet to exhibiting its collection of painting and sculpture. This space was now expanded to 19,000 square feet. The Museum also added a total of 6,700 square feet to house the prints and drawings, architecture and design and photography collections. (The curators of these collections usually divided their gallery spaces between permanent and temporary displays.) The Johnson expansion thus more than doubled the amount of space available for the permanent collection.[15]

Johnson's handling of the expansion provides further evidence of MOMA's growing attachment to its own past. Planning had begun in the early 1960s, only a little more than twenty years after the completion of the Goodwin-Stone building. Yet in those two decades the building, and especially the façade, had acquired canonical status. The façade was now in effect MOMA's logo, an architectural emblem signalling the Museum's nostalgic attachment to the corporate Utopianism of the 1930s. Although in the course of the renovation Johnson slightly modified the original building, moving the entrance to the left and eliminating the few art-deco curves Goodwin and Stone had allowed themselves, he deliberately maintained through contrasts of colour and structure a clear distinction between the 1939 façade and his two Bauhaus-style wings. Yet if Johnson strove to preserve something of the visual contrast between the Goodwin-Stone building and adjacent structures, the resulting historical contrast reversed the original temporal sequence. The 1939 façade now signified MOMA's past – a past made evident through its

opposition to Johnson's representation of the Museum's present. This contrast was not without its ironies. MOMA's Utopianism now appeared as a historical relic, as so much failed prophecy in the face of Johnson's no-nonsense steel and glass designs and dozens of similar designs in the vicinity of the Museum: in effect the futuristic hopes of the 1930s overwhelmed by the sleek, banal reality of postwar corporate capitalism. Johnson's tripartite design thus produced a set of meanings about MOMA's historical situation and the significance of its collections that quite precisely anticipated – but also helped to determine – all that viewers would encounter in the Museum itself.

Forever Modern

MOMA's choice of Cesar Pelli to carry out the 1980–4 renovation was far from fortuitous. In an interview given in 1981, just as work was getting under way, Pelli acknowledged that his role was above all that of custodian of MOMA's architectural heritage: ' ... and when you are working on a building designed by Goodwin and Stone, that has already been changed and added to by Philip Johnson, the issue is very different; the functions, the ideas, the beliefs that shaped these buildings are still present today. Transformation is not possible'.[16] Like Johnson, Pelli insisted upon the inviolability of the Goodwin–Stone façade:

> The primary reading of the new west wing will be a shiny dark wall, in the same relation to and contrast with the Goodwin–Stone façade as Johnson's east wing. The Goodwin–Stone building will continue being the symbol and entrance of the Museum of Modern Art and will maintain its now historical relationship with the rest of the block as a white medallion on a dark ground.[17]

Yet contrary to Pelli's assertion, transformation was not only possible, it was inevitable. By now the Goodwin–Stone facade had been dwarfed by its neighbours on 53rd Street. It made a certain sense to preserve the façade or to create something on the same scale (it is about the largest rectangular shape that can be readily taken in by a viewer looking at the Museum from the opposite side of the street). Still, the issue was not purely visual – how could it be? – but visual-ideological. The surrounding office buildings and especially the condominium tower, itself a part of the Museum's fabric, intensified the contrast between past and present, between Utopian hopes frozen in the past, and the unfocused dynamism of the late-capitalist present. Pelli was quite right to emphasize that 'the functions, the ideas, the beliefs that shaped these buildings are still present today'. What he failed to add, however, is that they are present in a form that puts them just beyond the viewer's grasp.

Johnson's 1964 renovation left the original lobby areas and the galleries on the second and third floors pretty much intact. Visitors still reached the second and third floors via Goodwin–Stone's modest staircase located in a corner of the lobby. Pelli demolished most of the staircase,[18] enlarged the

lobby and added his glassed-in atrium or garden hall, an entirely new structure placed against the main body of the building. Gaining access to the galleries is now a memorable experience. Visitors to the post-Pelli MOMA pass from the street into the lobby and after paying admission proceed to the garden hall. In other words, having first entered the old Museum (the façade) they then enter the Museum a second time, but this time it is in effect the new Museum they enter. Their progress through the building repeats this alternation between old and new, between the space of the present and the (nostalgic) space of MOMA's past. In other words, the experience of the building is now (literally) structured around a spatial dichotomy between the new Museum of the atrium and the old Museum of the galleries housing the permanent collection and temporary displays.

MOMA's garden hall or atrium is representative of an increasingly familiar form of public space, a space that is at once grandiose and overwhelming and yet barely legible. It is a space that tends to suppress older forms of subjectivity to produce, in their place, an experience that is at once impersonal and fragmented, and yet tinged with a sense of euphoria.[19] Critics complained that MOMA's atrium, with its banks of elevators, polished marble floors and all-consuming light, is unsuited to the exhibition of works of art. For example, Hilton Kramer, in his grumpy, moralizing fashion, observed that the atrium 'is sheer spectacle and gives the visitor a lot to look at when he [sic] doesn't want to look at art'.[20] But isn't this precisely the function of such a space – a space that has been deliberately spectacularized (more or less in the manner of a thousand 'post-modern' shopping malls), a space that radiates a sort of free-floating intensity destined to overwhelm any object placed within it?

The Museum's exhibition spaces might be read as so many 'insides' to the atrium's 'outside'. Yet 'inside' and 'outside' do not entirely fit the situation: to cross the boundary from one to the other, to go, for example, from the atrium to the 'intimate' spaces of the galleries housing MOMA's permanent collection of painting and sculpture, is to experience a profound disjunction. In effect, Pelli's design further distances MOMA's past – a past that thus acquires an aura of unreality, a sense of being sealed-off as in a time capsule, since it is now experienced through the medium of the atrium's present.

Brief Conclusion

MOMA's inability seriously to come to grips with contemporary art has long been a matter of debate. Some critics have urged that a change of policy or a change of curators might remedy the problem. Others, for example Hilton Kramer, have maintained that MOMA's adherence to a 'false orthodoxy', its attachment to a formalist art history, is the cause for its dilemma.[21] If I have been in any way successful in this paper, such arguments will immediately ring false. The history of MOMA, as I have tried to show, is not simply a history of policies and persons but also a history of 'mutation', a process of

evolution and institutional change that inscribes itself on the body of the Museum and on the works of art it displays. Such a history cannot be undone – and any effort, at this late date, to mitigate its impact has, in all probability, not the slightest chance of success,

Notes

1 The story of MOMA's tower deal is a fable of its time. In this tale of megabuck real estate speculation and high-powered political manipulation, art, or rather the glamour and prestige associated with art, functions as a catalyst. In a three-way agreement between MOMA, the City of New York and a real estate developer, the Museum sold its air rights to the Museum Tower Corporation for $17,000,000 with the proviso that tax income from the Tower would go to the Museum via a specially created New York City Trust for Cultural Resources. In addition to funnelling tax money to the Museum the Trust was responsible for the $40,000,000 bond issue that financed MOMA's expansion. (The Museum's endowment and the $17,000,000 payment for air rights were used as collateral.) For brief and curiously deadpan accounts of these matters, see 'MOMA', *Architectural Record*, vol. 169, no. 4, March 1981, p. 94; Lee Rosenbaum, 'A New Foundation for MOMA's Tower', *Art News*, vol. 79, February 1980, pp. 64-9.

2 'Marvelous MOMA', *New York Times*, 13 May 1984, section 4, p. 22.

3 *Time Magazine*, 14 May 1984, p. 80.

4 See Hilton Kramer, 'MOMA Reopened: The Museum of Modern Art in the Postmodern Era', *The New Criterion*, vol. 2 (special issue), Summer 1984, pp. 1-44.

5 Kramer, p. 12.

6 Jo-Anne Berelowitz, 'From the Body of the Prince to Mickey Mouse', *Oxford Art Journal*, vol. 13, no. 2, 1990, p. 82.

7 See Fredric Jameson, 'Postmodernism, or The Cultural Logic of Late Capitalism', *New Left Review*, vol. 146, July-August 1984, pp. 53-93; see also Rosalind Krauss, 'The Cultural Logic of the Late Capitalist Museum', *October*, vol. 54, 1990, pp. 3-17.

8 Jameson, p. 59.

9 For the history of the building campaign and a discussion of the decisions affecting the choice of architects see Dominic Ricciotti, 'The 1939 Building of the Museum of Modern Art: The Goodwin-Stone Collaboration', *The American Art Journal*, vol. 17, no. 3, Summer 1985, pp. 50-76; and Rona Roob, '1936: The Museum Selects an Architect, Excerpts from the Barr Papers of the Museum of Modern Art', *Archives of American Art Journal*, vol. 23, no. 1, 1983, pp. 22-30.

10 The phrase is from Krauss, p. 11.

11 In saying this, I do not in any way mean to endorse the sort of ecstatic self-congratulation engaged in by MOMA and its publicists, who market MOMA in a debased language of 'revolution', 'miracles', and 'revelations'.

12 [...] See Richard Oldenberg, 'Director's Statement', in Helen Searing, *New American Art Museums*, New York, 1982, pp. 80-81; [...] 'Marvelous MOMA', *New York Times*, 13 May 1984, section 4, p. 22; William Rubin (director of the Museum's department of painting and sculpture from 1967 to 1988) [...] 'When Museums Overpower Their Own Art', *New York Times*, 12 April 1987, section 2, pp. 31ff.

13 Photography seems to be the one field where the Museum still exerts some authority. See Christopher Phillips, 'The Judgement Seat of Photography', *October*, vol. 22, Fall 1982, pp. 27-63; and Abigail Solomon-Godeau, 'Canon Fodder: Authoring Eugene Atget', *Photography at the Dock*, Minneapolis, 1991 (article originally published 1986), pp. 28-51.

14 Alfred Barr, 'Chronicle of the Collection', *Painting and Sculpture in the Museum of Modern Art, 1929-1967*, New York, 1967, p. 635.

15 For the information given here, see Barr, p. 637ff., 641, 644; Gerald Marzaroti, 'Is a Bigger MOMA a Better MOMA?', *Art News*, October, 1987, p. 64ff. [...]

16 Interview with Cesar Pelli, 'The Museum of Modern Art Project', *Perspecta: The Yale Architectural Journal*, vol. 16, 1981, p. 107.

17 Pelli interview, p. 107.

18 A portion survives as an internal link between the second and third floor galleries; it is in effect preserved (like the façade) as a relic of the original Goodwin-Stone design.

19 I follow here Jameson and Krauss's discussions of 'hyperspace': see especially Jameson, p. 61; Krauss, pp. 12ff.

20 Kramer, p. 5.

21 Kramer, p. 2.

Part IV
Aesthetic Theory and
Social Critique

Introduction to Part IV

In the 1930s, Walter Benjamin [Text 27] argued against the fetishization of the 'aura' of the art object. For many of his generation, inherent in 'art for art's sake' is a dialectic: it can be a resistance to, independence from, political doctrine and the kitsch of the culture industry *or* it can be a form of collusion with the forces of repression and control [see Text 9]. For Benjamin, mechanical reproducibility (film, photography etc.) offers a potentially democratic corrective to the unique value which bourgeois society accords to the 'authentic' work of art (the manifestations of supposed 'genius' marketed as a commodity). In this he seems to agree with Max Weber's analysis of how in industrialized societies art becomes a surrogate religion. Under these conditions, art becomes a 'cosmos of more and more consciously grasped independent values' which are claimed to exist in their own right:

[Art] provides a *salvation* from the increasing pressures of theoretical and practical rationalism. With this claim to a redemptory function, art begins to compete directly with salvation religion ... the refusal of modern men [sic] to assume responsibility for moral judgements tends to transform judgements of moral intent into judgements of taste ('in poor taste' instead of 'reprehensible'). The inaccessibility of appeal from aesthetic judgements excludes discussion.[1]

In contrast to this phenomenon, Benjamin wished to revise the function of art so that instead of 'being based on ritual, it begins to be based on another practice – politics'. Following on from his 'Author as Producer', 1934,[2] he regarded film, photography and photomontage as exemplary of the radical elements of modernism: such as the tradition of Dada, Surrealism and the film-makers of the Soviet Revolution. In the face of the pressures of capitalism, fascism and Stalinism, Benjamin argued that political art had to encourage spectators to be self-reflexive and, therefore, to raise their critical awareness of representations in society: whilst representations appeared to offer a 'truthful' view of reality, they were often ideological. A prime example of political art for Benjamin was Heartfield's photomontages [Plate 53] which were so 'constructed' that they enabled the viewer to 'deconstruct' the interests underlying Hitler's 'messages' in Nazi propaganda photography (Heartfield using the same medium to critique its (mis)use). As such, these

53 John Heartfield, *Adolf – The Superman Swallows Gold and Spouts Junk*. Photomontage published in *AIZ*, vol. 11, no. 29, 17 July 1932. Photo: Bildarchiv Preussischer Kulturbesitz Berlin. © DACS, London 1993.

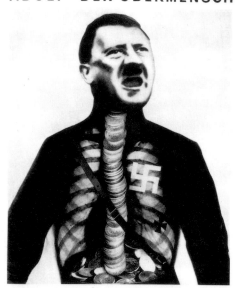

ADOLF – DER ÜBERMENSCH

SCHLUCKT GOLD UND REDET BLECH

photomontages were 'models' empowering viewers to deconstruct other representations where they were expected to be passive consumers of an ideological message. For Benjamin, photomontage, film and photography in the hands of socialist practioners had three necessary characteristics: a radical modern *technique* (on a par with many contemporary bourgeois forms); a political *tendency* (when used in the pursuit of socialism and the emancipation of the consuming populace into active, critical producers); and, crucially, a potentially critical subversive *position* in the conditions of production and reception. Unlike paintings they were not *easily* turned into fetishized unique commodities by, amongst others, the dealer and gallery system.

A typical claim made by those who do privilege the notion of 'aesthetic experience' [Texts 28, 30, 31] is that the value of socio-historical accounts of works of art lies in the encouragement they offer to scepticism about particular evaluations and interpretations. But, it is asserted, this value is always to some extent squandered if we allow 'the works of art themselves' to 'disappear' behind a 'tangle' of competing social and cultural commitments. In such a view the 'autonomy of art' [see Text 6] is claimed to be an essential quality not to be compromised by 'sociological categories'. Williams [Text 29] offers a powerful counter to those who appeal to the disinterested contemplation of 'the works of art themselves'.

Clement Greenberg's 'Modernist Painting', 1961 [Text 28], exemplifies such an appeal; it provides a celebratory account of the claimed immanent development of modern specialization in art and in its interpretation. His text is representative of a highly influential tradition of criticism and history, central to which is the notion of 'disinterested critical judgement'. The basic

process is this. A judgement of the 'quality' of a contemporary painting is made by a critic. It is assumed that this judgement is one of 'taste' which is claimed to be 'involuntary and objective'. That is, it is supposedly outside any moral, social or political demands; independent of social construction or differences of culture, ethnicity and gender. The critic's subjective judgement is, therefore, treated as a litmus test of 'objective' or 'universally admitted' quality. The task of the critic is then one of what is called 'historical retrodiction': a task of validating their judgement by tracing a historical narrative by means of which the claimed high aesthetic quality of the painting being viewed may be connected to other paintings whose status and quality are regarded by the critic's community and constituency as canonical.

In 1961, for Greenberg 'quality' was represented by, amongst others, the paintings of Pollock [Plate 54] and Noland [Plate 29]. These paintings were, thus, connected back in a claimed 'logic of development' to those by Manet [Plate 4]. Advocates of such criticism claim that there is a close mutual implication between value judgement and historical account. Sceptics argue that 'close mutual implication' means that we are presented with a circular argument which places the critic in the same position as a priest, soothsayer or cultural commissar: someone whose judgement we are expected to submit to because the critic is endowed with cultural authority. Such submission neglects the social, political, psychoanalytic and financial demands and pressures on and desires of, the critic and their judgement. And, the sceptic would argue, surely the process of 'historical retrodiction' actually means applying the doctrine of historicism: *selecting* those, supposed, essential 'rhythms' or 'patterns', 'laws' or 'trends' of the development of modern art which confirm the critics' judgement? Is this symptomatic of a culture in which class, gender and ethnically based *preferences* are dignified and mystified with the status of objective taste? Historicism has certainly been criticized by many, including Karl Popper, as an intellectual error and by others as the backbone of ideology.

The 'Modernism' of 'Modernist Painting' is, therefore *one* historicist version of the history of painting since Manet. Chomsky argues that the intelligentsia as a social class can consciously or unconsciously 'serve as mediators between the social facts [of the production of art and culture] and the mass of the population; they create the ideological justification for social practice' [Text 4]. For these and other reasons, Modernist criticism and history, traceable in the writings of Philip Leider and Yve-Alain Bois [Texts 30 and 31] have been heavily criticized by a variety of writers, especially since the 1960s [see Texts 2, 12 to 16 in particular].

The final text by Dick Hebdige follows in the tradition of Benjamin and Williams. Culture is regarded as a whole way of life within which visual images – paintings, photographs, television, adverts, magazines etc. – are elements of a network of communication. Here, Hebdige reviews the problems of postmodernism in terms of the issues of the self and society [see Text 1] in an era when mass reproduction has become further transformed by the interests of developed capitalism.

Notes

1 Max Weber, 'The Esthetic Sphere' in 'Religious Rejections of the World and Their Directions', 1915, reprinted in *From Max Weber: Essays in Sociology*, ed. by H. H. Gerth and C. Wright Mills, London, 1991, p.344.

2 Address delivered to the Institute for the Study of Fascism, Paris, on 27 April 1934, reprinted in Walter Benjamin, *Understanding Brecht*, translated by Anna Bostock, London, 1977, pp. 85-103.

27

Walter Benjamin
The Work of Art in the
Age of Mechanical Reproduction

Source: Walter Benjamin, 'The Work of
Art in the Age of Mechanical Reproduction',
translated by Harry Zohn, in Benjamin,
Illuminations, London, Jonathan Cape, 1970,
pp. 219-53. This text has been edited and end-
notes omitted; three footnotes have been
retained. Originally published in *Zeitschrift für
Sozialforschung*, vol. 5, no. 1, 1936.

Preface

When Marx undertook his critique of the capitalistic mode of production, this mode was in its infancy. Marx directed his efforts in such a way as to give them prognostic value. He went back to the basic conditions underlying capitalistic production and through his presentation showed what could be expected of capitalism in the future. The result was that one could expect it not only to exploit the proletariat with increasing intensity, but ultimately to create conditions which would make it possible to abolish capitalism itself.

The transformation of the superstructure, which takes place far more slowly than that of the substructure, has taken more than half a century to manifest in all areas of culture the change in the conditions of production. Only today can it be indicated what form this has taken. Certain prognostic requirements should be met by these statements. However, theses about the art of the proletariat after its assumption of power or about the art of a class-less society would have less bearing on these demands than theses about the developmental tendencies of art under present conditions of production. Their dialectic is no less noticeable in the superstructure than in the economy. It would therefore be wrong to underestimate the value of such theses as a weapon. They brush aside a number of outmoded concepts, such as creativity and genius, eternal value and mystery-concepts whose uncontrolled (and at present almost uncontrollable) application would lead to a processing of data in the Fascist sense. The concepts which are introduced into the theory of art in what follows differ from the more familiar terms in that they are completely useless for the purposes of Fascism. They are, on the other hand, useful for the formulation of revolutionary demands in the politics of art [Plate 53].

I

In principle a work of art has always been reproducible. Man-made artifacts could always be imitated by men. Replicas were made by pupils in practice

of their craft, by masters for diffusing their works, and, finally, by third parties in the pursuit of gain. Mechanical reproduction of a work of art, however, represents something new. Historically, it advanced intermittently and in leaps at long intervals, but with accelerated intensity. The Greeks knew only two procedures of technically reproducing works of art: founding and stamping. Bronzes, terracottas, and coins were the only art works which they could produce in quantity. All others were unique and could not be mechanically reproduced. With the woodcut graphic art became mechanically reproducible for the first time, long before script became reproducible by print. [...] During the Middle Ages engraving and etching were added to the woodcut; at the beginning of the nineteenth century lithography made its appearance.

With lithography the technique of reproduction reached an essentially new stage. This much more direct process was distinguished by the tracing of the design on a stone rather than its incision on a block of wood or its etching on a copperplate and permitted graphic art for the first time to put its products on the market, not only in large numbers as hitherto, but also in daily changing forms. Lithography enabled graphic art to illustrate everyday life, and it began to keep pace with printing. But only a few decades after its invention, lithography was surpassed by photography. For the first time in the process of pictorial reproduction, photography freed the hand of the most important artistic functions which henceforth devolved only upon the eye looking into a lens. Since the eye perceives more swiftly than the hand can draw, the process of pictorial reproduction was accelerated so enormously that it could keep pace with speech. A film operator shooting a scene in the studio captures the images at the speed of an actor's speech. Just as lithography virtually implied the illustrated newspaper, so did photography foreshadow the sound film. The technical reproduction of sound was tackled at the end of the last century. [...] Around 1900 technical reproduction had reached a standard that not only permitted it to reproduce all transmitted works of art and thus to cause the most profound change in their impact upon the public; it also had captured a place of its own among the artistic processes. For the study of this standard nothing is more revealing than the nature of the repercussions that these two different manifestations – the reproduction of works of art and the art of the film – have had on art in its traditional form.

II

Even the most perfect reproduction of a work of art is lacking in one element: its presence in time and space, its unique existence at the place where it happens to be. This unique existence of the work of art determined the history to which it was subject throughout the time of its existence. This includes the changes which it may have suffered in physical condition over the years as well as the various changes in its ownership. The traces of the first can be revealed only by chemical or physical analyses which it is impossible

to perform on a reproduction; changes of ownership are subject to a tradition which must be traced from the situation of the original.

The presence of the original is the prerequisite to the concept of authenticity. Chemical analyses of the patina of a bronze can help to establish this, as does the proof that a given manuscript of the Middle Ages stems from an archive of the fifteenth century. The whole sphere of authenticity is outside technical – and, of course, not only technical – reproducibility. Confronted with its manual reproduction, which was usually branded as a forgery, the original preserved all its authority; not so *vis-à-vis* technical reproduction. The reason is twofold. First, process reproduction is more independent of the original than manual reproduction. For example, in photography, process reproduction can bring out those aspects of the original that are unattainable to the naked eye yet accessible to the lens, which is adjustable and chooses its angle at will. And photographic reproduction, with the aid of certain processes, such as enlargement or slow motion, can capture images which escape natural vision. Secondly, technical reproduction can put the copy of the original into situations which would be out of reach for the original itself. Above all, it enables the original to meet the beholder halfway, be it in the form of a photograph or a phonograph record. The cathedral leaves its locale to be received in the studio of a lover of art; the choral production, performed in an auditorium or in the open air, resounds in the drawing room.

The situations into which the product of mechanical reproduction can be brought may not touch the actual work of art, yet the quality of its presence is always depreciated. This holds not only for the art work but also, for instance, for a landscape which passes in review before the spectator in a movie. In the case of the art object, a most sensitive nucleus – namely, its authenticity – is interfered with whereas no natural object is vulnerable on that score. The authenticity of the thing is the essence of all that is transmissible from its beginning, ranging from its substantive duration to its testimony to the history which it has experienced. Since the historical testimony rests on the authenticity, the former, too, is jeopardized by reproduction when substantive duration ceases to matter. And what is really jeopardized when the historical testimony is affected is the authority of the object.

One might subsume the eliminated element in the term 'aura' and go on to say: that which withers in the age of mechanical reproduction is the aura of the work of art. This is a symptomatic process whose significance points beyond the realm of art. One might generalize by saying: the technique of reproduction detaches the reproduced object from the domain of tradition. By making many reproductions it substitutes a plurality of copies for a unique existence. And in permitting the reproduction to meet the beholder or listener in his own particular situation, it reactivates the object reproduced. These two processes lead to a tremendous shattering of tradition which is the obverse of the contemporary crisis and renewal of mankind. Both processes are intimately connected with the contemporary mass movements. Their most powerful agent is the film. Its social significance, particularly in its most positive form, is inconceivable without its destructive, cathartic aspect, that

299

is, the liquidation of the traditional value of the cultural heritage. This phenomenon is most palpable in the great historical films. It extends to ever new positions. In 1927 Abel Gance exclaimed enthusiastically: 'Shakespeare, Rembrandt, Beethoven will make films ... all legends, all mythologies and all myths, all founders of religion, and the very religions ... await their exposed resurrection, and the heroes crowd each other at the gate.'[1] Presumably without intending it, he issued an invitation to a far-reaching liquidation.

III

[...] The concept of aura which was proposed above with reference to historical objects may usefully be illustrated with reference to the aura of natural ones. We define the aura of the latter as the unique phenomenon of a distance, however close it may be. If, while resting on a summer afternoon, you follow with your eyes a mountain range on the horizon or a branch which casts its shadow over you, you experience the aura of those mountains, of that branch. This image makes it easy to comprehend the social bases of the contemporary decay of the aura. It rests on two circumstances, both of which are related to the increasing significance of the masses in contemporary life. Namely, the desire of contemporary masses to bring things 'closer' spatially and humanly, which is just as ardent as their bent toward overcoming the uniqueness of every reality by accepting its reproduction. Every day the urge grows stronger to get hold of an object at very close range by way of its likeness, its reproduction. Unmistakably, reproduction as offered by picture magazines and newsreels differs from the image seen by the unarmed eye. Uniqueness and permanence are as closely linked in the latter as are transitoriness and reproducibility in the former. To pry an object from its shell, to destroy its aura, is the mark of a perception whose 'sense of the universal equality of things' has increased to such a degree that it extracts it even from a unique object by means of reproduction. Thus is manifested in the field of perception what in the theoretical sphere is noticeable in the increasing importance of statistics. The adjustment of reality to the masses and of the masses to reality is a process of unlimited scope, as much for thinking as for perception.

IV

The uniqueness of a work of art is inseparable from its being imbedded in the fabric of tradition. This tradition itself is thoroughly alive and extremely changeable. An ancient statue of Venus, for example, stood in a different traditional context with the Greeks, who made it an object of veneration, than with the clerics of the Middle Ages, who viewed it as an ominous idol. Both of them, however, were equally confronted with its uniqueness, that is, its aura. Originally the contextual integration of art in tradition found its expres-

sion in the cult. We know that the earliest art works originated in the service of a ritual – first the magical, then the religious kind. It is significant that the existence of the work of art with reference to its aura is never entirely separated from its ritual function. In other words, the unique value of the 'authentic' work of art has its basis in ritual, the location of its original use value. This ritualistic basis, however remote, is still recognizable as secularized ritual even in the most profane forms of the cult of beauty. The secular cult of beauty, developed during the Renaissance and prevailing for three centuries, clearly showed that ritualistic basis in its decline and the first deep crisis which befell it. With the advent of the first truly revolutionary means of reproduction, photography, simultaneously with the rise of socialism, art sensed the approaching crisis which has become evident a century later. At the time, art reacted with the doctrine of *l'art pour l'art*, that is, with a theology of art. This gave rise to what might be called a negative theology in the form of the idea of 'pure' art, which not only denied any social function of art but also any categorizing by subject-matter. (In poetry, Mallarmé was the first to take this position.)

An analysis of art in the age of mechanical reproduction must do justice to these relationships, for they lead us to an important insight: for the first time in world history, mechanical reproduction emancipates the work of art from its parasitical dependence on ritual. To an even greater degree the work of art reproduced becomes the work of art designed for reproducibility. From a photographic negative, for example, one can make any number of prints; to ask for the 'authentic' print makes no sense. But the instant the criterion of authenticity ceases to be applicable to artistic production, the total function of art is reversed. Instead of being based on ritual, it begins to be based on another practice – politics.

V

Works of art are received and valued on different planes. Two polar types stand out; with one, the accent is on the cult value; with the other, on the exhibition value of the work. Artistic production begins with ceremonial objects destined to serve in a cult. One may assume that what mattered was their existence, not their being on view. [...] With the emancipation of the various art practices from ritual go increasing opportunities for the exhibition of their products. It is easier to exhibit a portrait bust that can be sent here and there than to exhibit the statue of a divinity that has its fixed place in the interior of a temple. The same holds for the painting as against the mosaic or fresco that preceded it. And even though the public presentability of a mass originally may have been just as great as that of a symphony, the latter originated at the moment when its public presentability promised to surpass that of the mass.

With the different methods of technical reproduction of a work of art, its fitness for exhibition increased to such an extent that the quantitative shift

between its two poles turned into a qualitative transformation of its nature. This is comparable to the situation of the work of art in prehistoric times when, by the absolute emphasis on its cult value, it was, first and foremost, an instrument of magic. Only later did it come to be recognized as a work of art. In the same way today, by the absolute emphasis on its exhibition value the work of art becomes a creation with entirely new functions, among which the one we are conscious of, the artistic function, later may be recognized as incidental. This much is certain: today photography and the film are the most serviceable exemplifications of this new function. [...]

XII

Mechanical reproduction of art changes the reaction of the masses toward art. The reactionary attitude toward a Picasso painting changes into the progressive reaction toward a Chaplin movie. The progressive reaction is characterized by the direct, intimate fusion of visual and emotional enjoyment with the orientation of the expert. Such fusion is of great social significance. The greater the decrease in the social significance of an art form, the sharper the distinction between criticism and enjoyment by the public. The conventional is uncritically enjoyed, and the truly new is criticized with aversion. With regard to the screen, the critical and the receptive attitudes of the public coincide. The decisive reason for this is that individual reactions are predetermined by the mass audience response they are about to produce, and this is nowhere more pronounced than in the film. The moment these responses become manifest they control each other. Again, the comparison with painting is fruitful. A painting has always had an excellent chance to be viewed by one person or by a few. The simultaneous contemplation of paintings by a large public, such as developed in the nineteenth century, is an early symptom of the crisis of painting, a crisis which was by no means occasioned exclusively by photography but rather in a relatively independent manner by the appeal of art works to the masses.

Painting simply is in no position to present an object for simultaneous collective experience, as it was possible for architecture at all times, for the epic poem in the past, and for the movie today. Although this circumstance in itself should not lead one to conclusions about the social role of painting, it does constitute a serious threat as soon as painting, under special conditions and, as it were, against its nature, is confronted directly by the masses. In the churches and monasteries of the Middle Ages and at the princely courts up to the end of the eighteenth century, a collective reception of paintings did not occur simultaneously, but by graduated and hierarchized mediation. The change that has come about is an expression of the particular conflict in which painting was implicated by the mechanical reproducibility of paintings. Although paintings began to be publicly exhibited in galleries and salons, there was no way for the masses to organize and control themselves in their reception. Thus the same public which responds in a progressive

manner toward a grotesque film is bound to respond in a reactionary manner to surrealism.

XIII

The characteristics of the film lie not only in the manner in which man presents himself to mechanical equipment but also in the manner in which, by means of this apparatus, man can represent his environment. A glance at occupational psychology illustrates the testing capacity of the equipment. Psychoanalysis illustrates it in a different perspective. The film has enriched our field of perception with methods which can be illustrated by those of Freudian theory. Fifty years ago, a slip of the tongue passed more or less unnoticed. Only exceptionally may such a slip have revealed dimensions of depth in a conversation which had seemed to be taking its course on the surface. Since the *Psychopathology of Everyday Life* things have changed. This book isolated and made analysable things which had heretofore floated along unnoticed in the broad stream of perception. For the entire spectrum of optical, and now also acoustical, perception the film has brought about a similar deepening of apperception. It is only an obverse of this fact that behaviour items shown in a movie can be analysed much more precisely and from more points of view than those presented on paintings or on the stage. As compared with painting, filmed behaviour lends itself more readily to analysis because of its incomparably more precise statements of the situation. In comparison with the stage scene, the filmed behaviour item lends itself more readily to analysis because it can be isolated more easily. This circumstance derives its chief importance from its tendency to promote the mutual penetration of art and science. Actually, of a screened behaviour item which is neatly brought out in a certain situation, like a muscle of a body, it is difficult to say which is more fascinating, its artistic value or its value for science. To demonstrate the identity of the artistic and scientific uses of photography which heretofore usually were separated will be one of the revolutionary functions of the film. [...]

XIV

One of the foremost tasks of art has always been the creation of a demand which could be fully satisfied only later. The history of every art form shows critical epochs in which a certain art form aspires to effects which could be fully obtained only with a changed technical standard, that is to say, in a new art form. The extravagances and crudities of art which thus appear, particularly in the so-called decadent epochs, actually arise from the nucleus of its richest historical energies. In recent years, such barbarisms were abundant in Dadaism. It is only now that its impulse becomes discernible: Dadaism attempted to create by pictorial – and literary – means the effects which the

public today seeks in the film.

Every fundamentally new, pioneering creation of demands will carry beyond its goal. Dadaism did so to the extent that it sacrificed the market values which are so characteristic of the film in favour of higher ambitions – though of course it was not conscious of such intentions as here described. The Dadaists attached much less importance to the sales value of their work than to its uselessness for contemplative immersion. The studied degradation of their material was not the least of their means to achieve this uselessness. Their poems are 'word salad' containing obscenities and every imaginable waste product of language. The same is true of their paintings, on which they mounted buttons and tickets. What they intended and achieved was a relentless destruction of the aura of their creations, which they branded as reproductions with the very means of production. Before a painting of Arp's or a poem by August Stramm it is impossible to take time for contemplation and evaluation as one would before a canvas of Derain's or a poem by Rilke. In the decline of middle-class society, contemplation became a school for asocial behaviour; it was countered by distraction as a variant of social conduct. Dadaistic activities actually assured a rather vehement distraction by making works of art the centre of scandal. One requirement was foremost: to outrage the public.

From an alluring appearance or persuasive structure of sound the work of art of the Dadaists became an instrument of ballistics. It hit the spectator like a bullet, it happened to him, thus acquiring a tactile quality. It promoted a demand for the film, the distracting element of which is also primarily tactile, being based on changes of place and focus which periodically assail the spectator. Let us compare the screen on which a film unfolds with the canvas of a painting. The painting invites the spectator to contemplation; before it the spectator can abandon himself to his associations. Before the movie frame he cannot do so. No sooner has his eye grasped a scene than it is already changed. It cannot be arrested. Duhamel, who detests the film and knows nothing of its significance, though something of its structure, notes this circumstance as follows: 'I can no longer think what I want to think. My thoughts have been replaced by moving images.'[2] The spectator's process of association in view of these images is indeed interrupted by their constant, sudden change. This constitutes the shock effect of the film, which, like all shocks, should be cushioned by heightened presence of mind. By means of its technical structure, the film has taken the physical shock effect out of the wrappers in which Dadaism had, as it were, kept it inside the moral shock effect.

XV

The mass is a matrix from which all traditional behaviour toward works of art issues today in a new form. Quantity has been transmuted into quality. The greatly increased mass of participants has produced a change in the mode of

participation. The fact that the new mode of participation first appeared in a disreputable form must not confuse the spectator. Yet some people have launched spirited attacks against precisely this superficial aspect. Among these, Duhamel has expressed himself in the most radical manner. What he objects to most is the kind of participation which the movie elicits from the masses. Duhamel calls the movie 'a pastime for helots, a diversion for uneducated, wretched, worn-out creatures who are consumed by their worries ..., a spectacle which requires no concentration and presupposes no intelligence ..., which kindles no light in the heart and awakens no hope other than the ridiculous one of someday becoming a 'star' in Los Angeles.'[3] Clearly, this is at bottom the same ancient lament that the masses seek distraction whereas art demands concentration from the spectator. That is a commonplace. The question remains whether it provides a platform for the analysis of the film. A closer look is needed here. Distraction and concentration form polar opposites which may be stated as follows: A man who concentrates before a work of art is absorbed by it. He enters into this work of art the way legend tells of the Chinese painter when he viewed his finished painting. In contrast, the distracted mass absorbs the work of art. [...]

The distracted person, too, can form habits. More, the ability to master certain tasks in a state of distraction proves that their solution has become a matter of habit. Distraction as provided by art presents a covert control of the extent to which new tasks have become soluble by apperception. Since, moreover, individuals are tempted to avoid such tasks, art will tackle the most difficult and most important ones where it is able to mobilize the masses. Today it does so in the film. Reception in a state of distraction, which is increasing noticeably in all fields of art and is symptomatic of profound changes in apperception, finds in the film its true means of exercise. The film with its shock effect meets this mode of reception halfway. The film makes the cult value recede into the background not only by putting the public in the position of the critic, but also by the fact that at the movies this position requires no attention. The public is an examiner, but an absent-minded one.

Epilogue

The growing proletarianization of modern man and the increasing formation of masses are two aspects of the same process. Fascism attempts to organize the newly created proletarian masses without affecting the property structure which the masses strive to eliminate. Fascism sees its salvation in giving these masses not their right, but instead a chance to express themselves. The masses have a right to change property relations; Fascism seeks to give them an expression while preserving property. The logical result of Fascism is the introduction of aesthetics into political life. The violation of the masses, whom Fascism, with its *Führer* cult, forces to their knees, has its counterpart in the violation of an apparatus which is pressed into the production of ritual values.

All efforts to render politics aesthetic culminate in one thing: war. War and war only can set a goal for mass movements on the largest scale while respecting the traditional property system. This is the political formula for the situation. The technological formula may be stated as follows: Only war makes it possible to mobilize all of today's technical resources while maintaining the property system. It goes without saying that the Fascist apotheosis of war does not employ such arguments. Still, Marinetti says in his manifesto on the Ethiopian colonial war: 'For twenty-seven years we Futurists have rebelled against the branding of war as anti-aesthetic ... Accordingly we state: ... War is beautiful because it establishes man's dominion over the subjugated machinery by means of gas masks, terrifying megaphones, flame throwers, and small tanks. War is beautiful because it initiates the dreamt-of metallization of the human body. War is beautiful because it enriches a flowering meadow with the fiery orchids of machine guns. War is beautiful because it combines the gunfire, the cannonades, the cease-fire, the scents, and the stench of putrefaction into a symphony. War is beautiful because it creates new architecture, like that of the big tanks, the geometrical formation flights, the smoke spirals from burning villages, and many others. ... Poets and artists of Futurism! ... remember these principles of an aesthetics of war so that your struggle for a new literature and a new graphic art ... may be illumined by them!'

This manifesto has the virtue of clarity. Its formulations deserve to be accepted by dialecticians. To the latter, the aesthetics of today's war appears as follows: If the natural utilization of productive forces is impeded by the property system, the increase in technical devices, in speed, and in the sources of energy will press for an unnatural utilization, and this is found in war. The destructiveness of war furnishes proof that society has not been mature enough to incorporate technology as its organ, that technology has not been sufficiently developed to cope with the elemental forces of society. The horrible features of imperialistic warfare are attributable to the discrepancy between the tremendous means of production and their inadequate utilization in the process of production – in other words, to unemployment and the lack of markets. Imperialistic war is a rebellion of technology which collects, in the form of 'human material', the claims to which society has denied its natural material. Instead of draining rivers, society directs a human stream into a bed of trenches; instead of dropping seeds from airplanes, it drops incendiary bombs over cities, and through gas warfare the aura is abolished in a new way.

'Fiat ars – pereat mundus', says Fascism, and, as Marinetti admits, expects war to supply the artistic gratification of a sense perception that has been changed by technology. This is evidently the consummation of 'l'art pour l'art'. Mankind, which in Homer's time was an object of contemplation for the Olympian gods, now is one for itself. Its self-alienation has reached such a degree that it can experience its own destruction as an aesthetic pleasure of the first order. This is the situation of politics which Fascism is rendering aesthetic. Communism responds by politicizing art.

Notes

1 Abel Gance, 'Le Temps de l'image est venu', *L'Art cinématographique*, vol. 2, Paris, 1927, p.94ff.

2 Georges Duhamel, *Scènes de la vie future*, Paris, 1930, p. 52.

3 Duhamel, op. cit., p. 58.

28　　　　　　　　　　Clement Greenberg
　　　　　　　　　　　　　Modernist Painting

Source: Clement Greenberg, 'Modernist
Painting', 1961, Radio Broadcast Lecture 14 of
*The Voice of America Forum Lectures: The Visual
Arts*, reprinted, as spoken, in the paperback
edition of all 18 Lectures, Washington D.C.,
United States Information Agency, 1965, pp.
105-11. After its broadcast 'Modernist Painting'
was also published in *Arts Yearbook*, 4, 1961,
pp. 101-8.

Modernism includes more than art and literature. By now it covers almost
the whole of what is truly alive in our culture. It happens, however, to be
very much of a historical novelty. Western civilization is not the first civi-
lization to turn around and question Its own foundations, but it is the one
that has gone furthest in doing so. I identify Modernism with the intensifi-
cation, almost the exacerbation, of this self-critical tendency that began with
the philosopher, Kant. Because he was the first to criticize the means itself of
criticism, I conceive of Kant as the first real Modernist.

The essence of Modernism lies, as I see it, in the use of the characteristic
methods of a discipline to criticize the discipline itself, not in order to subvert
it but in order to entrench it more firmly in its area of competence. Kant
used logic to establish the limits of logic, and while he withdrew much from
its old jurisdiction, logic was left all the more secure in what there remained
to it.

The self-criticism of Modernism grows out of, but is not the same thing as,
the criticism of the Enlightenment. The Enlightenment criticized from the
outside, the way criticism in its accepted sense does; Modernism criticizes
from the inside, through the procedures themselves of that which is being
criticized. It seems natural that this new kind of criticism should have
appeared first in philosophy, which is critical by definition, but as the nine-
teenth century wore on, it entered many other fields. A more rational
justification had begun to be demanded of every formal social activity, and
Kantian self-criticism, which had arisen in philosophy in answer to this
demand in the first place, was called on eventually to meet and interpret it in
areas that lay far from philosophy.

We know what has happened to an activity like religion, which could not
avail itself of Kantian, immanent, criticism in order to justify itself. At first
glance the arts might seem to have been in a situation like religion's. Having
been denied by the Enlightenment all tasks they could take seriously, they
looked as though they were going to be assimilated to entertainment pure
and simple, and entertainment itself looked as though it were going to be
assimilated, like religion, to therapy. The arts could save themselves from this
levelling down only by demonstrating that the kind of experience they pro-

vided was valuable in its own right and not to be obtained from any other kind of activity.

Each art, it turned out, had to perform this demonstration on its own account. What had to be exhibited was not only that which was unique and irreducible in art in general, but also that which was unique and irreducible in each particular art. Each art had to determine, through its own operations and works, the effects exclusive to itself. By doing so it would, to be sure, narrow its area of competence, but at the same time it would make its possession of that area all the more certain.

It quickly emerged that the unique and proper area of competence of each art coincided with all that was unique in the nature of its medium. The task of self-criticism became to eliminate from the specific effects of each art any and every effect that might conceivably be borrowed from or by the medium of any other art. Thus would each art be rendered 'pure', and in its 'purity' find the guarantee of its standards of quality as well as of its independence. 'Purity' meant self-definition, and the enterprise of self-criticism in the arts became one of self-definition with a vengeance.

Realistic, naturalistic art had dissembled the medium, using art to conceal art; Modernism used art to call attention to art. The limitations that constitute the medium of painting – the flat surface, the shape of the support, the properties of pigment – were treated by the Old Masters as negative factors that could be acknowledged only implicitly or indirectly. Under Modernism these same limitations came to be regarded as positive factors, and were acknowledged openly. Manet's became the first Modernist pictures by virtue of the frankness with which they declared the flat surfaces on which they were painted. The Impressionists, in Manet's wake, abjured underpainting and glazes, to leave the eye under no doubt as to the fact that the colours they used were made of paint that came from tubes or pots. Cézanne sacrificed verisimilitude, or correctness, in order to fit his drawing and design more explicitly to the rectangular shape of the canvas.

It was the stressing of the ineluctable flatness of the surface that remained, however, more fundamental than anything else to the processes by which pictorial art criticized and defined itself under Modernism. For flatness alone was unique and exclusive to pictorial art. The enclosing shape of the picture was a limiting condition, or norm, that was shared with the art of the theatre; colour was a norm and a means shared not only with the theatre, but also with sculpture. Because flatness was the only condition painting shared with no other art, Modernist painting oriented itself to flatness as it did to nothing else.

The Old Masters had sensed that it was necessary to preserve what is called the integrity of the picture plane: that is, to signify the enduring presence of flatness underneath and above the most vivid illusion of three-dimensional space. The apparent contradiction involved was essential to the success of their art, as it is indeed to the success of all pictorial art. The Modernists have neither avoided nor resolved this contradiction; rather, they have reversed its terms. One is made aware of what the flatness contains. Whereas one tends to see what is in an Old Master before one sees the picture itself, one sees a

Modernist picture as a picture first. This is, of course, the best way of seeing any kind of picture, Old Master or Modernist, but Modernism imposes it as the only and necessary way, and Modernism's success in doing so is a success of self-criticism.

Modernist painting in its latest phase has not abandoned the representation of recognizable objects in principle. What it has abandoned in principle is the representation of the kind of space that recognizable objects can inhabit. Abstractness, or the non-figurative, has in itself still not proved to be an altogether necessary moment in the self-criticism of pictorial art, even though artists as eminent as Kandinsky and Mondrian have thought so. As such, representation, or illustration, does not attain the uniqueness of pictorial art; what does do so is the associations of things represented. All recognizable entities (including pictures themselves) exist in three-dimensional space, and the barest suggestion of a recognizable entity suffices to call up associations of that kind of space. The fragmentary silhouette of a human figure, or of a teacup, will do so, and by doing so alienate pictorial space from the literal two-dimensionality which is the guarantee of painting's independence as an art. For, as has already been said, three-dimensionality is the province of sculpture. To achieve autonomy, painting has had above all to divest itself of everything it might share with sculpture, and it is in its effort to do this, and not so much – I repeat – to exclude the representational or literary, that painting has made itself abstract.

At the same time, however, Modernist painting shows, precisely by its resistance to the sculptural, how firmly attached it remains to tradition beneath and beyond all appearances to the contrary. For the resistance to the sculptural dates far back before the advent of Modernism. Western painting, in so far as it is naturalistic, owes a great debt to sculpture, which taught it in the beginning how to shade and model for the illusion of relief, and even how to dispose that illusion in a complementary illusion of deep space. Yet some of the greatest feats of Western painting are due to the effort it has made over the last four centuries to rid itself of the sculptural. Starting in Venice in the sixteenth century and continuing in Spain, Belgium, and Holland in the seventeenth, that effort was carried on at first in the name of colour. When David, in the eighteenth century, tried to revive sculptural painting, it was, in part, to save pictorial art from the decorative flattening-out that the emphasis on colour seemed to induce. Yet the strength of David's own best pictures, which are predominantly his informal ones, lies as much in their colour as in anything else. And Ingres, his faithful pupil, though he subordinated colour far more consistently than did David, executed portraits that were among the flattest, least sculptural paintings done in the West by a sophisticated artist since the fourteenth century. Thus, by the middle of the nineteenth century, all ambitious tendencies in painting had converged, amid their differences, in an anti-sculptural direction.

Modernism, as well as continuing this direction, has made it more conscious of itself. With Manet and the Impressionists the question stopped being defined as one of colour versus drawing, and became one of purely

optical experience against optical experience as revised or modified by tactile associations. It was in the name of the purely and literally optical, not in the name of colour, that the Impressionists set themselves to undermining shading and modelling and everything else in painting that seemed to connote the sculptural. It was, once again, in the name of the sculptural, with its shading and modelling, that Cézanne, and the Cubists after him, reacted against Impressionism, as David had reacted against Fragonard. But once more, just as David's and Ingres's reaction had culminated, paradoxically, in a kind of painting even less sculptural than before, so the Cubist counter-revolution eventuated in a kind of painting flatter than anything in Western art since before Giotto and Cimabue – so flat indeed that it could hardly contain recognizable images.

In the meantime the other cardinal norms of the art of painting had begun, with the onset of Modernism, to undergo a revision that was equally thorough if not as spectacular. It would take me more time than is at my disposal to show how the norm of the picture's enclosing shape, or frame, was loosened, then tightened, then loosened once again, and isolated, and then tightened once more, by successive generations of Modernist painters. Or how the norms of finish and paint texture, and of value and colour contrast, were revised and re-revised. New risks have been taken with all these norms, not only in the interests of expression but also in order to exhibit them more clearly as norms. By being exhibited, they are tested for their indispensability. That testing is by no means finished, and the fact that it becomes deeper as it proceeds accounts for the radical simplifications that are to be seen in the very latest abstract painting, as well as for the radical complications that are also to be seen in it.

Neither extreme is a matter of caprice or arbitrariness. On the contrary, the more closely the norms of a discipline become defined, the less freedom they are apt to permit in many directions. The essential norms or conventions of painting are at the same time the limiting conditions with which a picture must comply in order to be experienced as a picture. Modernism has found that these limits can be pushed back indefinitely before a picture stops being a picture and turns into an arbitrary object; but it has also found that the further back these limits are pushed the more explicitly they have to be observed and indicated. The criss-crossing black lines and coloured rectangles of a Mondrian painting seem hardly enough to make a picture out of, yet they impose the picture's framing shape as a regulating norm with a new force and completeness by echoing that shape so closely. Far from incurring the danger of arbitrariness, Mondrian's art proves, as time passes, almost too disciplined, almost too tradition- and convention-bound in certain respects; once we have got used to its utter abstractness, we realize that it is more conservative in its colour, for instance, as well as in its subservience to the frame, than the last paintings of Monet.

It is understood, I hope, that in plotting out the rationale of Modernist painting I have had to simplify and exaggerate. The flatness towards which Modernist painting orients itself can never be an absolute flatness. The

311

heightened sensitivity of the picture plane may no longer permit sculptural illusion, or *trompe-l'oeil*, but it does and must permit optical illusion. The first mark made on a canvas destroys its literal and utter flatness, and the result of the marks made on it by an artist like Mondrian is still a kind of illusion that suggests a kind of third dimension. Only now it is a strictly pictorial, strictly optical third dimension. The Old Masters created an illusion of space in depth that one could imagine oneself walking into, but the analogous illusion created by the Modernist painter can only be seen into; can be travelled through, literally or figuratively, only with the eye.

The latest abstract painting tries to fulfil the Impressionist insistence on the optical as the only sense that a completely and quintessentially pictorial art can invoke. Realizing this, one begins also to realize that the Impressionists, or at least the Neo-Impressionists, were not altogether misguided when they flirted with science. Kantian self-criticism, as it now turns out, has found its fullest expression in science rather than in philosophy, and when it began to be applied in art, the latter was brought closer in real spirit to scientific method than ever before – closer than it had been by Alberti, Uccello, Piero della Francesca, or Leonardo in the Renaissance. That visual art should confine itself exclusively to what is given in visual experience, and make no reference to anything given in any other order of experience, is a notion whose only justification lies in scientific consistency.

Scientific method alone asks, or might ask, that a situation be resolved in exactly the same terms as that in which it is presented. But this kind of consistency promises nothing in the way of aesthetic quality, and the fact that the best art of the last seventy or eighty years approaches closer and closer to such consistency does not show the contrary. From the point of view of art in itself, its convergence with science happens to be a mere accident, and neither art nor science really gives or assures the other of anything more than it ever did. What their convergence does show, however, is the profound degree to which Modernist art belongs to the same specific cultural tendency as modern science, and this is of the highest significance as a historical fact.

It should also be understood that self-criticism in Modernist art has never been carried on in any but a spontaneous and largely subliminal way. As I have already indicated, it has been altogether a question of practice, immanent to practice, and never a topic of theory. Much is heard about programmes in connection with Modernist art, but there has actually been far less of the programmatic in Modernist than in Renaissance or Academic painting. With a few exceptions like Mondrian the masters of Modernism have had no more fixed ideas about art than Corot did. Certain inclinations, certain affirmations and emphases, and certain refusals and abstinences as well, seem to become necessary simply because the way to stronger, more expressive art lies through them. The immediate aims of the Modernists were, and remain, personal before anything else, and the truth and success of their works remain personal before anything else. And it has taken the accumulation , over decades, of a good deal of personal painting to reveal the

general self-critical tendency of Modernist painting. No artist was, or yet is, aware of it, nor could any artist ever work freely in awareness of it. To this extent – and it is a great extent – art gets carried on under Modernism in much the same way as before.

And I cannot insist enough that Modernism has never meant, and does not mean now, anything like a break with the past. It may mean a devolution, an unravelling, of tradition, but it also means its further evolution. Modernist art continues the past without gap or break, and wherever it may end up it will never cease being intelligible in terms of the past. The making of pictures has been controlled, since it first began, by all the norms I have mentioned. The Palaeolithic painter or engraver could disregard the norm of the frame and treat the surface in a literally sculptural way only because he made images rather than pictures, and worked on a support – a rock wall, a bone, a horn, or a stone – whose limits and surface were arbitrarily given by nature. But the making of pictures means, among other things, the deliberate creating or choosing of a flat surface, and the deliberate circumscribing and limiting of it. This deliberateness is precisely what Modernist painting harps on: the fact, that is, that the limiting conditions of art are altogether human conditions.

But I want to repeat that Modernist art does not offer theoretical demonstrations. It can be said, rather, that it happens to convert theoretical possibilities into empirical ones, in doing which it tests many theories about art for their relevance to the actual practice and actual experience of art. In this respect alone can Modernism be considered subversive. Certain factors we used to think essential to the making and experiencing of art are shown not to be so by the fact that Modernist painting has been able to dispense with them and yet continue to offer the experience of art in all its essentials. The further fact that this demonstration has left most of our old value judgements intact only makes it the more conclusive. Modernism may have had something to do with the revival of the reputations of Uccello, Piero della Francesca, El Greco, Georges de la Tour, and even Vermeer; and Modernism certainly confirmed, if it did not start, the revival of Giotto's reputation; but it has not lowered thereby the standing of Leonardo, Raphael, Titian, Rubens, Rembrandt or Watteau. What Modernism has shown is that, though the past did appreciate these masters justly, it often gave wrong or irrelevant reasons for doing so.

In some ways this situation is hardly changed today. Art criticism and art history lag behind Modernism as they lagged behind pre-Modernist art. Most of the things that get written about Modernist art still belong to journalism rather than to criticism or art history. It belongs to journalism – and to the millennial complex from which so many journalists and journalist intellectuals suffer in our day – that each new phase of Modernist art should be hailed as the start of a whole new epoch in art, marking a decisive break with all the customs and conventions of the past. Each time, a kind of art is expected so unlike all previous kinds of art, and so free from norms of practice or taste, that everybody regardless of how informed or uninformed he happens to be, can have his say about it. And each time, this expectation has been disap-

313

pointed, as the phase of Modernist art in question finally takes its place in the intelligible continuity of taste and tradition.

Nothing could be further from the authentic art of our time than the idea of a rupture of continuity. Art *is* – among other things – continuity, and unthinkable without it. Lacking the past of art, and the need and compulsion to maintain its standards of excellence, Modernist art would lack both substance and justification.

Raymond Williams
'The Works of Art Themselves'?

Source: Raymond Williams, 'Identifications',
Culture, London, Fontana Press, 1981,
pp. 119-47. Extract from pp. 119-25.

We can go a long way in the sociology of culture by studying cultural institutions, formations and means of production. But at some point we are bound to stop and ask if what we are studying, however important it may be in its own terms, is sufficiently central to its presumed subject. We now have the sociology, it is sometimes said, but where is the art?

This is usually a reasonable question. It is true that there is one unreasonable apparent form of it, which is intended, really, to halt the whole inquiry. Certain sociological facts and considerations are rather hastily admitted, usually in a received and well-worn form, and some minor place is reserved for them. But then, we understand, the real work can begin; we go to 'the works of art themselves'.

Of course, as an everyday decision, something like this is possible. We can and often should stop reasoning about art, and go instead to look at a painting, listen to some music, read a poem. But this is quite different from that *conceptual* shift, in which we are invited to break off the sociological inquiry and move, not to some specific attention, but to a generalized category with its presumed internal rules. It is the difference between a necessary empirical shift, when reasoning is taken across to one of its presumed objects and must take the full strain of the encounter, and a deceptive (because falsely generalized) empiricism, in which certain kinds of attention to certain presumptively autonomous objects are held to be justified and protected by the terms of an unargued immediacy. It is one thing to leave sociological analysis and instead read a poem; it is another to leave socio-cultural analysis and forthwith adopt a socio-cultural category whose forms and terms ought, precisely, to be the object of analysis.

For 'the works of art themselves' is of course a category, and not some neutral objective description. It is a socio-cultural category of the highest importance, but just because of this it cannot be empirically presumed. Consider only the very diverse practices it offers to unite or even, in some versions, to make in some sense identical. Radically different manual practices, directed to radically different human senses (over a range, for example, from sight alone to hearing alone), are presumptively encompassed by this single general category. The concept would be difficult enough if it were

only at this level, where we say that music, dance, painting, sculpture, poetry, drama, fiction, film have crucial properties in common, which suffice to distinguish them, as a group, from other human practices.

But another level is immediately in question, even as we nominate the group. The case of dance is an obvious example. There are forms of dance which we all admit as forms of art: for example, classical ballet. But then there are other forms where this description does not suggest itself, or might not be admitted if it did: for example, ballroom dancing, which would be normally set down simply as 'a pleasurable social activity' (and as such different from art?).

One early distinction suggests itself: ballet is performed for an audience; ballroom dancing is where we can all join in. But what would then be the case with an exhibition or competition of ballroom dancing? The next distinction suggests itself: ballet is a higher, more developed form of dance, and as such is art, while ballroom dancing is at best only marginally so, and normally not at all so. But then consider folk-dance, ordinarily less developed, formally, than ballet; indeed often no more developed than ballroom dances. Yet folk-dance is regularly presented, in certain kinds of exhibition and performance, as at least a simple kind of art.

Art as Performance?

Is this where the earlier distinction returns: that 'art' depends on conscious performance? It clearly takes us some way, but there are still major difficulties. Cave paintings, for example, are now generally and understandably seen as art, indeed in many of their examples as major art. Yet they are commonly sited in dark and inaccessible places, and we really do not know how often, if at all, they were generally seen within the period and culture in which they were made. Then take a limiting case: if nobody but the original painter or painters of the great roof bison of Altamira had ever seen this work (and comparable work may still be lying undiscovered), would any of us wish, on our first sight of it, to deny its status as art because it had not been consciously exhibited?

Art as Quality?

Is its status then a matter of its superlative material execution? This is obviously crucial, but it will not serve to delimit art; the same criterion, on its own, would distinguish many works of other manual skills and of engineering. Indeed often, and only sometimes rhetorically, we speak of such works as works of art – a particular knife, pot, aeroplane, bridge – but usually with the sense that this is an additional quality, when the primary purpose of the object has been already acknowledged. Meanwhile the category of 'art' is normally and even insistently applied to works which have no other purpose but to be works of art.

'Aesthetic' Purpose

This definition by purpose, by an in effect autonomous intention, is perhaps the most common modern justification of the category. It commands an entire vocabulary, centred on the specification of the '*aesthetic*': a work of art is designed for, and/or has, aesthetic properties and effects. In fact 'aesthetic' in this sense is a new term from the late eighteenth century, moving directly in line with the modern specializing generalization of 'the arts' and 'the creative arts', though the qualities it indicates had often previously been described. Because of the interlock of terms – 'aesthetic intention', 'creative arts', 'aesthetic effect' – an effective categorical grouping has indeed been achieved. But then it should be clear, when we see this as a categorical formation rather than an obvious and neutral description, that what passes, often very effectively, as a solution brings in its train some particularly difficult problems.

It can seem relatively easy to categorize 'the aesthetic'. It is usually done by introducing supporting or specifying terms: either general terms like 'beauty' or more particular terms like 'harmony', 'proportion', 'form'. And indeed there can be little doubt that the qualities these terms indicate, as processes and as responses, are very significant and important. Much might be done in the scientific analysis of these processes and responses, many of which are self-evidently material and physical. But whether or not this is done we have a great body of human testimony to the reality of what is being (if still generally) described.

Specialization of the 'Aesthetic'

The real problem is not at this level, where the significance of perceptions of colour, form, harmony, rhythm, proportion and so on can be readily confirmed. The intractable problem is the presumed specialization of these 'perceptions' – these processes and responses – to 'works of art'. For it is common to experience similar or comparable perceptions of the human body, of animals and birds, or of trees, flowers and the shapes and colours of land. There is certainly interaction between these and the processes and responses of many arts: many works are derived from or stimulated by them; other works articulate new 'natural' perceptions. But even when we have allowed for this, there is no ready way of defining the category 'art' from these undoubted and general human perceptions, which we are bound to recognize as more widely applicable and thus not reducible to a specialization.

Moreover there are problems of marginal definition. In wholly man-made processes, the 'arts' run through into the significant areas of dress, ornament, furnishing, decoration, gardening, where many of the same criteria of beauty, harmony and proportion apply yet where the full definition of 'art' is usually withheld, within the modern specialization. At the same time, in a quite different direction, the 'arts' run through into areas of human thought and

317

discourse – values, truths, ideas, observations, reports – where, though the 'aesthetic' perceptions may be still quite relevant, they cannot be and in practice are not taken as wholly defining. Most of us want, at times, to speak of the 'truth' of a work of art as much as, or even more than, its 'beauty'.

'Art' and 'Not Art'

The second major problem which follows from the conventional categorization is of great sociological interest. It is that within the practices thus selected and grouped there is a common further delimitation, by value or by presumed value.

Now of course distinctions between works in the various practices, in terms of the quality of their professional execution or, more generally, of some wider values, are normal and inevitable. But this does not, without forcing, mean that such distinctions are clear and regular enough to delimit a category, and especially a category as difficult as this: that some works in a practice which has been specified as an art are 'not art' or 'not really art'. Yet whole socio-cultural theories, of a kind, have been built on this kind of argument. Thus some novels are 'works of art', but others are 'pulp fiction', 'commercial trash', sub-literature' or 'para-literature', and yet others, between these poles, are 'routine', 'mediocre' or 'lending-library fodder'. We can all think of examples to which we would apply these descriptions and be willing to give reasons. The terms are harsher in the more popular arts, but the tendency exists through the whole range.

And what we can then see happening is a hardening of specific judgements into presumptions of classes, based now not only on mixed criteria (for these are held to be cases of 'skilfully executed nonsense' or 'professionally brilliant hokum' as well as of 'clumsy art' or 'raw but authentic artistic power') but also, and crucially, on criteria which are incompatible with the original delimitation by the nature of the practice. Thus a 'bad novel' does everything that the category 'novel' indicates, at the level of generic definition, but then fails to do something else, either in its 'aesthetic process' or in terms of its 'seriousness' or its 'relation to reality', which, at least explicitly, the original definition had not included).

Moreover, if we bring to this common confusion the elementary historical observation that these presumptive classes of 'art' and 'sub-art' or 'non-art' tend to shift (all novels, once, would have been in the downgrading classes; particular classes of novel, for example 'science fiction', move from one side of the divide to another, or are straddled across it; cinema films are 'commercial popular culture but then some films are high art'), we become more and more certain that we must refuse that beguiling invitation to leave aside 'sociological categories' and move to 'the works of art themselves'. Moreover we must refuse by a criterion often rhetorically invoked in these doubtful positions; by the criterion of the strictest intellectual coherence and rigour. [...]

Philip Leider
Literalism and Abstraction:
Frank Stella's Retrospective
at the Modern

Source: Philip Leider, 'Literalism and
Abstraction: Frank Stella's Retrospective at the
Modern', *Artforum*, vol. 8, no. 8, April 1970,
pp. 44-51. The text has been edited. Eleven
plates have been omitted.

The idea in being a painter is to declare an identity. Not just my identity, an identity
for me, but an identity big enough for everyone to share in. Isn't that what it's all
about?

Frank Stella, in conversation

Both abstraction and literalism look to Pollock for sanction; it is as if his work
was the last achievement of whose status every serious artist is convinced
[Plate 54]. The way one reads Pollock influences in considerable measure the
way one reads Stella, and the way in which one reads Pollock and Stella has
a great deal to do, for example, with the kind of art one decides to make; art
ignorant of both looks it. The abstractionist view of Pollock was most clearly
expressed by Michael Fried, basing himself in part on Clement Greenberg,
and that view is now so thoroughly a part of the literature that students run it
through by rote; how his art broke painting's dependence on a tactile, sculp-
tural space; how the all-over system transcended the Cubist grid; how it freed
line from shape, carried abstract art further from the depiction of *things* than
had any art before; how it created 'a new kind of space' in which objects are
not depicted, shapes are not juxtaposed, physical events do not transpire. In
short, the most exquisite triumph of the two-dimensional manner. From this
appreciation of Pollock, or from views roughly similar, have come artists like
Morris Louis, Kenneth Noland, Jules Olitski, Helen Frankenthaler and, par-
tially at least, Frank Stella.

The literalist view of Pollock emerged somewhat more hazily, less explic-
itly, more in argument and conversation than in published criticism. Literalist
eyes – or what were to become literalist eyes – did not see, or did not see first
and foremost, those patterns as patterns of line freed from their function of
bounding shape and thereby creating a new kind of space. They saw them
first and foremost as *skeins of paint dripped directly from the can*. Paint, that is,
which skipped the step of having a brush dipped into it; paint transferred
from can to canvas with no contact with the artist's traditional transforming
techniques. *You could visualize the picture being made* – there were just no
secrets. It was amazing how much energy was freed by this bluntness, this
honesty, this complete obviousness of the process by which the picture was

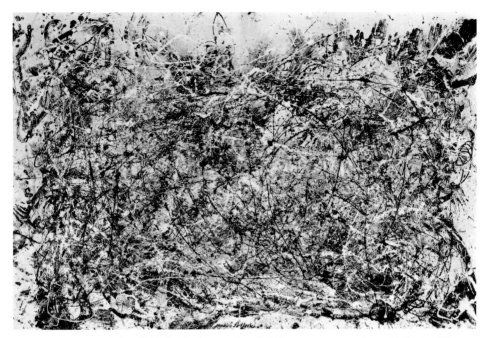

54 Jackson Pollock, *Number 1, 1948*, 1948. Oil on canvas, 173 × 264 cm. Collection, The Museum of Modern Art, New York. Purchase. ©1992 The Pollock-Krasner Foundation/ARS, New York.

made. Another thing about Pollock was the plain familiarity with which he treated the picture as a *thing*. He left his handprints all over it; he put his cigarette butts out in it. It is as if he were saying that the kind of objects our works of art must be derive their strength from the directness of our attitudes toward them; when you feel them getting too arty for you (when you find yourself taking attitudes toward them that are not right there in the studio with you, that come from some place else, from some transmitted view of art not alive in the studio with you) give them a whack or two, re-establish the plainness of your relations with them.

Literalism thus sees in Pollock the best abstract art ever made, deriving its strength from the affirmation of the *objectness* of the painting and from the directness of the artist's relations to his materials. In short, the greatness of the abstraction is in large measure a function of the literalness of Pollock's approach. Such a view of Pollock would naturally lead one to seek in quite different places for a way to continue making meaningful abstract art than would a view based on the abstractionist reading of Pollock. The kind of an object a painting was began to emerge forcefully as an issue in painting.

The objectness of painting was explored with great ingenuity and enormous sophistication by Jasper Johns during the middle and late 1950s, but his literalism is consistently undermined by a Duchampian toying with irony and paradox, an impulse to amuse and be amused above all [Plate 55]. How clev-

erly he seemed to dismiss problems that were draining the life out of abstract art! How easily those flags and targets seemed to diagnose and then cure the lingering illusionism and vestigial representationalism that plagued abstraction in the 1950s. All that had to be done was a simple rehearsal of the differences between actual flags and actual paintings.

Needless to say, abstraction was not looking like that. Abstraction was discovering that objectness was the thing to beat, and that the breakthrough to look for was a breakthrough to an inspired two-dimensionalism, and that the way to do it was through *colour*, and, as much as possible, through colour alone. That the differences were immense can be seen simply by comparing a Noland circle painting with a Johns target [Plates 29 and 55]. The one is about colour and centredness and two-dimensional abstraction, with no references whatever to objects or events of any kind in the three-dimensional world. The other is about an object called a target and an object called a painting, and, given the cleverness with which the problems are posed, [both paintings] were an instant success in colleges everywhere.

One college student, Stella, saw in Johns a way to an advanced all-overness. The cleverness, irony and paradox parts he left to others, perhaps figuring that if Still and Pollock could do without them he probably could too. From Johns, Noland could only have taken, if anything at all, the suggestion of the possibilities of a centred image. Stella, however, takes from Johns directly the striping idea: it solved the problem of keeping his pictures

321

55 Jasper Johns, *Target with Four Faces*, 1955. Assemblage: encaustic on newspaper and cloth over canvas, 66 × 66 cm, surmounted by four tinted plaster faces in wood box with hinged front. Box closed 9.5 × 66 × 8.9 cm. Overall dimensions with box open 85.3 × 66 × 7.6 cm. Collection, The Museum of Modern Art, New York. Gift of Mr and Mrs Robert C. Scull. © Jasper Johns/DACS, London/VAGA, New York 1993.

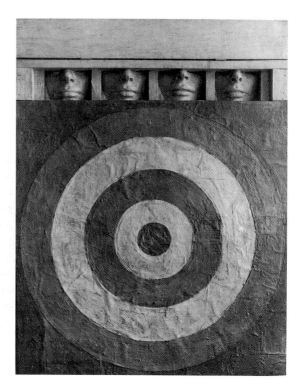

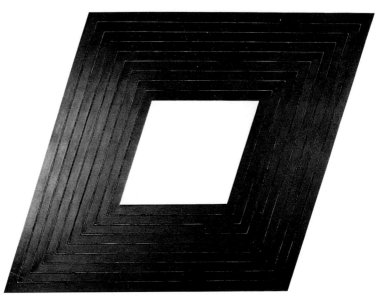

322

56 Frank Stella, *Carl Andre*, 1963. Oil on canvas, 203.2 × 213.4 cm. Private collection.
©1992 Frank Stella/ARS, New York.

flat, and it solved it simply, clearly, and in a way that allowed him to move on
to other things [Plate 56].

Stella was crucially interested in keeping his pictures flat because he was
crucially interested in making abstract pictures that could survive as post-
Pollock art. He was crucially interested in making abstract pictures, and *only*
in making abstract pictures, and has never been interested in anything else to
this day; the consistency of Stella's anti-literalist ideas throughout his career is
remarkable, as the extensive quotations from both Stella's public and private
remarks, scattered through the catalogue text, make clear. As other abstrac-
tionists like Louis, Noland and Olitski – all older by at least ten years than
Stella – pursued this ambition by exploring colour, Stella thought the biggest
obstacles to a greater abstraction were structural and compositional, and he
went to work overcoming these with a cold, smartaleck, humourless
methodicalness that showed up, in the paintings he finally exhibited at the
Museum of Modern Art in 1960, like a slap in the face.

The pictures were insufferably arrogant. They seemed to reiterate nothing
but insultingly simple principles that only his paintings, however, seemed to
understand. Thus, if you are going to make an abstract painting, then you
cannot make it in the kind of space used for not-abstract painting. And if you
are going to make abstract pictures you have to be sure that your colours
don't suggest or take on the quality of non-abstract things, like sky or grass or
air or shadow (try black, or if that's too poetic, copper or aluminium). And if
one is going to make an abstract painting one should be thoughtful about
what kind of image one chooses, how it is placed and what kind of shape the
entire picture has because otherwise, before you know it, you are going back

into all the classical problems: objects in a tactile space. Also, a picture isn't abstract just because the artist doesn't know when it's finished. Pollock's message wasn't 'Go wild'; it was (1) keep the field even and without dominant image or incident; (2) be careful about colour; (3) keep the space as free from the space needed to depict three-dimensional forms as possible; (4) eliminate gesture, let the method chosen seem to generate the picture. If the *whole* picture is working right, accidents and inconsistent details don't matter any more than handprints and cigarette butts; there can be mistakes, awkward stretcher bars, even drips.

The main criticism of the pictures seems to have been that they had nothing to say.

The great irony that comes in here is this: all the while that Stella is pursuing, with ferocious single-mindedness, the idea of the completely consistent non-referential abstract painting, artists like Carl Andre and Don Judd are being absolutely fascinated with the literal *objectness* of Stella's paintings. Andre, who was very close to Stella in the early 1960s, seems to have been the first to draw the conclusion that almost all the literalist artists were to come to: if the best painting was moving inevitably toward three dimensions, then the best hope for a true post-Pollock abstraction may lie in three-dimensional art. The incipient move into three dimensions implied in Stella's paintings is made manifestly clear in Andre's work of the early 1960s, most explicitly in a work like the 1959-60 untitled construction. Judd, too, made works which seemed to spell out the three-dimensional implications of Stella's work [Plate 47]. Both artists seemed to share what can be called a fundamental presumption of literalism: if one has moved into three dimensions because that seems to be where the best abstract art can take form, then there is no sense in making art in three dimensions that tries to approximate the sensations or appearances of two dimensions. On the contrary, the more three-dimensionality is affirmed, acknowledged, declared, explored, the more powerful the work of art can be. One of the ways in which this is done, for Judd, is in the employment of simple orders. Writing in 1965, Judd remarked, 'Stella's shaped paintings involve several important characteristics of three-dimensional work', and he goes on to list them. Among the things he lists is the *order* of the stripes, which he calls 'simply order, like that of continuity, *one thing after another*'. Stacking is such an order, simple progressions another. Andre depends heavily on orders which, as often as possible, correspond to the way in which materials are used in the literal world, common orders, one thing beside another, like a row of bricks [Plate 44]. Almost all the literalist imperatives come from the need to explicitly acknowledge three-dimensionality: structural clarity, everyday materials, directness of relations with materials.

The differences between Andre and Judd emerged slowly and steadily all through the 1960s; Andre was to consistently limit himself to solutions that were respectful of, and consonant with, the problems of sculpture, while Judd's indifference to sculpture and its problems would become more obvious every day. Both artists got better and better. Criticism might have

focused on this and life for both men might have been, if not easier, at least a little more dignified. Instead, both got washed into the mud slide called 'Minimal art', or ABC art, or Primary Structures, and found themselves part of a 'movement' that included work as utterly extraneous to their interests as Larry Bell's glass boxes, Tony Smith's architectural abstractions, Robert Morris's psychology-oriented constructions. (Judd's protesting voice, utterly lost in the ballyhoo, can be picked up in the catalogue of 'Primary Structures': 'I object to several popular ideas ...')

The Minimal art craze set everyone back for years; the job of criticism now would seem to be to patiently undo the damage and carefully begin the work of revealing the development of a literalist art in America which extends quite unbrokenly from about 1959 to the present and which, in one way or another, involves in its network at least part of the work of artists as diverse as Andre, Judd, Flavin, Serra, Heizer, Morris [Plates 44, 45, 46, 47, 49 and 50], Smithson, Sonnier, Nauman, Saret and undoubtedly many others including, for example, early Poons and early Ron Davis. It is a development which cannot be contained in categories like minimal, reductive, anti-form, process or anti-illusion, and museums, rushing to organize exhibitions around such 'themes' are, as usual, doing more damage than they can imagine.

The abstractionist critics – mainly Clement Greenberg, then Michael Fried, William Rubin and others in greater or lesser degree – had, by the mid-1960s, done monumental work. They had turned the stampede toward a second-rate, imitative gestural painting ('Tenth Street') and redirected the eyes of the art world to where the quality really was coming from: Louis, Newman, Noland, Olitski, Stella, Kelly, Frankenthaler, David Smith and Caro. (Don Judd's critical writing in many cases made similar judgements, but from an utterly different point of view.) In the development of literalism, however, abstractionist criticism has figured hardly at all: to the extent that the abstractionist critics considered it at all, they condemned it. (No critics of the quality of the best abstractionist critics came forward to champion or explain the literalist development, and this may account for the fact that the literalist artists do a lot more of their own writing than had been customary.)

Abstractionist criticism tended to ignore the literalists except when it had to deal with Stella. Noland and Olitski, for example, worked as if literalism never existed; they were years older and seem to have felt no compulsion to engage with it. But literalism was being made by Stella's friends and contemporaries and it was palpably clear that on one level or another Stella *was* engaged with it, even, perhaps, against his will, certainly against his explicit convictions about where quality in contemporary art lay. So in dealing with Stella abstractionist criticism had either to condemn him for seeming to be inextricably mixed up with artists like Judd and Andre and Flavin[Plates 43,44,46 and 47] and those others, or it had to somehow disassociate him from them. In the latter case, the line was always that the literalists misunderstood Stella. [...]

[...] As the 1960s drew to a close, the relationship between literalism and

abstraction in American art changed considerably. When the decade opened, both literalism and abstraction shared the ambition to make the most advanced abstract art it was possible to make after Pollock. As the decade came to an end it was clear that within literalism several tendencies had emerged and the issue of whether the goal of art making was still high abstraction was no longer one on which everyone agreed. The move into three dimensions led further than anyone had anticipated; the interest in materials led to orders and applications vastly more complex than anyone had dreamed. Literalism was encompassing acts and arrangements unthinkable seven or eight years before and artists were making choices which had no sanction as certain, say, as Pollock had granted to the work of the early 1960s. Sanction for many of the undertakings of these artists was sought – if it was sought at all – in traditions much older than Modernism, and in this many of the literalist artists of the late 1960s resemble the emerging Abstract Expressionists of the mid-1940s. For both, the sense of a new beginning was overwhelming; for both the idea of *what to do* as artists was up for grabs; for both uncertainty, especially as it pertains to their relationship to the tradition of modern art – and not merely the plastic tradition but the social and economic traditions of museums, dealers, collections and collectors – is the fundamental condition of their creative lives. [...]

Certainly by 1969 and 1970, Stella had thoroughly loosened the overall design structure and seems to have systematically turned more and more of the authority of the paintings over to colour. Pictures like *Ile à la Crosse II* and its companions have an expansiveness of decorative grandeur which bursts upon us like the interior of the Guggenheim Museum, triumphs of sheer confidence. In pictures like these, the identity we all share in Stella's art as *our* art, the art of *our* time, is deepened, broadened, and made, of all things, joyous.

Yve-Alain Bois
Painting:
The Task of Mourning

Source: Yve-Alain Bois, 'Painting: the Task of Mourning', *Endgame: Reference and Simulation in Recent Painting and Sculpture*, Cambridge, Mass.,The MIT Press and the Institute of Contemporary Art, Boston, 1986, pp. 29-49. This text has been edited and footnotes renumbered accordingly. Eleven plates have been omitted.

Nothing is more conservative than the apocalyptic genre
Jacques Derrida

Nothing seems to be more common in our present situation than a millenarianist feeling of closure. Whether celebratory (what I will call manic) or melancholic, one hears endless diagnoses of death: death of ideologies (Lyotard); of industrial society (Bell); of the real (Baudrillard); of authorship (Barthes); of man (Foucault); of history (Kojève) and, of course, of modernism (all of us when we use the word post-modern). Yet what does all of this mean? From what point of view are these affirmations of death being proclaimed? Should all of these voices be characterized as the voice of mystagogy, bearing the tone that Kant stigmatized in *About a Recently Raised Pretentiously Noble Tone in Philosophy* (1796)? Derrida writes, '*Each time* we ask ourselves uncompromisingly what they are driving at and to what end, the ones who declare the end of this or that, of man or of the subject, of consciousness, of history, of the Occident or of literature, and to the latest news of progress itself whose idea was never rated so low from the right to the left. Which effects do those nice prophets or eloquent visionaries want to achieve? For which immediate or postponed benefits? What do they do, what do we do by saying all that? To seduce or to subjugate whom, to intimidate whom, to give an orgasm to whom?'[1] *Each time*, which means that there is no generic answer to this question: there is no single paradigm of the apocalyptic, and no ontological inquiry about 'its' tone. Because the tone of their writings is so different, it would be particularly misguided, and perverse, to connect Barthes to Baudrillard, Foucault to Bell, Lyotard to Kojève – but it is done in the theoretical pot-pourri one reads month after month in the flashy magazines of the art world. Derrida's proviso, *each time*, means that in each instance one must examine the tone of the apocalyptic discourse: its claim to be the pure revelation of truth, and the last word about the end.

[My paintings] are about death in a way: the uneasy death of modernism
Sherrie Levine

I will focus here on a specific claim: that of the death of painting, and more

specifically, the death of abstract painting. The meaning of this claim is bounded by two historical circumstances: the first is that the whole history of abstract painting can be read as a longing for its death and the second is the recent emergence of a group of neo-abstract painters who have been marketed as its official mourners (or should I say resurrectors? But we will see that it is the same). The first circumstance leads to the question: when did all of this start? Where can we locate the beginning of the end in modern painting – that is, the feeling of the end, the discourse about the end, and the representation of the end? The existence of a new generation of painters interested in these issues leads to the question: is abstract painting still possible? In turn, this question can be divided into at least two others: is (abstract, but also any other kind of) *painting* still possible? and is *abstract* (painting, but also sculpture, film, modes of thought, etc.) still possible? (A third thread of the question, specifically apocalyptic, would be: is (abstract painting, but also anything, life, desire, etc.) still possible?)

327

The question about the beginning of the end and the question about the (still) possibility of painting are historically linked: it is the question about the (still) possibility of painting which is at the beginning of the end and it is this beginning of the end which has been our history, namely what we are accustomed to name *modernism*. Indeed the whole enterprise of modernism, especially of abstract painting, which can be taken as its emblem, could not have functioned without an apocalyptic myth. Freed from all extrinsic conventions, abstract painting was meant to bring forth the pure *parousia* of its own essence, to tell the final truth and thereby terminate its course. The pure beginning, the liberation from tradition, the 'zero degree' which was searched for by the first generation of abstract painters could not but function as an omen of the end. One did not have to wait for the 'last painting' of Ad Reinhardt to be aware that through its historicism (its linear conception of history) and through its essentialism (its idea that something like the essence of painting existed, veiled somehow, and waiting to be unmasked), the enterprise of abstract painting could not but understand its birth as calling for its end. As Malevich wrote: 'There can be no question of painting in Suprematism; painting was done for long ago, and the artist himself is a prejudice of the past.'[2] And Mondrian endlessly postulated that his painting was preparing for the end of painting – its dissolution in the all-encompassing sphere of life-as-art or environment-as-art – which would occur once the absolute essence of painting was 'determined'. If one can take abstract painting as the emblem of modernism, however, one should not imagine that the feeling of the end is solely a function of its essentialism; rather it is necessary to interpret this essentialism as the effect of a larger historical crisis. This crisis is well known – it can be termed industrialization – and its impact on painting has been analysed by the best critics, following a line of investigation begun half a century ago by Water Benjamin.[3] This discourse centres around the appearance of photography, and of mass production, both of which were understood as causing the end of painting. Photography was perceived this way by even the least subtle practitioners ('"*From today painting is dead*": it is

now nearly a century and a half since Paul Delaroche is said to have pronounced that sentence in the face of the overwhelming evidence of Daguerre's intention').[4] Mass production seemed to bode the end of painting through its most elaborate *mise-en-scène*, the invention of the readymade [Plate 3]. Photography and mass production were also at the base of the essentialist urge of modernist painting. Challenged by the mechanical apparatus of photography, and by the mass-produced, painting had to redefine its status, to reclaim a specific domain (much in the way this was done during the Renaissance, when painting was posited as one of the 'liberal arts' as opposed to the 'mechanical arts').

The beginnings of this agonistic struggle have been well described by Meyer Schapiro: the emphasis on the touch, on texture, and on gesture in modern painting is a consequence of the division of labour inherent in industrial production. Industrial capitalism banished the hand from the process of production; the work of art alone, as craft, still implied manual handling and therefore artists were compelled, by reaction, to demonstrate the exceptional nature of their mode of production.[5] From Courbet to Pollock one witnesses a practice of one-upmanship. In many ways the various 'returns to painting' we are witnessing today seem like the farcical repetition of this historical progression. [...]

[...] Benjamin once noted that the easel painting was born in the Middle Ages, and that nothing guarantees that it should remain forever. But are we left with these alternatives: either a denial of the end, or an affirmation of the end of the end (it's all over, the end is over)? The theory of games, used recently by Hubert Damisch, can help us overcome this paralysing trap. This theory of strategy dissociates the generic *game* (like chess) from the specific performance of the game (the Spassky/Fisher match, for example), which I will call the *play*. Let us suppose that Newman and Pollock were opposing partners in the development of Abstract Expressionism. How can we determine what in their exchange is in the order of *play* (which is unique, but can be repeated by simulation) and what is in the order of the *game* (with a definite set of rules)? It seems clear that this type of question transforms the problem of historical repetitions, which had worried Wölfflin so much: 'It is certain that through the problematic of abstraction, the American painters [of the generation of Abstract Expressionism], as already in the 1920s the advocates of suprematism, neo-plasticism, purism, etc. could entertain the illusion that, far from being engaged in a specific play which would take part in the succession or the set of plays which would define the *game* "Painting", they were indeed returning to the foundations of the game, its immediate, constitutive given. The American episode would then represent less an unprecedented development in the history of abstraction than a new departure, a revival, but at a deeper level and with more powerful practical and theoretical means, of the play which had begun thirty or forty years before, under the title of abstraction.'[6] This strategic interpretation is rigorously anti-historicist: it is not premised on the exhaustion of things and the linear genealogy of which art criticism is so fond, always ready, consciously or not, to follow the

328

requirements of the market in quest of new products. But the theory of games does not propose a homogeneous time either (the time without ruptures of art history). The question becomes: 'what is the status which must be ascribed to the *play* "Painting", as it is *seen* played at a given moment in a given situation, in relationship with the *game* which bears the same name?'[7] Such a question has the immediate merit of casting doubt on assumptions which seem obvious: does the convention of depth, for example, which, according to Greenberg, has been rejected as 'unnecessary' by the pictorial art of this century participate more appropriately in the order of the play or that of the game? Or rather, should we speak of a modification of this convention within the game? Without becoming a theoretical machine producing indifference (since one is obliged to take a side), this strategic approach deciphers painting as an agonistic field where nothing is ever terminated, or decided *once and for all*. It reinvests the analysis of painting with a type of historicity which, under the pressure of the market, has been neglected — the history of the *longue durée*. In other words, it dismisses all certitudes about the absolute truth upon which the apocalyptic discourse is based. Rather, the fiction of the end of art (or of painting) is understood as a 'confusion between the end of the game itself (as if a game could really have an end) and that of such and such a play (or suite of plays)'.[8]

One can conclude then, that, if the play 'modernist painting' is finished, it does not necessarily mean that the game 'painting' is finished: many years to come are ahead for this art. But the situation is even more complicated: for the play 'modernist painting' was the play of the end of painting; it was both a response to the feeling of the end, and a working through of the end. And this play was historically determined — by the fact of industrialization (photography, the commodity, etc.). To claim that the 'end of painting' is finished is to claim that this historical situation is no longer ours, and who would be naive enough to make this claim when it appears that reproducibility and fetishization have permeated all aspects of life: have become our 'natural' world? [...]

[...] Mourning has been the activity of painting throughout this century. 'To be modern is to know *that which is not possible any more*', Roland Barthes once wrote.[9] But the work of mourning does not necessarily become pathological: the feeling of the end, after all, did produce a cogent history of painting, modernist painting, which we have probably been too prompt to bury. Painting might not be dead. Its vitality will only be tested once we are cured of our mania and our melancholy, and we believe again in our ability to act in history: accepting our project of working through the end again, rather than evading it through increasingly elaborate mechanisms of defence (this is what mania and melancholy are about) and settling our historical task: the difficult task of mourning. It will not be easier than before, but my bet is that the potential for painting will emerge in the conjunctive deconstruction of the three instances which modernist painting has dissociated (the imaginary, the real and the symbolic), but predictions are made to be wrong. Let us simply say that the desire for painting remains, and that this desire is not

entirely programmed or subsumed by the market: this desire is the sole factor of a future possibility of painting, that is, of a non-pathological mourning. At any rate, as observed by Robert Musil fifty years ago, if some painting is still to come, if painters are still to come, they will not come from where we expect them to.[10]

Notes

1 Jacques Derrida, *D'un ton apocalyptique adopté naguère en philosophie*, Paris, 1983, p. 65. This small book is a reading of Kant's pamphlet mentioned above.

2 Kasimir Malevich, *Suprematism. 34 Drawings* (Vitebsk, 1920), English trans. in Malevich, *Essays on Art,* ed. Troels Andersen, vol. I, New York, 1971, p. 127.

3 I refer here to the critical work accomplished in the magazine *October* by Rosalind Krauss, Douglas Crimp and Benjamin H. D. Buchloh; but also to Hal Foster's recent anthology of articles, *Recodings; Art, Spectacle, Cultural Politics*, Port Townsend (Wash.), 1985, and to various articles by Thierry de Duve.

4 Douglas Crimp, 'The End of Painting', *October*, no. 16, Spring 1981, p. 75.

5 See Meyer Schapiro, 'Recent Abstract Painting', in *Modern Art; 19th and 20th Century (Collected Papers)*, New York, 1978, pp. 217-19. The text appeared first under the title 'The Liberating Quality of Avant-Garde Art' in *Art News* during the summer of 1957.

6 Hubert Damisch, *Fenêtre jaune cadmium ou les dessous de la peinture*, Paris, 1984, p. 167.

7 Ibid., p. 170.

8 Ibid., p. 171.

9 Roland Barthes, 'Réquichot et son corps', in *L'obvie et l'obtus, Essais Critiques*, III, Paris, 1982, p. 211.

10 Robert Musil, 'Considérations Désobligeantes', *Oeuvres prépostumes* (1936), French trans., Paris, 1965, p. 87.

32

Dick Hebdige
A Report on the Western Front:
Postmodernism and the
'Politics' of Style

Source: Dick Hebdige, 'A Report on the
Western Front: Postmodernism and the
"Politics" of Style', *Block*, 12, 1986-7, pp. 4-26.
This text has been edited and footnotes renum-
bered accordingly. Thirty-four plates have
been omitted.

[...] Postmodernism – we are told – is neither a homogeneous entity nor a consciously directed 'movement'. It is instead a space, a 'condition', a 'predicament', an *aporia*, an 'unpassable path' – where competing intentions, definitions, and effects, diverse social and intellectual tendencies and lines of force converge and clash. When it becomes possible for people to describe as 'postmodern' the décor of a room, the design of a building, the diegesis of a film, the construction of a record, or a scratch video, a television commercial, or an arts documentary, or the intertextual relations between them, the layout of a page in a fashion magazine or critical journal, an anti-teleological tendency within epistemology, the attack on the metaphysics of presence, a general attenuation of feeling, the collective chagrin and morbid projections of a post-war generation of baby boomers confronting disillusioned middle age, the 'predicament' of reflexivity, a group of rhetorical tropes, a proliferation of surfaces, a new phase in commodity fetishism, a fascination for images, codes and styles, a process of cultural, political or existential fragmentation and/or crisis, the 'decentring' of the subject, an 'incredulity towards meta-narratives', the replacement of unitary power axes by a plurality of power/discourse formations, the 'implosion of meaning', the collapse of cultural hierarchies, the dread engendered by the threat of nuclear self-destruction, the decline of the University, the functioning and effects of the new miniaturized technologies, broad societal and economic shifts into a 'media', 'consumer' or 'multinational' phase, a sense (depending on who you read) of placelessness (Jameson on the Bonnaventura Hotel) or the abandonment of placelessness (e.g. Kenneth Frampton's 'critical regionalism' or (even) a generalized substitution of spatial for temporal co-ordinates[1] – when it becomes possible to describe all these things as 'postmodern' (or more simply, using a current abbreviation, as 'post' or 'very post') then it's clear that we are in the presence of a buzzword.

That a single word should serve as the inflated focus for such a range of contradictory investments does not necessarily render it invalid or meaningless. An ambivalent response to what Barthes might have called the 'happy Babel' of the Post seems on the whole more honest and in the long run more productive than a simple either/or. Viewed benignly, the degree of semantic

complexity surrounding the term might be seen to signal the fact that a significant number of people with conflicting interests and opinions feel that there is something sufficiently important at stake here to be worth struggling and arguing over. The substantive appeal of these debates consists in the degree to which within them a whole bunch of contemporary crises are being directly confronted, articulated, grappled with. In other moments, for me at least, an uneasiness concerning the rapidity and glee with which some intellectuals seem intent on abandoning earlier positions staked out in the pre-Post-erous ground of older critical debates predominates: an uneasiness which is no doubt underpinned in this case by a squarer, more puritanical aversion to 'decadence', 'fatalism', 'fashion' …

For example, one influential mapping of the postmodern – fatally inflected through the work of Georges Bataille – revolves around the 'death of the subject'. In the (ob)scenario sketched out by Jean Baudrillard, the vagina and the egg – the images compulsively reiterated in Bataille – give way to the metaphor of television as nether-eye (never I): the 'empty' point of origin to which everything returns:

> It is well known how the simple presence of television changes the rest of the habitat into a kind of archaic envelope, a vestige of human relations whose very survival remains perplexing. As soon as this scene is no longer haunted by its actors and their fantasies, as soon as behaviour is crystallized on certain screens and operational terminals, what's left appears only as a large useless body, deserted and condemned. The real itself appears as a large useless body … Thus the body, landscape, time all progressively disappear as scenes. And the same for public space: the theatre of the social and the theatre of politics are both reduced more and more to a large soft body with many heads …[2]

Sometimes this image of contemporary metropolitan existence as a kind of decentred, 'hyperreal' or technicolour version of Hobbes's Leviathan seems more clearly applicable to the term 'postmodernism' itself than to any hypothetical 'postmodern' ontology. The claims made on behalf of the Post can appear grotesquely inflated. The putative signs and symptoms of a 'postmodern condition' sometimes look too much like the morbid projections of a cohort of marginalized, liberally educated critics trapped in declining institutions – the academy, the gallery, the 'world' of art criticism – for them to be taken seriously at face value. The Post becomes a monstrous phantasm: a shapeless body of ungrounded critique with countless tiny heads. We know from mythology that such a hideous apparition must be approached obliquely rather than directly. The monster must be read at an angle in the same way that the signal on a video tape is read diagonally by helical scan. It is this need for indirection that dictates the eccentric trajectory of the present report. What follows is an attempt to re-present my own ambivalence *vis-à-vis* the prospect(s) of the Post: to engage with some of the issues raised in debates on postmodernism, to cruise the text of postmodernism without forfeiting the possibility of another place, other positions, other scenarios, different languages. In what I take to be the postmodern spirit, I shall try to reproduce on paper the flow and grain of television discourse switching back

and forth between different channels. In this way what follows is likely to induce in the reader that distracted, drifting state of mind we associate with watching television. I shall address the problematic of postmodernism, then, in the form in which I shall pose questions rather than in the arguments I shall incidentally invoke. [...]

Postmodernism resembles modernism in that it needs to be thought in the plural.[3] Not only do different writers define it differently but a single writer can talk at different times about different posts. Thus, for instance, Jean-François Lyotard has recently used the term to refer to three separate tendencies: (i) a trend within architecture away from the Modern Movement's project 'of a last rebuilding of the whole space occupied by humanity'; (ii) a decay of confidence in the idea of progress and modernization ('there is a sort of sorrow in the Zeitgeist'); and (iii) a recognition that it is no longer appropriate to employ the metaphor of the 'avant-garde' as if modern artists were soldiers fighting on the borders of knowledge and the visible, prefiguring in their art some sort of collective global future.[4] To pick through some of these definitions, there is, first and most obviously, postmodernism in architecture though even here there are conservative, conservationist and critical regional conjugations. There is postmodernism as a descriptive category within literature and the visual arts where the term is used to refer to a tendency towards stylistic pluralism, the crisis of the avant-garde as idea and as institution, and the blurring on an allegedly unparalleled scale of the categories of 'high' and 'low' forms, idioms, and contents. There have also been attempts to describe as postmodern the emergent cultures and sub-cultures associated with the new user-friendly communication technologies (VCRs, home computers, synthesizers, beat boxes, portable and 'personal' audio cassette machines etc.) and to place these emergent forms within the context of a general shift into a new 'consumer', or 'media' phase in capitalist development. Here there is much talk of bricolage, creative consumption, the decentring and de-professionalization of knowledge and technical expertise, the production of meaning in use. There is talk, too, of a general breakdown of social and cultural distinctions: an end not only to the 'outmoded' fantasy of the (suffering) 'masses' and their corollary in the market (the 'mass' in 'mass culture', 'mass media' etc.) but also of the historically grounded 'communities' of the industrial period: end of existing subjectivities, existing collectivities. These fragmentations in their turn are sometimes linked to the erosion of the boundaries *between* production and consumption, between different media, and the incommensurable 'times' and unsynchronized rhythms of different processes, experiences, actions. It is sometimes suggested that together these blurrings and mergers have led to the collapse of the hierarchies which kept apart the competing definitions of culture – high culture, low culture, mass culture, popular culture, culture as a whole way of life – in such a way that these categories and their contents can no longer be regarded as separate, distinct and vertically ranked.

333

To introduce another though related nexus of concerns, Hal Foster in his Preface to *Postmodern Culture* distinguishes between neo-conservative, anti-modernist and critical postmodernisms and points out that whereas some critics and practitioners seek to extend and revitalize the modernist project(s), others condemn modernist objectives and set out to remedy the imputed effects of modernism on family life, moral values etc.; while still others, working in a spirit of ludic and/or critical pluralism, endeavour to open up new discursive spaces and subject positions outside the confines of established practices, the art market and the modernist orthodoxy. In this latter 'critical' alternative (the one favoured by Foster) postmodernism is defined as a posi-tive critical advance which fractures through negation (1) the petrified hege-mony of an earlier corpus of 'radical aesthetic' strategies and proscriptions, and/or (2) the pre-Freudian unitary subject which formed the hub of the 'progressive' wheel of modernization and which functioned in the modern period as the regulated focus for a range of 'disciplinary' scientific, literary, legal, medical and bureaucratic discourses. In this positive 'anti-aesthetic', the critical postmodernists are said to challenge the validity of the kind of global, unilinear version of artistic and economic-technological development which a term like modernism implies, and to concentrate instead on what gets left out, marginalized, repressed or buried underneath that term. The selective tradition is here seen in terms of exclusion and violence. As an initial counter-move, modernism is discarded by some critical postmodernists as a eurocentric and phallocentric category which involves a systematic prefer-ence for certain forms and voices over others. What is recommended in its place is an inversion of the modernist hierarchy – a hierarchy which, since its inception in the eighteenth, nineteenth and early twentieth centuries (depending on your periodization),[5] consistently places the metropolitan centre over the 'underdeveloped' periphery, Western art forms over Third World ones, men's art over women's art, or, alternatively, in less anatomical terms 'masculine' or 'masculinist' forms, institutions and practices over 'fem-inine', feminist, or 'femineist' ones.[6] Here the word 'postmodernism' is used to cover all those strategies which set out to dismantle the power of the white, male author as privileged source of meaning and value. [...]

Many of these diagnoses of the postmodern condition cluster round the threat or the promise of various kinds of merger. As we have seen, a number of immanent mergers have been identified: the coming together of different literary, televisual, and musical styles and genres, the mergers of subjects and objects, originals and copies, hosts and parasites, of 'critical' and 'creative' dis-courses, of criticism and paracriticism, fiction and metafiction. This tendency is signalled at one level in the much vaunted contemporary preference in art, literature, film, television and popular music for parody, pastiche, simulation and allegory – the figures which have risen like ghosts from the grave of the fatally afflicted author. Epistemologically, the shift towards these tropes is rooted in deconstructionism, in the abandonment of the pursuit of origins and the post-structuralist attack on the metaphysics of presence. From the academy to Academy One, from Jacques Derrida to *Blade Runner*, there is the

same cultivation of postures of confusion or distress around the undecidabil-
ity of origins, there is the same blurring of the line(s) between shadows and
substances, metaphors and substantive truths, the same questioning of the
validity of all such binaries.

Somewhere in the middle, between the seminar and the cinema sits the
work of Jean Baudrillard (the rhyme seminar/cinema/Baudrillard is an irri-
tating if apposite coincidence ...). [...] Baudrillard attempts to evacuate not
only Plato, the Western philosophical inheritance, and any untheorized
belief in space-time oppositions, but also the Enlightenment achievement
/legacy, the dual drives toward universal liberation and social engineering
which underpin that achievement/legacy and any notion of history, progres-
sive or otherwise, which might be used to clarify or valorize the experience
of modernity.[7]

Behind this erosion of the twin epistemic faiths of the modern epoch –
positivism and Marxism – a question is being posed. The question is: if the
fictionalizing prepositional copula 'as if' has been allowed into the 'hard'
sciences along with the theory of relativity, catastrophe theory, recursive
computational logics and a recognition of the limits of controls, then on what
grounds is it to be excluded from social critique and critical theory, from
the descriptive, interpretative and predictive discourses of the soft social
sciences? [...]

Postmodernism in architecture is identified with the end of the European
modernist hegemony imposed with growing conviction and on a global scale
from the 1920s onwards through what became known as the International
Style. The reaction against International style architecture was pioneered in
Britain by people like Edward Lutyens and has been taken up by a whole
generation of British architects from the neo-classicists like Quinlan Terry to
the bricolage builders like Terence Farrell and Piers Gough and community
architects like Rod Hackney.

What this generation have renounced is the rationalist theology of High
Modernism with its puritanical (some have called it 'totalitarian') insistence
on clean, uncluttered lines, a theology framed by the programmatic utter-
ances of le Corbusier and Mies van der Rohe and realized throughout the
world with varying degrees of finesse, varying degrees of brutalism in
countless skyscrapers, office blocks, and tower blocks from Brazilia to
British council housing estates. Modernism in architecture is identified with
the abolition of the particular, the irrational, the anachronistic and with the
more or less intentional destruction of the co-ordinates through which
communities orient themselves in space and time: the destruction, that is,
of history as a lived dimension and of neighbourhood as socially inhab-
ited space.

In the 1980s, the Great British Tower Block collapses along with the
exhausted rhetoric of postwar optimism, welfarism, bureaucratic collectivism
and the related cults of industrial expansion and mechanical progress – all of

which it uniquely is seen to symbolize. Typically, modernist architecture and architects are linked (at least by their neo-conservative opponents) to the discredited ideals and objectives of Planning with a capital 'p' – that means – obviously in this context – town planning, but also, by association, economic planning, and, by extension, social planning of any kind. The reaction is fuelled partly by the observation – which is, after all, pretty hard to refute – that the apocalypse when realized in concrete begins to look decidedly seedy twenty years on when covered in English drizzle, cracks, obscene graffiti and pigeon shit. For many opponents of architectural modernism, the decline of the tower block coincides with the decline of what it stands for in Britain. The tower block's collapse serves as a ghostly reminder of the weaknesses of that other larger edifice – the post-war corporate state with its mixed economy, its embattled health services, its strained, unlikely and ultimately illusory social and political consensus forged in the white heat of Harold Wilson's modernizing techno-jargon. In architectural journals and books, the postmodernist putsch can be heard in the following keywords: 'value', 'classical proportion', or alternatively 'community', 'heterogeneous', 'diverse', 'choice', 'conservation', 'neo-Georgian', and in the substitution of organic metaphors for the more mechanical analogies of High Modernism. No more futurist manifestos. No more Spaceship Earth. No more talk about houses being 'factories for living'. To borrow Alexei Sayle's words, 'No more living 200 feet up in the air in a thing that looks like an off-set lathe or a baked bean canner.'[8]

Instead we get the reaffirmation of either or all of the following: the particular, the vernacular, the sanctity of regional or national materials, styles, methods and traditions; the desirability of maintaining continuity with the past. The architect-as-surgeon has been replaced by the architect-as-holistic-practitioner, the architect-as-homeopath, in some cases, on some severely under-financed community housing schemes, by the architect-as-faith-healer.

Architecture is a relatively independent and isolable field but none the less there are definite links that can be made with other postmodernisms. There is the assertion, at least in the literature, of the legitimacy of ordinary people's desires and aspirations, if not always an unqualified endorsement of their tastes. Here we find a theme common to all the radical postmodernisms: the articulation – in this case quite literally – of a horizontal rather than a vertical aesthetic: a flat-spread aesthetic rather than a triangular figure with the élite, the expert at its apex and the masses at the base. An emphasis on difference and diversity replaces the stress on system, order, hierarchy (though this doesn't apply to Quinlan Terry who believes that the laws of both architecture and social structure were laid down in the time of Solomon).[9] But more importantly, what links the architecture of the Post to its artistic, critical and more purely philosophical and speculative equivalents is the shrinkage in the aspirations of the intellectual practitioner him/herself. It is there in the questioning of the godlike role and absolute rights of the enlightened expert-as-engineer-of-the-future. It is there in the preference for structural, holistic or

ecological models of the field over dynamic, teleological or modernizing ones.

For the word 'postmodernism', if it signifies at all, announces at the very least a certain degree of scepticism concerning the transformative and critical powers of art, aesthetics, knowledge. In its critical inflections, it announces the end of any simple faith in what have sometimes been called the 'grand metanarratives' – the Great Stories which for thousands of years the cultures of the West have been telling themselves in order to keep the dread prospect of otherness at bay. The word 'postmodernism' marks the decline of the Great Stories the West has told itself in order to sustain itself *as* the West *against* the Rest, in order to place itself as Master and as Hero at the centre of the stage of world history. Those great stories, those metanarratives, have many different titles, many different names. Here are just a few:

divine revelation, the unfolding Word, the shadowing of History by the Logos, the Enlightenment project, the belief in progress, the belief in Reason, the belief in Science, modernization, development, salvation, redemption, the perfectibility of man, the transcendence of history through divine intervention, the transcendence of history through the class struggle, Utopia, subtitled End of History ...

These stories – who knows? – may have functioned in the past as forms of reassurance like the first stories which John Berger talks about[10] – stories perhaps designed by men – for this is the gender which constitutes itself as *the* subject of History. Berger imagines the first men crouching round their fires at night telling stories – perhaps dreams, embellished or idealized biographies, perhaps boasts intended to amplify the storyteller's tribe to keep the fear of ghosts and wolves at bay. Each story represents a ring of fire and light lit to pierce the ambient darkness. To chase it back forever ... And we today crouching on our haunches centred round the dying embers of so many great stories, so many heroic, epic master–narratives – stories which have lost their light and lustre, their power and their plausibility – we, today, may have to learn to live without their solace and their comfort in a world where nothing – not even the survival of the world itself as something to wake up to in the morning – is any longer certain.

If postmodernism means anything at all, it means an end to a belief in coherence and continuity as givens, an end to the metaphysic of narrative closure (and in this it goes no further than the modernism it claims to super-sede). Postmodernism may mean what Paul Virilio calls (in a phrase that echoes Benjamin) the 'triumph of the art of the fragment':[11] a loss of totality, a necessary and therapeutic loss of wholeness.[12]

It may mean recognizing in ways that were prefigured years ago in Einstein's physics that subjects can merge with objects, that discontinuities are as significant, as productive, as continuities, that observer effects and random factors must be taken into account in understanding or re-presenting any process whatsoever, however material the process, however 'materialist'

337

the account.[13] It may mean at worst substituting history as a game of chance for the older, positivist models of productive causality. less fatalistically, it may mean substituting a history without guarantees for the older models of mechanical and 'necessary' progress. The choice is still there even in the nuclear age: history as a sound and fury signifying nothing or history as a desperate struggle to snatch back reason with a small 'r' from the jaws of desperation.

But if this still sounds too grandiose and pretentious and far too close to the modernist project it claims to displace, we can cut postmodernism down to size by reducing its terms of reference. There are plenty of signs of the Post on the frantic surfaces of style and 'life style' in the mid to late 1980s.

Postmodernism could certainly be used loosely to designate that range of symptoms which announce a break with traditional cultural and aesthetic forms and experiences: the break, for instance, with traditional notions of authorship and originality. Postmodernism has been used as a shorthand term to reference certain qualities and tendencies which characterize the contemporary (Western) metropolitan milieu: a growing public familiarity with formal and representational codes, a profusion of consumption 'life styles', cultures, subcultures; a generalized sensitivity to style (as language, as option, as game) and to difference:ethnic, gender, regional and local difference: what Fredric Jameson has called 'heterogeneity without norms'.[14]

For it's not all dark Wagnerian brooding, this postmodern thing. In fact, it often gets depicted (in a spirit which can be hostile or approving) as quite the opposite – as a celebration of what is there and what is possible rather than what might be there, what might be hypothetically possible.

The switch from the austere and critical negations (of the sensuous, of the doxa) which marked the counter-cinema, 'anti-art' and the conceptualism of the late 1960s and 1970s into 1980s eclecticism, bricolage and play etc indicates not so much a lowering of expectations as a shift in the register of aspirations: from the drive towards a total transformation in historical time (May 1968 and all that) to the piecemeal habitation of finite space – the space in which we live. If we were to talk in terms of master-disciplines the shift would be from sociology to architecture.

While some artists and critics (e.g. Fuller) denounce postmodernism as a flatulent retreat from the sacred responsibility of the Artist to bear critical witness for the times in which we live, [15] others (e.g. Owens and Kruger) stress the extent to which the sacerdotal postures and 'duties' of the Artist must themselves be questioned and dismantled insofar as they serve to amplify and duplicate the voice of the Father.[16]

Clearly, there are many good things to be grown in the autumn of the patriarch, many good things to be found in the ruins, in the collapse of the older explanatory systems. The unfreezing of the rigid postures of the past – the postures of the hero, the critic, the spokesman – may merely signal the long-awaited eclipse of many oppressive powers in our world – the power, for

instance, of the white male middle-class pundit. It may open things up so that sense may begin to flow with less alarming gusto through more varied and more winding channels. Such a dispersion of sense might lead to a loosening of the bonds that bind us to the single and the singular track, to a paranoid obsession with certitude and fixed and single destinations.

[...] The drift of some postmodernist accounts implies that the modernist avant-garde constituted itself through what amounted to an imaginary and paranoid projection of absolute Otherness onto an idealized non-existent bourgeois 'norm'. The unitary subject which is incessantly attacked, dis-stressed, deconstructed in modernist art and literature and modernist criticism becomes the imaginary Subject of both economic/political and cultural /symbolic power: the absolute Father. The avant-garde – were it to exist today – could no longer feasibly counterpoise itself against such a clearly phantasmagoric, literally fantastic projection. In the days of *Dallas* and Princess Di we find it hard to pin down the contemporary correlative of any-thing so coherent and stable as a unitary bourgeois 'norm'.

In some declensions of the Post, the unitary subject as the principal target of radical modernist avant-garde practice has been revealed as a straw man in the late twentieth century because capitalism these days has absolutely no stake whatsoever in the idea of individuals being tied to fixed and stable iden-tities. The Ideal Consumer of the late 1980s is a bundle of contradictions: monstrous, brindled, hybrid. The Ideal Consumer as deduced from contem-porary advertisements is not a 'he' or a 'she' but an 'it'. At the moment (November 1985) it is a young but powerful (i.e. solvent) Porsche-owning gender bender who wears Katherine Hamnet skirts and Gucci loafers, watches *Dallas* on air and *Eastenders* on video, drinks, lager, white wine or Grolsch and Cointreau, uses tampons, smokes St Bruno pipe tobacco, and uses Glintz hair colour, cooks nouvelle cuisine and eats out at McDonald's, is an international jetsetter who holidays in the Caribbean and lives in a mock-Georgian mansion in Milton Keynes with an MFI self-assembled kitchen unit, an Amstrad computer and a custom-built jacuzzi. The ideal consumer is not the ideal productive worker of an earlier epoch – a sexually repressed nobody, alienated from sensual pleasure, subjected to the turgid, life-denying disciplines of the working week and the nuclear family. Instead the Ideal Consumer – It: enemy of the personal pronouns – is a complete social and psychological mess. The Ideal Consumer as extrapolated from the barrage of contradictory interpellations from advertising billboards to magazine spreads to television commercials is a bundle of conflicting drives, desires, fantasies, appetites. What advertising conceived as a system offers is not a sanctuary from conflict and necessity, not a 'magical' refuge from the quotidian grind. It does not address or constitute a subject so much as promise an infinite series of potentially inhabitable (and just as easily relinquished) subject positions. What capitalism these days *wants* is a world full of loaded drunken boats – *bâteaux ivres* loaded down with loot. The subject of advertising is not the

339

rational sovereign subject of Descartes, the subject of 'consumer sovereignty'. Nor is it the manipulated dupe of some 'critical' analyses of advertising signs: the malleable wax to the thumbprint of either commerce or the Law. Rather it is Deleuze and Guattari's 'body without organs'[17] – the absolute decentred subject, the irresponsible, unanchored subject: the psychotic consumer, the schizophrenic consumer.[18] [....]

This disruption of the relative certainties and stabilities of High Modernism takes place within the transfigured social/informationl space opened up by electronic communications. In a world of instantaneous communication, multi-user systems, electronic polylogue, the artist and the critic pale even further than before into impotence and insignificance. The intellectual, the critic, the artist can no longer claim to have privileged access to the Truth or even to knowledge, at least to the knowledge that counts. What artist can compete with advertising when it comes to visual impact, ubiquity, effect and general exposure? What use is a critical interpretation of a text or a semiotic reading of an image in a world where information never stays in place, where information, communication, images are instantly produced, transformed, discarded in a process of endless complexification, polyphony, supersession and flux?

But all is not lost. We may have lost the Big Theories, the Big Stories but postmodernism has helped us rediscover the power that resides in little things, in disregarded details, in aphorism (miniaturized truths), in metaphor, allusion, in images and image-streams. [...]

Notes

1 See for instance, Hal Foster *Postmodern Culture*, London, 1985; Lisa Appignanesi and Geoff Bennington, eds., *Postmodernism. ICA Documents 4*, London, 1986; Jean-François Lyotard, *The Postmodern Condition*, Manchester, 1984; *New German Critique: Modernity and Postmodernism Debate*, no. 33, Fall 1984; Fredric Jameson, 'Postmodernism or the Cultural Logic of Late Capitalism' in *New Left Review*, no. 146, July-August 1984; Larry Grossberg, *Rocking with Reagan* (1985, unpublished); Hilary Lawson, *Reflexivity: The Post-Modern Predicament*, London, 1985. For a more developed and conventional critique of postmodernism than the one presented in this report, see Dick Hebdige, *Hiding in the Light: On Images and Things*, London, 1988.
2 Jean Baudrillard, 'The Ecstasy of Communication', in Foster, ed., *Postmodern Culture*.
3 See, for instance, Michael Newman, 'Revising Modernism, Representing Postmodernism' in Appignanesi and Bennington, eds., *Postmodernism*. Newman posits two distinct modernist traditions, one centring on an 'autonomous' fixation on 'honesty', 'purity' and 'reflexivity' (from Kant to Greenberg); the other focused round a 'heteronomous' aspiration to dissolve art into everyday life (from Hegel to the Surrealists). Any simplistic model of a single modernist movement unfolding globally in time to the rhythm of 'development' is effectively dismantled by Perry Anderson in his response to Marshall Berman's book, *All that's Solid Melts into Air*. See P. Anderson, 'Modernity and Revolution', in *New Left Review*, no. 144, March-April, 1984.
4 Jean-François Lyotard, 'Defining the Postmodern' in Appignanesi and Bennington, eds., *Postmodernism*.
5 For problems of periodization, see Foster, ed., *Postmodernism*, especially Foster, 'Postmodernism. A Preface' J. Habermas, 'Modernity – An Incomplete Project', F. Jameson, 'Postmodernism and Consumer Society'. Also Anderson, 'Modernity and Revolution', and Newman, 'Revising Modernism'.
6 For a discussion of these categories see Shirley Ardener, *Perceiving Women*, 1975; Annette Kuhn, *Women's Pictures: Feminism and Cinema*, London.

7 See Jean Baudrillard, 'The Precession of Simulacra' in *Art & Text*, 11, Spring 1983. Also *Simulations*, Paris, 1983. Paul Virilio explores similar themes in 'The Overexposed City', *Zone* 1/2 *The City*, 1986.

8 Alexei Sayle, *Train to Nowhere*, London, 1983.

9 See Patrick Wright, 'Ideal Homes', *New Socialist*, no. 31, October 1985.

10 John Berger in conversation with Susan Sontag on the televison discussion programme *Voices*.

11 Paul Virilio and Sylvere Lotringer, *Pure War*, Paris, 1983.

12 The most extreme formulation of the 'postmodern ontology' thesis has been put forward by Baudrillard who argues that the 'space of the subject' (interiority, psychological 'depth', motivations etc.) is being 'imploded' and destroyed by the new communication technologies. See Baudrillard 'The Precession of Simulacra', and 'The Ecstacy of Communication'.

13 See Jean-François Lyotard, 'Les Immateriaux' in *Art & Text,* 17, *Expressionism*, April 1985. This article is a translation of a document writen by Lyotard as an accompanying gloss to the exhibition of the same name organized by Lyotard at the Pompidou Centre in Paris from 28 March to 15 July 1984. The mixed media installations which formed a series of nodal points through which the spectator/auditor was invited to 'drift' were designed to force modifications to existing models of aesthetics, knowledge and communications by exploring/exposing the epistemological implications of the new technologies. The installations were designed to stand as analogues of/catalysts for the new 'postmodern sensorium' – a sensorium constituted in part directly through exposure to the new technologies (understood first and foremost as the bearers of the next phase in human evolution: the era of the Simulacra). This new sensorium, it is argued, can only be properly understood/inaugurated if we 'move beyond' the post-Socratic distinctions between, for instance, mind and matter, body and spirit, subject and object which formed and go on forming the founding 'moment' of so much of what we call 'western' thought and culture.

14 Fredric Jameson, 'Postmodernism or the Cultural Logic of Late Capitalism'.

15 See for instance, Peter Fuller, *Aesthetics After Modernism,* London, 1983; *Beyond the Crisis in Art*, London, 1980.

16 See Barbara Kruger, *We won't Play Nature to your Culture*, London, 1983, and Craig Owens, 'The Medusa Effect or, The Spectacular Ruse' in Kruger, op.cit. Also Craig Owens, 'The Discourse of Others: Feminists and Postmodernism' in Foster, ed., *Postmodernism*.

17 Gilles Deleuze and Felix Guattari, *The Anti-Oedipus: Capitalism and Schizophrenia*, Minnesota, 1983.

18 Ibid. and F. Jameson ('Postmodernism or the Cultural Logic of Late capitalism' and 'Postmodernism and Consumer Society'). Also Baudrillard ('The Ecstasy of Communication'). For a more critical engagement with the postmodernist 'appropriation' of schizophrenia see D. Hebdige, 'Staking out the Posts' in *Hiding in the Light: On Images and Things* and 'Postmodernism and The Other Side' in *Journal of Communication Inquiry,* vol. 10, part 2, Summer 1986, pp. 78-98.

341